Arts & Crafts

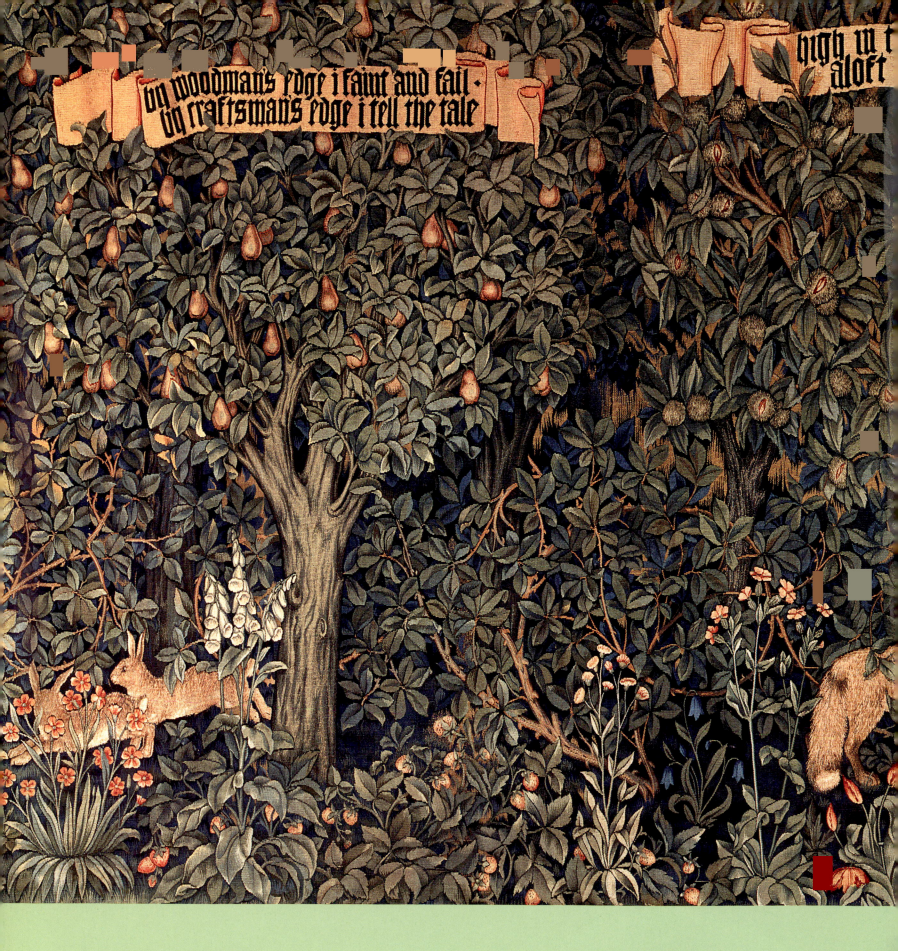

by woodmans edge i faint and fail ·
by craftsmans edge i tell the tale

high in t
aloft

MILLER'S

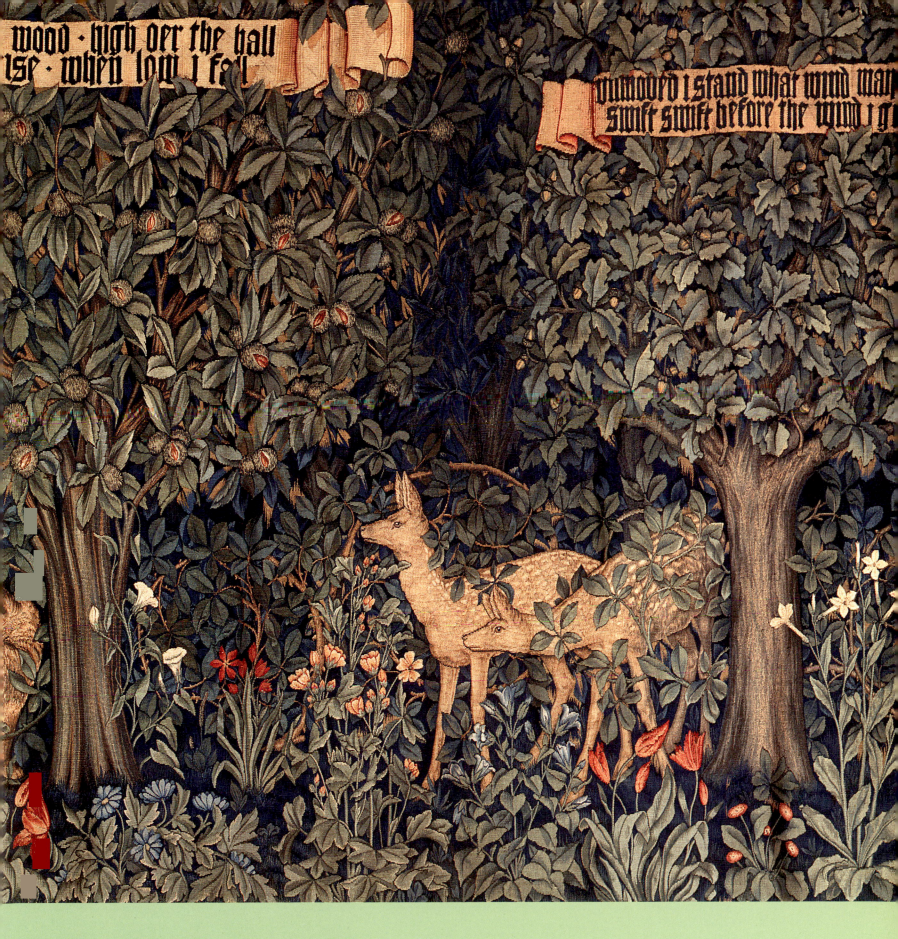

wood · high oer the hall
ise · when low I fall

vnmoved I stand what wind may
swift swift before the wind I g

Arts & Crafts

Miller's Arts and Crafts
by Judith Miller

First published in Great Britain in 2014 by Miller's,
a division of Mitchell Beazley, imprints of Octopus Publishing Group Ltd,
Endeavour House, 189 Shaftesbury Avenue, London WC2 8JY
www.octopusbooks.co.uk
www.octopusbooksusa.com

Miller's is a registered trademark of Octopus Publishing Group Ltd
www.millersonline.com

An Hachette UK Company
www.hachette.co.uk

Distributed in the US by Hachette Book Group,
1290 Avenue of the Americas, 4th and 5th Floors, New York, NY 10020

Distributed in Canada by Canadian Manda Group,
664 Annette Street, Toronto, Ontario, Canada, M6S 2C8

ISBN 978 1 84533 943 2

A CIP record of this book is available from the British Library and the Library of Congress.

Printed and bound in China

Chief contributors: Julie Brooke (Furniture, Jewellery), Lesley Jackson (Textiles, Lighting and Glass),
Esmé Whittaker (Metalware, Books and Graphics)

Publisher: Alison Starling
Art Director: Jonathan Christie
Designer: David Rowley
Head of Editorial: Tracey Smith
Senior Production Manager: Peter Hunt
Project Editor: Alex Stetter
Editorial Co-ordinator: Christina Webb
Copy Editor: Linda Schofield
Proof Reader: Jane Birch
Indexer: Isobel McLean

Value codes

Throughout this book the value codes used at the end of each caption correspond to the approximate value of the item. These are broad price ranges and should be seen only as a guide to the value of the piece, as prices vary depending on the condition of the item, geographical location, and market trends. The codes are interpreted as follows:

A	£200,000/$335,000 and over		**H**	£10,000–15,000/$17,000–25,000
B	£100,000–200,000/$165,000–335,000		**I**	£5,000–10,000/$8,500–17,000
C	£75,000–100,000/$125,000–165,000		**J**	£2,000–5,000/$3,500–8,500
D	£50,000–75,000/$85,000–125,000		**K**	£1,000–2,000/$1,750–3,500
E	£30,000–50,000/$50,000–85,000		**L**	£500–1,000/$850–1,750
F	£20,000–30,000/$35,000–50,000		**M**	under £500/$850
G	£15,000–20,000/$25,000–35,000			

Previous pages

An 1892 Morris and Company tapestry designed by John Henry Dearle, woven in coloured wools and mohair by John Martin and William Sleath,

Opposite

A Martin Brothers stoneware triple bird group, by Robert Wallace Martin. 1914, 7¾in (19.5cm) high, **E**

Contents

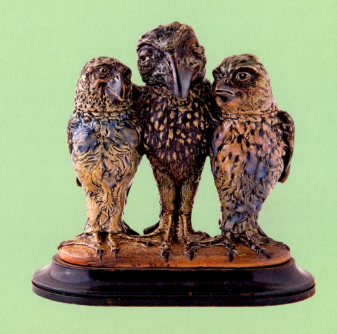

The Origins of Arts and Crafts

The Arts and Crafts Movement was one of the most significant, philosophical, and far-reaching design movements of recent times.

It was a movement born of ideals and socialist doctrine. It grew out of a concern for the effects of industrialization: on the decorative arts, on craftsmanship, and on the lives of the working class. The Arts and Crafts Movement was inspired by William Morris, John Ruskin, and Edward Burne-Jones, British artists and social reformers who mourned the lessening role of the artist-craftsman and the increasing dependence on the machine to meet the demands of a growing middle class.

The Arts and Crafts style was partly a reaction against the style of many of the items shown in the *Great Exhibition* of 1851, which were ornate, artificial, and ignored the qualities of the materials used. The art historian Nikolaus Pevsner has said that exhibits in the *Great Exhibition* showed "ignorance of that basic need in creating patterns, the integrity of the surface" and was horrified by the "vulgarity in detail". Owen Jones, an organizer of the *Exhibition*, later declared that "Ornament...must be secondary to the thing decorated", that there must be "fitness in the ornament to the thing ornamented".

Morris was an idealist and romantic, who believed in the importance of the individual craftsman and a vision of harmony that looked back to the medieval guild system for inspiration. The Movement was largely a reaction against the impoverished state of everything from furniture and textiles, jewellery to ceramics to the building of the house itself. Many of its leading figures were architects, rather than designers, and they came to view buildings and their interiors as a whole. They worked in a variety of media, often with other artists, and hoped to bring a greater unity to the arts. Another defining feature of Arts and Crafts architecture was an interest in the vernacular. Architects used local materials and traditional styles to produce something that would not jar with its surroundings, but would look at the same time distinctive and modern. Many hoped to design buildings that appeared as if they had grown over many years.

These imaginative architects, designers, and craftsmen working to create a better, more authentic world looked to nature for inspiration – from the inherent beauty of the wood and the visible construction of a chair or cupboard, to the luxurious colours and decorative motifs based on flowers and birds that embellished a stained-glass window, a necklace, or a textile. They used simple forms and often applied medieval, romantic, and folk decoration. In order to express the beauty of craft, some products were deliberately left slightly unfinished, resulting in a certain rustic and robust effect.

However, the insistence in Britain on a dogmatic approach to hand craftsmanship meant that the Movement could not appeal to even the wealthiest of the middle classes – the only people who could buy into Morris's utopian ideal were the rich.

Morris and his disciples sought to revive traditional craft techniques and restore the dignity and prestige of the artisan, which he felt had been sacrificed on the altar of Victorian progress and industrialization. He based much of his social and aesthetic philosophy on the medieval ideal, celebrating the central role of the craftsman and the establishment of workers' guilds. Morris and his followers, including A.H. Mackmurdo, Walter Crane, and Philip Webb, were convinced that bringing artistic integrity to everyday household objects played a vital role in improving the quality of life.

"If you want a golden rule that will fit everything, this is it: have nothing in your house that you

Opposite

The owners of this house in Holland Park, west London, have combined Arts and Crafts pieces with new, custom-made furniture to create an airy and inviting dining room.

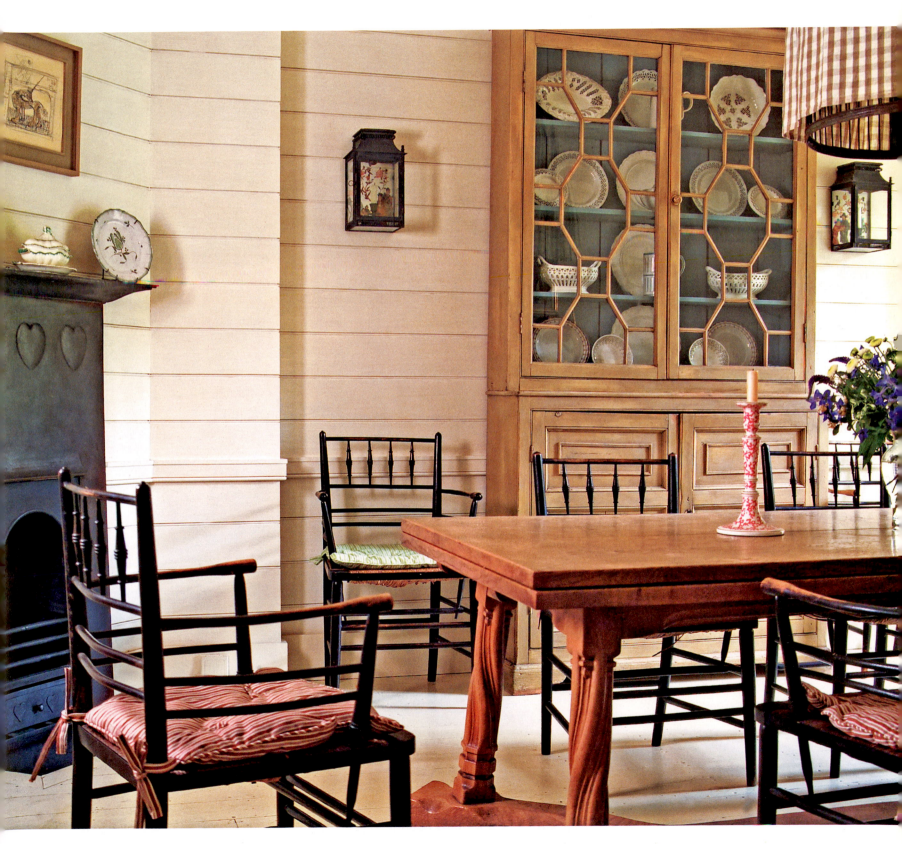

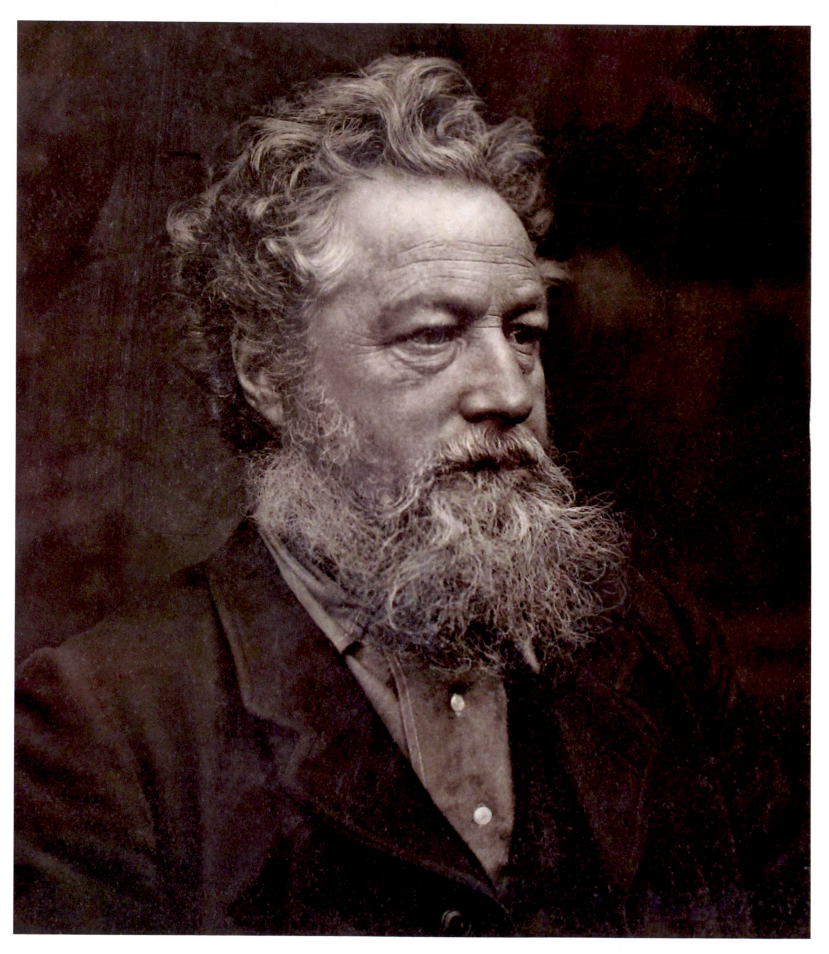

do not know to be useful, or believe to be beautiful,"Morris wrote. To this end the Movement emphasized local materials and craftsman, the importance of honesty to function, and the near deification of hand craftsmanship. How could anyone live a fulfilled life, the proponents believed, surrounded by the cheaply made furniture, mass-produced ceramics, tawdry textiles, and general clutter that typified the Victorian home?

The writings of William Morris exercised profound influence on a younger generation of architects and decorators on both sides of the Atlantic. They determined to bring a renewed vitality to craft traditions and stem the decline in quality that resulted from marginalizing the craftsman in favour of industrialization. The Red House, in Bexleyheath, southeast London, was designed for Morris in 1859 by architect Philip Webb. The building exemplifies the early Arts and Crafts style, with its well-proportioned solid forms, wide porches, steep roof, pointed window arches, brick fireplaces, and wooden fittings. Webb rejected the grand classical style and based the design on British vernacular architecture expressing the texture of ordinary materials, such as stone and tiles, with an asymmetrical and quaint building composition.

Morris pioneered this new interior decorative style and Morris & Co. produced influential and distinctive textiles, wallpapers, and tiles with stylized repeated patterns inspired by nature. As Morris said, "Do not be afraid of large patterns – if properly designed they are more restful to the eye than small ones". The art of textile-making and embroidery rose to a prominence at the end of the 19th century not seen since the medieval period.

Wallpapers, carpets, furniture, ceramics, metalware, and glass lamps – as well as the fittings and structural decoration of a room – were created as part of a cohesive design scheme that often depended for unity upon recurring decorative motifs. In the hands of a new breed of architect-designer, led by M.H. Baillie Scott, the Arts and Crafts interior was a warm and welcoming evocation of the simple life, with the fireplace the designated focus of a long room boasting a low-beamed ceiling, leaded windows, and an abundance of finely crafted wood that included panelling and built-in, multipurpose furniture. Others designers had their own interpretation of the integrated style: Charles Francis Annesley Voysey favoured bright interiors with light, whitewashed walls and little ornament, while Charles Rennie Mackintosh developed stunning decorative schemes that used delicate, elongated geometric lines to punctuate everything from cutlery to carpets.

This integrated style was reflected by architects on both sides of the Atlantic who condemned the mass-production of everything from buildings to metalware and furniture to textiles and claimed that moral decline was brought about by the proliferation of inferior-quality decorative household wares. They also believed passionately that the craftsman should be intimately involved with his craft, whereby a jeweller should hand-hammer his own designs, a furniture maker should choose the wood and only use hand tools, and a painter should grind his own pigments. Morris insisted that "without dignified, creative human occupation people became disconnected from life." Ruskin thought machinery was to blame for many social ills and that a healthy society depended on skilled and creative workers.

The social and aesthetic principles that were championed by William Morris were enthusiastically

The designer, craftsman, and writer William Morris inspired the Arts and Crafts Movement in England and revolutionized Victorian taste.

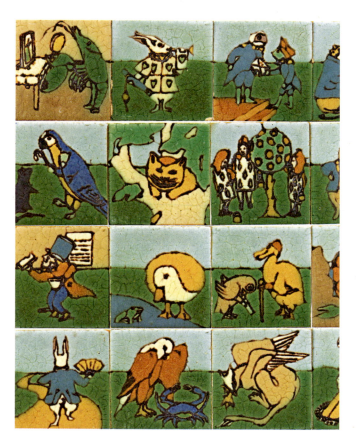

embraced in North America where his visionary ideals were adapted to create a uniquely American and Canadian incarnation of Arts and Crafts style that reflected the confidence of the relatively young nation. This can be seen especially in a radical new approach to the house and its interior, which remains influential to this day. In the United States, the terms "American Craftsman" or "Craftsman" style are often used to denote the style of architecture, interior design, and decorative arts that prevailed btween 1910 and 1925. The "Prairie School" of Frank Lloyd Wright, George Washington Maher, and other architects in Chicago promoted handcrafting and craftsman guilds as a reaction against the new assembly line and mass-production manufacturing techniques, which they felt created inferior products and dehumanized workers. The style is usually marked by horizontal lines, flat or hipped roofs with broad overhanging eaves, windows grouped in horizontal bands, integration with the landscape, solid construction, craftsmanship, and restricting the use of ornament. Lloyd Wright, the most famous advocate of the style, called it "organic architecture", whose tenet was that the building should grow naturally from the site. Wright was passionately opposed to many things, including the machine, which he said was: "invincible, triumphant, the machine goes on, gathering force and knitting the material necessities of mankind ever closer into a universal automatic fabric; the engine, the motor, and the battleship, the works of art of this century!"

The Country Day School Movement and the bungalow and ultimate bungalow style of houses popularized by Greene & Greene and Bernard Maybeck are some examples of the American Arts and Crafts and American Craftsman style of architecture.

Arts and Crafts ideals disseminated in America through magazine and newspaper writing were supplemented by societies that sponsored lectures. The first was organized in Boston in the late 1890s, when a group of influential architects was determined to introduce the design reforms begun in Britain by William Morris. The first meeting was held on 4 January 1897, at the Museum of Fine Arts in Boston, to organize an exhibition of contemporary crafts. When craftsmen, consumers, and manufacturers realized the aesthetic and technical potential of this movement, the process of design reform in Boston was well under way.

The Society of Arts and Crafts was incorporated on 28 June 1897, with a mandate to "develop and

Left

These glazed tiles made by the Grueby Faience Company in Massachusetts around 1915 show characters from Lewis Carroll's *Alice in Wonderland*.

Opposite

The front door of the Red House, Bexleyheath. Completed in 1860, the house was designed by Philip Webb for William Morris, who lived there with his family until 1865.

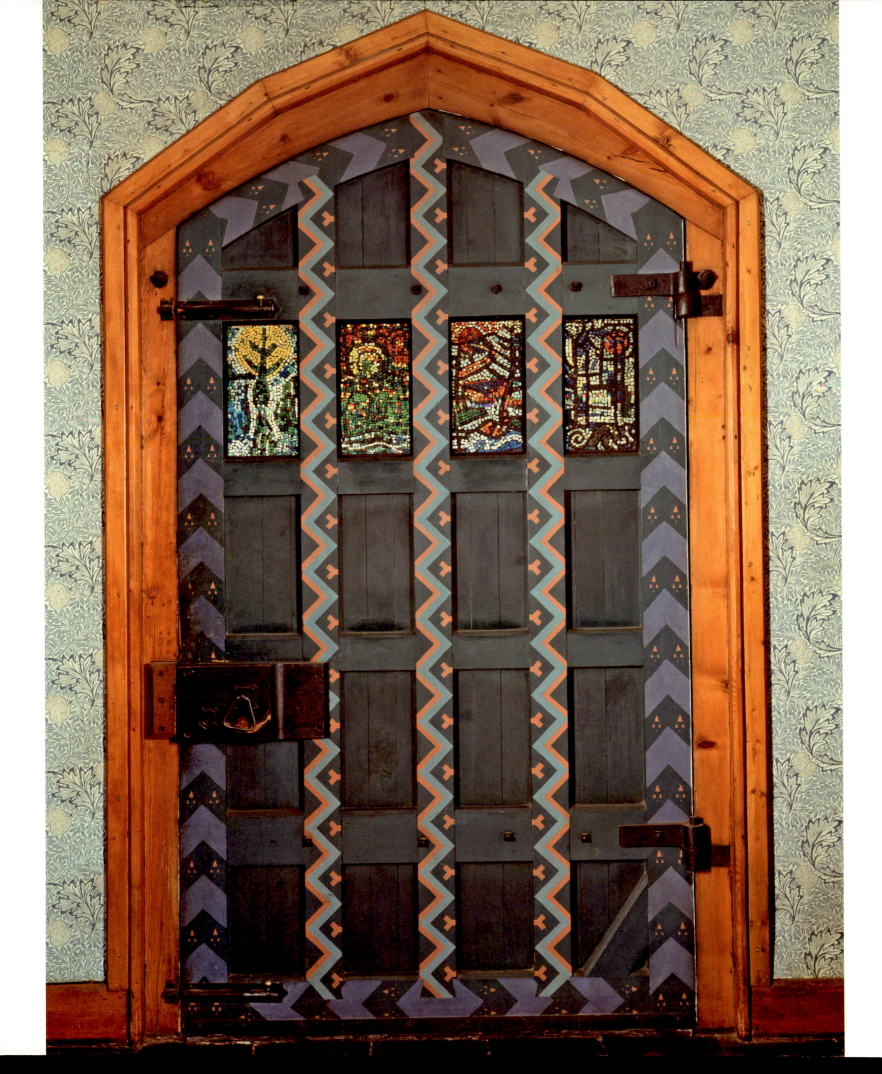

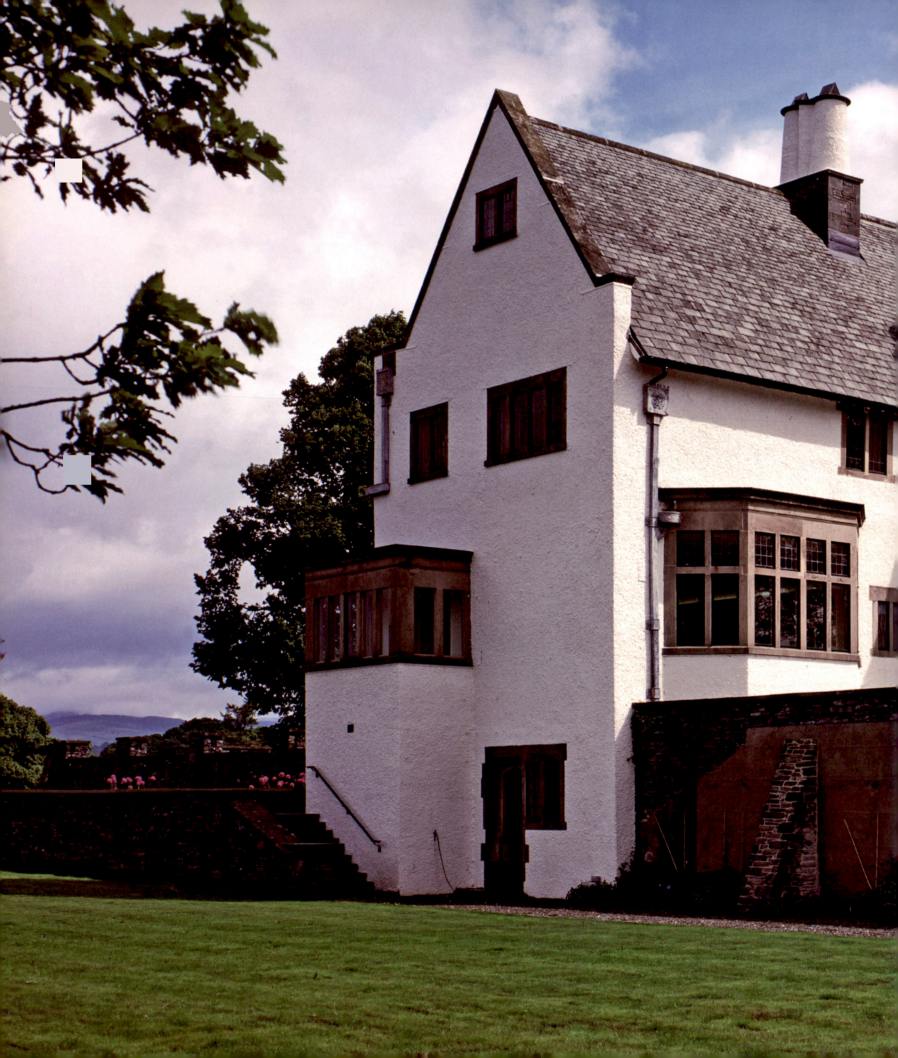

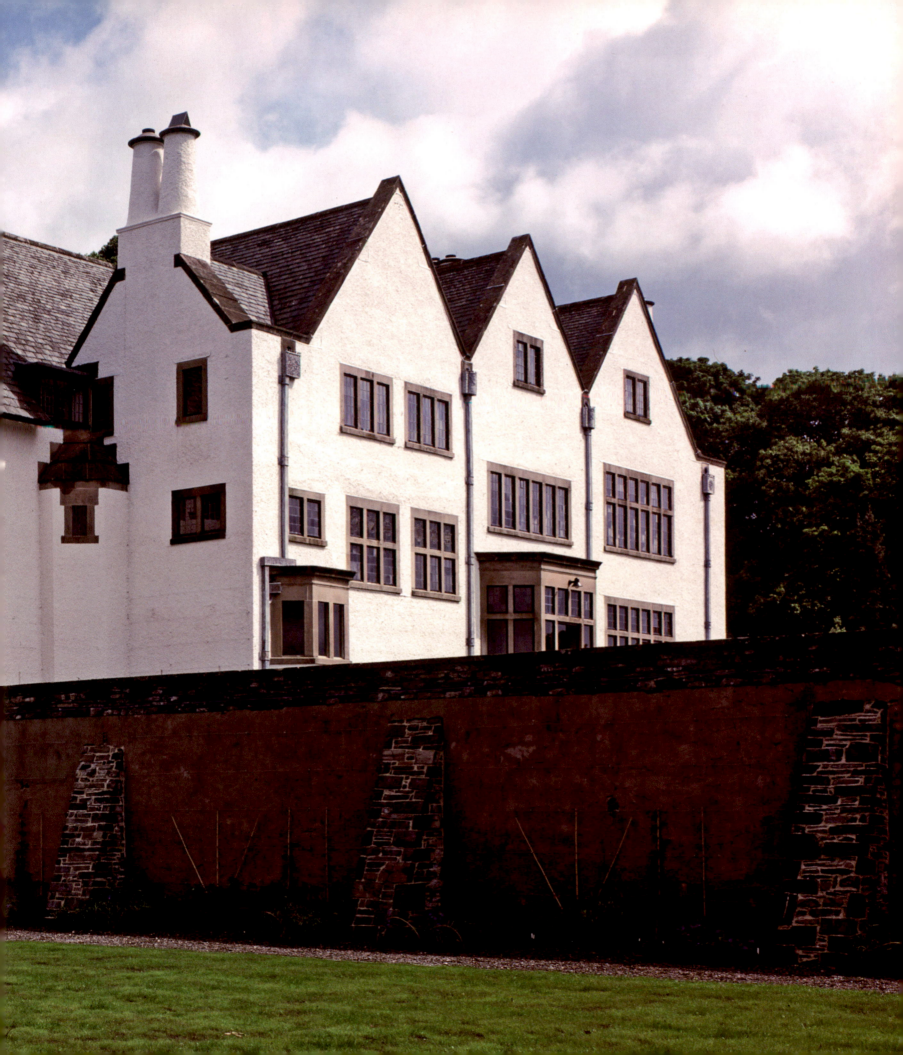

encourage higher standards in the handicrafts." The founders stated that they were interested in more than sales, and emphasized encouragement of artists to produce work with the best quality of workmanship and design. This led to a credo, which read: "This Society was incorporated… to encourage workmen to execute designs of their own. It endeavours to stimulate in workmen an appreciation of the dignity and value of good design; to counteract the desire for over-ornamentation and specious originality.

Gustav Stickley's magazine, *The Craftsman*, was one of the most far-reaching publications of the Arts and Crafts Movement in America. From 1904 it featured a series of "Craftsman" homes designed and built by Stickley's Craftsman Workshops. They included models for a range of incomes, from the smallest cottages upwards. Craftsman homes illustrated the ideals of "honesty, simplicity and usefulness". Stickley believed that the living room was the heart of the home; the furniture should be simple and harmonize with the woodwork in colour and finish.

Entrepreneurs such as Elbert Hubbard and the Stickley family developed a new style of furniture and metalware made affordable to the middle classes through carefully controlled use of machines. The Arts and Crafts style found a voice in the simple shapes and minimal decoration of the furniture created by Gustav Stickley and the Gothic and medieval designs produced by Charles Rohlfs. Inspired by a trip to England in 1894, Hubbard established the Roycroft community in East Aurora, New York, in 1896, based on the English guilds and producing hand-crafted books, furniture, and leather goods. Both individual American potters and ceramics companies such as George Ohr, Artus Van Briggle, and Rookwood also strived to live up to Ernest Batchelder's motto, "no two tiles are the same".

The style found a ready voice with young architects on the West Coast of the United States. The climate and unique local materials of California encouraged a very individual response to Arts and Crafts ideals. Charles and Henry Greene were California's foremost Arts and Crafts architects and were known for extraordinarily fine craftsmanship in their designs. The Greenes saw the house as a total work of art and created furniture specifically for each room. Their richly coloured and beautifully crafted interiors are notable for the exquisite joinery in sumptuous Californian redwoods and for the subtle play of light through stained-glass windows and doors. The Greene brothers' design of the Gamble House displayed an inspired use of clean lines, natural wood, and art glass to create a warm, integrated interior with abundant natural light.

The enormous influence of this movement can be witnessed in its influence, by the end of the 19th century, on architecture, painting, sculpture, graphics, illustration, bookmaking, photography, domestic design, and the decorative arts, including furniture and woodwork, stained glass, leatherwork, lacemaking, embroidery, rug-making and weaving, jewellery and metalwork, enamelling and ceramics.

By the onset of the First World War, the Arts and Crafts Movement had moved beyond its socialist aims and the world looked ahead to Modernism. Nevertheless, Arts and Crafts always was, and remains today, a philosophy, style, and lifestyle for those who appreciate simplicity, quality materials, and hand craftsmanship.

Previous pages

Designed by architect M.H. Baillie Scott and completed in 1901, Blackwell House overlooks Lake Windermere in Cumbria. The house was built as a holiday retreat for Sir Edward Holt.

Opposite

The Gamble House in Pasadena, California was designed in 1908 by Charles and Henry Greene. The architects also custom-designed the building's furniture in the same distinctive Craftsman style.

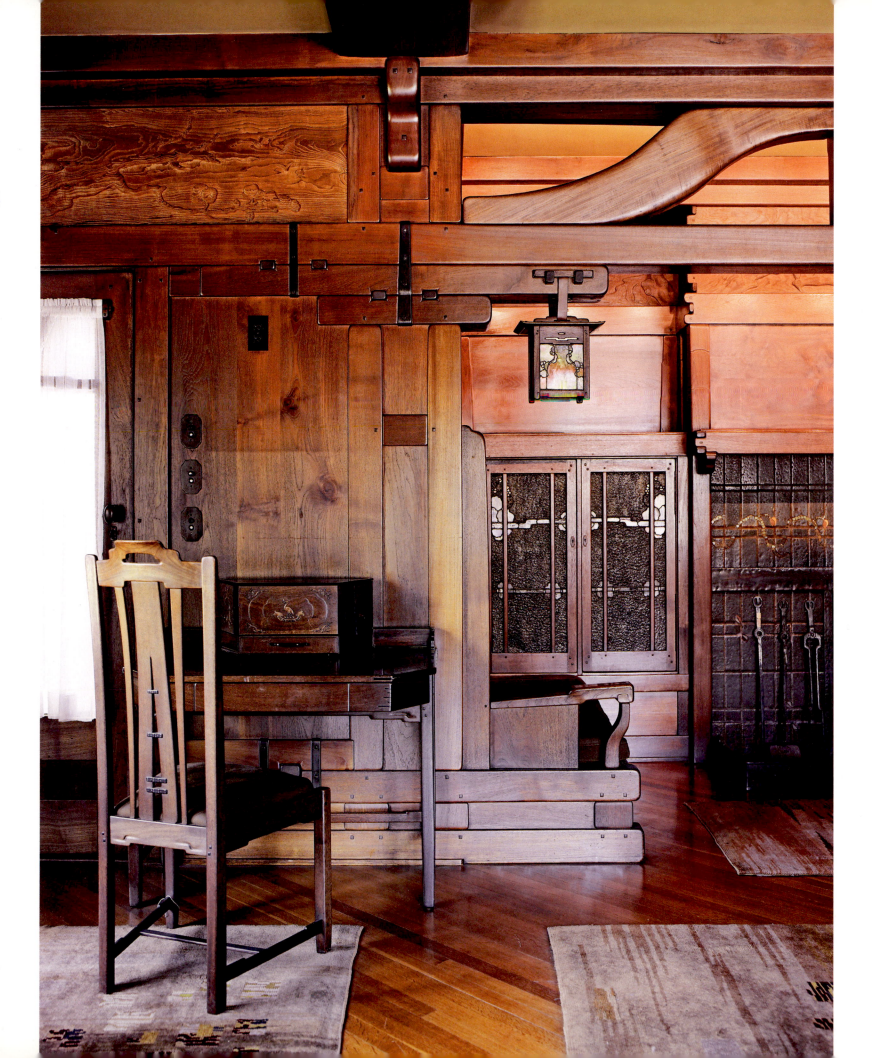

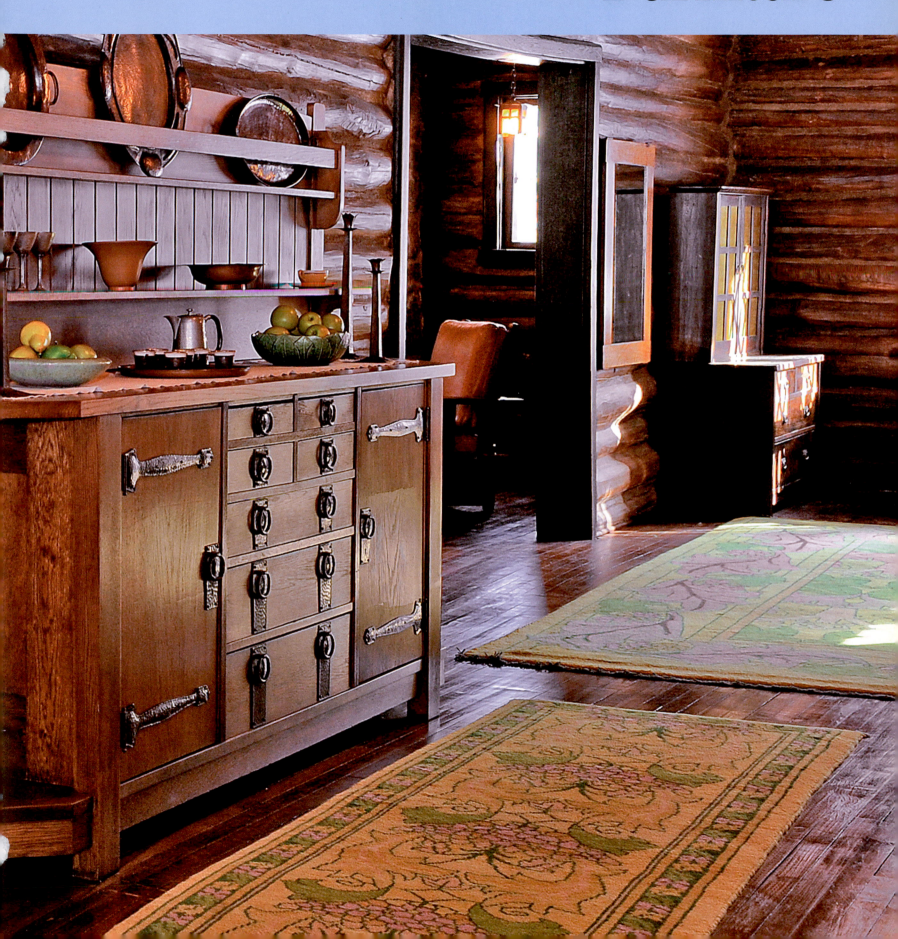

Furniture

British Furniture

In the late 19th century, a new generation of British architects and designers was inspired to take furniture design in a fresh direction. The revolution was, of course, inspired by William Morris (1834–96), who wanted to see homes filled with "the necessary workaday furniture…simple to the last degree" and "the other kind…the blossoms of the art of furniture". Their output was varied: carving, painting, and inlays were used to decorate elaborate sideboards and cabinets, while solid oak was employed for simple chairs and tables.

The typical Victorian home was filled with furniture in a range of historical styles, much of it mass-produced. Arts and Crafts designers preferred to follow the traditional ideal that furniture should be well made from solid, honest materials and, above all, be functional.

Morris provided the blueprint that many followed. His first business – Morris, Marshall, Faulkner & Company (1861–75) – was run like a medieval workshop. In general, it produced sturdy, well-proportioned and functional furniture with minimal decoration. This path was followed by craftsmen including Mackay Hugh Baillie Scott (1865–1945), Philip Webb (1831–1915), and Ernest W. Gimson (1864–1919). They all combined Morris's desire for the traditional with modern decorative ideas to create combinations of useful, plain, and homely furniture in local materials as well as highly decorative "blossoms" from rich timbers including walnut and ebony. These might be inlaid with exotic woods or given decorative metal handles and strap hinges.

Another interpretation of the style was made by "the Glasgow Four", led by Charles Rennie Mackintosh (1868–1928) and Charles Frances Annesley Voysey (1857–1941). Mackintosh favoured simple but elegant shapes with elongated proportions, but he was more concerned with beauty than function. Voysey, on the other hand, made plain and elegant furniture which relied on its shape for its visual appeal and used little decorative ornament.

The Century Guild, led by Arthur Heygate Mackmurdo (1851–1942), the Guild of Handicraft, headed by Charles Robert Ashbee (1863–1942), and William Lethaby's (1857–1931) Art Workers' Guild were inspired by Morris and John Ruskin (1819–1900) and based on the medieval guild system. They championed the skill of the designer-craftsman, as did Ernest Gimson and the Barnsley brothers in the Cotswolds. However, these hand-made pieces were costly to produce and it was commercial retailers and manufacturers, such as Liberty & Co., Heal & Son, Wylie & Lochhead, and Shapland & Petter who sold Arts and Crafts-style furniture to the middle classes.

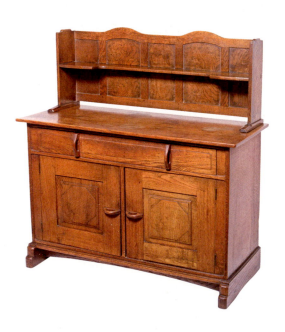
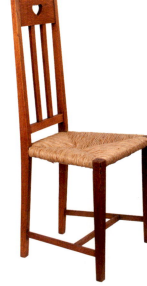
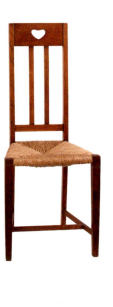
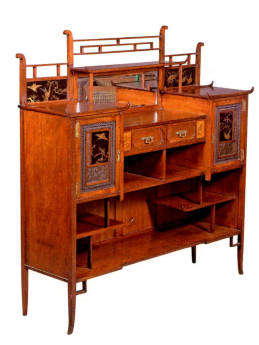

Above

Sidney Barnsley (1865–1926) interpreted the style of a cottage dresser in burr-oak, using carved wooden handles and minimal decoration. c1907, 44in (112cm) wide, **H**

Above

Ernest Archibald Taylor (1874–1951) designed these oak side chairs with rush seats and pierced heart decoration for Wylie & Lochhead, Glasgow. c1910, **L**

Above

The brass fretwork flowers on the doors of this cypress wood writing cabinet are typical of the work of C.R. Mackintosh. c1900, 63in (160cm) high, **C**

Opposite

At Wightwick Manor in Wolverhampton, original furnishings and fittings made by Morris and Co., such as this chair and the wallpaper, have remained largely intact.

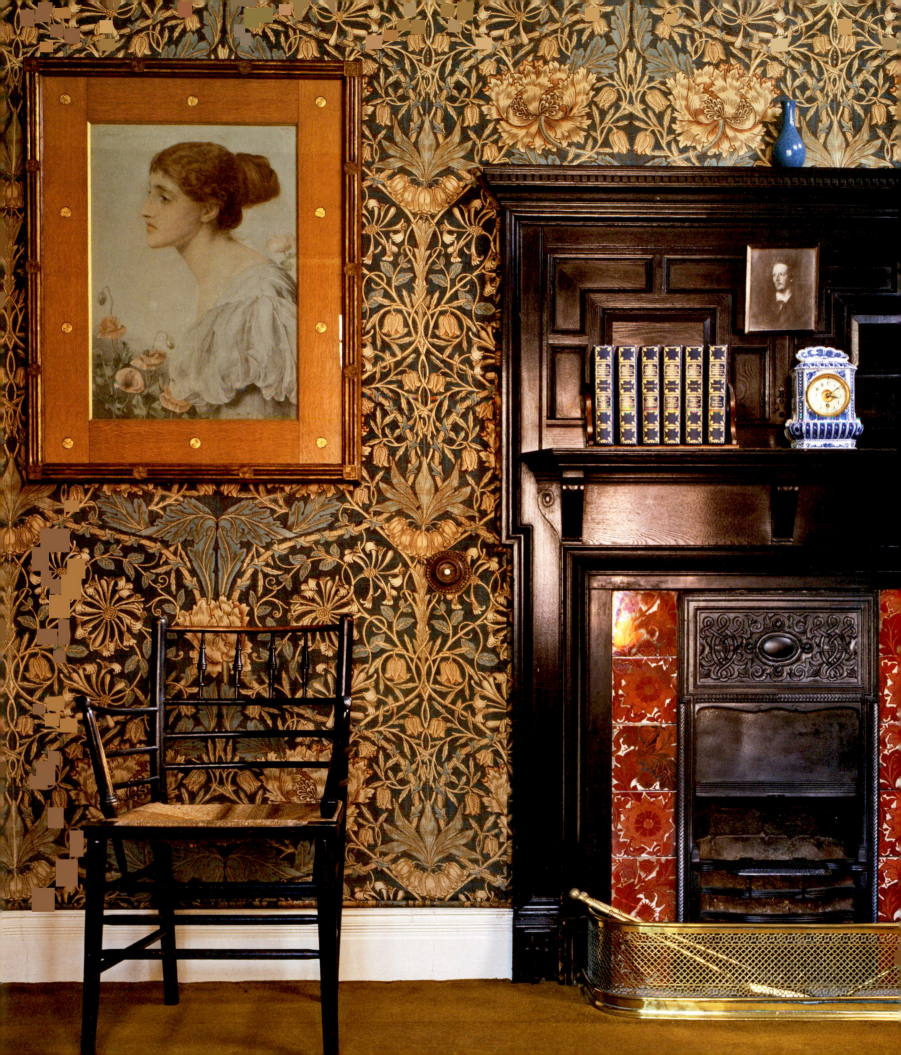

Morris & Co.

William Morris is considered to be one of the founding fathers of the Arts and Crafts Movement. He campaigned against factories, machines, and mass-production, and for the employment of skilled craftsmen to make beautiful, hand-made items using traditional techniques.

In 1861 he founded a design company – Morris, Marshall, Faulkner & Company – with his friends the artists Dante Gabriel Rossetti (1828–82), Edward Burne-Jones (1833–98), and Ford Madox Brown (1821–93), and the architect Philip Webb. Known as "the Firm", and based in London, its output was inspired by nature and a romanticized view of the myths and legends of the Middle Ages. The result was a range of furniture, ceramics, textiles, wallpaper, and carpets that used local, natural materials to create highly innovative forms. Webb designed and built the Red House, Morris's home in Bexleyheath, southeast London, and worked exclusively for the company as a designer of everything from furniture and wallpaper to ceramics and carpets.

Pieces of furniture from the early years of the company are often made from ebonized wood. It was only later that the woods normally associated with country furniture (and for which Morris is usually associated), such as ash and oak, and some mahogany, were used. Decoration is often limited to the joints and hinges.

In 1875 the company was disbanded and Morris founded Morris & Co. Furniture from this era is relatively conventional, often made from mahogany inlaid with satinwood decoration. Successful designs included the "Sussex" and "Morris" chairs. The first "Sussex" chairs were made in the 1880s to a design by Webb. This traditional country chair was made in ash with a hand-woven rush seat and the backs featured turned wood spindles. Later it was made from ebonized wood in a number of forms, including a settee and an armchair. The "Morris" chair – which inspired a similar design by Gustav Stickley (1858–1942) – was a hefty armchair, usually upholstered in Morris & Co. fabric.

In the 1890s George Jack (1855–1932), an American craftsman, was made

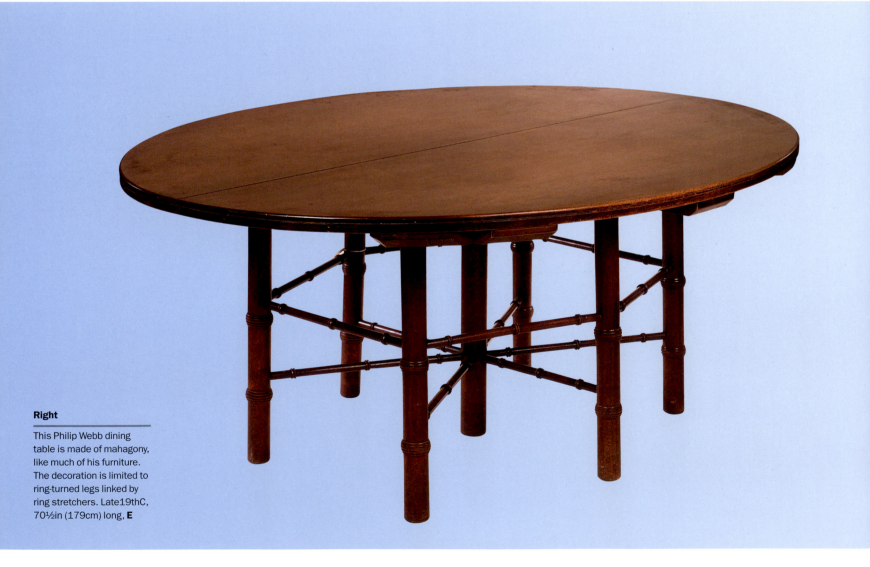

Right

This Philip Webb dining table is made of mahogony, like much of his furniture. The decoration is limited to ring-turned legs linked by ring stretchers. Late19thC, 70½in (179cm) long, **E**

chief designer. His furniture was more elaborate than earlier Morris pieces. This reflected Webb's interest in the Queen Anne style, which had become fashionable, and a change in thinking from Morris. His 1882 lecture, "The Lesser Arts of Life", included the statement that "there should be both 'work-a-day' tables and chairs" and "what I should call state furniture...sideboards, cabinets and the like, which we have quite as much for beauty's sake as for use: we need not spare ornament on these, but may make them as elegant and elaborate as we can with carving, inlaying or painting".

The result was immense mahogany dressers and buffets decorated with extravagant marquetry, pierced carving, and glazed doors, which were very different from the simple country furniture that remained a staple of the company's output.

Morris & Co. closed in 1940. The furniture was widely copied but genuine pieces were clearly marked with a Morris & Co. stamp.

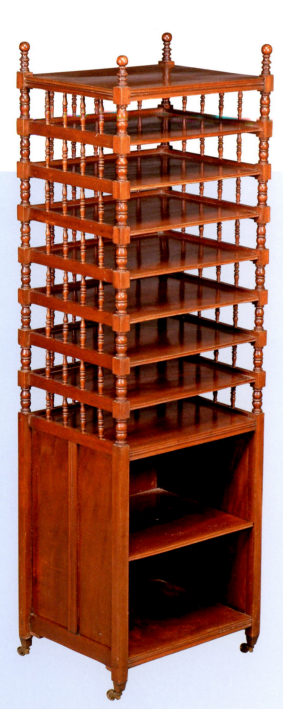

Left

This mahogany sheet music or folio stand with turned supports is an example of the practical items designed by Webb. c1880, 60in (152cm) high, **I**

Top Right

Webb's interest in medieval furniture is evident in this oak centre table. It has solidity and architectural presence, with features drawn from his knowledge of early furniture from around the world. Late 19thC, 71in (180cm) wide, **I**

Bottom Right

This ebonized wood settle, with a rush seat and turned bobbin back, is one of several pieces of furniture based on a traditional country chair design. Late 19thC, 54in (137cm) wide, **K**

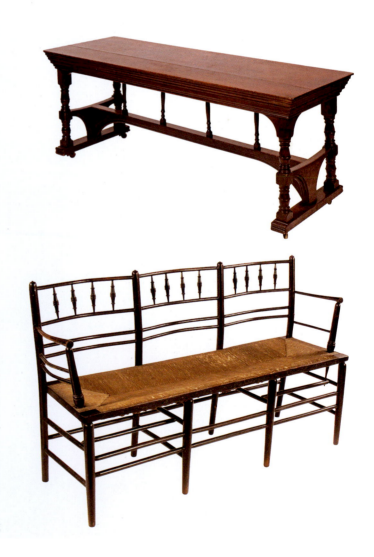

Liberty & Co.

In 1875 Arthur Lazenby Liberty (1843–1917) opened his pioneering department store on Regent Street, London. He believed that he could change the public's taste for homewares and fashion, and reportedly said: "I was determined not to follow existing fashion but to create new ones." His aim was to "combine utility and good taste with modest costs" and to produce "useful and beautiful objects at prices within the reach of all classes". He began by selling ornaments, fabric, and objets d'art from Japan and the East, but he soon saw that there was profit to be made from "art furnishings", and by 1883 had set up a design studio to supply his store with affordable furniture in the Arts and Crafts style.

Leonard Francis Wyburd (1865–1958) led the studio and created some of the company's best-known designs, including the "Thebes" stool. Among the other items attributed to him are country-style oak chairs, stools, tables, and cupboards made from oak, mahogany, and walnut. In general, Liberty furniture used simple construction techniques and featured symmetrical shapes with the minimum of embellishment. However, the studio also created a successful range of high-backed chairs with pierced patterns such as squares, rectangles, hearts, and trefoils; and simple cabinets embellished with painted or stained-glass panels, metal handles, elaborate beaten copper or brass hinges, and even inset tiles by William De Morgan (1839–1917). Some of the more complex pieces were made by other workshops.

Liberty catalogues from the late 19th century show that it had an eclectic customer base. Furniture might be inspired by the Renaissance, Tudor, or Gothic styles, or progressive designers of the day such as William Morris and C.R. Mackintosh. As well as imitating these designers, Liberty commissioned them to make pieces for sale in the store. C.F.A. Voysey and George Walton (1867–1933) were among these, as was M.H. Baillie Scott who created 81 pieces for Liberty. However, those visiting the store to buy furniture in the Arts and Crafts

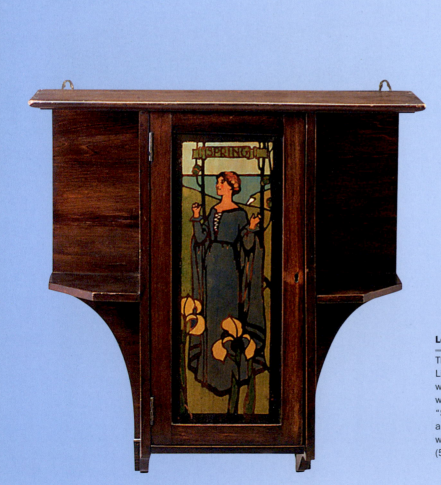

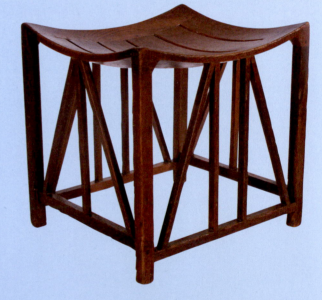

Left

The door of this stained Liberty softwood hanging wall cabinet is stencilled with a panel entitled "Spring", which features a pre-Raphaelite maiden with irises. c.1900, 23in (58.5cm) high. **K**

Above

The "Thebes" stool is one of the firm's best-known designs. This example has a square-section slat seat, while others have leather seats. 1884, 12in (30cm) wide, **K**

style without a designer name found that the "Quaint" range met their needs.

By 1900 Liberty & Co. was acknowledged as the leading producer of Arts and Crafts furniture. Its famous clientele included the writer Oscar Wilde (1854–1900) who said: "Liberty is the chosen resort of the artistic shopper."

The company reinforced its message by printing quotations from John Ruskin in its illustrated catalogue, and copying Morris's technique of applying mottoes to its country furniture. For buyers who wanted the Arts and Crafts style in their homes – and who were content to ignore the Movement's ideal that the skills of the artist-craftsman were paramount – Liberty's provided the ideal solution. However, Liberty's success at selling Arts and Crafts to a wider audience helped to bring about the end of the guilds it emulated so well during the first years of the 20th century.

Liberty furniture is most commonly marked "Liberty & Co" within a rectangular ivorine plaque.

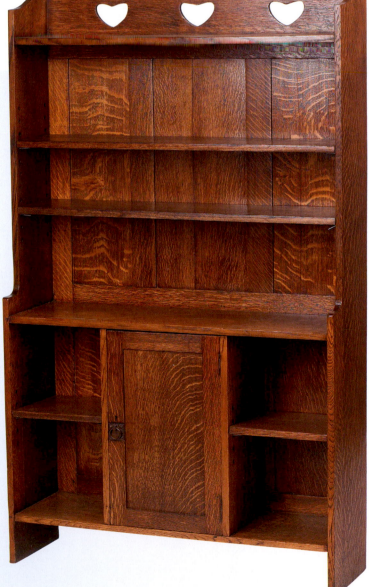

Right

Decoration on many pieces was limited to pierced designs. This oak bookcase with adjustable shelves has stylized heart fretwork at the top. c1900, 70in (177cm) high, **G**

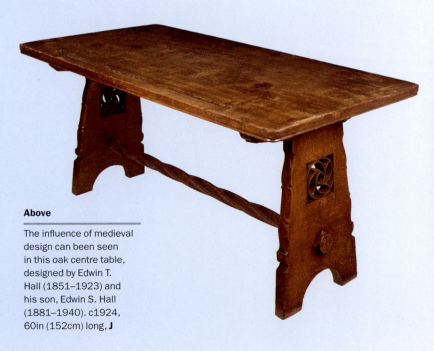

Above

The influence of medieval design can been seen in this oak centre table, designed by Edwin T. Hall (1851–1923) and his son, Edwin S. Hall (1881–1940). c1924, 60in (152cm) long, **J**

C.F.A. Voysey

Charles Francis Annesley Voysey thought of himself as a traditionalist and conservative, but his individuality and sense of purpose made him a radical in others' eyes. Voysey believed that, above all, furniture should be practical. As a result his designs were graceful, useful, and featured minimal decoration. This ethos can been seen in his textile and metalwork designs, and influenced other Arts and Crafts designers – so much so that characteristics of his work can be often be seen in their work.

Voysey trained as an architect and began to design furniture in 1890; his background enabled him to create furniture that was an integrated part of a home rather than a collection of disparate items within it.

Writing in *The Studio* in 1893 he said: "In most modern drawing rooms confusion is the first thing that strikes one. Nowhere is there breadth, dignity, repose or true richness of effect, but a symbolism of money alone. Hoarding pretty things together is more often a sign of vanity and vain-glory than good taste. Let us begin by discarding the mass of useless ornaments and banishing the millinery that degrades our furniture and fittings. Reduce the vanity of patterns and colours in a room. Eschew all imitations and have each thing the best of its sort, so that the decorative value of each will stand forth with increased power and charm."

Though he was influenced by William Morris and A.H. Mackmurdo, Voysey's work was innovative rather than derivative. His elegant furniture relied on the natural beauty of the timber for much of its appeal, giving it a rustic element similar to that of his architecture. Voysey often used untreated pale oak, the finish of which tended to be free from stain or polish. His furniture relied on the structure and proportion of the design for its originality.

The craftsmanship of the cabinetmaker was paramount. Simple cabinets were decorated with panels carved in low relief, or made from brass and leather panels, and might be given elaborate metal strap hinges. Some furniture features tapering legs or supports that end in a wide square cap, which were inspired by Mackmurdo. Voysey's chairs commonly have rush or leather seats with vertical, tapering uprights and heart-shaped cutouts.

Voysey's practice flourished in the early years of the 20th century and he was the architect of choice for progressive middle-class clients. However, his work fell out of favour and by 1914 he had to be content with designing furniture and wallpaper. His income reduced to the extent that he had to live with his son.

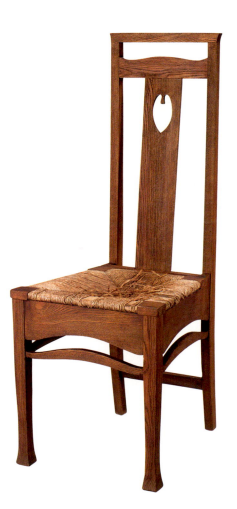

Left

Voysey's chairs often combine rush seats with back rests decorated with a heart-shaped cutout and tapering legs terminating in block feet. This chair was designed for Liberty & Co. c1905, 41½in (105cm) high, **J**

Right

A rare table secretaire, which was exhibited at the Hamilton 1905 *Arts and Crafts Exhibition*. c1900, 18in (45.5cm) wide, 20in (50cm) high, 12in (30cm) deep, **C**

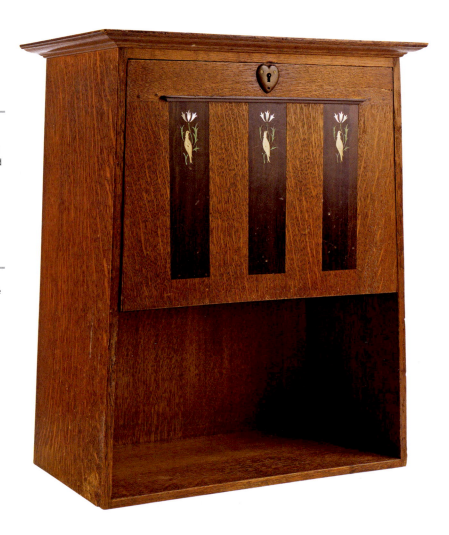

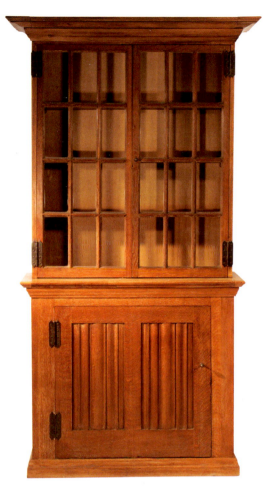

Above

Low-relief carved fluted panels decorate the doors of this late-19th century limed oak bookcase. The brass fittings were made by Elsey & Co. 63in (159cm) high, **J**

A Closer Look

This hall chair is typical of C.F.A. Voysey's work in that it uses pale oak and minimal decoration. The tacked-on leather seat is a replacement but this does not detract significantly from the value. c1905, 55in (139.5cm) high, **H**

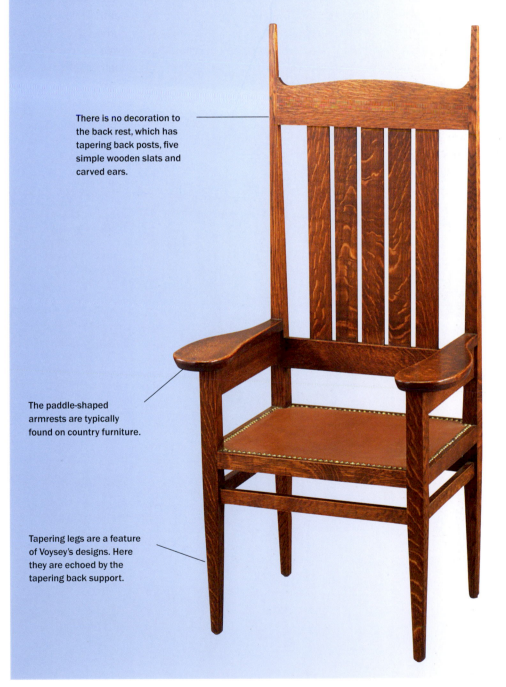

There is no decoration to the back rest, which has tapering back posts, five simple wooden slats and carved ears.

The paddle-shaped armrests are typically found on country furniture.

Tapering legs are a feature of Voysey's designs. Here they are echoed by the tapering back support.

Charles Rennie Mackintosh

The furnishings designed by Charles Rennie Mackintosh do not conform to the Arts and Crafts ideal espoused by Morris and Ruskin. He eschewed their pre-occupation with craftsmanship and the natural beauty of wood in favour of creating unique, sophisticated pieces. He used strong geometric forms with little decoration and his furniture was often painted in pale colours. Rather than re-imagining vernacular styles, Mackintosh designed cupboards with broad projecting cornices and chairs with tall, slim backs.

Mackintosh was born and educated in Glasgow and began his career as an architect in 1889. Four years later – with artists James Herbert McNair (1868–1955) and sisters Margaret (1864–1933) and Frances MacDonald (1873–1921) – he became one of "the Glasgow Four". They went on to create a new, alternative design movement, known as the Glasgow School, which created integrated interiors as well as metalwork, textiles, and posters.

Mackintosh designed furniture for Glasgow manufacturers Guthrie & Wells, but he is celebrated for his pioneering schemes for buildings and interiors. In 1896, he won a competition to design the new building for the Glasgow School of Art. A year later he collaborated with the decorator George Walton on a series of tearooms for Miss Kate Cranston (1849–1934) across the city.

While the Mackintosh style did not fit with contemporary British fashions, it was widely celebrated in Continental Europe. In 1900, an exhibition of his furniture at the *8th Secessionist Exhibition* in Vienna left an enduring impression on contemporary German and Austrian designers, including Josef Hoffmann (1870–1956). The Secessionists went on to develop furniture that relied heavily on the strong, rectilinear shapes and highly stylized decorative motifs that were hallmarks of the Mackintosh style.

Mackintosh's furniture was often made from oak and beech. "Light feminine" pieces might be painted white or in pale pastel colours, while "dark masculine" ones could be grey, brown, and olive. The simple, rectilinear shapes feature little decoration. Geometric shapes might be used, but he also favoured inset panels of leaded glass, embroidery, or metalwork.

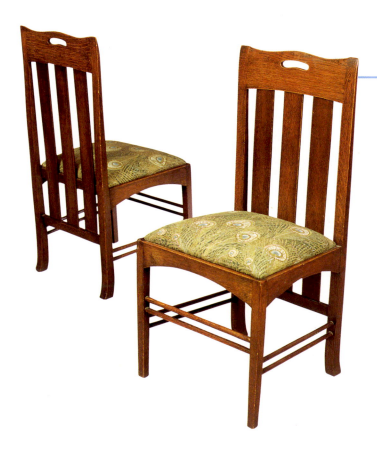

Good

These stained oak side chairs for the Argyle Street Tea Rooms, Glasgow, have a slatted back and drop-in upholstered seat. 1897, 39in (99cm) high, **I** (for a pair)

Better

Inspired by a traditional Windsor chair, this green lacquered beech armchair was made for the Argyle Street Tea Rooms in Glasgow. Mackintosh's use of rectilinear forms can be seen in the row of uprights around the back. 1906, 30in (75cm) high, **H**

Best

This ladderback chair designed for W.J. Basset-Lowke for the guest bedroom of 78 Derngate, Northampton, shows the attenuated chairbacks for which Mackintosh is renowned. c1917, 34¼in (87cm) high, **H**

Masterpiece

An ebonized sycamore chair designed for the White Bedroom at Hous'hill, Nitshill, Glasgow. The back is filled with slats that extend to the lower stretcher and are connected by crosspieces forming a stylized tree. 1904, 16½in (42cm) wide, 28¼in (71.5cm) high, 13¾in (34.5cm) deep, **C**

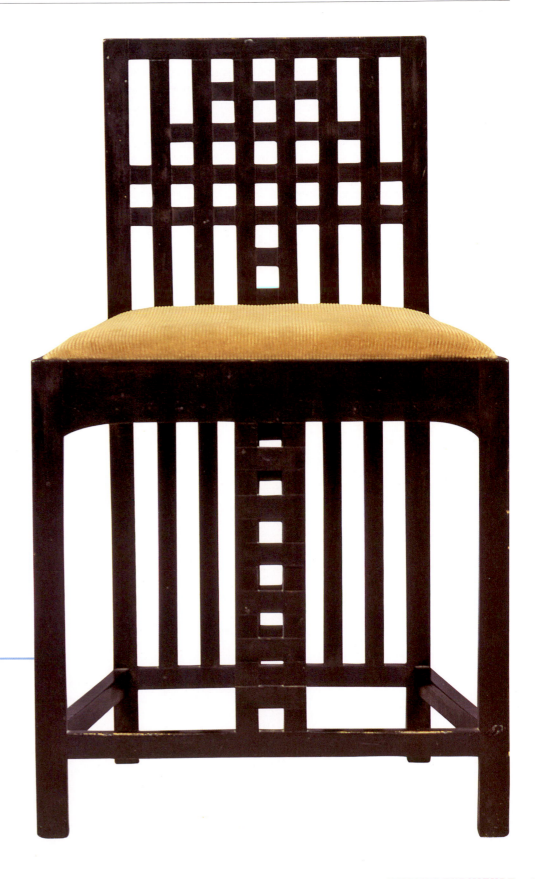

George Walton

George Walton was an architect and designer who made furniture in the Arts and Crafts style. However, his designs were also influenced by 18th-century pieces and traditional Scottish furniture.

The youngest of 12 children from an artistic Glasgow family, Walton was forced to leave school to support the family by working as a bank clerk when his father died. However, he was able to attend evening classes at the Glasgow School of Art and in 1888 was commissioned to redesign the interiors of Miss Kate Cranston's Tea Rooms at 114 Argyle Street, Glasgow. This success encouraged him to open his own showrooms. The business took off quickly and he designed more interiors for Miss Cranston – working in collaboration with C.R. Mackintosh after 1896 – as well as interiors for the shipping magnate William Burrell (1861–1958). George Walton & Co. created complete Arts and Crafts interiors, including wallpapers, glass, furniture, and metalwork.

Walton moved to London in 1897 and worked on a number of high-level commissions, including the Kodak camera company's branches across Europe. From the opening of the first showroom in Clerkenwell Road, London, in 1898, the success of Walton's designs meant that further showrooms began to open at the rate of two a year. Walton resigned from his company in 1903 and it closed four years later. He worked as an architect in private practice until the outbreak of the First World War in 1914. In 1916 he became assistant architect

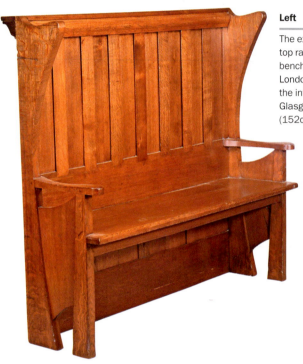

Left

The extended sides and top rail of this oak-panelled bench designed for Kodak's London showrooms show the influence of "the Glasgow School". 60in (152cm) wide, **F**

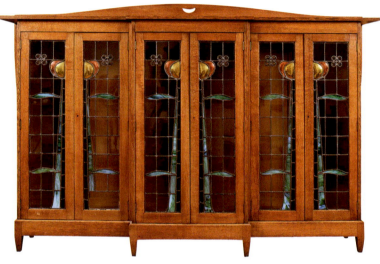

Above

Like Mackintosh, Walton decorated his furniture with leaded-glass panels. This breakfront library bookcase may have been designed for one of his shops. c1900, **I**

Chairs

The designs show the development of Walton's style from his early days in Glasgow to his years of international fame.

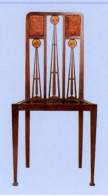

MAHOGANY DINING CHAIR
More flamboyant than chairs by other designers, the back features circular stylized inlaid floral discs above elongated triangular pyramidal fretwork. c1900s, **K** (set of six)

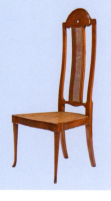

WALNUT SIDE CHAIR
A classical influence can be seen in the arched top rail with carved and gilded ribbon edging and pierced oval aperture, and slender square outswept legs. The splat and the seat are caned. c1900, **J**

and designer to the Central Control Board. He returned to private practice in 1920 but the majority of his commissions were textile designs.

Walton's elegant furniture made him one of the most important Scottish Arts and Crafts designers but his use of flamboyant decoration set him apart from his English contemporaries. Like them he used local woods such as oak and birch, as well as imported mahogany, and he used vernacular sources for designs such as the rush-seated chairs he made for the Buchanan Street Tea Rooms, which had pierced heart decoration taken from traditional Scottish examples. Unlike their designs, however, his chairs had elegant, tapering legs and his decoration might include stylized floral and geometric wooden inlays.

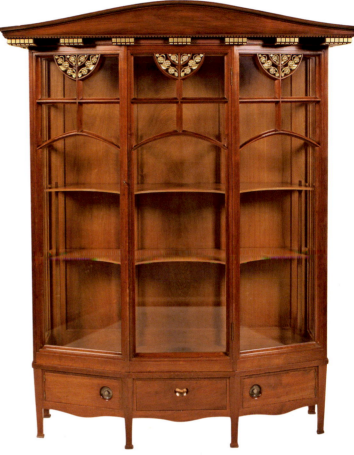

Above

The cornice details and gilt embellishments of this walnut display cabinet were used in the decoration of the room for which it was designed. 1902, 77¼in (196cm) high, **H**

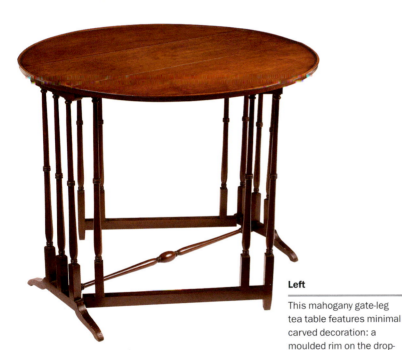

Left

This mahogany gate-leg tea table features minimal carved decoration: a moulded rim on the drop-leaf top and ring-turned and blocked legs. c1903, 33in (84cm) diam (open), **J**

EBONIZED ARMCHAIR

A Japanese theme can be found in the ebonized wood and spindled panel in the back rest of this chair. The dark wood contrasts with pale upholstery on the seat. c1900, **K**

OAK SIDE CHAIR

Country-style ladderback chairs inspired these side chairs designed for Miss Cranston's Buchanan Street Tea Rooms. The shaped backs and pad feet add a Glasgow School flavour. c1896, **M** (pair)

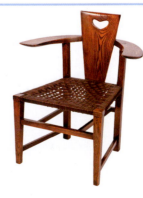

ABINGWOOD CHAIR

This sturdy design is a blend of an "Old English" style and Arts and Crafts revivalism. It was used for John Rowntree's café in Scarborough in 1896–7 and later in Miss Cranston's Buchanan Street Tea Rooms. c1896, **J**

Ernest Archibald Taylor

Ernest Archibald Taylor studied at the Glasgow School of Art and – like many of his contemporaries – was influenced by "the Glasgow Four" and Charles Rennie Mackintosh in particular.

He was apprenticed as a shipyard draftsman but in 1898 began studying art. He went on to design furniture and stained glass in an elegant and refined Arts and Crafts style, which won him awards at home and abroad. Taylor worked for the Glasgow cabinetmaker Wylie & Lochhead Ltd, and he was one of three young designers chosen to produce designs for the company's pavilion at the 1901 *Glasgow International Exhibition*. He created a drawing room decorated in pale greens, pinks, and mauves. The furnishings were embellished with roses, butterflies, and hearts, which were all familiar Taylor motifs.

A year later he won a medal at the *Esposizione Internazionale* in Turin where his work was shown alongside that of Mackintosh and other Glasgow School artists. His exhibit included stained-glass panels designed with his fiancée, the textile and jewellery designer Jessie Marion King (1875–1949).

The success of Taylor's interior designs led one critic to write in *The Studio* magazine in 1904: "The progress of modern decorative art in Glasgow is remarkable, and that progress has been materially effected by E.A.Taylor".

Taylor's furniture tends to be made from oak and mahogany, with the prominent use of stained glass. It may be decorated with marquetry panels in precious woods with a medieval theme, or feature a stylized design influenced by Mackintosh. Taylor's chairs, like those designed by Mackintosh, often have rush seats and elongated back rests.

Taylor later designed stained glass for George Wragge Ltd in Manchester. In 1911 he and King, whom he married in 1907, moved to Paris and opened the Shealing Atelier of Fine Art. The couple returned to Scotland at the outbreak of the First World War and lived in Kirkcudbright, where they played a major role in an art community that was referred to as the "Scottish St Ives".

Below

Like the furniture Taylor designed for the , this sideboard features stained-glass panels and carved stylized roses and foliage. c1900, 72in (183cm) wide, **I**

Below

Precious wood and pewter marquetry, and pewter strap hinges, were features of Taylor's work. Here they are used to show a medieval scene. c1900s, 70in (177cm) wide, **I**

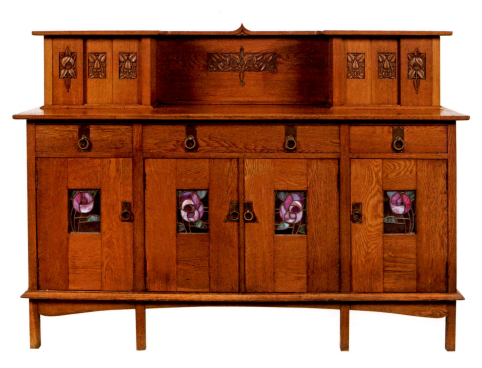

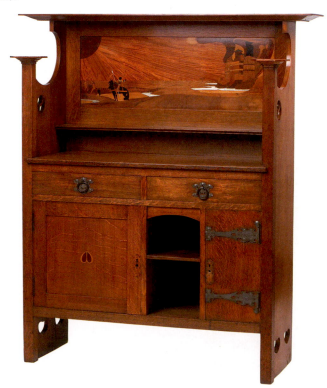

Edward William Godwin

The architect Edward William Godwin was a leading light in the Aesthetic Movement, but his dedication to the use of fine materials and craftsmanship echoes the ideals of the Arts and Crafts Movement.

The influence of Japanese design can be seen in his light, elegant pieces in ebonized wood with minimal decoration. His designs show a careful balance between vertical and horizontal elements and generally appear lighter and more refined than those of his Arts and Crafts contemporaries. Instead of hammered metal hinges and stained glass, Godwin used panels of embossed Japanese paper, or painted or stencilled geometric patterns as decoration. He also commissioned his artist friends, including James Abbott McNeill Whistler (1834–1903) and Edward Burne-Jones, to paint panels to finish his cabinets.

Godwin's designs were executed by some of the best London cabinetmakers, such as William Watt, John Gregory Crace, and Collinson & Lock. However, these pieces were all perfect for factory production and so – despite the fact that they were patented – they were widely copied. As none of the furniture is marked, sketches and other evidence are used to identify it.

Godwin wanted his furniture to be practical. He wrote in *The Architect* in 1876: "We require first that the furniture be well lifted from the floor and second that it be as light as is consistent with real strength. But this is not all. It is essential for true domestic comfort in these high pressure nervous times, that the common objects of everyday life should be quiet, simple and unobtrusive in their beauty".

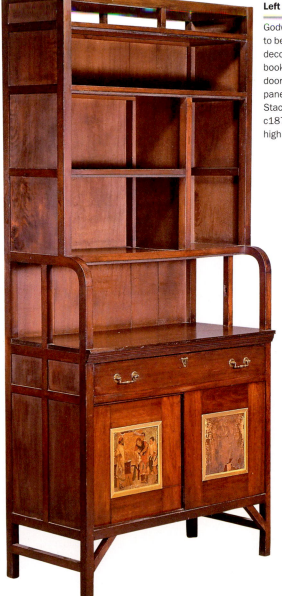

Left

Godwin's designs tend to be plain with minimal decoration. This walnut bookcase has sliding doors inset with painted panels attributed to Henry Stacey Marks (1829–98). c1871, 85in (216cm) high, **C**

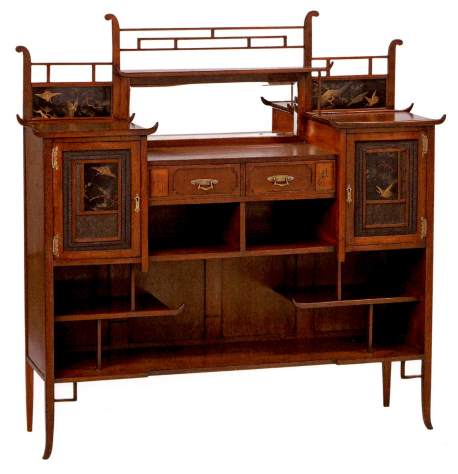

Below

The influence of Japanese design can be seen in the open lattice top and lacquered panels set into embossed leather paper on this mahogany sideboard. c1880, 50in (127cm) wide, **C**

Sir Robert Lorimer

Scottish architect and designer Sir Robert Lorimer (1864–1929) eschewed the influence of "the Glasgow Four" and Charles Rennie Mackintosh. Instead, this Edinburgh-based craftsman looked to traditional 17th- and 18th-century styles and Scottish vernacular architecture for his inspiration.

Lorimer started an architectural practice in Edinburgh in 1893, following his education at the city's Academy and University and a four-year apprenticeship with Sir Robert Rowland Anderson (1834–1921) in London.

He was inspired to follow the tenets of the Arts and Crafts Movement after becoming fascinated by traditional Scottish architecture and discovering the work of architect Richard Norman Shaw (1831–1912) and the English Domestic Revival Movement.

During his early career he designed a number of houses. These included a series of cottages in the Colinton area of Edinburgh. The design of the buildings, gardens, and interiors was faithful to the Arts and Crafts style. Eight had been built by 1900, with four more under construction. However, the onset of war brought a drop in demand for new homes large and small, but Lorimer continued to accept commissions to restore or alter a number of country houses and castles – in England as well as Scotland. These made up a large proportion of his work and tended to be sympathetically done – Mackintosh is reported to have called him "the best domestic architect in Scotland". Lorimer also designed public buildings, including the Scottish National War Memorial at Edinburgh Castle and the Thistle Chapel at St Giles Cathedral, Edinburgh.

Lorimer's furniture was faithful to the original designs by which it was inspired, and often made from oak. Although it featured the exposed peg joints and adzed surface finishes favoured by other Arts and Crafts designers, it did not include any of the innovations such as stained-glass panels used by many of his contemporaries. As a result, his furniture – which included refectory tables, cupboards, cabinets, benches, and high-backed settles – was often combined with antiques and older furnishings to create the ideal, harmonious, Arts and Crafts interior. He brought together a group of craftsmen and artists who exhibited furniture in Arts and Crafts exhibitions in London. Lorimer was elected to the Art Workers' Guild in 1896.

His furnishings were made by local craftsmen as well as cabinetmakers such as Whytock & Reid of Edinburgh.

Below left

This walnut library desk, made by Whytock & Reid, Edinburgh, is based on early Renaissance models Lorimer saw in Rome but the design remains modern and functional. c1927, 59½in (150.5cm) wide, **H**

Below right

Unusually, this oak settle features carved and marquetry decoration. However, the solid-hinged, panelled sides and arms, and sled feet are faithful to the vernacular tradition. 1892, 66in (167.5cm) wide, **I**

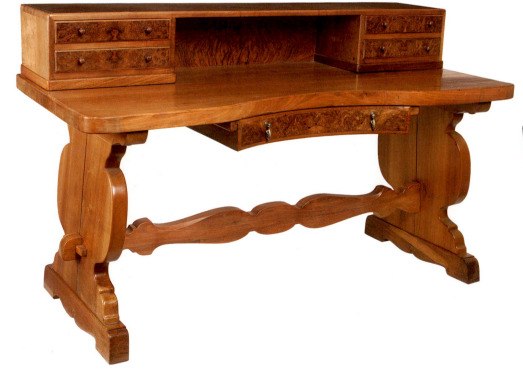

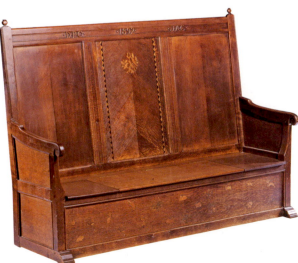

Wylie & Lochhead

Robert Wylie and William Lochhead were brothers-in-law who went into business together in 1829. Their Glasgow department store stocked imported furnishings as well as pieces made by local craftsmen and in their own workshops. By 1900 Wylie & Lochhead was the leading cabinetmaker and upholsterer in the city. The company employed many graduates from the Glasgow School of Art, including E.A. Taylor and John Ednie (1876–1934). Consequently the influence of Charles Rennie Mackintosh and "the Glasgow Four" can be seen in items bearing the store's label. Most pieces are based on sturdy, rectilinear models, and simple shapes made from oak, elm, beech, and walnut. The decoration is frequently supplied by the use of contrasting woods, stained-glass panels, and motifs such as a carved or inlaid stylized briar rose. Hinges and handles are usually made from brass, while top rails and supports may feature pierced decoration.

Above

The panelled top of this fumed-oak centre table has an adzed surface and exposed peg joints. This piece was designed for Liberty & Co. c1924, 34in (86.5cm) diam, **J**

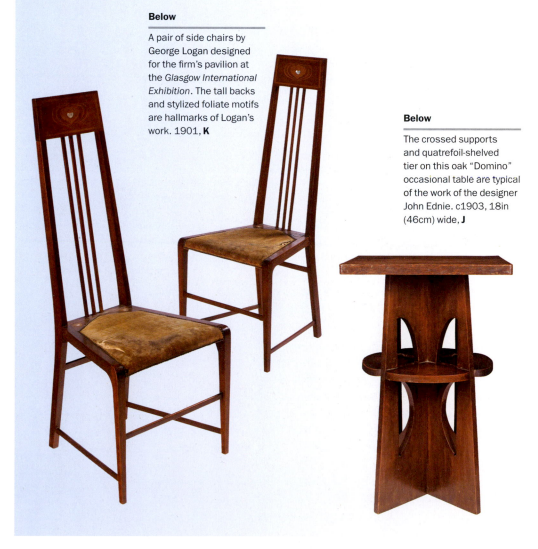

Below

A pair of side chairs by George Logan designed for the firm's pavilion at the *Glasgow International Exhibition*. The tall backs and stylized foliate motifs are hallmarks of Logan's work. 1901, **K**

Below

The crossed supports and quatrefoil-shelved tier on this oak "Domino" occasional table are typical of the work of the designer John Ednie. c1903, 18in (46cm) wide, **J**

Shapland & Petter

Traditional craftsmanship and modern machine technology were combined at this British factory, which became a leading supplier of Arts and Crafts furniture. Shapland & Petter was founded in 1854 by cabinetmaker Henry Shapland (1823–1909) and accountant Henry Petter. The success of their factory in Barnstaple, north Devon, was due to a combination of excellent design and the finest craftsmanship.

Shapland had created a machine for creating "wavy" timber mouldings efficiently and accurately, based on one he had seen on a trip to America. Petter provided the financial and commercial expertise Shapland needed to grow the business.

After fire destroyed the company's works in 1888, they were rebuilt on a larger site and with the latest machinery. A production line was set up at this model factory – beginning with saw mills and ending with the finishing sheds. The company imported American machine tools that were used alongside a team of skilled cabinetmakers, carvers, designers, and polishers. The factory was based next to the river, where timbers imported from around the world were unloaded and cut by the first log-cutting bandsaw in Britain.

More than 400 employees turned high-quality materials into well-made furniture, which was then hand-finished in a number of fashionable styles. Some used metal inlay (from the company's in-house metal department), marquetry, woodcarving, stained-glass panels, and mounted ceramic and enamel decorations. Other pieces featured more restrained medieval decoration with piercing (often heart-shaped), angled arches, and hammered metal panels. Some of the floral marquetry and stained-glass designs tend to be more extravagant than that used by other Arts and Crafts designers.

Hallmarks of the Shapland & Petter style include square tapered spindles used to fill vertical spaces; geometric arches; pierced splats; and legs that finish with a spade foot or platform, which give weight to the furniture and detract from any top-heaviness.

The attention to detail extended to the training of the company's staff. For example, all carvers were expected to study at Barnstaple School of Art and complete a seven-year apprenticeship. As well as machines, a large number of hand tools were used to create the intricate designs.

Shapland & Petter produced hundreds of standard designs and the furniture was sold through several showrooms and a catalogue. It also copied designs by leading Arts and Crafts designers, such as C.R. Ashbee and M.H. Baillie Scott, and made furniture for retailers, including Morris & Co. What set it apart from other Arts and Crafts cabinetmakers was that its art furniture was both fashionable and affordable to the growing middle classes.

It is probable that its designs were created by its own designers; none was ever registered. The influence of Ashbee may be attributed to the fact that he visited Barnstaple in 1893 to give a 12-week course on the design and decoration of furniture, which some Shapland & Petter employees are likely to have attended.

After its founders' deaths the company went on to create hand-finished furniture for cruise liners and Pullman railway carriages. It continues today as part of Leaderflush Shapland, although the Barnstaple factory closed in 2009.

Right

Skilled craftsmen made the blue pewter enamel drop handles and mother-of-pearl inlay on this display cabinet retailed by Dibb & Son, Otley. c1900, 46in (116.5cm) wide, I

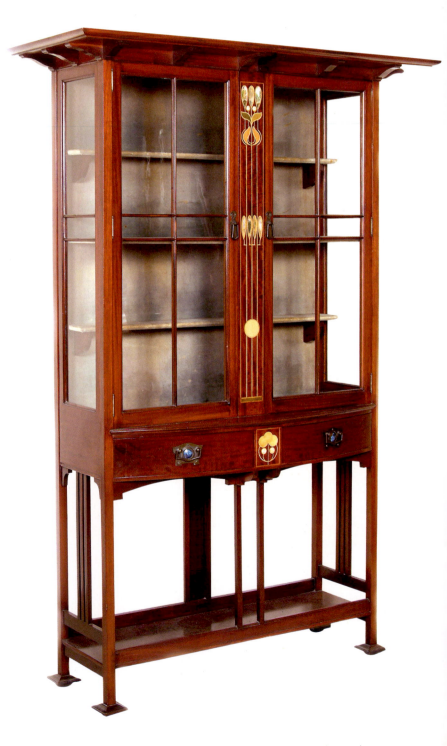

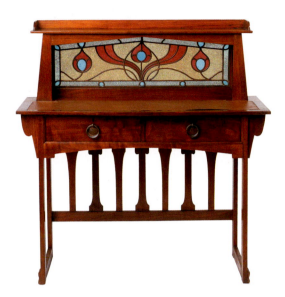

Above

A stylized floral stained-glass panel decorates this walnut ladies' desk, while the base is supported by a series of shaped slats. c1903, 42in (106.5cm) wide, **J**

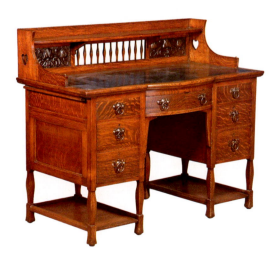

Above

Turned spindles and embossed copper panels enhance this oak twin-pedestal desk, which has platforms at the base. c1900, 48in (122cm) wide, **J**

A Closer Look

This mahogany high-backed side chair shows the influence of the Glasgow Style on Shapland & Petter's work. The back splat is inlaid with a pewter cherub's head in a heart-shaped setting. The upholstered seat is a replacement. c1905, 42in (106.5cm) high, **K**

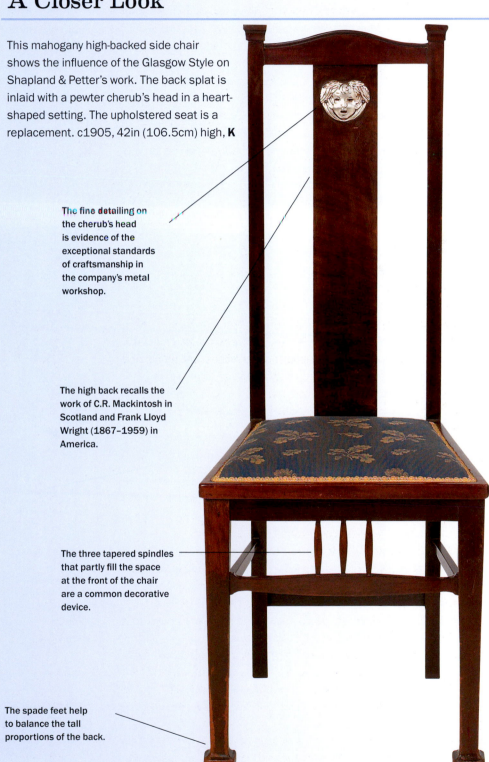

The fine detailing on the cherub's head is evidence of the exceptional standards of craftsmanship in the company's metal workshop.

The high back recalls the work of C.R. Mackintosh in Scotland and Frank Lloyd Wright (1867–1959) in America.

The three tapered spindles that partly fill the space at the front of the chair are a common decorative device.

The spade feet help to balance the tall proportions of the back.

Charles Robert Ashbee

An architect who went on to found a medieval-style guild in the Cotswolds, Charles Robert Ashbee is considered one of the most important Arts and Crafts designers.

After studying at Cambridge University, he started training to be an architect at the London offices of G.F. Bodley in the East End of the city. There he read the works of William Morris and John Ruskin and, with a group of local young men, in 1888 was inspired to set up the Guild and School of Handicraft.

The School lasted only seven years, but the Guild survived for 20. It combined the ideals of the Arts and Crafts Movement – that everything should be made by skilled craftsmen and by hand – with a romantic socialism. At first, five guildsmen made furniture and metalware, but three years later the enterprise was expanded to include jewellery, silverwork, and enamelling. In 1898 the Guild took over Morris's Kelmscott Press. By 1900 the Guild was at its most successful. It had about 30 members and had exhibited successfully in Britain, Europe, and America. Ashbee designed most of the pieces.

In 1902, seeking a rural utopia away from the corruptness of city life, the Guild moved to Chipping Camden in Gloucestershire, following Ashbee's belief that "The standard of work and the standard of life are one". After initial success, trade began to decline in 1905 and the company went into liquidation in 1907. The Guild struggled on until 1919 when Ashbee was appointed Civic Adviser to the city of Jerusalem, but he resigned from the post in 1922 and retired to Godden Green, near Sevenoaks in Kent.

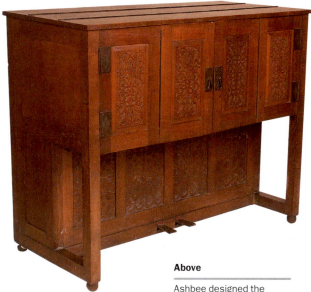

Above

Ashbee designed the strapwork panels, silvered hinges, and handle plates on this "Manxman" oak upright piano, but the customer arranged for the doors to be carved. c1904, 54¼in (138cm) wide, **J**

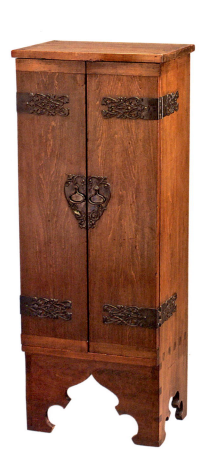

Left

The square tenon mortise joints on this pine music cabinet form part of the decoration with the elaborate brass hardware and "Moorish" cutout base. c1899, 49in (124cm) high, **H**

Above

A country-style beech ladderback armchair, a form commonly used by Arts and Crafts designers and created by Ashbee for his London home. c1896, 47in (119cm) high, **G**

Cotswold School

The Cotswolds – a picture-perfect region in the west of England – became home to a number of Arts and Crafts designers who wanted to escape London to live an idyllic, rural life.

The first to move were the architect and designer Ernest Gimson, and brothers Sidney and Ernest Barnsley (1863–1926), in 1893. They were later joined by Peter Waals (1870–1937) and Gordon Russell (1892–1980), and the furniture they created became known as "Cotswold School".

Gimson and the Barnsleys set up a workshop on Pinbury Park, where Sidney Barnsley worked alone to create furniture he conceived, while a team of craftsmen fulfilled Gimson's plans for clean-lined designs.

They used local woods including oak, elm, ash, and fruitwoods, making the most of their natural colour and the beauty of their grain for decoration to make well-proportioned, functional furniture. Usually the dovetail joins and wooden pins securing them provided a decorative effect. The only other embellishment tended to be chamfered and gouged wood. However, some of the more extravagant pieces might be inlaid with ivory, pearl, brass, and even silver.

The business thrived and moved to larger premises in Sapperton where Waals joined as foreman and Russell as a designer. Russell used machinery as part of the cabinetmaking process and this enabled them to make functional furniture that was affordable to more people. The Sapperton workshop in 1919 following the death of Gimson. The Barnsleys continued to work as architects while Russell and Waals produced furniture.

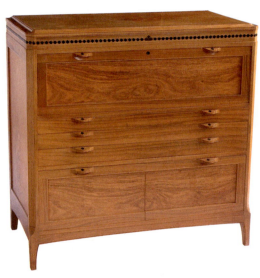

Above

The colour and grain of the walnut timbers were chosen to enhance the simple construction of this secretaire chest with diamond ebony inlay by Edward Barnsley. It took 632 hours to make and cost £848 10d when new. c1900, 43in (109cm) wide, **H**

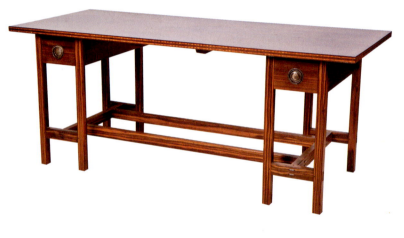

Left

Gimson used visible tenon joints and chequered banding of satinwood and walnut to decorate the top of this macassar ebony library table. c1900, 72in (183cm) wide, **E**

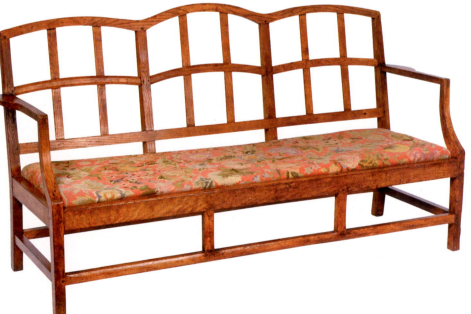

Right

A country-style oak settee by Sidney Barnsley uses simple lattice work and a shaped mid-rail to enhance the backrest. c1907–15, 59in (151cm) wide, **H**

Heal's

The London company Heal & Son was founded as a bed manufacturer in 1810, but by the 1880s was selling furniture, including room sets, from its store on Tottenham Court Road.

Sir Ambrose Heal (1872–1959), the great-grandson of the founder, designed all the furniture for the firm from 1896 until the 1950s. After leaving school he learnt cabinetmaking rather than go to university and went on to work for Graham and Biddle of Oxford Street, London, before joining the family business in 1893. His early pieces are simple and sturdy, and gave Heal's a new direction that was a contrast to the "old English" styles it had sold previously.

Ambrose was made a partner in the business in 1898 and was allowed to show his work in the store, where he became recognized for his Arts and Crafts style. He took the aesthetic ethos of the Movement and translated it into high quality, commercial production techniques. Typically, pieces were not carved or given other decorative finishes – the colour and natural beauty of the wood were their own decoration. He preferred light-coloured woods, especially limed oak, and his furniture tends to have an architectural feel.

The first catalogue of Heal's furniture was published in 1898 and items designed by Ambrose, and made by the firm, were shown at the sixth exhibition of the Arts and Crafts Exhibition Society in 1899. His work received a number of prizes at the 1900 *Paris Exposition* and was shown at the 1901 *Glasgow Exhibition*. Ambrose became a member of the Arts and Crafts Exhibition Society in 1906 and the Art Workers' Guild in 1910. When the Guild and School of Handicraft moved to Gloucestershire in 1902, he employed some of the craftsmen who did not want to join C.R. Ashbee's move to the countryside.

Under Ambrose Heal's direction (as managing director from 1907 and chairman from 1913) the store sold both conventional and fashionable furniture as well as historical styles and antique pieces.

With the outbreak of the First World War, the demand for Arts and Crafts furniture declined and Heal was a founder member of the Design and Industries Association (DIA) which had been inspired by the Deutscher Werkbund with the aim of inspiring good design and craftsmanship for mass-produced goods.

Heal's furniture from the 1920s onwards maintained an Arts and Crafts element. For example, a set of dining chairs made for Prime Minister Sir Winston Churchill's (1874–1965) country home, Chartwell, in Kent, had lattice backs, which were inspired both by late 18th-century English chairs and the honesty and simplicity of pieces by Arts and Crafts designers.

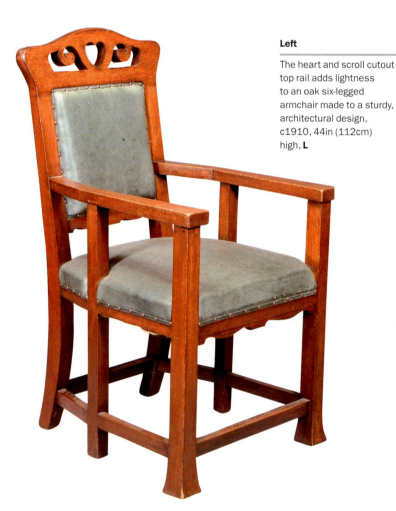

Left

The heart and scroll cutout top rail adds lightness to an oak six-legged armchair made to a sturdy, architectural design. c1910, 44in (112cm) high, **L**

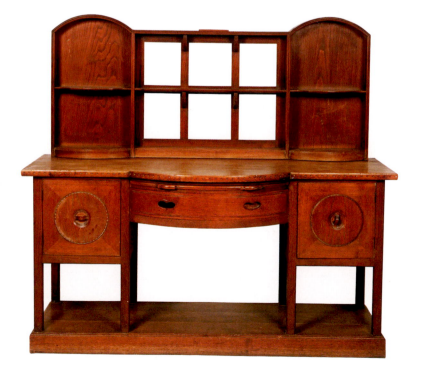

Below

The grain of the chestnut wood and a chip-carved border add visual appeal to this bowfront dresser. c1905, 72in (183cm) wide, **H**

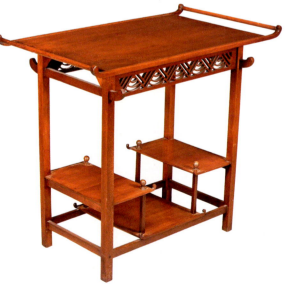

Above

A Letchworth dresser from Heal's "Simple Cottage" range. This Arts and Crafts-inspired piece was in the company's range for many years. c1905, 54in (137cm) wide, **K**

Above

Fashionable Anglo-Japanese designs such as those by E.W. Godwin inspired this walnut "Pagoda" side table. c1884, 33in (84cm) high, **L**

Limed Oak

Ambrose Heal favoured limed oak for many of his designs. Oak and other timbers were historically treated with lime to protect them from insect damage. The result bleached the wood, and many late 19th- and early 20th-century furniture designers liked the effect and chose to use it in their work. Heal employed it into the 1920s and 1930s for simple, modern designs with minimal decoration. The design of the traditional bedside cabinet with bun feet (right), and the 1930s sideboard that formed part of a dining suite (below), are enhanced by the pale colour of the limed wood.

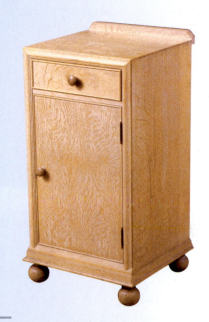

Below

A Heal's limed oak dining suite, comprising sideboard, dining table and six chairs. Table c1930, 72in (183cm) wide, **J**

Above

A Heal's oak bedside cabinet. c1920, 16in (41cm) wide, **M**

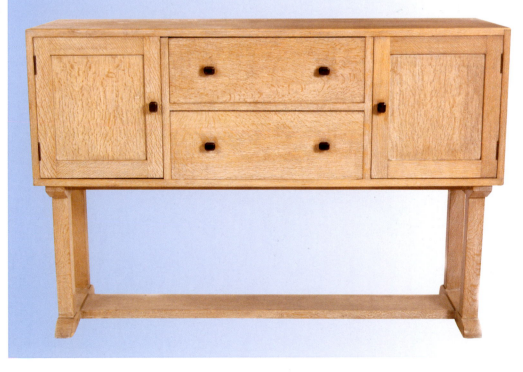

Other British Furniture

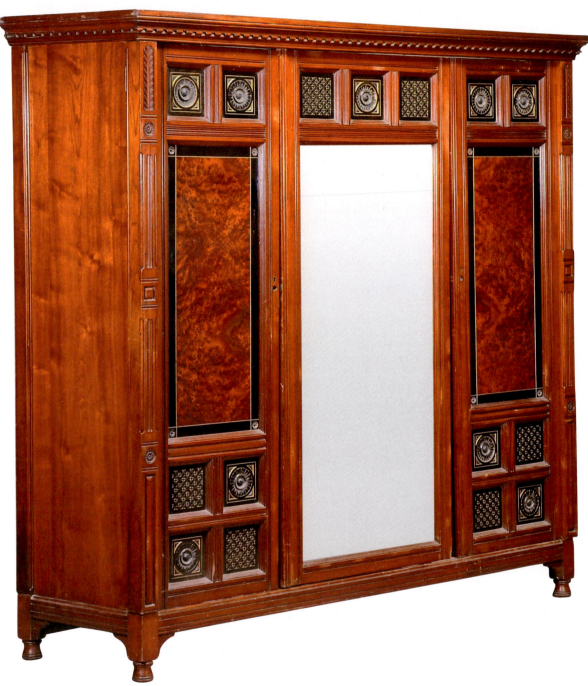

Carved floral panels enhance this walnut and amboyna wardrobe designed by Bruce Talbert (1838–81) for Gillows & Co. as part of a bedroom suite. c1868, 82in (208cm) high, **J** for the set

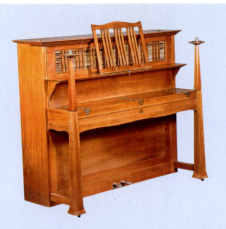

Candleholders taper into the front supports of this walnut upright piano designed by Walter Frederick Cave (1863–1939) and exhibited in the 1893 *Arts and Crafts Exhibition*. c1893, 61in (155cm) wide, **L**

This oak military hall stand designed by Harry Napper (1860–1930) includes a stand for swords and polo sticks and was exhibited at the Earl's Court *Military Exhibition* in 1901. It was made by the Hemlock League – a small society of young artists and craftsmen dedicated to the creation of suitable modern decoration at affordable prices. 1901, 70in (177cm) high, **L**

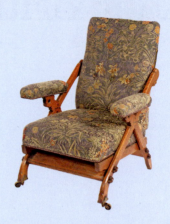

The work of Morris & Co. inspired this armchair by A. Marsh & Jones and designed by Charles Bevan (d.1882). The adjustable mahogany frame is inlaid with ebony. Late 19thC, 35in (90cm), **J**

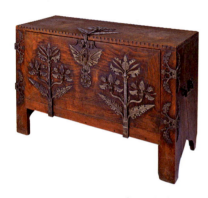

This elm cabinet by F.A. Lawrence is decorated with wrought iron flowers on the front and hammered metal mounts and clasps to the top and sides. c1900, 50¾in (129cm) wide, **E**

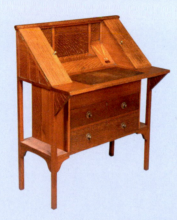

The structure of this oak and inlaid writing desk by George Montague Ellwood (1875–1955) for J.S. Henry enhances the architectural design. The handles are after a design by C.F.A. Voysey, who also designed for J.S. Henry. Late 19thC, 43in (109cm) high, **J**

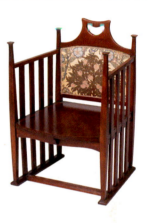

The slatted sides, square tapering legs, sledge feet, and stylized heart cutout were common design features. The back of this walnut armchair for William Birch of High Wycombe by E. Punnet is upholstered in a fashionable fabric. c1903, 32in (81cm) high, **J**

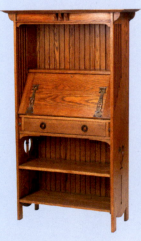

A flared cornice and shaped supports add elegance to this oak bookcase by Harris Lebus. Stylized fretwork and decorative hinges add to the decoration. c1900s, 65in (165cm) high, **J**

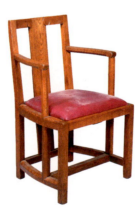

This oak elbow chair by Sir Frank Brangwyn (1867-1956) has a typical square back, with carved ram's horns and square supports joined by stretchers. c1930, 35in (89cm) high, **J**

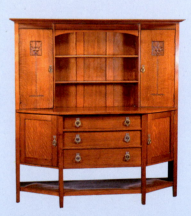

An arts and crafts sideboard by Mackay Hugh Baillie Scott (1865-1945) for J.P. White with stylized floral detailing to upper doors. c1901, 72in (183cm) wide, **J**

Mouseman – the Tradition Continues

Yorkshire cabinetmaker Robert Thompson (1876–1955) began making oak furniture using traditional tools and techniques in the late 19th century. A team of craftsmen continue his mission today – as Robert Thompson's Craftsmen Ltd – employing the same skills and equipment to make classic furniture designs, each one marked with Thompson's carved mouse signature.

Thompson began his career as an apprentice, working at his father's joinery in Kilburn, Yorkshire. He became fascinated by English oak, traditional methods of working with timber, 17th-century designs, and the medieval carvings he had seen at Ripon and York cathedrals.

He took over the business following his father's death in 1895, and perfected the art of making solid hand-crafted oak furnishings in the spirit of the Arts and Crafts Movement, eschewing machinery in favour of traditional methods.

Thompson's first major commission did not arrive until 1919 when he was asked to create carved furniture for Ampleforth Boys' School. After this, the business expanded. By 1925 he employed six men, and this increased to ten in 1928, when he received his first commission from America for a dining table and four chairs. By the 1930s he employed 30 men, had expanded the

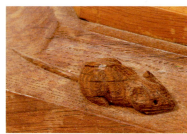

A mouse is carved on every piece made at Robert Thompson's workshop. Some are placed conspicuously, while others appear to hide from prying eyes.

workshop, and created furnishings for several schools and churches, including York Minster.

Most Thompson furniture is of plain, English oak with an uneven, rippled surface created by shaping it with an adze. It is based on simple, solid, traditional British designs. Some pieces may also incorporate cowhide or wrought iron.

A carved mouse can be found on all Thompson's pieces. It was registered as a trademark in the 1930s, and is said to have been inspired by the early days of his career, when he found himself "as poor as a church mouse".

Each item continues to be handmade by one craftsman, who is responsible for the complete process – from choosing the timber to applying the final coat of wax. Sections are joined by mortise and tenon joints with dowels added for strength and stability. The colour of the wood is created by a process known as fuming, which uses ammonia fumes to give a colour that ages to a rich golden brown.

Many Mouseman-trained craftsmen have set up their own workshops, producing furniture using the same style and techniques as their mentor. These include Sid Pollard and some of the Yorkshire "Crittermen".

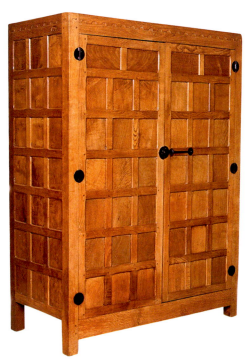

Left

Adze marks can be seen in the surface of this "Mouseman" oak wardrobe. Geometric panels and a wrought iron latch and hinges add to the decoration. c1930s, 66in (167.5cm) high, **J**

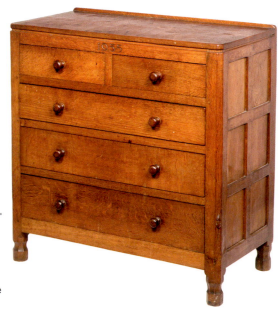

Left

Oak panels were used to create this "Mouseman" chest of drawers, which has hand-turned handles and octagonal feet. 1935, 36in (91.5cm) wide, **J**

Crittermen

Several craftsmen trained by Robert Thompson went on to set up their own businesses. They used Yorkshire oak and the same tools and techniques as the Mouseman himself, but each signed their pieces with a different creature. Their work tends to be similar to Mouseman in style, structure, and quality. These "Crittermen" include Wilf "Squirrelman" Hutchinson, Albert "Eagleman" Jeffray and David "Oakleafman" Langstaff.

Derek "Lizardman" Slater trained with Alan "Acornman" Grainger at Acorn Industries. His early pieces feature a fish, but he changed to a lizard when he began working with Martin "Lizardman" Dutton in the 1960s. Other "Crittermen" include Colin "Beaverman" Almack, Don "Foxman" Craven, Malcolm "Foxman" Pipes, Nick "Hedgehogman" Hill, Peter "Rabbitman" Heap, Simon "Dalesbred" Robinson, Thomas "Gnomeman" Whittaker, and Bob "Wrenman" Hunter.

Below

Every section of this oak-panelled hall wardrobe has been worked with an adze. It stands on simply shaped block feet. 1931, 48in (122cm) wide, **I**

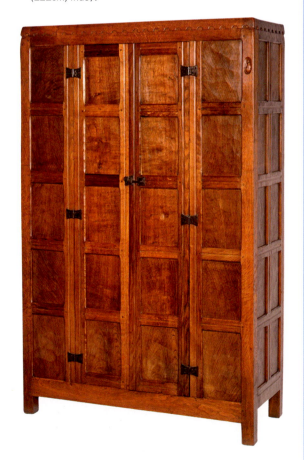

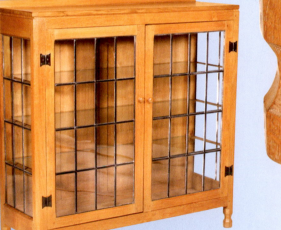

Far Left

The hand-carved and decorative hinges show the Mouseman heritage of this Wilf "Squirrelman" Hutchinson oak display cabinet. 1960s, 42in (106.5cm) wide, **K**

Left

The hand-carved squirrel signature sits on one of the feet.

Above

The hand-carved lizard signature sits on a stretcher.

Left

Leather has been used to upholster these Derek "Lizardman" Slater oak dining chairs. 1960s, 35¾in (91cm) high, **K**

American Furniture

By the end of the 19th century, American designers and consumers had discovered the work of William Morris (1834–96) and his contemporaries, and the first American Arts and Crafts furniture was being made.

Like their British counterparts, enthusiasts set up Arts and Crafts societies – the earliest were in New York, Chicago and California – and organized the first American *Arts and Crafts Exhibition* in Boston in 1897.

New York saw some of the earliest American pieces. In Syracuse, Gustav Stickley (1858–1942) made furniture inspired by the simple pieces found in California missions and referred to as "Craftsman" or "Mission" style. He also interpreted classic Arts and Crafts designs such as the "Sussex" chair and the "Morris" chair for his customers. In East Aurora, Elbert Green Hubbard (1856–1915) and the Roycroft craftsmen made furnishings that were sold by mail order. The simplicity of their work echoes that of Morris and C.F.A. Voysey (1857–1941).

Charles Rennie Mackintosh (1868–1928) and the Glasgow School influenced the work of Charles Limbert (1854–1923) of Grand Rapids, Michigan. Like them, he used cutout shapes to decorate his work.

Other notable American designers include other members of the Stickley family, Greene & Greene, Frank Lloyd Wright (1867–1959), Charles Rohlfs (1853–1936), Lifetime, The Ship of the Crafters, Onondaga Shops and Harvey Ellis (1852–1904). The latter brought a sophisticated edge to Stickley's Mission designs. He used inlays of exotic woods, copper, and pewter to decorate pieces in a European style, and elongated the proportions of the furniture in the style of Mackintosh.

However, the British and American Arts and Crafts ideals differed when it came to the use of factories and machines. Those in the "Old World" held firm to the belief that craftsmen using traditional techniques and working by hand were the solution, but their colleagues in the "New World" considered that functional, quality furniture should also be affordable. Consequently, they used the latest machinery to lower costs while relying on skilled craftsmen to produce a high-quality finish. While American designers flourished, selling practical, well-made, and honest furniture made from native woods as late as the 1920s, those in Britain saw the prohibitively high cost of their work – as well as changing fashions – bring an end to the Arts and Crafts dream before the outbreak of war in 1914.

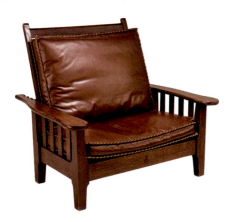

Above

Roycroft extended the Morris chair model to create this rare double version, with tapered legs and narrow slat supports. c1905, 49in (124cm) wide, **G**

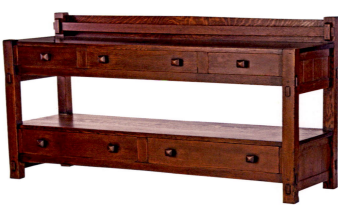

Above

Gustav Stickley made this simple server for the dining room at Vancroft, the $1 million hunting lodge built for Joseph B. Vandergrift 1901, 72in (183cm) wide, **F**

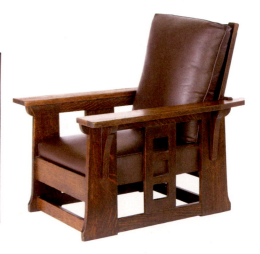

Above

Limbert's interpretation of the Morris chair relied on vertical supports, one with cutout squares, for its broad armrests and deep leather cushions. c1905, 35in (89cm) wide, **I**

Opposite

The panelled dining room in Pasadena's Gamble House, designed by Greene & Greene, features custom-designed built-in cabinets as well as Arts and Crafts furniture.

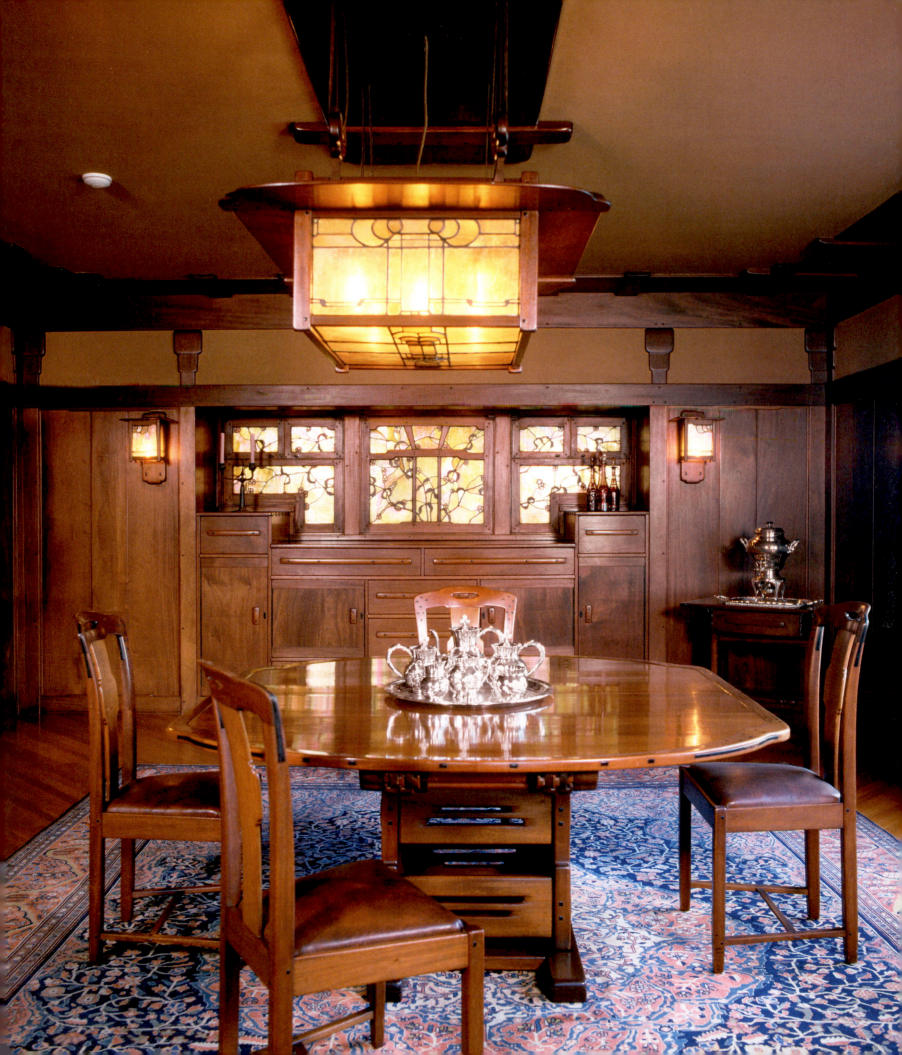

Gustav Stickley

Gustav Stickley learnt cabinetmaking skills in his uncle's furniture workshop, where he made Victorian-style furniture. But a trip to Europe in 1898 introduced him to the Arts and Crafts Movement. The result was a transformation in the furniture he made – and American design as a whole.

Early pieces made by the Gustav Stickley Company in Eastwood, New York, are an uncomfortable hybrid of Victorian excess and Arts and Crafts simplicity, but in 1900 Stickley's furniture won praise at a Michigan trade show and was becoming widely known thanks to a catalogue he produced, and his magazine *The Craftsman*, which was first published in 1901.

The Craftsman helped to promote Arts and Crafts ideals and the appreciation of hand-crafted furniture. Readers saw illustrations of interiors that satisfied Stickley's design principles: items should be suited to their purpose, have little applied decoration, and created using the ideal materials.

In 1901 he renamed the company United Crafts and began to use a joiner's compass as a trademark. By 1902 he was producing simple, solid furniture in the style of Morris and his British contemporaries using American white oak. It was based on the style of furniture found in Californian missions and is consequently often referred to as "Mission" furniture. Other inspirations included Colonial furniture and an adjustable, reclining, upholstered chair designed by Morris. After 1905 the work of Frank Lloyd Wright at the Darwin House near Buffalo, New York, can be seen in a line of spindle-backed chairs.

Stickley furniture from this time is usually hand-made from thick pieces of heavy, quartered oak. The wood was fumed – treated with chemicals – rather than stained to create a dark finish. It often has a broad "tiger-striped" grain, keyed-through tenons, long arched corbels, and uses circular pins to secure major joints. A few tables and chairs have "reversed tapered" legs, where the legs broaden as they extend downwards.

In *Craftsman Furniture*, Stickley's 1909 catalogue, he wrote: "I had no idea of attempting to create a new style, but merely tried to make furniture which would be simple, durable, comfortable, and fitted for the place it was to occupy and the work it had to do. It seemed to me that the only way to do this was to cut loose from all tradition and to do away with needless ornamentation, returning to the plain principles of construction and applying them to the making of simple, strong, comfortable furniture."

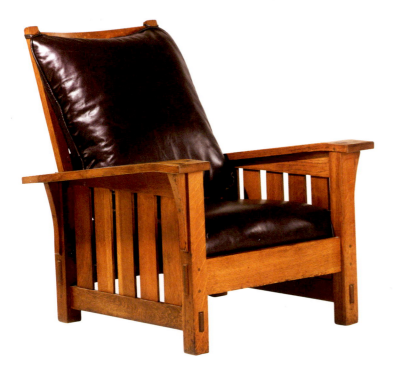

Above

Stickley's Craftsman interpretation of the adjustable armchair designed by Philip Webb (1831–1915) for William Morris. c1904, 37in (94cm) high, **J**

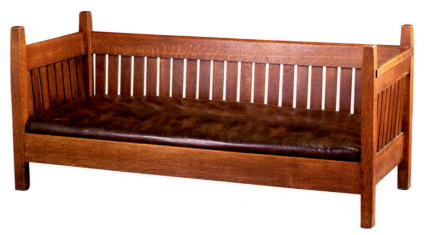

Below

Colonial furniture inspired many early pieces. This settle no. 222 has tapering posts, tightly spaced canted slats, and a leather-upholstered seat. c1901, 80in (203cm) wide, **I**

Harvey Ellis

In 1903 Gustav Stickley commissioned the architect Harvey Ellis (1854–1904) to supply new furniture and interior designs. The result was a lighter style of furniture influenced by European Jugenstil designers and the work of C.R. Mackintosh. Ellis used small, inlaid metal motifs, and exotic and local timbers, some of which were stained. His designs also feature overhanging tops and bowed sides.

Ellis's design style outlived his nine-month association with Stickley, whose own designs went on to become lighter and more refined.

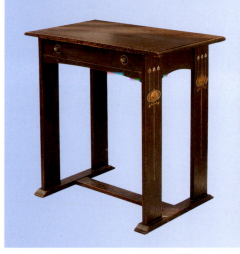

Far left

The overhanging top and shoe feet of this rare writing desk, designed by Harvey Ellis, are elements often seen in the work of C.R. Mackintosh. c1903, 29½in (75cm) wide, **E**

Left

Ellis inlaid the legs with several woods and copper. The desk drawer has pewter pulls.

Construction

Like his British counterparts, Stickley used elements of the construction of his furniture as part of the design. Tenons were inserted through table legs and legs into table tops, and the contrasting wood grain used as decoration. Joints were reinforced with wooden pins, which added a decorative element too. All these elements required a high degree of craftsmanship – another factor that was important to Arts and Crafts designers.

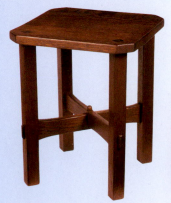
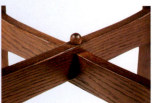

Left and below

The X-frame corseted cross-stretchers are reinforced by a lap joint with an acorn finial and provide a decorative finish.

Above

Flush through-tenoned legs embellish a tabouret. c1902, 22in (56cm) high, **K**

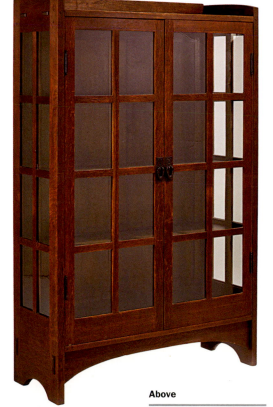

Above

Hand-wrought metal door pulls provide the only applied decoration on this double-door china cabinet. c1904, 39½in (101cm) wide, **I**

Gustav Stickley (continued)

In 1904 Stickley changed the company name again, to the Craftsman Workshops, perhaps to reflect the way its activity had broadened to include a guild of apprentices learning cabinetmaking, leatherwork, and metalwork.

By 1905 his furniture was lighter in size and colour and the designs were simpler. These modified designs were cheaper to produce and sold at more affordable prices – making them available to the middle-class buyers whom Stickley hoped would benefit from his ethos. He aimed to create furniture "that shows plainly what it is and in which the design and construction harmonize with the wood."

The workshop combined the latest technology with hand-finishing techniques, helping to maintain the affordability of its output. Like many of his British counterparts, Stickley founded a medieval-style guild in a rural setting. His was the Craftsman Farms project in New Jersey, which opened in 1908.

Later furniture – from about 1910 to 1916, when the factory closed – is lighter still in size and colour.

Some of the pieces designed by Ellis are in decorated fruitwood with metal inlays. Later pieces were also made from mahogany and silver-grey maple. Hand-wrought copper or iron hinges and handles were used to embellish many of his pieces and could be considered to be a hallmark of his work.

Nearly all pieces are marked, most with Stickley's signature, a joiner's compass, and the slogan "Als Ik Kan" (Flemish for "As I can" or "To the best of my ability"). The mark may be burned into the wood or a red decal.

Gustav was the eldest of five brothers who were born in Wisconsin to German migrant parents. All the brothers worked individually, and occasionally in partnerships, as cabinetmakers. While Gustav was a visionary designer, Albert's strength was in marketing, Charles excelled in production, Leopold was a successful manager, and John was a great salesman. But they were unable to work together for long, and so rather than build what was potentially an invincible family firm, they set up short-term companies that rarely lived up to their potential.

Stickley is often credited as being the father of the American Arts and Crafts Movement, and the enthusiasm he created for the style inspired around 50 other companies to follow him.

The competition, changing fashions, and an ill-judged decision to open a store in New York City, forced him into bankruptcy in 1915. *The Craftsman* closed a year later.

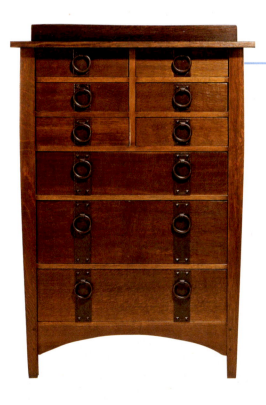

Good

The subtlety of Harvey Ellis's designs can be seen in the arched skirt and overhanging top of this chest of drawers, model no.913. However, the hammered strap hardware jars with the elegance of the cabinetmaking. c1912, 50¾in (129cm) high, **H**

Better

Wrought-iron arrowhead and arched strap hardware complement the panelled top and sides of this blanket chest, which has its original finish. 1902–3, 34¾in (88cm) wide, **H**

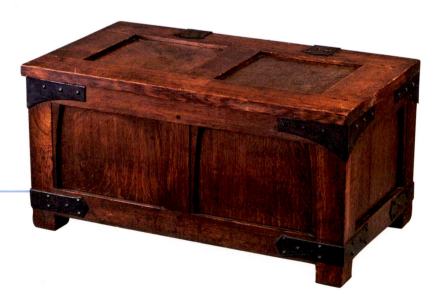

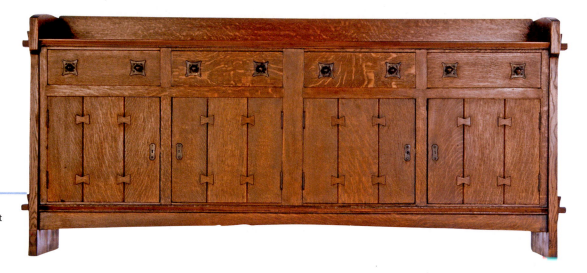

Best

Butterfly joints, through-tenoned sides and discreet pull handles add elegance to a custom-made sideboard. This level of detail was not financially viable on Stickley's mass-produced pieces. c1901, 100in (254cm) wide, **E**

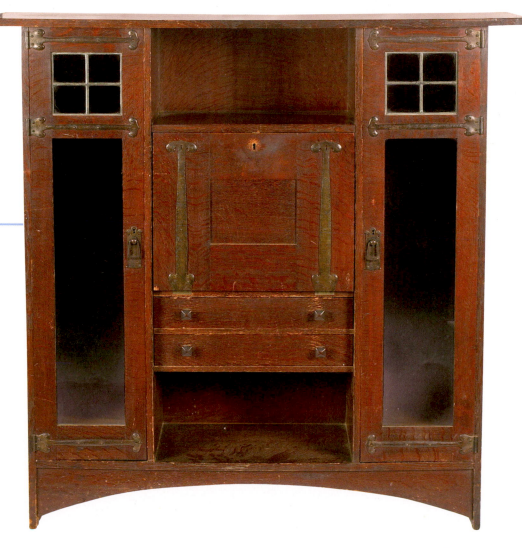

Masterpiece

Harvey Ellis designed elegant, highly desirable furniture for Stickley. This oak bureau-bookcase has hand-wrought and hammered iron strap hinges and door pulls. The wood still has its factory finish and the doors are set with the original glass. It also has a stylish pale hardwood compartmentalized fitted interior. 1903, 56in (142cm) wide, **C**

L. & J.G. Stickley

The two youngest of the five Stickley brothers – Leopold (1869–1957) and John George (1871–1921) – worked for their older brothers before setting up on their own. Leopold, who had been working as a foreman for Gustav, was the first to leave. He founded the Onondaga Workshops in 1904 (see box opposite). Later that year John George, who had been working with Albert (1862–1927), joined him, and the enterprise in Fayetteville, a suburb of Syracuse, New York, became L. & J.G. Stickley.

The brothers' first furniture line was shown at a trade show in Grand Rapids, Michigan, in 1905 where it was advertised as "simple furniture built along mission lines".

Like their brothers, L. & J.G. Stickley used high-quality local woods and traditional furniture construction techniques to make pieces inspired by those of Gustav. But they were not purists like their oldest brother – their furniture was largely made by machine whereas he used technology in a limited way.

Rather than the dark, fumed finishes favoured by Gustav, they used stains that allowed the grain of the wood to show through.

In 1906 the company name changed to Handcraft, and from 1912 it was called The Work of L. & J.G. Stickley.

By this time, L. & J.G. Stickley was among the companies that dictated the direction of the American Arts and Crafts aesthetic. Several influences can be seen in its pieces: the Prairie style of Frank Lloyd Wright, the work of designers in Vienna and of British designers such as Voysey. Peter Hansen, who had been employed by Gustav, started working for the brothers at this time and his interpretation of the Arts and Crafts style can be seen in the longer corbels used on chairs, elegant arches, and overhanging bevelled tops on cabinets.

In 1918, following Gustav's bankruptcy, L. & J.G. Stickley took over his Craftsman Workshops and combined it with its own successful Mission furniture line. The company was quick to adapt to changing fashions. As Arts and Crafts furniture fell out of favour with consumers, it created colonial revival pieces in the 1920s with the Cherry Valley Collection, and made and supplied furniture to institutions through large contract furniture sales.

By 1950, L. & J.G. Stickley was the only remaining Stickley furniture company. It was bought by Alfred (1938–2007) and Aminy Audi from Leopold's widow in 1974. It continues today as Stickley's, and since 1985 has been based in Manlius, New York.

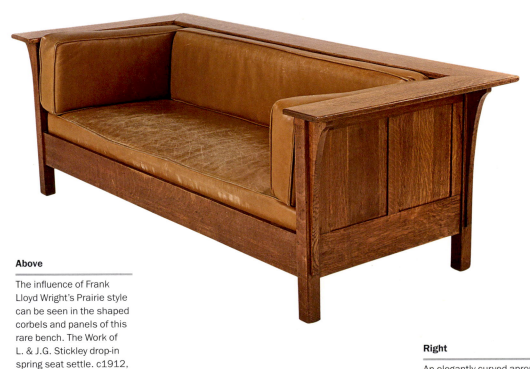

Above

The influence of Frank Lloyd Wright's Prairie style can be seen in the shaped corbels and panels of this rare bench. The Work of L. & J.G. Stickley drop-in spring seat settle. c1912, 84½in (214cm) long, **G**

Right

An elegantly curved apron and back, and turned wood pulls, enhance this Handcraft nine-drawer chest. 1907–11, 39in (99cm) wide, **J**

Onondaga Shops

When Leopold Stickley started his own business in Fayetteville, New York, the first name he chose for it was Onondaga Shops – after a local tribe of Native Americans.

He was joined in the business by his brother John George, and together they produced more affordable versions of older brother Gustav's Mission-style furniture. Gustav was generous with his designs, encouraging others to customize and therefore profit from his genius. Leopold and John George scaled the original designs down and made them more cost effective – enabling them to cut prices and increase sales. The resulting furniture is lighter and less imposing than the originals.

The name Onondaga Shops was used from 1904 until 1906, when the brothers began to use the Handcraft label.

Above

Hammered copper strap hinges and pulls embellish this L. & J.G. Stickley pale oak sideboard. It has a plate-rail splashback and bottom linen drawer. c1910, 66in (167.5cm) wide, **J**

Right

The brothers' reworking of Gustav Stickley's interpretation of the William Morris armchair is not as bulky as the Mission furniture original. c1904, 32in (81cm) wide, **J**

Above

Square-section supports and rows of vertical slats form the back and sides of a Handcraft hall bench with hinged seat compartment and long corbels under the apron. c1910, 42in (106.5cm) wide, **J**

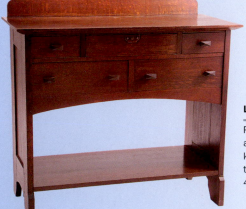

Left

Panelled sides, an arched apron, and pyramidal knobs lend a subtlety to this rare server. c1904, 47½in (120.5cm) wide, **I**

Stickley Brothers

The name Stickley is perhaps the one most associated with American Arts and Crafts furniture. Gustav – the eldest of the five brothers from Osceola, Wisconsin – is celebrated as a leading light of the Movement. But they all achieved varying degrees of success as furniture makers.

They first made furniture at their uncle's factory in Brandt, Pennsylvania, in around 1877. Although at no time did all five work together, they all worked with each other at one time in at least one venture.

In 1883 Albert started the Stickley Brothers Chair Co. with Gustav and Charles (1860–1927). It was the first furniture company to bear the family name and moved to Binghamton, New York, in 1884. In 1891 Charles, Albert and Gustav founded the Stickley & Brandt Chair Company in Binghampton. It became the largest furniture manufacturer in the state during the 1890s.

The arrangement was short-lived as that same year Albert moved to Grand Rapids, Michigan, to work with his brother John George. At the time Grand Rapids was the furniture-making capital of the United States. Gustav left soon after but Charles stayed in Binghampton for the rest of his career.

The Grand Rapids company was named Stickley Brothers in tribute to the original company and Albert designed the furniture. Like the rest of the family, he used plain oak and mahogany but his designs are the least like those of Gustav. He was greatly influenced by British Arts and Crafts furniture and his pieces tend to be rectilinear, with exposed structural elements such as through-tenoned stretchers and rails. He used a number of stained finishes, which ranged in colour from rich mahogany to a yellow limed oak.

Albert's work was marketed as "Quaint" from the early 1900s into the late 1920s. The Quaint trademark was also applied to more decorative items inspired by members of the Glasgow School. From around 1910 Stickley Brothers began to produce Colonial Revival style too. Albert retired in 1927 and the company continued until around 1947.

John George – who was said to be the best furniture salesman of his time – worked with Albert until he married and moved to New York. He was the principal salesman for L. & J.G. Stickley from 1902 to 1921 while continuing to work as a salesman for Gustav, Albert, and Charles.

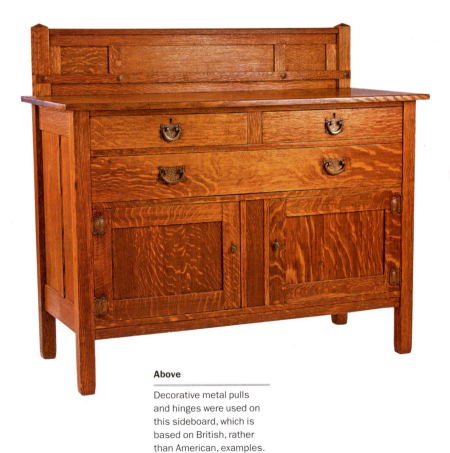

Above

Decorative metal pulls and hinges were used on this sideboard, which is based on British, rather than American, examples. c1910, 50in (127cm) wide, **J**

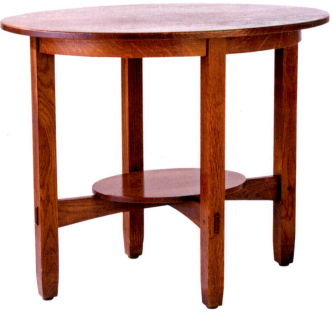

Below

A rare double oval lamp table with through-tenoned stretchers. c1910, 36in (91.5cm) wide, **K**

A Closer Look

An oak side table made of quarter-sawn oak in the rectilinear style favoured by Albert Stickley. The legs and sides are united by a flat under tier and the whole table is stained a rich, warm brown. It has the original metal "Quaint Furniture" plaque. The through-tenon joints are reinforced by wooden pegs, which remain visible. c1900, 30in (76cm) wide, **J**

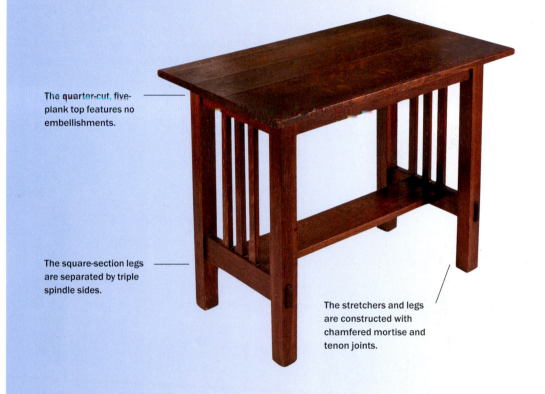

The quarter-cut, five-plank top features no embellishments.

The square-section legs are separated by triple spindle sides.

The stretchers and legs are constructed with chamfered mortise and tenon joints.

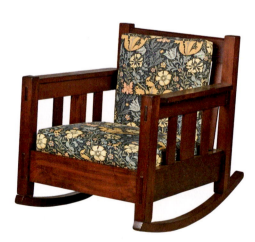

Above

This Quaint pedestal dining table still has its original finish. It has a four-sided base with shoe feet. c1905, 29¾in (75.5cm) long, 48in (122cm) wide, **K**

Above

This interpretation of Gustav Stickley's Morris chair has a rocker base and William Morris fabric upholstery, rather than the leather used on American versions. c1912, 32in (81cm) high, **K**

Charles Rohlfs

Charles Rohlfs (1853–1936) is regarded as one of the most innovative furniture makers of the early 20th century, and a leading light of the American Arts and Crafts Movement. However, in many ways his furniture defies categorization – too elaborate to be true to the Arts and Crafts creed that decoration should be minimal, yet too rectilinear to be part of the Gothic Revival Movement. Rohlfs called his work "Artistic Furniture" or "The Rohlfs Style". In 1900 he told *House Beautiful* magazine: "[My designs] are like those of no other period nor people...I do not read Ruskin nor anybody nor anything that might influence my ideas. I never get them from books...They are mine and into their execution I put all my heart and force and that is why they appeal."

The son of a New York cabinetmaker, Rohlfs grew up in Brooklyn. As a young man he earned his living as a pattern maker for an iron foundry, eventually being promoted to designer. His marriage to the novelist Anna Katharine Green (1846–1935) in 1884 gave him the financial freedom to pursue his dream of being an actor, but by 1896, when that had not been successful, he began making furniture for their home in Buffalo, New York.

In the late 1890s he opened a workshop in Buffalo making unique solid oak, and sometimes mahogany, furniture with exposed joinery, stylized abstract ornament, and a rich, dark patina. The pieces won widespread acclaim when exhibited at Marshall Field and Company in Chicago in 1899, the 1900 *Arts and Crafts Exhibition* at the National Arts Club in New York, and the 1902 *International Exposition of Decorative Modern Art* in Turin, Italy. By 1909 he employed eight craftsmen. But although he received prestigious commissions, his workshop was not a commercial success. Rohlfs retired in the mid 1920s.

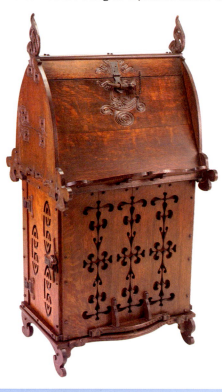

Left

Elaborate carving and flame finials decorate this drop-front desk. Other design features include a pivoting base and bookstand. 1900, 25¾in (65.5cm) wide, **B**

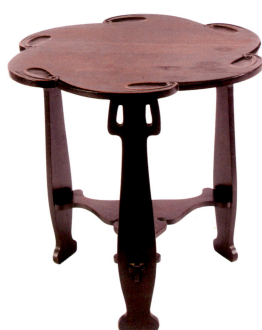

Left

A floriform table with a carved top, reticulated legs, a cutout lower shelf, and the original, light finish. c1910, 26in (66cm) wide, **J**

Chairs

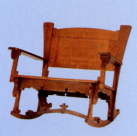

ROCKING CHAIR
A rocking chair with a carved apron, stretcher, and rockers. 1902, 36in (91.5cm) wide, **I**

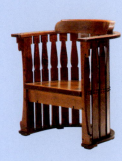

BARREL CHAIR
A barrel chair with carved slats that extend from the backrail to the base. 1902, 35in (89cm) high, **I**

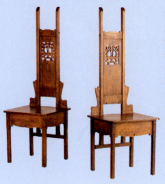

HALL CHAIRS
A pair of hall chairs, with tall cutout backs and saddle seats. The backs of Rohlfs's chairs tend to be elongated and often have detailed, hand-carved fretwork. 1901, 54¾in (139cm) high, **G**

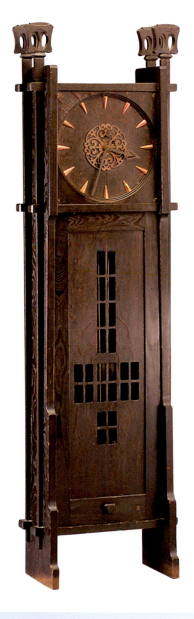

Left

A rare Charles Rohlfs tall case clock, with carved and cut-out posts keyed through side panels. Excellent original finish. c1900. 85½in (216.5cm) high, **E**

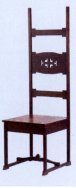

HALL CHAIR

A tall-back hall chair, with shaped back slats, cut with stylized cloverleaf reticulation, and a carved cross stretcher. c1905, 16½in (42cm) wide, **I**

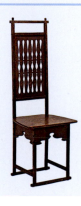

HALL CHAIR

A hall chair with carved back slats and marked with Rohlfs' "R". Rohlfs described his chairs as having "the spirit of today blended with the poetry of the medieval ages." c1905, 50in (127cm) high, **J**

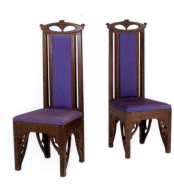

UPHOLSTERED CHAIRS

A pair of upholstered tall-back chairs with carved legs and top rail similar to those used in Rohlfs's living room. c1905, 47in (119cm) high, **G**

Roycroft

The writings of William Morris inspired Elbert Green Hubbard to set up a medieval-style guild of craftsmen in East Aurora, New York, in 1895. Hubbard was initially inspired by Morris's Kelmscott Press, and so his Roycroft community began by printing books, but it soon expanded to produce leatherwork, lighting, wrought metalwork, and simple oak Mission-style furniture.

Hubbard had been a successful soap salesman for J.D. Larkin & Co. in Buffalo, New York. Dissatisfied with this line of work he sold his interests in the company in 1892 and enrolled at Harvard. This, too, failed to satisfy him and so he travelled to England, where he briefly met Morris.

Hubbard's Roycroft project was such a success that a year after opening, the Roycroft Inn opened its doors, providing visitors curious to see the craftsmen at work with a place to stay furnished with their pieces. The woodwork shop started to produce souvenirs, which were such a success that by 1910 small decorative items such as bookends, ashtrays, and candlesticks had become the foundation of the company's output and were being sold through mail order

catalogues. Such a commercial venture might appear to go against the Arts and Crafts ideal, but it is an indicator of Hubbard's commercial sense.

Roycroft's cabinetmakers made high-quality oak, ash, and mahogany furniture. The designs were rectilinear, with bold proportions and used prominent pins, pegs, and mortise and tenon joints with a warm, nut-brown finish. Legs were usually tapered and sides canted; bun feet are a frequent feature. Some pieces have restrained moulded or carved decoration (leaves and stylized flowers were sometimes used), or hand-wrought copper or iron hardware. Motifs inspired by the Wiener Werkstätte were used following a visit to Vienna by Roycroft designer Dard Hunter (1883–1966) in 1908.

Hubbard and his wife, Alice Moore Hubbard (1861–1915), died on the RMS *Lusitania*, which was sunk by a German submarine off the coast of Ireland in 1915. The Roycroft workshops were taken over by their son Elbert Junior (1882–1970), who set up Roycroft departments in stores across the United States. The company closed in 1938.

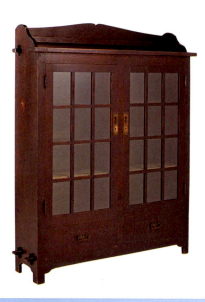

Left

Pegged-through tenons and hand-wrought hardware adorn the front and sides of this double-door bookcase. c1905, 52in (132cm) wide, **G**

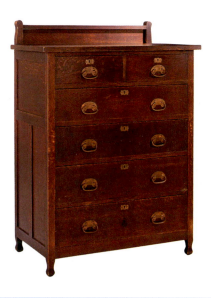

Left

A solid, rectilinear chest of drawers, with bun feet and hand-hammered drawer handles. c1905, 41½in (105.5cm) wide, **H**

Right

Four square-section legs support the top of this dining table. The timber has been stained a warm, brown colour. c1905, 54in (137cm) diam, **I**

LEFT
Hubbard was an early advocate of brand logos: furniture was marked with an orb and cross symbol or an incised "ROYCROFT". In this Roycroft logo found on the front of a chair seat, the cross is hidden by the leather upholstery.

LEFT
An applied metal label found on a stand designed to hold volumes of the Little Journeys series produced at the workshops. c1910

LEFT
The incised logo found on much Roycroft furniture – here seen on a lamp table. c1880–1920.

RIGHT
"Entrance to Roycroft Inn" menu cover by Dard Hunter. 1920, 3¼in (8cm), M.

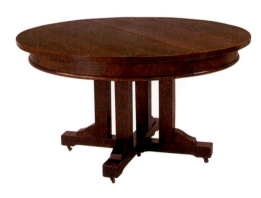

Above

Known as the "Special Armchair", this was an extravagant piece, costing $130 at a time when the average annual income was $300. c1905, 24in (60cm) wide, **H**

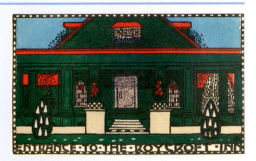

A Closer Look

Solid dark-stained oak timbers were used to construct the sides and shelves of this triangular bookcase. c1900–10, 20½in (52cm) wide, **G**

Above

The bookcase features rare signature and leaf carvings on both sides.

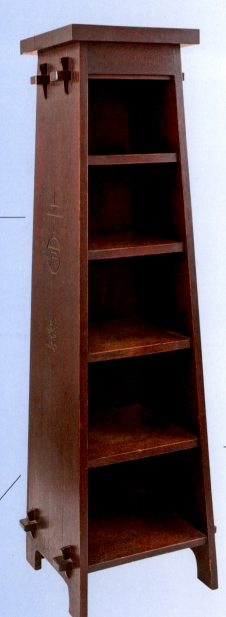

Pegged-through tenons are used to secure and decorate the sides of the bookcase.

The flared sides are scalloped at the base.

The graduated shelves are plain timbers – there is no moulded or carved decoration.

Limbert

Charles P. Limbert, the son of a furniture dealer and cabinetmaker, founded the Limbert Furniture Company in 1894 in Grand Rapids, Michigan, which at the time was the capital of American furniture manufacture. There was a large immigrant Dutch community near the factory, and in 1902 the company began to make a Dutch Arts and Crafts line inspired by the vernacular traditions of the Dutchmen who worked there. Before this it made simple Mission-style pieces.

From 1904 until around 1910 the factory developed the designs for which it is best known – rectilinear, well-proportioned pieces made in high-quality materials and using machines as well as traditional hand-tool techniques. The results did not have the exceptional finish of pieces from Gustav Stickley's workshop, but are nevertheless fine examples of American Arts and Crafts furniture. Like its contemporaries, the Limbert factory designed chairs, desks, and lamp tables from solid wood – usually oak but sometimes mahogany. However, where Stickley and his ilk followed William Morris, Limbert used repeating cutout squares, rectangles, triangles, or hearts similar to those employed by Mackintosh and other Glasgow School designers.

The branded mark used by the Limbert company on many of its wares. It shows a cabinetmaker working at his bench.

Other influences include the plain, geometric styles promoted by the Austrian and German Secessionist movements. Limbert visited Britain and other European countries to study historical furniture styles and modern furniture production. It is believed that some of the more elegant examples may have been designed by the Austrian-trained William J. Gohlke, who worked at the factory from 1909 until 1914 and was made a vice-president in 1921.

Limbert furniture was sold through mail order catalogues. Early pieces have darker finishes similar to the fumed oak used by Gustav Stickley. A few of these are decorated stylized motifs created from metal and fruitwood inlays. The furniture the company produced before the First World War is considered to be its finest and includes solid, well-proportioned cabinets, tables, and chairs featuring geometric outlines and often made in tiger-grained oak. After the war, the style became diluted with spindly forms that were of lower quality than its earlier output or were modern interpretations of 17th- and 18th-century English styles. The factory eventually closed in 1944.

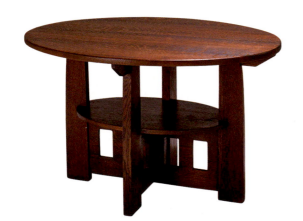

Left

An oval table with an under tier. The plank-like legs taper towards the top, which is supported by buttresses. c1905, 48in (122cm) long, **J**

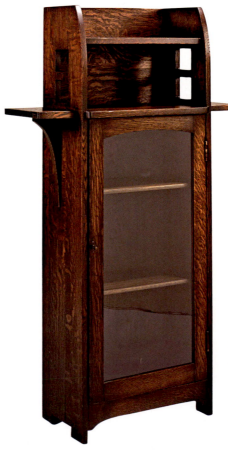

Left

The upper shelf of this single-door cutout bookcase is supported by corbels and the sides have square cutouts. c1905, 30in (76cm) wide, **J**

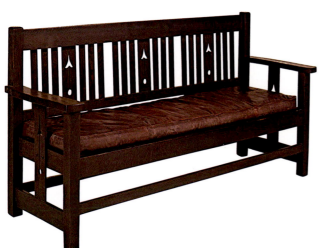

Left

A rare and early drop-arm settee with geometric tree cutouts in the back slats. c1906, 81in (205.5cm) long, **J**

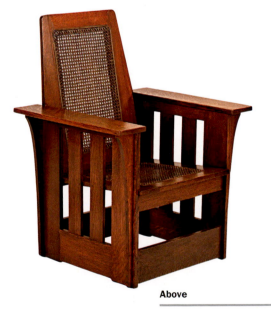

Above

The graceful form of this two-door bookcase was inspired by the simple, elegant furniture of the European Secessionist movement. c1910, 48in (122cm) wide, **J**

Above

The back rest of this rare armchair is set with caned panels. c1910, 30½in (77.5cm) wide, **J**

A Closer Look

A sideboard with flush top and plate rack, an arched apron, and metal drawer pulls. This rectilinear form is typical of the fumed oak designs produced by the factory after 1904. c1910, 54in (137cm) wide, **J**

The plate rack features a geometric cutout design similar to those used by Glasgow School and Secessionist designers.

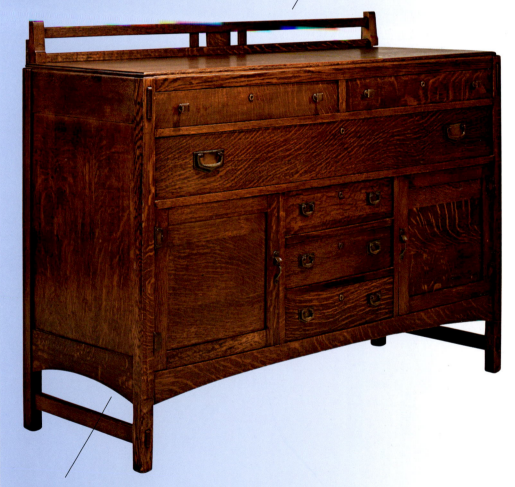

The sides have an arched apron, which echoes the shape of the apron at the front.

Rose Valley

The Rose Valley community, built just outside Media, Pennsylvania, was the vision of architect William Lightfoot Price (1861–1916). Price, a Philadelphia free-thinking Quaker, was inspired by the writings of William Morris to found an artistic village built on the principles of the Arts and Crafts Movement.

In 1901 he bought 80 acres of land and began to design and build a new neighbourhood based on the utopian English village described by Morris in his book *News from Nowhere*. His plan was for the inhabitants to make some of their income from crafts they produced – some of these were made by residents, others by craftsmen who rented workshops in the village. Rose Valley was also home to a book bindery, the Rose Valley Press; its own magazine, *The Artsman*, and a metal workshop. Items made in the community – including the furniture and ceramics by William Jervis (1849–1925) – bore the Rose Valley seal.

The Rose Valley seal, showing a rose with a superimposed "V" circled with a buckled belt to symbolize friendship, was marked on the community's furniture.

Before he started work on Rose Valley, Price designed furniture for the houses he built and these pieces are identical to those made for his artists' community. These pieces are considered to be the most important legacy of the Rose Valley experiment. Price used a high Gothic style, characterized by elaborately hand-carved decoration. The furniture workshop was active from 1901 until 1906, and during this time six cabinetmakers produced 500 pieces of furniture.

Price did not advertise his furniture or publish a catalogue, and when potential customers, who had seen his designs at the 1904 *Louisiana Purchase Exhibition*, requested alterations he turned them away – the furniture was part of his Arts and Crafts vision and could not be tailored to suit other homes. However, the furniture was expensive and when, in 1906, it proved to be too great a drain on his resources, Price closed the workshop.

Above

Monkeys and dragons adorn the armrests and finials of this armchair designed by Price. c1901, 46in (116.5cm) high, **G**

Below

A carved owl's head adorns this folding oak chair's back rest. It bears a carved signature and original painted decoration. 1905, 33in (84cm) wide, **I**

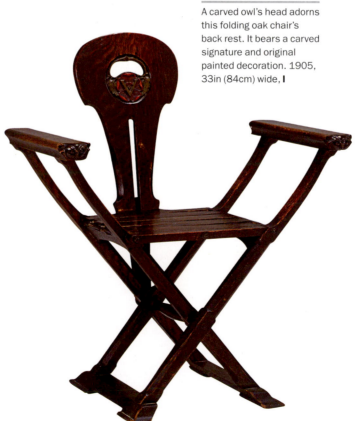

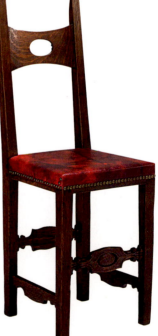

Above

Carved lower stretchers, a pierced back rest and scrolled finials provide minimal decoration on this custom-made oak typist's chair. c1905, 46in (116.5cm) high, **K**

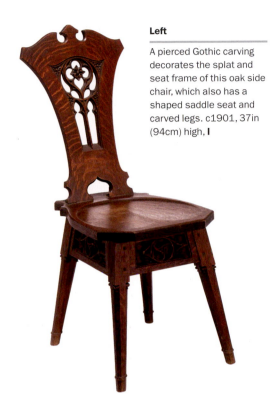

Left

A pierced Gothic carving decorates the splat and seat frame of this oak side chair, which also has a shaped saddle seat and carved legs. c1901, 37in (94cm) high, **I**

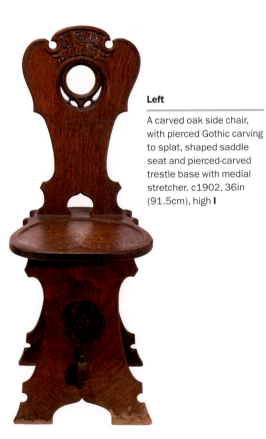

Left

A carved oak side chair, with pierced Gothic carving to splat, shaped saddle seat and pierced-carved trestle base with medial stretcher. c1902, 36in (91.5cm), high **I**

Shop of the Crafters

The city of Cincinnati, Ohio, was a thriving centre for Arts and Crafts enterprises, among them the Shop of the Crafters, which was founded by businessman Oscar Onken (1858–1948), who saw an opportunity to make and sell Arts and Crafts furniture in the European style following a visit to the 1904 *Louisiana Purchase Exposition* in St Louis.

Onken employed Hungarian designer Paul Horti (1865–1907) to create pieces aimed at Americans keen to follow European fashions.

Horti used colourful Austrian woods to create inlaid marquetry panels, setting his work apart from the American designers who slavishly copied the Mission style of Gustav Stickley. Other embellishments included inlaid Art Nouveau-inspired stained- and leaded-glass panels, Limbert-style cutouts and leather panels studded with brass nails. The innovative waxed finishes given to the furniture were advertised as "Weathered, Fumed, Flemish, Austrian or Early English shades". The Shop of the Crafters had stopped producing Arts and Crafts furniture by 1920, although the Oscar Onken Company continued until 1931.

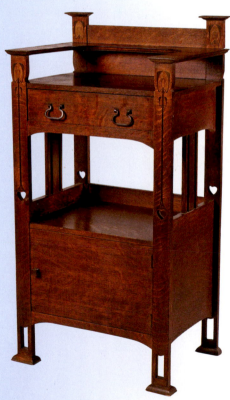

Below

A postcard desk with a gallery top incorporating drawers and cupboards with glass doors, faceted square pulls, and the original finish. c1915, 35in (89cm) wide, **L**

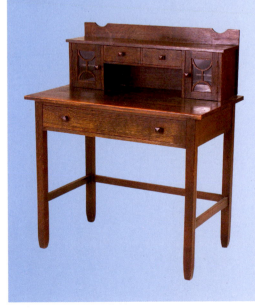

Above

A fumed oak and marquetry cabinet, with hand-wrought iron handles, the supports embellished with cutout heart motifs and pierced feet. c1915, 23¼in (58.5cm) wide, **I**

Other American Furniture

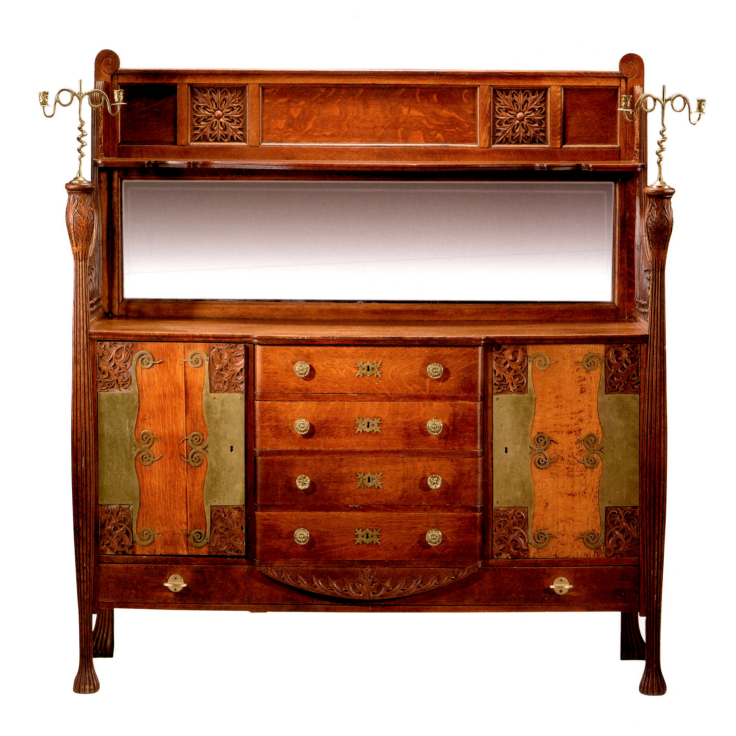

A breakfast sideboard by
Hert Brothers, New York,
the back embellished
with a mirrored panel.
The brass candelabra are
a later addition. c1910,
69½in (176.5cm) high, **J**

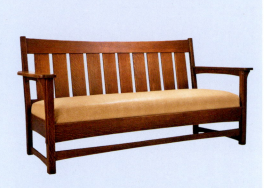

The vertical back slats and drop-in spring seat of this Lifetime "Puritan" settle recall the designs of Gustav Stickley. c1910, 74in (188cm) wide, **L**

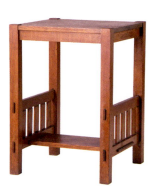

The legs of this Harden square lamp table are mortised through the top. The stretchers and lower shelf are through-tenoned. It has its original finish. Early 20thC, 18½in (47cm) wide, **K**

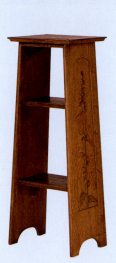

The Byrdcliffe Community made simple furniture decorated with carving or painting. This rare magazine stand is carved with hollyhocks. 1904, 36in (91.5cm) high, **I**

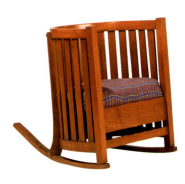

A Plail Brothers barrel rocker. The vertical slats recall the work of Gustav Stickley, Frank Lloyd Wright, and Charles Rennie Mackintosh. c1910, 29½in (75cm) high, **K**

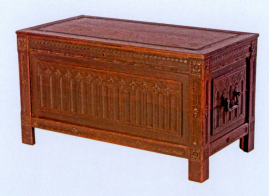

A Walfred Thulin (1878–1949) Gothic blanket chest. In 1919 Thulin received a medal from the Boston Society of Arts and Crafts for his work. c1910, 42in (106.5cm) wide, **G**

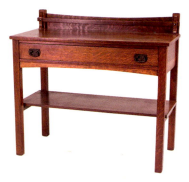

A Mission-style server by the C.S. Paine Company of Grand Rapids, Michigan. The plate rack features a simple wooden horizontal support. c1910, 38in (96.5cm) wide, **K**

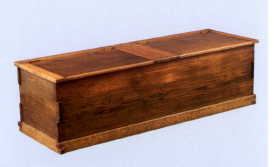

A rare Greene & Greene oak and yellow pine double blanket chest from the Pratt Residence, Ojai, California, with unusually mortised corners. c1910, 65in (165cm) long, **G**

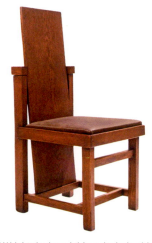

Frank Lloyd Wright designed this oak chair with leather upholstery for the Hillside Home School, Spring Green, Wisconsin. c1904, 40in (102cm) high, **F**

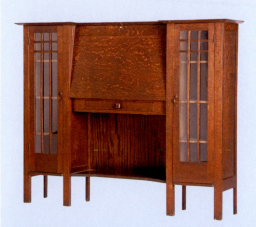

This Brooks drop-front desk lacks embellishment. The bookcases on either side have glazed doors with simple wooden frames. c1910, 62½in (159cm) wide, **K**

Nakashima – the Tradition Continues

George Nakashima (1905–90) was a Japanese-American architect and designer who became one of the leading figures in the American craft movement.

He was born in Spokane, Washington, and, after graduating from the University of Washington and gaining a master's degree from the Massachusetts Institute of Technology, travelled to Paris and then Tokyo where he worked for the Modernist architect Antonin Raymond (1888–1976), overseeing the construction of the first reinforced concrete building in India.

At the outbreak of the Second World War he returned to the United States and opened a furniture workshop in Seattle, Washington. However, in 1942 he was interned in a camp in Minidoka, Idaho, with his wife and daughter. While there, a Japanese carpenter taught him traditional woodworking skills. Around 1943, thanks to sponsorship by Raymond, Nakashima and his family moved to New Hope, Pennsylvania, where he built a home and workshop.

Nakashima's iconic furniture is characterized by free-form organic shapes and by perfectionism in every stage of its construction. His signature pieces are large tables with tops made from irregular-shaped slabs of wood with smoothed surfaces but unfinished sides, raised on asymmetrical supports. He believed that his distinctive style gave "a second life" to the trees he loved. He wrote: "Each flitch, each board, each plank can have only one ideal use. The woodworker applying a thousand skills, must find that ideal use and then shape the wood to realize its true potential. The result is our ultimate object, plain and simple."

Nakashima designed a series of furniture for Knoll in 1946; he kept the production rights for the pieces and sold them through his own shop. Among his commissions were furniture for the home of New York Governor Nelson A. Rockefeller (1908–79), Columbia University, and the church of Christ the King in Katsura, Kyoto. One of Nakashima's projects was to create an Altar of Peace for each of the seven continents. The first was installed at the Cathedral of St John the Divine in New York City in 1986. The second is now at the Russian Academy of Art in Moscow and the third at the Unity Pavilion of the "City of Peace" Auroville, India. A fourth is planned for the Desmond Tutu Peace Centre in Cape Town, South Africa.

Today his daughter, Mira Nakashima-Yarnall (b.1942), runs the Nakashima Studio in New Hope, Pennsylvania.

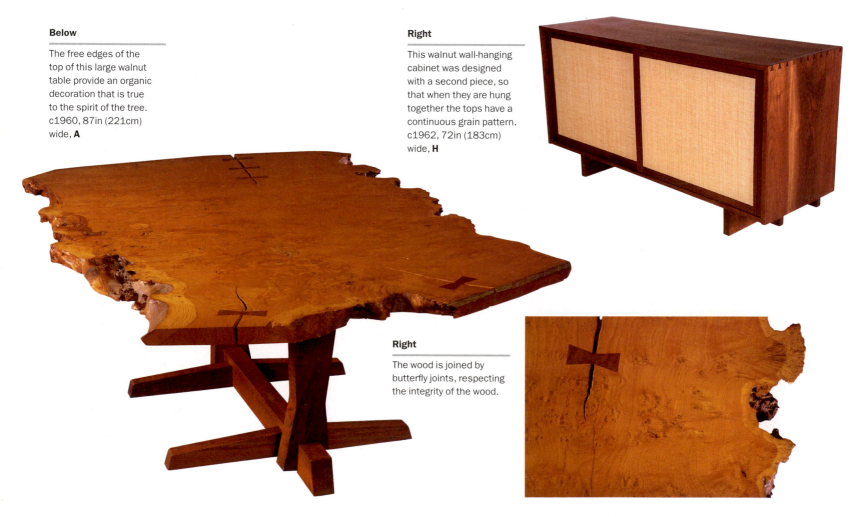

Below

The free edges of the top of this large walnut table provide an organic decoration that is true to the spirit of the tree. c1960, 87in (221cm) wide, **A**

Right

This walnut wall-hanging cabinet was designed with a second piece, so that when they are hung together the tops have a continuous grain pattern. c1962, 72in (183cm) wide, **H**

Right

The wood is joined by butterfly joints, respecting the integrity of the wood.

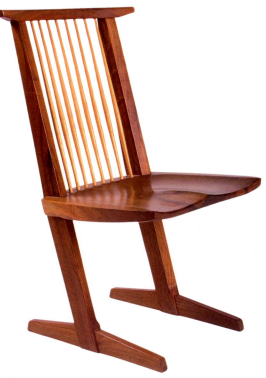

Above

A fine Conoid bench with English walnut back, hickory spindles and free edge seat, supported by tapering dowel legs. c1960, 83in (211cm) long, **G**

Above

The seat of this chair cantilevers from the two back legs. This Persian walnut version has hickory spindles and a single board saddle seat. c1960, 35¼in (89.5cm) high, **J**

Phillip Lloyd Powell

Phillip Lloyd Powell (1919–2008) studied mechanical engineering and worked as a meteorologist before returning to his native Pennsylvania and his first love – making furniture. In 1947 he began to build his own home in New Hope and by 1953, with the encouragement of George Nakashima, he had opened a showroom from which he sold his designs.

Powell was self-taught and his furniture was inspired by Nakashima and Wharton Esherick

(1887–1970). Hand-carved in organic shapes and sinuous forms, it incorporated unexpected materials: his cabinets were often lined with silver leaf or fine fabrics.

Powell described himself as "an artist working with furniture that has sculptural qualities". In 1955 he began working with designer-craftsman Paul R. Evans (1931–87) and they opened a showroom where they created screens, tables, and cabinets. The partnership ended in 1966.

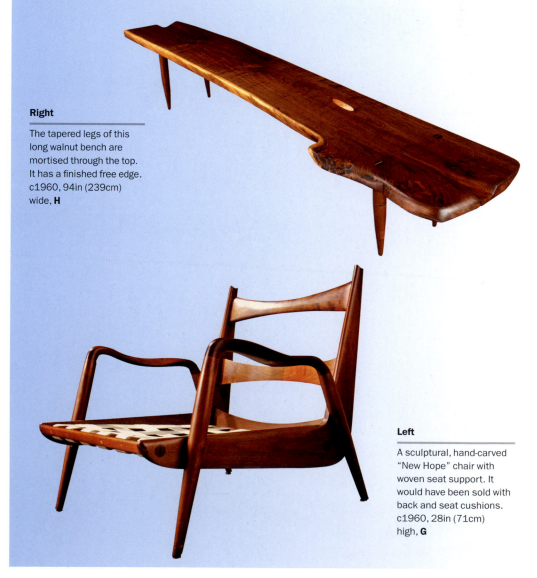

Right

The tapered legs of this long walnut bench are mortised through the top. It has a finished free edge. c1960, 94in (239cm) wide, **H**

Left

A sculptural, hand-carved "New Hope" chair with woven seat support. It would have been sold with back and seat cushions. c1960, 28in (71cm) high, **G**

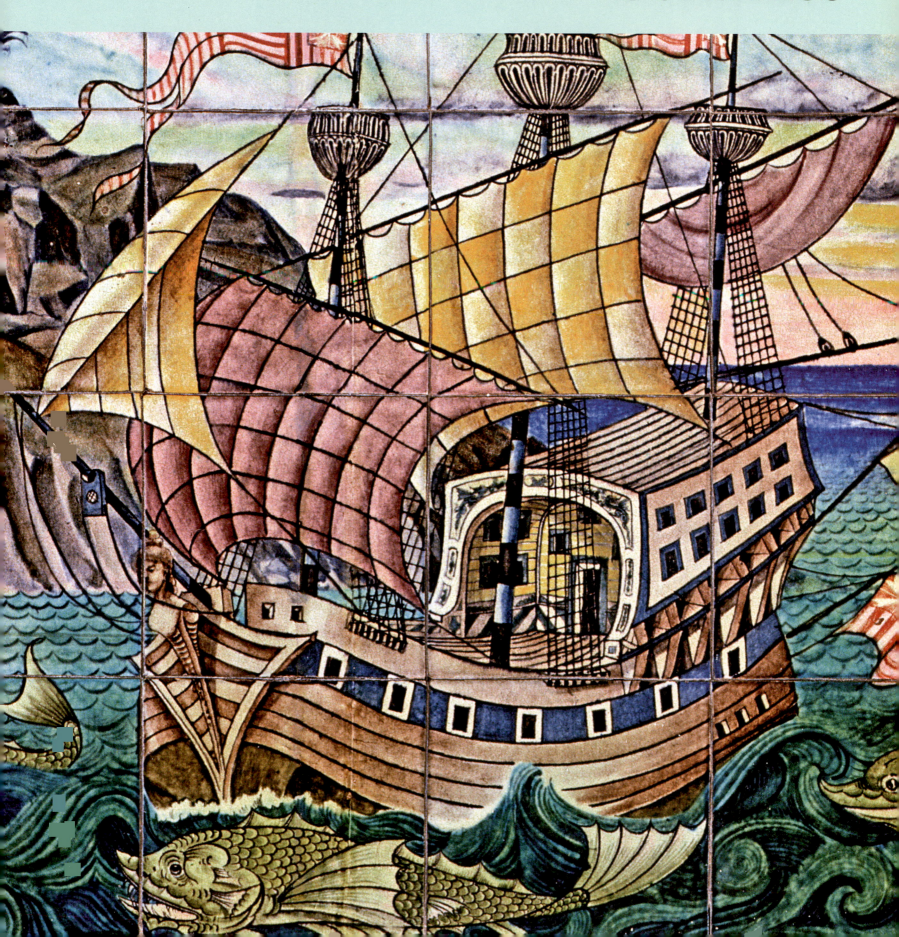

British Ceramics

The market for hand-crafted ceramics in Britain burgeoned at the end of the 19th century. It was mainly led by small art potteries with a few, influential potters promoting the simple and functional designs championed by Arts and Crafts pioneer William Morris (1834–96). The potting world was invigorated by the work of artists such as William Moorcroft (1872–1945) and William De Morgan (1839–1917), known for the individuality and high quality of their designs. De Morgan started his career as a potter by decorating mass-produced tiles, although he soon rejected this practice in favour of manufacturing his own pottery. He was obsessively interested in irregularity and individuality, and involved himself personally with every stage of the process. Larger potteries, such as Martin Brothers in Southall, tended to divide labour so that one person or a team of people could specialize in particular aspect of production. Most Arts and Crafts ceramics studios followed this practice to a greater or lesser extent as it allowed for a more economic use of resources and permitted craftsmen to develop their skills to a very high level within a specific role.

The idea that ceramics were also an ideal medium for mass-production did not go unnoticed by a number of British manufacturers, who established art pottery studios where designers could experiment freely with new techniques of potting, glazing, and decorating. Among these innovators was the industrial manufacturer Doulton & Co., which collaborated with students from the Lambeth School of Art in south London to produce a distinctive group of hand-thrown stonewares that were decorated by a talented team of highly creative artists. Hannah Barlow (1851–1916) is a classic example of someone devoted to the Arts and Crafts idiom, working under the auspices of a corporation – Doulton – that had little more than commercial interest in the Movement.

Ceramicists re-interpreted time-honoured shapes such as the baluster and urn in accordance with the prevailing ideals of individual craftsmanship. Other potters frequently used classical shapes in their original state as canvases to showcase a glaze or a finish. Bright colours – including flambé glazes and Pilkington's lustrous "Lancastrian" wares – provided a stark contrast to the more subdued hues of Doulton and Martin Brothers.

When Frederic Leighton (1830–96) built the Arab Hall within his London house, he employed De Morgan to augment the schemes of Persian wall tiles fitted throughout the Hall. De Morgan's research into and emulation of Eastern ceramics led to some remarkable breakthroughs, not least of which was his rediscovery of the technique of lustre glazing.

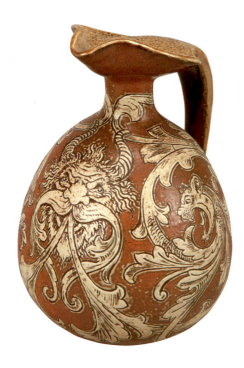

Above

As well as the animal grotesques, Martin Brothers' mainstream production was of stoneware jugs and vases. 1893, 9¾in (24.5cm) high, **J**

Above

This Doulton Lambeth stoneware "Galleon finial", designed by Gilbert Bayes, was made for the washing-line posts at a London housing estate. c1906, 20in (50cm) high, **I**

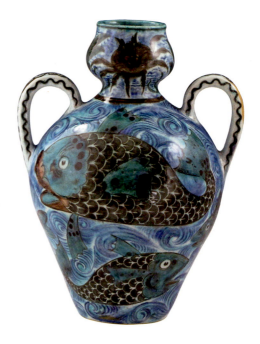

Above

The William De Morgan Pottery was greatly influenced by the glazes and colours of Persia, as shown in this vase. c1876, 14in (35cm) high, **I**

Opposite

Dating from c1910, this photograph of the Martin Brothers Pottery Studio in Fulham shows a potter, likely to be Walter F Martin, turning a vase. Two "Wally" birds are in the foreground.

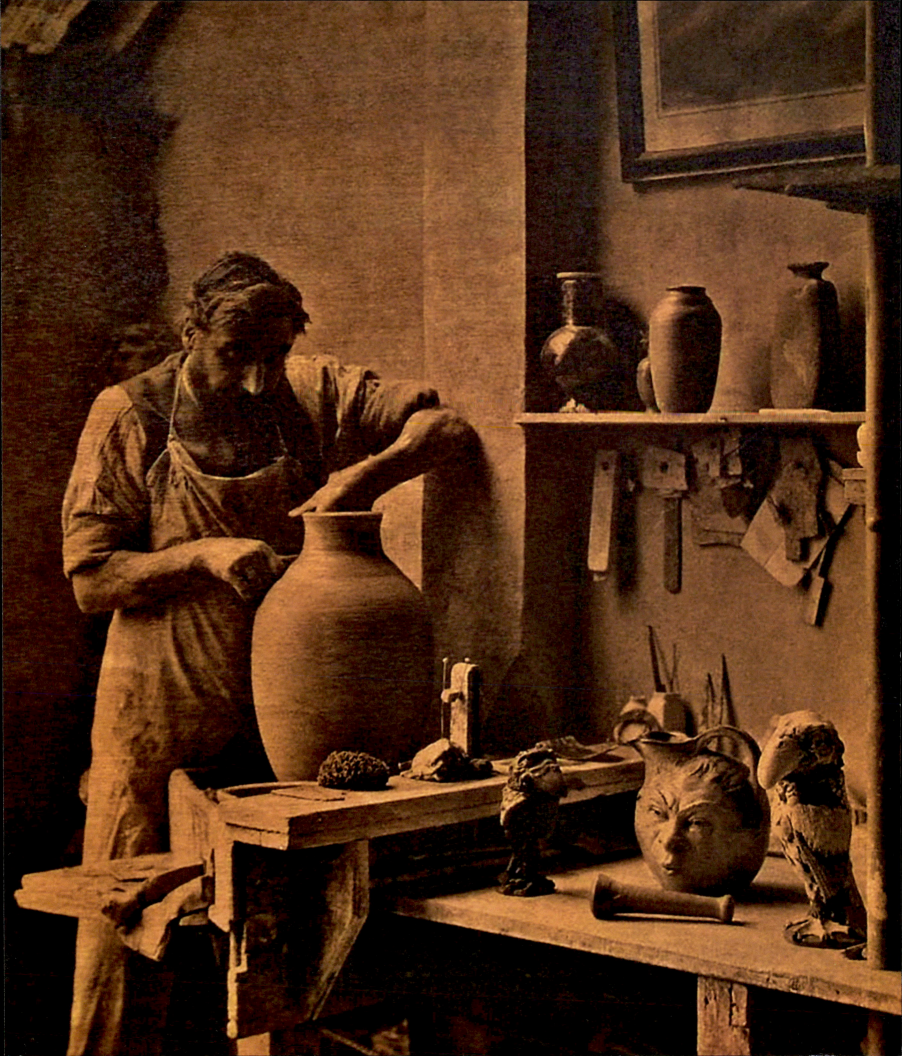

Martin Brothers

One of the most imaginative Arts and Crafts potteries was established by the Martin Brothers in Fulham, London, in 1873. Their grotesque creations include birds and animals with human features, as well as goblins and dragons. As unique in the United Kingdom as George Ohr's (1857–1918) pots were in Biloxi, Mississippi, they represent perfectly the transition in the late 19th century from sentimental Victorian ceramics to studio pottery.

Robert Wallace Martin (1843–1923) studied at the Lambeth School of Art, London, and began his career working as a freelance artist for the Doulton Pottery. He was a trained sculptor, and in his work as a stone carver for London's Houses of Parliament he was inspired by the Neo-Gothic grotesque gargoyles he saw there. Within the pottery, Robert had the greatest creative input and was responsible for the characterful "Wally" birds and other fantastical creatures that still define the firm's work. Walter Frazer (1857–1912) was responsible for throwing the pots by hand, developing coloured glazes and creating much of the incised decoration. Edwin (1860–

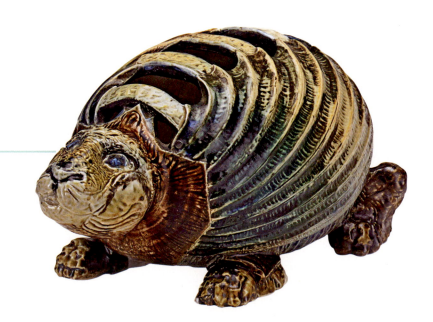

1915), who also trained at Lambeth School of Art, was the chief decorator specializing in seascapes and murky marine scenes, and Charles (1846–1910) was in charge of the administrative side of the business. The pottery moved to larger premises in 1877, at Southall in Middlesex.

The Martin enterprise was a highly successful collaboration that produced a formidable range of fanciful salt-glazed stoneware objects. The taste for these bizarre motifs has its origins in the decoration of the ancient subterranean ruins – or grotte – from Roman antiquity, which were rediscovered by artists during the Renaissance and reappraised in the late 19th century.

The company also produced a collection of vases, water jugs, and punch bowls with incised patterns of scrolling foliage that were inspired by the popular designs of William Morris. Ceramics made at Southall between 1882 and 1914 are nearly always marked with an incised "RW Martin & Brothers London & Southall", along with a number and date, while early pieces are generally signed only "Martin". The works closed in 1914.

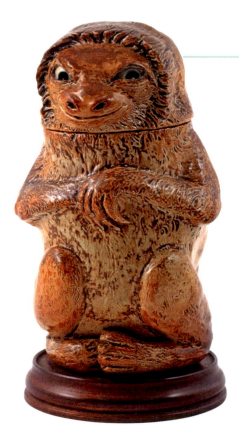

Good

This stoneware monkey jar is a rare animal and quite a late piece. It may be associated with the Martin brothers' sister's death from a monkey bite. 1903, 10in (25cm) high, **H**

Better

This is a rare glazed stoneware armadillo vessel for flower arrangements. Its appealing face and good glazes make it desirable. 1890, 8½in (22cm) long, **G**

Masterpiece

This grotesque "Wally" bird tobacco jar, in salt-glazed stoneware is the most desirable. With his supercilious sneer and glorious strong glazes, he is also an early bird. 1892, 11in (28cm) high, **O**

Best

This rare stoneware grotesque jar and cover is strangely unsettling. Most sinister is the way the creature casts a sideways glance and smiles. He is a collector's delight. 1900, 6½in (17cm) high, **D**

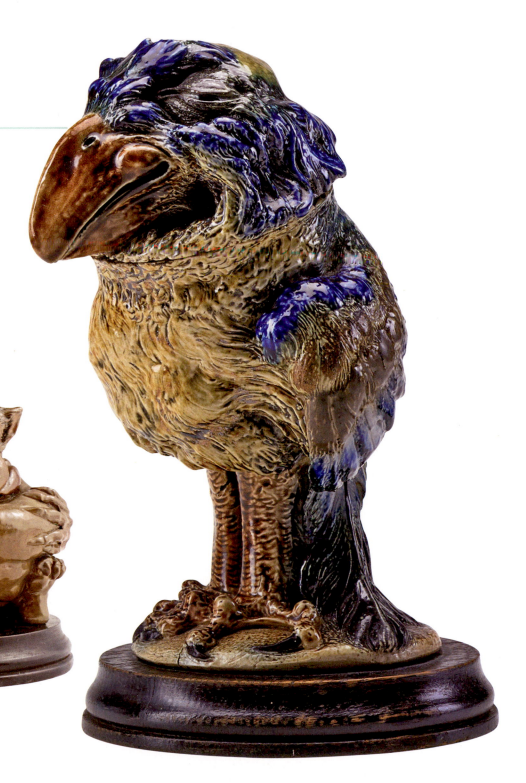

William Moorcroft

William Moorcroft was born in Burslem, the heart of the Staffordshire potteries, in 1872. After studying at the National Art Training School (later the Royal College of Art), London, in 1897 he was appointed a designer of ceramics by James Macintyre & Co. of the Washington Works, Burslem. Although the firm had made its reputation with utilitarian wares, it was willing to develop an art pottery range which, because of the Arts and Crafts Movement, had become the vogue. Moorcroft had also studied ceramic chemistry, which enabled him to execute his own designs – he was very much a hands-on potter.

From the beginning Moorcroft's earthenware pottery was embellished with stylized floral arrangements and landscapes painted in vivid shades of blue, yellow, and red. His first ware was "Aurelian", which was transfer-printed and coloured with red and blue enamels highlighted with gilding. After being given access to the firm's laboratories, clayrooms, dipping house, and kilns Moorcroft designed the distinctive hand-made "Florian" ware, which was decorated with formal patterns of brightly painted flower blossoms, foliage, and peacock feathers. He was inspired by organic forms and nature, as reflected in the pattern names: "Poppies", "Liberty Daffodil", and "Peacock".

In his use of slip-trailing and a flowing style of decoration he transformed the techniques historically found at Macintyre. His designs completely cover the surface and to add texture he employed a technique known as "tube-lining", whereby creamy, semi-liquid slip is piped in thin trails onto the body of a vessel to create relief patterns that can be filled in with glazes. Moorcroft drew every pattern produced and was responsible for many of the shapes. "Florian" ware was instantly successful, stocked by Liberty in London and Tiffany of New York.

The Liberty connection was particularly important to Moorcroft. In 1913 he left Macintyre & Co. to set up his own Cobridge Works in Burslem, with the financial backing of Liberty. He developed designs such as "Pansy", "Orchid", "Leaf and Berry", "Green Flamminian", "Hazeldene", and "Red Persian", as well as a popular range of wares decorated with a combination of sumptuous glazes called "Flambé". Moorcroft adopted the name "Claremont" (as shown opposite) for his toadstool pattern, after it was first used by Liberty.

In 1928 Queen Mary, a keen collector, made him "Potter to the Queen", which was stamped on the base of the pottery. Moorcroft's son, Walter (1917–2002), joined the company in 1935 and took over the running of the pottery in 1945.

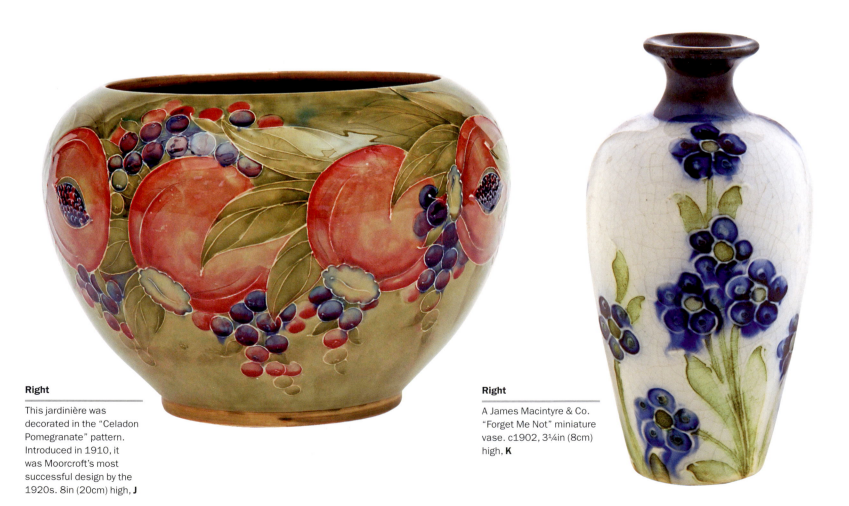

Right

This jardinière was decorated in the "Celadon Pomegranate" pattern. Introduced in 1910, it was Moorcroft's most successful design by the 1920s. 8in (20cm) high, **J**

Right

A James Macintyre & Co. "Forget Me Not" miniature vase. c1902, 3¼in (8cm) high, **K**

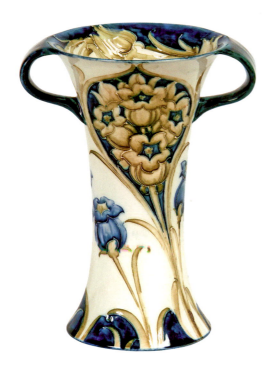

Above

This "Harebell" pattern vase shows the inspiration from nature that was at the heart of Moorcroft's designs. c1905, 7¾in (19.5cm) high, **J**

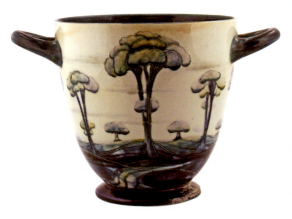

Above

As well as the floral themes, Moorcroft developed many landscape patterns as shown on this "Hazeldene" jardinière. c1925, 8in (20cm) high, **J**

A Closer Look

This prestigious loving cup, decorated in an early example of the "Claremont" pattern, combines the talents of William Moorcroft and the San Francisco jewellers Shreve & Co. Awarded a gold medal at the *St Louis International Exhibition* in 1904, Moorcroft pottery was sold by Shreve & Co. from 1904, with Tiffany and other famous American stores following shortly afterwards. Many pieces were silver-mounted as requested by the export customers. c1905, 7½in (19cm) high, **F**

The base has the usual Moorcroft signature and the retailer mark.

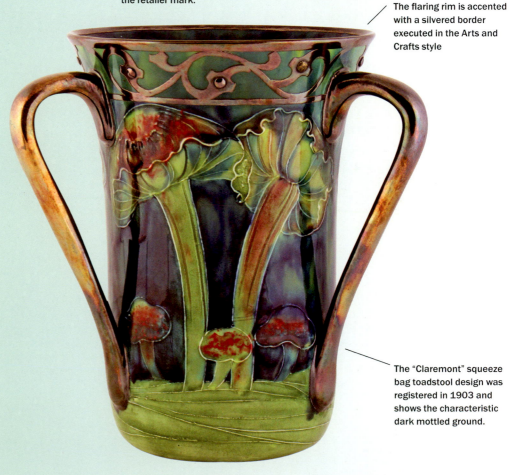

The flaring rim is accented with a silvered border executed in the Arts and Crafts style

The "Claremont" squeeze bag toadstool design was registered in 1903 and shows the characteristic dark mottled ground.

Doulton & Co.

Although the market for hand-crafted ceramics at the end of the 19th century was led in Britain by numerous small art potteries, the prolific and innovative Doulton & Co. took advantage of opportunities to collaborate with Arts and Crafts designers by establishing an art pottery studio alongside their mass-produced ranges.

Doulton & Co. was founded at Lambeth, south London, in 1815 by John Doulton (1793–1873) specializing in utilitarian stonewares. John's son, Henry (1820–97), established an art pottery studio in 1871 dedicated to the production of hand-crafted, hand-decorated ceramic wares. Collaborating with the nearby Lambeth School of Art, Doulton produced a range of decorated stonewares and a line of hand-painted faience over the following decades. Several of the talented designers, painters, and sculptors became pre-eminent in their field and contributed to the remarkable success of the Doulton studio, among them Frank Butler, Emily Edwards, Mark V. Marshall, Eliza Simmance, George Tinworth (1843–1913), and Arthur, Lucy, Florence, and Hannah Barlow.

Most of the artists concentrated on ornamental wares, especially vases, jugs, and tankards. Henry Doulton gave his designers extraordinary free rein. Every piece was unique, as the artists were free to choose the form and decoration of their vases, and all wares were individually signed. Most of the glazes were in a sombre, subdued palette of dark green, brown, blue, and grey although that did not prevent the decoration being lively, spirited, and inventive.

The practice of scratching into the body or paste of a ceramic vessel with a sharp instrument, such as a metal point – for decoration or to record a name, date, or inscription – has roots in the pottery of classical antiquity. A decorative technique popular in both the East and the West commonly known as *sgraffito*, the design is scratched, or incised, onto the vessel through the slip before glazing in order to reveal the ceramic body beneath, although incising through the glaze will produce a similar effect.

Left

A Doulton Lambeth ewer by Mark V. Marshall (1876–1912). c1895, 11in (28cm) high, **J**

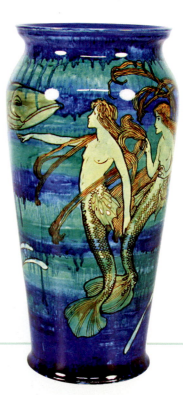

Right

This Doulton vase is typically hand-painted by Margaret E. Thompson. The background glazes reflect the changing tones of the sea. c1910, 13in (33cm) high, **H**

Doulton Marks

This mark was used from 1880 to 1902 having been adapted from an early Lambeth mark. It incorporates the interlocking "D" motif. It also shows the date 1881.

"HB" is the monogram of Hannah Barlow. She worked at Doulton for three decades from 1871.

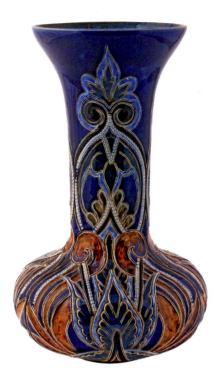

Above

A Doulton Lambeth stoneware vase by Edith Lupton. 1888, 11¾in (29.5cm) high, **K**

Hannah Barlow

Doulton pioneered the employment of women who enjoyed the same autonomy as their male colleagues. After studying at the Lambeth School of Art, in 1871 Hannah Barlow became the first female artist to work at Doulton and remained there for three decades. An expert tube-liner her designs are among the most sought after of those by Doulton artists. Her *sgraffito* designs featuring horses, goats, and other animals came from sketches she made when she was a child. Hannah had a passionate love of nature and she later had a small zoo at her home. This love and understanding of animals permeates her work. Some of the pieces with more exotic animals such as lions can be the most valuable as they tend to be rarer. Hannah decorated the band with animals around the pots and left the remaining decoration to other designers and assistants. She could produce 20 vases each day. She retired In 1913.

Below

The pride of lions adorning this vase made it slightly exotic compared with the more common horses, deer, and cows. c1888, 19in (48cm) high, **K**

Above

A distinctive *sgraffito* decorated biscuit barrel by Hannah Barlow. With a silver-plated rim, handle, and cover, this was very much the norm at Doulton Lambeth. c1890, 6¾in (17.5cm) high, **K**

Above

A Royal Doulton Arts and Crafts floor vase, incised and painted by Charles Noke (1858–1941). c1890, 24in (60cm) high, **J**

Doulton & Co. (continued)

One of the most talented and original artists to work at the Doulton studio was George Tinworth. He was the son of a wheelwright and his only education was from his mother who was deeply religious and instructed George on the scriptures. His knowledge of them was later to provide him with the inspiration for his terracotta and statuary work. From 1861 he took evening classes at the Lambeth School of Art. He also attended the Royal Academy Schools in 1864 where he won medals for "the Antique" and "the Life". He worked at Doulton from 1867 until his death in 1913. From records kept by Doulton, Tinworth (described as the "Rembrandt of Clay") would work from sunrise to sunset. During his life he produced over five hundred large religious panels and countless smaller ones showing biblical scenes. He also produced numerous portrait memorials, terracotta medallions, figurines, and thousands of "Doulton" ware vases, of which he could apparently decorate up to 70 a day. The pieces tend to be densely populated with busy compositions, often on a small scale.

An exhibition-quality stoneware vase. c1890s, 25in (64cm) high, **I**

He produced many works that were highly acclaimed at international exhibitions. A figural salt-glazed stoneware fountain for the 1878 *Paris Universal Exhibition* was modelled in relief around a pyramidal column with scenes relating to water from the Old and New Testaments. Each scene is separated by groups of figures modelled in the likeness of animals, birds, and reptiles. It sold in 2008 for over £25,000 at Bonhams, London. His 52-inch (132-cm) tall "History of England" vase was one of the major pieces made for the *Chicago World's Fair* after which he "rose to be recognized as the most notable artist of the early Doulton period and the most comprehensively represented artist."

In contrast to his religious panels and enormous sculptures, it is Tinworth's most endearing and smallest works that are eagerly sought after by collectors, particularly the mice and frog groups. His witty "humoresques", as he called them, show animals in human situations. They can be identified by his "GT" monogram.

Good

Tinworth's cheeky "Mouse on a Bun" figure is appealing but not uncommon. Collectors prefer more interaction between the animals. c1890, 3in (7.5cm) high, **K**

Better

"The Combat" figure group shows two frogs fighting with a mouse. The combination of two of the favourite animals makes this more desirable. c1885, 4in (10cm) high, **J**

Best

This is a rare "The Scrimmage" stoneware frog group, and has six figures of frogs fighting for a football. It has great character and movement. 1880, 4¾in (12.5cm) high, **I**

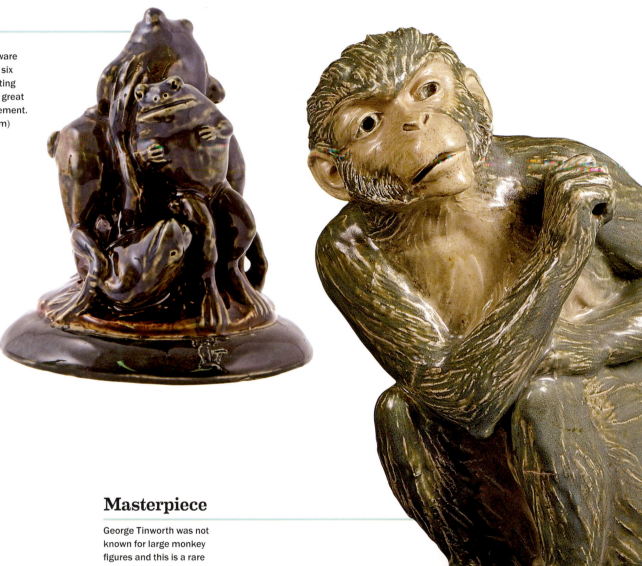

Masterpiece

George Tinworth was not known for large monkey figures and this is a rare piece. What collectors love is the personality of the figure and this monkey peers up with an inquisitive air. c1885, 20½in (52cm) high, **G**

William De Morgan

William De Morgan was one of the most prolific and creative ceramic artists of the Arts and Crafts Movement. He was born in 1839 into a family of French Huguenot descent. In 1859 he became a student at the Royal Academy Schools and two years later began to experiment with stained glass. He joined the influential circle of artist-craftsmen led by William Morris and Edward Burne-Jones (1833–98) in the early 1860s.

De Morgan designed tiles, stained glass, and furniture for Morris & Co. from 1863 to 1872. He decorated the tiles and pottery with animal, plant, and grotesque designs. His early work with stained glass is reflected in the use of delicate golds, ruby reds, and the vivid purple, green, and turquoise blue found on 15th- and 16th-century Iznik and Persian ceramics.

By 1872 De Morgan had established his own pottery and showroom in Chelsea. Around 1873–4 he made a striking rediscovery of the secrets of lustre ware found in Hispano-Moresque pottery and Italian maiolica. His interest in the East was not limited to glazing techniques – it pervaded his notions of design and colour. As early as 1875, he began to work in earnest with a "Persian" palette: dark

A Chelsea period tile, painted with an indigo coloured Griffin. 1870s, 6in (15cm), **J**

blue, turquoise, manganese purple, green, Indian red, and lemon yellow. Study of the motifs of 15th- and 16th-century Isnik ware profoundly influenced his unmistakeable style, in which fantastic creatures with geometric motifs glide under luminous glazes. Most of his designs were carried out by decorators such as Charles and Fred Passenger, Joe Juster, and Frank Iles.

In the late 1870s Frederic Leighton commissioned De Morgan to install the Turkish, Persian, and Syrian tiles, from the 15th to the beginning of the 16th centuries, which he had collected on his travels, into the Arab Hall of his house. Able to make up deficiencies in many of the panels, De Morgan completely lined the entrance hall and staircase with tiles of an intense Turkish turquoise. From 1882 to 1887 De Morgan worked at William Morris's workshops at Merton Abbey, southwest London. He moved again to Sands End, Fulham, in 1888. During the Fulham period he mastered many complex lustres and underglaze painting. In 1907 a disillusioned De Morgan left the pottery: "All my life I have been trying to make beautiful things and now that I can make them nobody wants them."

Above

This "Parrot" tile, from the Sands End Pottery period, shows the influence of De Morgan's work with Persian tiles. c1890, 8in (20cm) wide, **K**

Right

De Morgan was inspired by the shapes of Near East pots. This "Livadia" ruby and copper lustre vase and cover was decorated by Fred Passenger. 15in (38cm) high, **H**

A Closer Look

William De Morgan proved to be an expert in harmonizing flat patterns to luxuriant effect, with individual motifs – fish, mythical animals, and peacocks – well suited to the shapes of the vessels on which they are painted. This vase is marked "D M, FULHAM, JJ", showing that it is from the final period of De Morgan's ceramic work from 1888 to 1907. 11½in (29cm) high, **F**

The rich deep, ruby red lustre and gold swirls provide a luxuriant background.

Below

The rich ruby lustre vase painted with animated dragons is typical of De Morgan's designs in the 1870s. 10in (25cm) high, **I**

Above

This vase is an excellent example of the "Persian" palette. c1878, 12in (30cm) high, **K**

The fish seem to actually "swim" around their three-dimensional ruby "sea".

This vase was painted with great energy by Joe Juster.

Ruskin

Established by William Howson Taylor (1876–1935) in 1898 at West Smethwick near Birmingham, the Ruskin Pottery paid homage to the Arts and Crafts champion John Ruskin (1819–1900). It was not an immediate success – it took over £10,000 (a huge amount at the time) and three years of experimentation before the first pieces were available for sale. As the quality was so high, they became very popular, despite prices of as much as £50 for the best pieces.

Taylor's father, Edward Richard Taylor (1838–1911), was the principal of Birmingham School of Art and a friend of both William Morris and Edward Burne-Jones. He furnished a number of designs for the pottery, while his son experimented with a new clay body for vases that were often rendered in Chinese-inspired shapes. Howson Taylor also pursued the study of innovative glazing techniques, which included lustre, crystalline, and high-fired glazes in vibrant colours, and the mastering of complex "soufflé" and "flambé" glazes.

The earliest of the glazes, soufflé, was derived from a form of 17th- and 18th-century Chinese ceramic, in which cobalt powder was blown onto wet glaze, producing a mottled effect. The shiny, "jewel-like" lustre glaze was produced from 1905 to 1925, in lemon, orange, lilac, green, and "Kingfisher blue" – the most desirable colourway.

Crystalline and matt wares, which could be created in just two firings, were produced from 1922, in an attempt to counter the cheap machine-made wares appearing on the market. Crystalline pieces were heavy and often decorated with contrasting bands of colour, which were allowed to bleed into each other. The most desirable Ruskin pieces are those decorated with Howson Taylor's complex, high-fired glazes. From 1903, techniques such as mottled "Snake Skin" were applied to a fine porcelain and stoneware mix body. Although Howson Taylor's achievements as an art potter were internationally acclaimed, the Ruskin Pottery was forced to close in 1935.

Above

An early Ruskin Pottery vase. 1905, 8in (20cm) high, **K**

Above

A Ruskin Pottery high-fired vase. 1907, 12in (30cm) high, **K**

Above

Ruskin Pottery high-fired stoneware vase, covered in a running and speckled *sang de boeuf* lavender and mint glaze. 1910, 10½in (26cm) high, **J**

Above

A Ruskin Pottery high-fired vase, decorated in a "concrete" style glaze. 1927, 10in (25cm) high, **K**

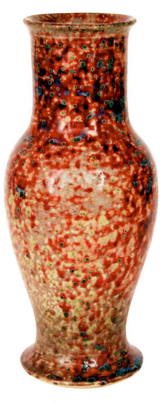

Above

A Ruskin Pottery high-fired stoneware vase glazed in "air-brushed" *sang de boeuf* over silver grey. 1920, 12in (30cm) high, **J**

Above

A Ruskin Pottery vase, the cream base glaze graduating to *sang de boeuf* and rich magenta. 1920s, 15½in (39cm) high, **J**

Above

A Ruskin Pottery vase. 1926, 13in (33cm) high, **J**

Christopher Dresser

Christopher Dresser (1834–1904) was born in Glasgow. He was a contemporary of William Morris and had an equal influence on the decorative arts. A precocious talent, at 13 he was enrolled in the Government Design School at Somerset House, London. Dresser's studies there included botany and he continued to specialize in this field. When his application for the Chair of Botany at the University of London was rejected, Dresser decided to concentrate on design and set up his studio in 1860. From this early date his design work, as well as ceramics, encompassed carpets, metalwork, including silver and electroplate, furniture, glass, graphics, wallpaper, and textiles

A visit to Japan in 1876–7, as a representative of the South Kensington Museum (later the Victoria and Albert Museum), was a decisive influence on the ceramic designs created by the multitalented Dresser. It strengthened his preference of form over ornament and confirmed his view that "fitness for purpose" was the basis of good design.

He was employed by a number of companies looking to capitalize on the fashionable taste for art pottery, beginning with the Minton factory in Stoke-on-Trent in the 1870s. By 1879 Dresser and entrepreneur John Harrison founded Linthorpe Pottery near Middlesbrough. His inventive forms for Linthorpe wares – including gourd-shaped vases with multiple handles and "camel backed" jugs – looked to Japanese ceramics and Pre-Columbian wares for inspiration. A favoured decorative technique saw vessels covered with poured or dripped glazes in a rich, lustrous dark brown highlighted with tones of green, blue-green, or yellow and coupled with stylized ornamental motifs. Between 1879 and 1882 he designed over a thousand pots.

By 1892 Dresser had moved on to the Ault Pottery in Derbyshire, where he produced highly original designs for earthenware jugs, vases, and jardinières that were frequently enhanced with a shimmering aventurine glaze. He died in 1904, having made his "pre-modernist" vision available to the masses.

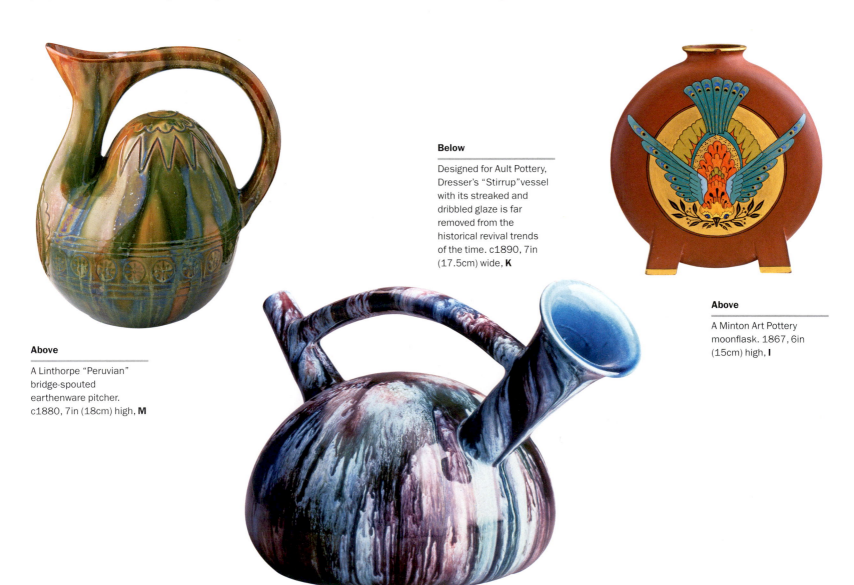

Below

Designed for Ault Pottery, Dresser's "Stirrup" vessel with its streaked and dribbled glaze is far removed from the historical revival trends of the time. c1890, 7in (17.5cm) wide, **K**

Above

A Linthorpe "Peruvian" bridge-spouted earthenware pitcher. c1880, 7in (18cm) high, **M**

Above

A Minton Art Pottery moonflask. 1867, 6in (15cm) high, **I**

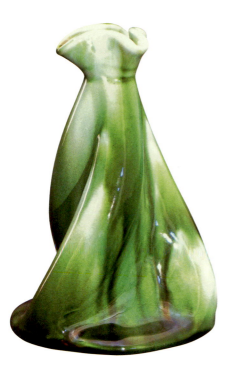

Below

A Minton bone china pseudo-cloisonné vase, with bleu-celeste ground. c1870, 10¼in (25.5cm) high, **J**

Above

This iconic Ault Pottery "Propellor" vase is covered in running green glazes. The form is fluid and dynamic.c1880, 5½in (14cm) high, **M**

A Closer Look

When Dresser's Linthorpe pottery venture failed in 1889, Ault Pottery bought many of the moulds and later persuaded him to contribute a number of new designs. Dresser believed passionately in economy of style. One of his maxims was "maximum effect with minimum means". These Linthorpe bottle vases are 10¼in (25.5cm) high, **K**

By the late 1870s Dresser's stature was so great that many manufacturers used his signature as a marketing ploy.

The form of these vases is inspired by Dresser's study of Islamic pots.

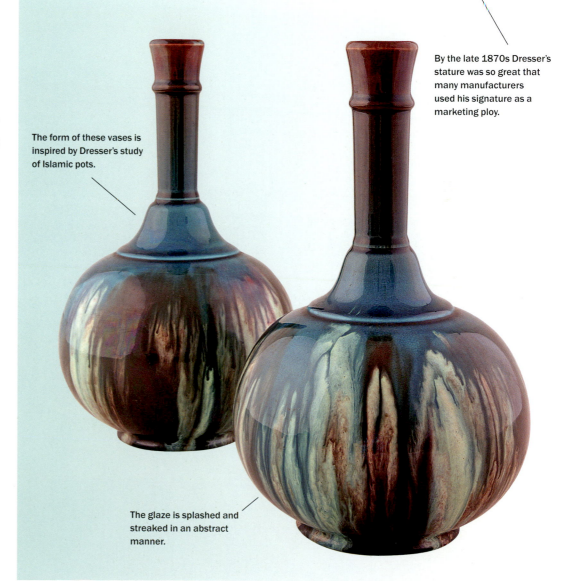

The glaze is splashed and streaked in an abstract manner.

Sunflower Pottery

A talented self-taught art potter, Sir Edmund Harry Elton (1846–1920) founded the Sunflower Pottery at his Clevedon Court estate in Somerset in 1879. He embraced the Arts and Crafts Movement enthusiastically and his bold hand-made Elton Ware, launched in 1882, reflects a broad range of influences, including Renaissance Italy, ancient Greece, China, and Japan. His pots successfully marry past cultures with imaginative ceramic shapes and innovative glazing techniques. Elton taught himself all aspects of the potter's art – building his own kiln, throwing the pots, and developing new glazes.

Elton is celebrated for his vases decorated in relief with flowering branches, as well as for his experiments with imaginative pottery forms, which frequently boasted multiple handles or spouts fashioned in bizarre shapes. He also developed a number of highly successful glazing techniques. Vases, cups, and jugs were often covered with platinum, silver, copper, or streaky gold glazes,

or glazed in several colours that were swirled to create a marbling effect and sometimes embellished with heavily enamelled and incised decoration. His foreman from the beginning was George Masters, who interpreted many of Elton's designs and glazes.

Elton began to experiment with lustre glazes around 1902, and early examples used it as an additional background glaze. After this the Sunflower Factory introduced a range of metallic lustre glazes over a heavily crackled surface. Elton Ware was exhibited at the Arts and Crafts Exhibition Society in London, and was celebrated throughout Europe and the United States.

Although officially called the Sunflower Pottery, the pots are more generally referred to as Elton Ware. The ceramic artist William Fishley Holland joined the company after the death of Sir Edmund Elton in 1920, and started his own pottery near Clevedon Court on the closing of the Sunflower Pottery in 1922.

Below

A Sunflower Pottery ewer. c1910, 10in (25cm) high, **M**

Below

A Sunflower Pottery white-slipped clay vase. c1890, 10in (25cm) high, **M**

Below

This rare Sunflower Pottery vase is an important crossover point from Elton's early slip-decorated wares to designs with lustrous metallic glazes. c1902, 9in (23cm) high, **J**

Below

A large Sunflower Pottery vase. c1900, 12½in (31cm) high, **L**

Della Robbia Pottery

The Della Robbia Pottery was started by Harold Rathbone (1858–1929) and Conrad Dressler (1856–1940) in 1894 in Birkenhead. Rathbone had been a pupil of the painter Ford Madox Brown (1821–93). Dressler was a sculptor, potter, and also the inventor of the continuous firing tunnel kiln. The pottery was established as a true Arts and Crafts concern, using local labour and raw materials. It was known for its lustrous lead glazes and patterns of interweaving plants, heraldic, and Islamic motifs. Dressler was mainly responsible for the colourful architectural panels inspired by the work of the 15th-century Florentine sculptor Luca della Robbia. When these did not prove to be popular, the pottery turned to large vases, presentation wares, and plates, as well as ceramic clock cases and tiled window boxes. Giovanni Manzoni (1855–1910) was the chief artistic director. The high cost of production made the business unviable and it closed in 1906.

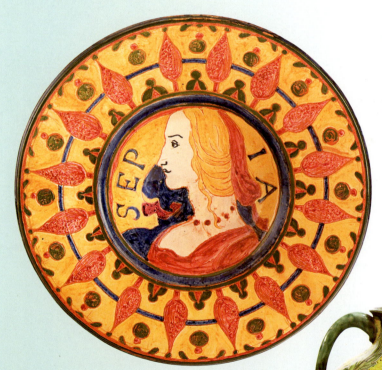

Left

A dished charger, "Sepia", designed by Harold Rathbone. The head and shoulders profile has a distinctive Italian look. 1895, 14in (35cm) diam, **K**

Below

A slip-decorated jug by Sir Edmund Elton. c1900, 6in (15cm) high, **M**

Above

A tall Sunflower Pottery vase in an unusual shape for Elton Ware. c1900, 15¼in (38.5cm) high, **L**

Right

A sgraffito-decorated faience vase, designed and decorated by Charles Collis and Lizzie Wilkins. The tonal quality is pure Arts and Crafts. c1900, 11½in (29cm) high, **J**

Other British Ceramics

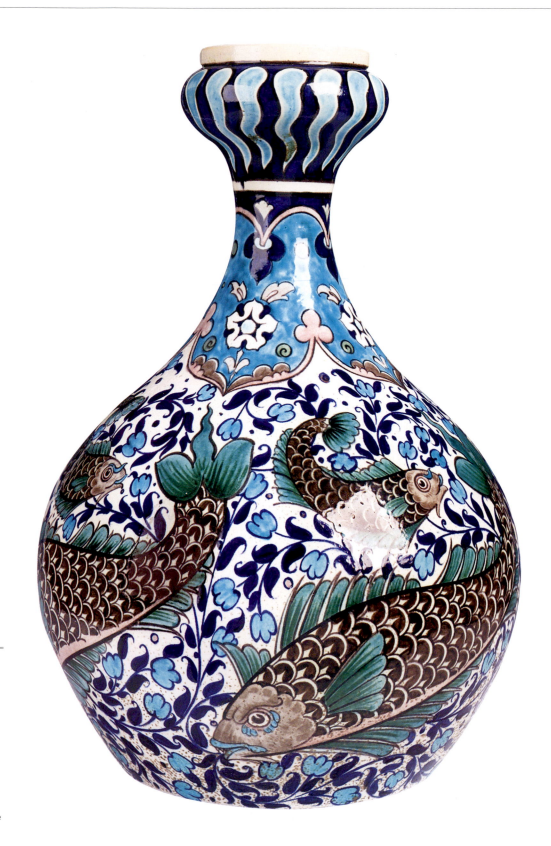

Burmantofts

A faience vase, painted in the "Anglo-Persian" style. Some of these wares bear the initials of an unknown decorator "L.K." These wares made their first documented appearance at the *Saltaire Exhibition* in 1887 and were inspired by the "Persian" wares of William De Morgan. Large pieces such as this vase were expensive to produce and are rare. 1880s, 21¼in (54.5cm) high, **H**

A Maw & Co. four-tile panel, designed by C.F.A. Voysey (1857–1941). The connection to Voysey adds to its desirability. c1895, 11½in (29cm) wide, **K**

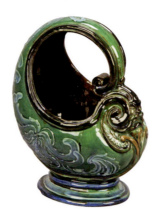

A pottery vase, by Beauchamp Wimple for Brannam with a grotesque mask. 1899, 8in (20cm) high, **M**

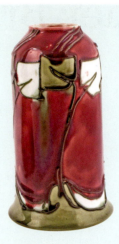

A tube-lined Seccessionist vase designed for Minton by Léon Solon (1872–1957) and John Wadsworth (1879-1955). c1900, 6in (15cm) high, **M**

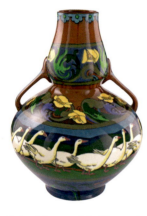

A Foley "Intarsio" vase of double gourd shape. This decorative range of earthenware was designed by Frederick Alfred Rhead (1856–1933), 11¾in (29.5cm) high, **M**

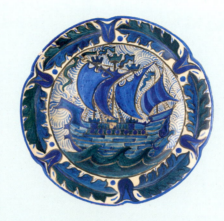

An earthenware plate designed by J. Selwyn Dunn for Johnson Brothers. c1920s, 12in (30cm) diam, **M**

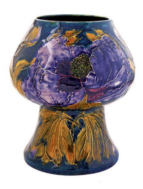

A Hancock and Sons "Morrisware" vase by George Cartlidge painted with purple poppies on a blue ground. 1920s, 7in (17.5cm) high, **K**

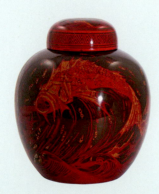

A ruby flambé ginger jar and cover for Bernard Moore decorated by Dora M. Billington, who said that Moore (1850–1935) taught her the "rapid use of the brush". c1910, 8in (20cm) high, **J**

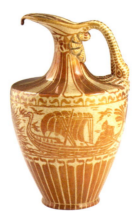

A ship ewer designed by Walter Crane (1845–1915) for Maw & Co. c1890, 12½in (31cm) high, **I**

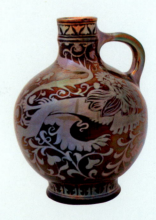

A "Lancastrian" lustre vase by Richard Joyce (1873–1931) for Pilkington's, which held the Royal warrant for its lustreware in 1913. 1909, 10in (25cm) high, **J**

American Ceramics

The philosophical tenet of Arts and Crafts ceramics is often best exemplified by an unsociable practitioner, unconstrained by the commerciality of a large company. In America, George Edgar Ohr (1857–1918) carried out each stage of production at his pottery in Biloxi, Mississippi, from digging his own clay to moulding, firing, and then decorating the finished product. He was the forerunner of the true studio potter. Most Arts and Crafts ceramics studios permitted craftsmen to develop their skills to a very high level within a specific role. Rookwood built an extremely successful business on this model, employing designers, potters, and artists to work in turn on each of its products.

As much as production methods and company structures differed, certain themes feature throughout the Arts and Crafts potteries. Sculpted and applied floral forms proliferated throughout the period, especially in America where Roseville, Chelsea Keramic, and Hampshire produced designs featuring plant forms in relief. Grueby is especially noted for the tooled and applied leaves that adorn many of its vessels. Rookwood developed this theme further, embossing vases and bowls with motifs as diverse as peacock feathers and seahorses. Classicism pervaded the decorative arts at the time, and ceramicists re-interpreted time-honoured shapes in accordance with the prevailing ideals of individual craftsmanship. Ohr's pinched and twisted versions of archaic forms are a fine example of this attitude. The American ceramicist Ernest A. Batchelder's (1875–1957) motto, "no two tiles are the same", embraced a sentiment with which even the largest factories were keen to associate.

Bright colours – including flambé glazes as employed by Fulper and Weller – provide a stark contrast to the more subdued greens of Grueby and Teco. Numerous matte finish glazes were developed during this period, many of them particularly suited to either the forms they were applied to – the matte green on Teco's vegetal wares – or the subject matter of the decoration – the vellum glazes on Rookwood's misty landscapes. These glazes sat rather well with the soft grain and texture of much Arts and Crafts oak furniture. The irredeemably contrary Ohr eventually rejected the entire concept of glazing, or "adulterating", his work: "God put no colour in souls, and I'll put no colour on my pots."

Japanese art was becoming increasingly popular in America following the end of the Edo period of Japanese isolation. Maria Longworth Nichols (1849–1932), the founder of Rookwood pottery, had been impressed by an exhibition of Japanese ceramics in Philadelphia in 1876 and this influence is clear in the wares produced by her company.

A number of American potters appropriated Native American themes and styles. Rookwood produced wares with naturalistic portraits of Native American subjects and Clifton developed a range of "Indian" ware with geometric patterning based on motifs used by indigenous tribes. But the most widespread decorative inspiration was the native flora and fauna of the North American landscape. American ceramicists wholeheartedly adopted the pastoral essence of the British Arts and Crafts Movement, resulting in a joyous celebration of the abundance and variety of the "New World".

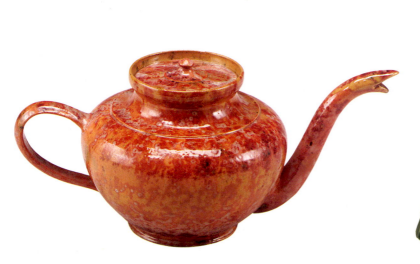

Above

A George Ohr teapot with an exaggerated snake-like spout. 1890s, 12½in (31cm) wide, **E**

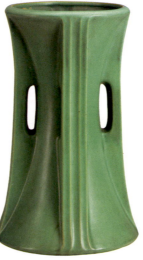

Above

A Teco matte green tall buttressed vase. The strong lines and simple matte finish predate Modernism. c1905, 18in (46cm) high, **F**

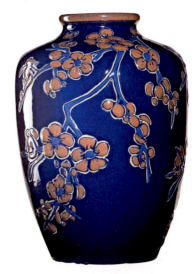

Above

A North Dakota School of Mines vase, "Apple blossoms", by Flora Huckfield. c1936, 9in (23cm) high, **G**

Opposite

This 1930s photograph offers a view into the huge kiln at Rookwood Pottery at Mount Adams, Ohio, where a worker is shown preparing some pieces for the firing process.

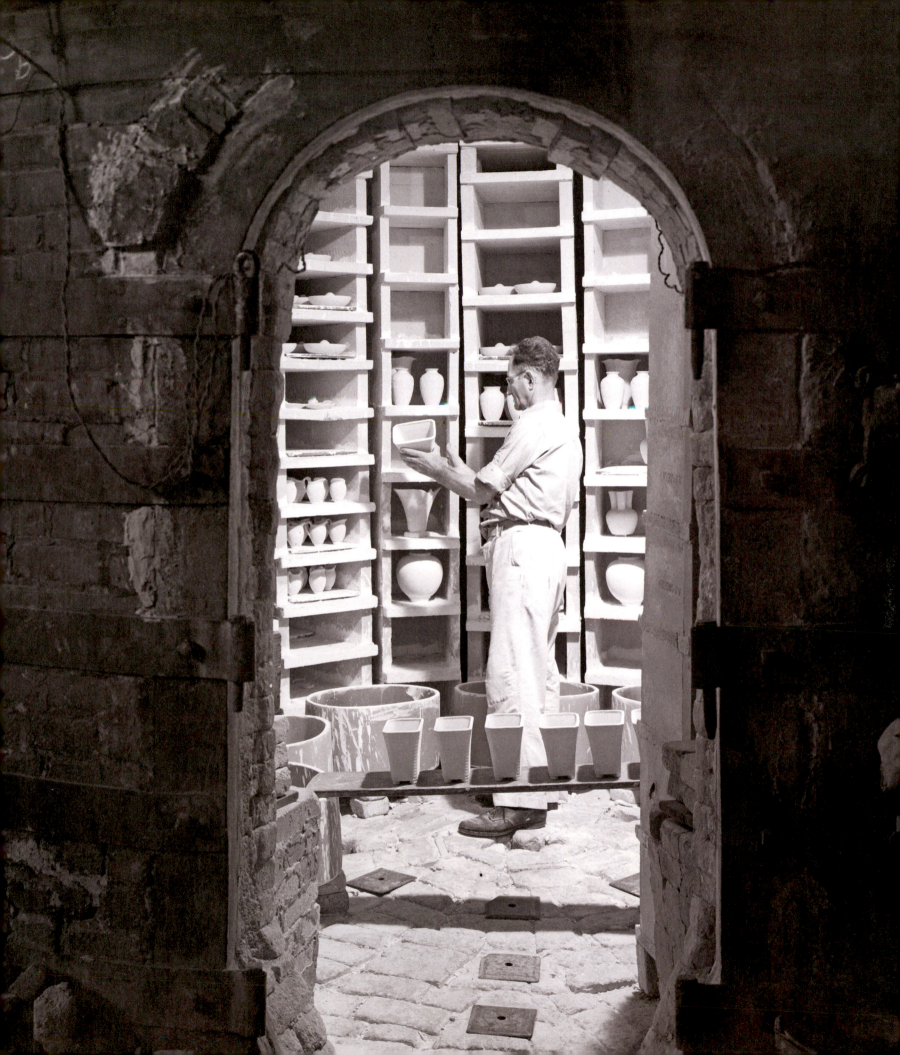

Rookwood

Started as the hobby of a wealthy young lady, Maria Longworth Nichols, in Cincinnati, Ohio, in 1880, Rookwood was to become the largest and most influential pottery in the United States. It was named after the country estate of her father, the wealthy art patron Joseph Longworth (1813–83), who provided the capital for launching the venture. The Rookwood Pottery was established with the specific aim of producing hand-wrought and hand-decorated art wares. Rookwood's high-quality ceramics embraced the Arts and Crafts style and enjoyed both critical and commercial success.

From the beginning, the factory employed an exceptional team of talented artists and skilled technicians – including the chemist Karl Langenbeck (1861–1938) and Mary Louise McLaughlin (1847–1939), who founded the Cincinnati Women's Pottery Club in 1879 – and prescribed extremely high standards of production. In the early years of the factory, Rookwood fostered a "spirit of cooperation and good fellowship" among its workmen, according to the socialist writer Oscar Lovell Triggs (1865–1930) in 1902, who called the enterprise "an ideal workshop".

Rookwood earthenware designs embraced a variety of influences, not least the style and quality of Japanese ceramics. A visit to the *Philadelphia Centennial Exposition* in 1876 so impressed Mrs Nichols that in the following year she invited the Japanese ceramicist Kataro Shirayamadani (1865–1947) to join the firm. He became one of the company's most important designers, remaining until his death in 1948. Early wares were heavily potted, slip-cast, or thrown – often in Japanese-inspired forms – and painted with naturalistic decoration of asymmetrical Oriental flower sprays and dragon motifs.

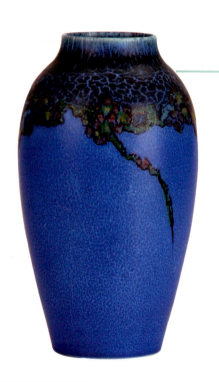

Good

This is a rather late example of matte glazes on a vase decorated by Vera Tischler. The single floral band and generally plain body are not particularly popular. 1922, 9in (23cm) high, **L**

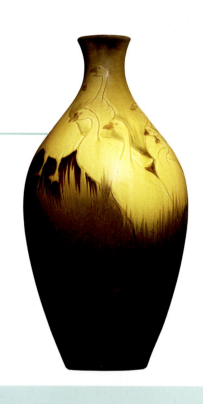

Better

Although decorated by Kataro Shirayamadani, this "Standard" glaze vase lacks the vivacity that typifies his work. The geese motif adds to the appeal but the colouration is less popular. 1898, 11in (28cm) high, **I**

Rookwood Mark

The flame mark with Rookwood monogram was used from 1887, with an extra flame used each year. By 1900 there were 14 flames. In 1901 the Roman numeral "I" was added below and changed accordingly with each year. This mark has "XIV" impressed below for 1914.

Glazes

STANDARD
The "Standard" glaze was developed in 1884. A translucent, high gloss with a yellow tinge, it gives a heavier aspect to the decoration.

SEA GREEN
"Sea Green", developed in 1894, confers a blue-green colour on the underglaze decoration and was suited to marine subjects and seascapes.

IRIS
Also developed in 1894, "Iris" is a clear, lead-based glaze with a high sheen, allowing for light shades and cooler colours. "Black Iris" was also produced.

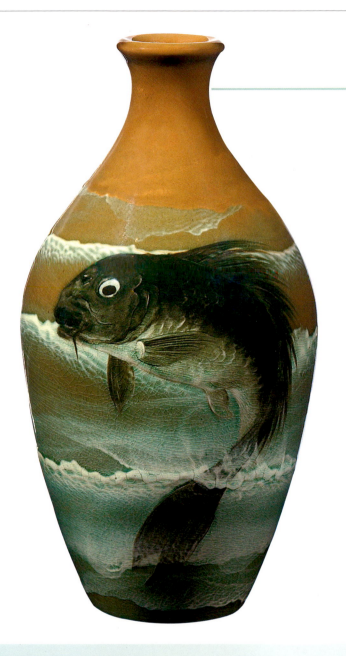

Best

This is an exceptional "Sea Green" vase painted by E. Timothy Hurley. The condition is perfect: crazing, which was a problem with this glaze, would decrease the value. 1901, 8¼in (21cm) high, **H**

Masterpiece

This tall vase decorated by Kataro Shirayamadani is covered with the highly desirable "Black Iris" glaze. This crystal clear, translucent gloss glaze covers the decoration of flora on background colours that shade from dark to light. 1901, 17½in (44cm) high, **F**

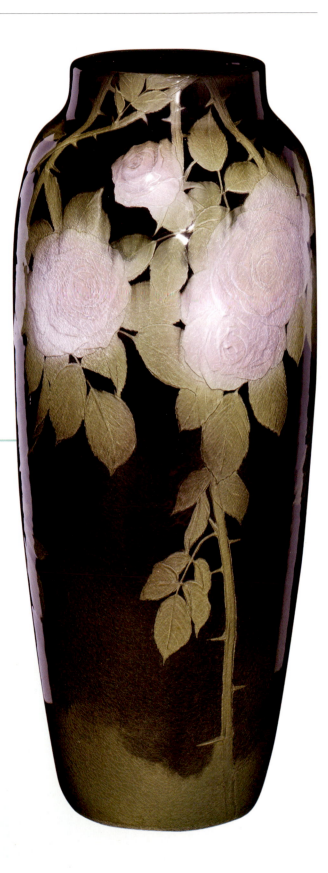

MATTE
Having experimented with a "matte" glaze in 1886, the factory perfected it around 1900. It was flat and opaque with a relatively coarse texture.

VELLUM
"Vellum" was developed around 1903. It creates a hazing effect on the underglaze decoration, as if it were being viewed through a film.

JEWEL
"Jewel" was first used in 1916. A clear, gloss glaze, it has tiny air bubbles that produce a hazy effect similar to "Vellum" but without the waxiness.

Rookwood (continued)

Rookwood, inspired by the burgeoning interest in the Arts and Crafts Movement, produced hand-carved wares decorated with plants, flowers, and sea creatures. Quick to recognize the commercial potential afforded by the use of sophisticated glazing techniques, the company employed many talented designers who experimented with richly coloured, high-quality glazes – among them the celebrated decorator Artus Van Briggle (1869–1904), whose tenure at Rookwood spanned some 13 years before he left to set up his own pottery studio in Colorado Springs.

The first great accomplishment was the "Standard" glaze, developed in 1884. A technique conceived by Rookwood artist Laura Fry (1857–1943), the "Standard" glaze saw colour applied with an atomizer to give the ground a graduated shaded effect that moved from one tone to another. A translucent high gloss with a yellow tinge, the glaze gives the underlying artwork depth and makes the subject look darker and heavier. Among the most renowned wares are the vessels and plaques with underglaze portraits. Particularly impressive are those painted by Grace Young (1868–1947) and Matthew A. Daly (1860–1937) of African Americans and Native Americans.

Kataro Shirayamadani was born in Kanazawa, Japan. He is considered by many to be Rookwood's greatest artist. Previously, he worked at Fujiyama, an important retail and decorating shop in Boston. He was hired by Rookwood in 1887, with the specific goal of bringing a Japanese influence to the pottery. He continued to work at Rookwood until his death. Shirayamadani also designed many of the company's moulds. He typically decorated the entire surface of a vase, rather than just the front.

The year 1889 was a turning point for the company. It was awarded a Gold Medal at the *Paris Exposition Universelle*, giving it global recognition and leading to it becoming financially profitable.

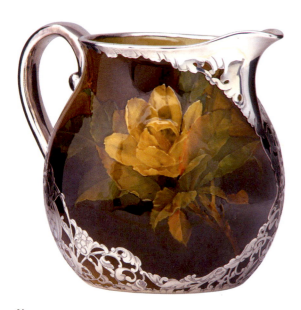

Above

A Rookwood "Standard" glaze pitcher, painted by Kataro Shirayamadani. 1890, 8¼in (21cm) high, **J**

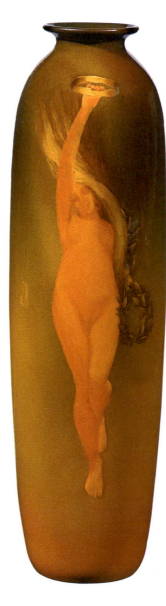

Left

An unusual Rookwood "Standard" glaze vase, painted by William P. McDonald. 1894, 14½in (37cm) high, **I**

Above

A tall silver-overlaid Rookwood "Standard" glaze two-handled vase, painted by Kataro Shiriyamadani. 1898, 12in (30cm) high, **I**

A Rookwood "Standard" glaze "Indian" portrait pillow vase, by Matthew A. Daly, "Chief Hollow Horn Bear, Sioux". c1900, 16in (40cm) high, **D**

A Rookwood "Standard" glaze vase, painted by Grace Young with a portrait of artist Anthony van Dyck (1599–1641). 1902, 10in (25cm) high, **K**

A Closer Look

An exceptional and important Rookwood "Standard" glaze plaque painted by Grace Young, "Chief High Hawk", depicting a Native American chief in headdress, with breast plate and tomahawk. 1903, 14¾in (37.5cm) high, **D**

This plaque was made for the *Louisiana Purchase Exposition* in St Louis, Missouri, in 1904. Exquisite in detail, it lends great dignity to the subject.

These plaques reflect a growing appreciation of, and respect for, the indigenous cultures of the United States. The plaque is in its original frame.

This remains one of Rookwood's most important "Standard" glaze plaques by one of the best artists.

Rookwood (continued)

Rookwood's first chemist, Karl Langenbeck, joined in 1885, followed by Stanley G. Burt in 1892. Several versions of the "Standard" glaze were developed in 1884 with pale cool colours including "Iris" – a muted grey shade – and "Black Iris". They retained the richness of "Standard" glaze but without the deep yellow tinge, which allowed lighter shades and cooler colours to be used by the artists. "Iris" glaze is an incredibly crystal clear, translucent gloss glaze covering an object with a slip-painted decoration of flora (or to a lesser degree fauna) on background colours that shade imperceptively from dark to light with a high sheen. The main production dates are 1893 to around 1912.

The pots are often marked with an incised "W", for white glaze. (At Rookwood the "Iris" glaze was known as white glaze because it is white in its unfired state.) "Iris" glaze was one of the finest glaze lines ever produced at the Cincinnati pottery. The name derived from the iris plant, known for its luminosity and opalescence. The glaze is unsurpassed for the clarity, richness of colour, and depth that it imparts to the objects it covers. It is highly refractive and makes the surface very shiny. It has a tendency to craze, which detracts from value. In order to attain the shiny surface the glaze had an extremely high lead content that by 1912 was recognized as a health hazard. The "Black Iris" variation is highly collectable.

Another high-gloss glaze developed at this time was "Sea Green". Rookwood described it as "opalescent sea green relieved by a few flowing warm touches to a cooler green with bluish touches". "Sea Green" gives the underglaze decoration a blue-green colour and an impression of depth. It was particularly suited to seascapes and fish (as shown opposite) but was also used for flowers.

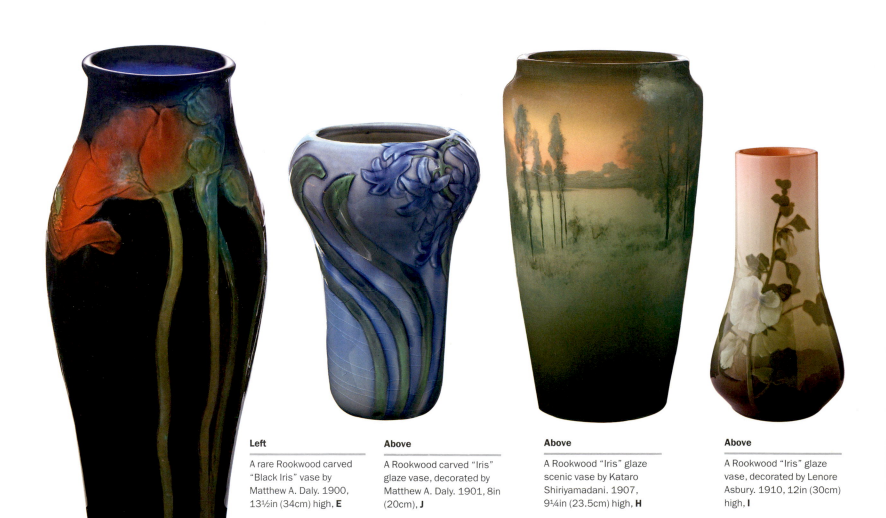

Left

A rare Rookwood carved "Black Iris" vase by Matthew A. Daly. 1900, 13½in (34cm) high, **E**

Above

A Rookwood carved "Iris" glaze vase, decorated by Matthew A. Daly. 1901, 8in (20cm), **J**

Above

A Rookwood "Iris" glaze scenic vase by Kataro Shiriyamadani. 1907, 9¼in (23.5cm) high, **H**

Above

A Rookwood "Iris" glaze vase, decorated by Lenore Asbury. 1910, 12in (30cm) high, **I**

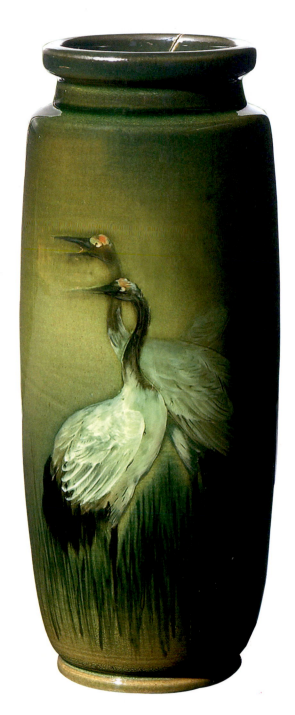

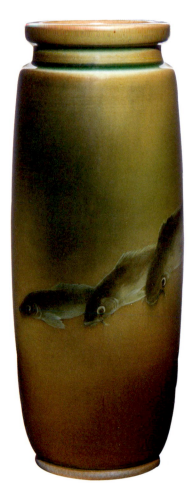

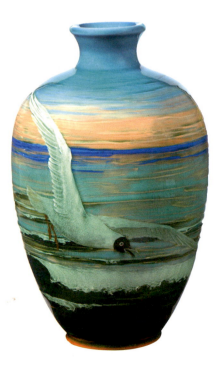

Above

A Rookwood "Sea Green" vase by Matthew A. Daly. 1894, 7¼in (18.5cm) high, **J**

Above

A Rookwood "Sea Green" vase by Matthew A. Daly. 1894, 8½in (22cm) high, **J**

Above

A rare and important Rookwood "Sea Green" vase, painted by William P. McDonald. 1899, 11¾in (29.5cm) high, **E**

Rookwood (continued)

The company continued to experiment and branch out in new directions, introducing the decorative technique of silver appliqué in 1892, and adding to its considerable output of useful wares, ceramic portraits, figures, animals, birds, and tiles. In 1904 Rookwood patented a matte glaze called "Vellum", which featured stylized flowers – wisteria, orchid, and crocus – as well as landscape, forest, and sailing boat scenes. "Vellum" is considered the link between Rookwood's gloss and matte glazes. It gives a slightly hazy or frosted appearance to the decoration. "Vellum" was usually clear although it was also available in yellow and blue tints.

Rookwood's chemists were constantly experimenting with different aspects of the "Standard" glaze, including the top-secret aventurine "Tiger Eye" glaze.

Rookwood was aware of the tremendous commercial success of Grueby's matte glaze and had been experimenting as early as 1886. At the *Buffalo*

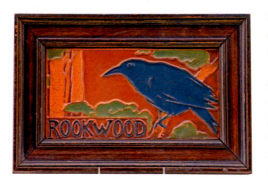

A rare advertising tile, decorated in the cuenca technique and not meant for commercial sale. Early 20thC, 9in (23cm) wide, **G**

Exposition of 1901 a wide range of coloured "Matte" glazes was shown. Many of the decorators used the matte glaze as an inlay on their pots.

Roodwood's Production wares were developed to compete with the large number of potteries in the mass-production and cheaper end of the market. The glazes were rich and heavy and were designed to flow over the simple shapes of these lines. They did not rely on specialist artists and decorators, and they appeared without the customary artists' monograms.

Clay marks were used on Rookwood. They include "G" indicating a ginger body, "O" for olive, "R" for red, "S" for sage green, "W" for white, "Y" for yellow, and "P" for soft porcelain.

Rookwood suffered heavily during the Depression and filed for bankruptcy in 1941. It survived the Second World War but the output was significantly inferior to the glorious Arts and Crafts wares produced in its heyday from the 1890s to the 1920s.

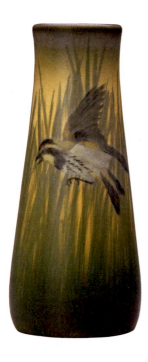

Above

A Rookwood "Vellum" tapered vase painted by E.T. Hurley. 1907, 9in (23cm) high, **J**

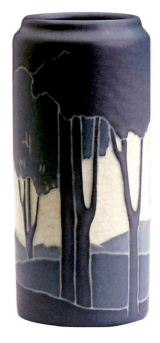

Above

A Rookwood carved "Vellum" vase decorated by Sarah Sax. 1908, 7½in (19cm) high, **H**

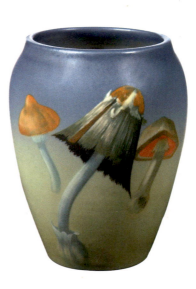

Above

A Rookwood "Vellum" vase painted by Carl Schmidt (1909–93). 1906, 7in (18cm) high, **I**

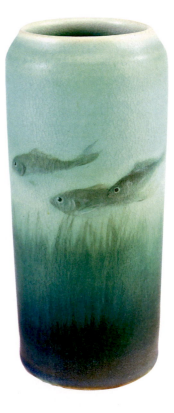

Above

A Rookwood "Green Vellum" vase painted by E.T. Hurley. 1905, 7in (18cm) high, **J**

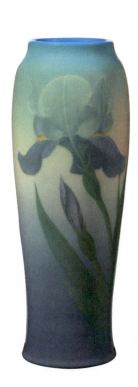

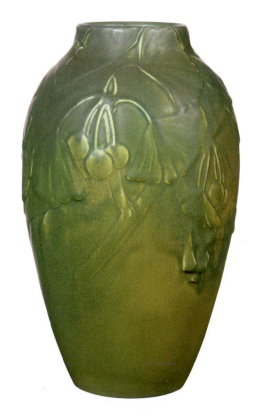

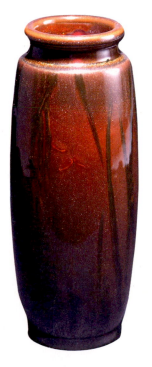

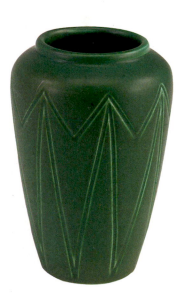

Above

A Rookwood "Jewel" porcelain vase painted by Carl Schmidt. 1925, 11¾in (29.5cm) high, **H**

Above

A Rookwood carved "Matte" vase by Kataro Shiriyamadani. 1905, 10½in (26cm) high, **I**

Above

A Rookwood "Tiger Eye" vase painted by Harriet Wilcox (1869–1943). 1894, 8¼in (21cm) high, **K**

Above

A Rookwood early Production vase. 1906, 7½in (19cm) high, **L**

Roseville

First established at Roseville in Ohio in 1890 – and later at the nearby town of Zanesville – the Roseville Pottery Company produced basic, utilitarian stoneware under the directorship of George F. Young. Roseville was widely considered to be the finest of the "second-tier" companies working in the Arts and Crafts style.

While Roseville's mass-produced pottery enjoyed great success, it was a growing demand for decorated art pottery that prompted the company to introduce a number of lines of hand-painted art ware at the beginning of the 20th century. They were marketed as "Rozane" ware (the fusion of the Roseville and Zanesville names), characterized by painted, incised, or moulded decoration of flowers, fruit, and leaves and typically covered with luminous, richly coloured glazes. Roseville earned a solid reputation for its art wares, which were created from 1900 until 1920.

A significant portion of Roseville's art ceramics was comprised of authentic and cheaper copies of the ceramic ranges made famous by the rival Rookwood Pottery. Under the management of art director John Herold, the firm initially produced decent-quality, underglaze slip-painted stonewares that predictably copied the Rookwood designs – among them "Rozane Royal light", "Rozane Royal dark", "Standard Glaze", "Azurean-replicated Iris Glaze", and "Aerial Blue Glaze". Roseville was also in competition with the local Weller pottery. The renowned British potter Frederick Hurten Rhead (1880–1942), who held the post of art director from 1904 until 1908, designed the company's celebrated "Della Robbia" range, which proved the company's ability to produce well-designed, high-quality ceramic wares. With Frank Ferrell he introduced a series of imaginative ranges of art pottery such as "Fuji", "Crystallis", and "Woodland". Rhead was succeeded as art director

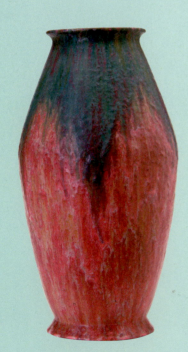

Above

A Roseville "Carnelian III" vase. c1920, 20in (50cm) high, **I**

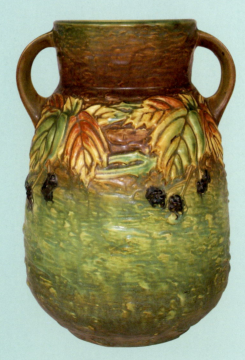

Above

This is the largest vase made in the Roseville "Blackberry" series. c1932, 12¼in (30.5cm) high, **L**

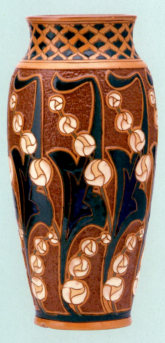

Above

A Roseville "Della Robbia" vase, signed "H.L." c1910, 13in (33cm) high, **H**

by his brother Harry G. Rhead (1881–1950), although the company's fortunes had begun to wane by 1910, when only the factories in Zanesville continued to operate. With the onset of the First World War, the market for art wares diminished and the company shifted to the more commercially viable moulded wares, and by 1920 mechanical processes were being employed to add decorative details. The Roseville Pottery ceased production in 1954.

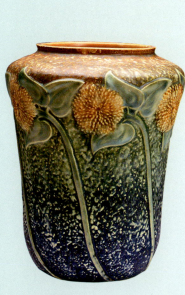

Above

A Roseville "Sunflower" vase. c1930, 10½in (26cm) high, **K**

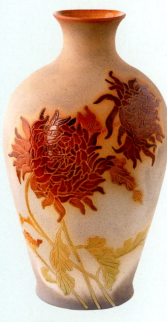

Above

A Roseville Rozane "Woodland" vase. c1905, 15in (38cm) high, **K**

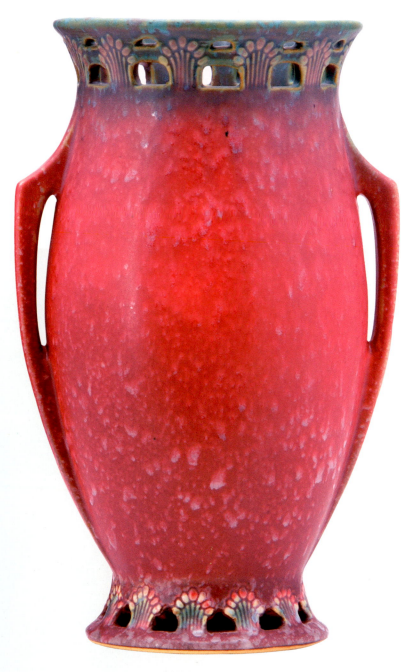

Above

A Roseville "Red Ferella" vase. Although this was a mass-produced line, it has a simple quality and decorative appeal. c1930, 13in (33cm) high, **L**

Weller

Samuel A. Weller established his pottery in Fultonham, Ohio, in 1872 producing sewer tiles and plain, utilitarian pots. Ten years later his pottery lines included painted jardinières, flowerpots and umbrella stands. In 1888 he built a pottery in Putnam, now part of Zanesville. He started an art pottery line in 1893. He had been inspired by a visit to the *Chicago World's Fair* where he saw William A. Long's (1844–1918) "Lonhuda" ware. He persuaded Long to come to Weller and started the pottery's own line. Following Long's departure from Weller after less than a year, Charles Babcock Upjohn (1829–1913) became the art director for Weller. Upjohn worked in that position from 1885 to 1904 and is credited with the introduction of the famous Weller "Dickens Ware" line.

The success of Rookwood inspired Weller. To replicate Rookwood's "Standard" glaze, Weller created "Louwelsa"; Rookwood's "Iris" glaze elicited "Eocean" from Weller. The quality of the overglaze was not on the same level as Rookwood's. In addition to lacking Rookwood's clarity and depth, it was also susceptible to heavy crazing and buckling. But it was the competition with his cross-town rival Roseville that was a strong motivating force. When Roseville hired Frederick Hurten Rhead to create "Della Robbia", Weller hired him to

develop "Jap Birdimal". He also attracted artists to work in the pottery including Albert Haubrich (1875–1931), Jacques Sicard and Henri Gellée. In 1901 Weller brought Sicard, who had studied under Clément Massier (1844–1917) in France, to Zanesville to produce a scintillating iridescent art pottery line. In order to compete, Roseville developed "Mara" ware. Artists at Weller Pottery decorated some of the early wares with excellent glazes. Sicard's lustrous metallic glazes were produced by him in tones ranging from rose and blue to crimson and purple. "Sicardo" was produced until 1907 when Sicard returned to France, although Weller continued to offer it until 1912. At the same time, Weller developed a large range of Production ware that was decorated almost entirely in-mould. It was a way of reconciling beauty and cost and satisfying the demand for good-quality inexpensive art pottery. Some Production ware was successful with ranges such as "Coppertone", "Selma", and "Woodcraft" matching Roseville's popularity.

By 1915 Weller Pottery claimed to be the largest art pottery in the world. After the First World War Production ware replaced the art pottery and quality diminished. The pottery closed in 1945.

Below

A rare "Coppertone" pitcher, with fish handle. c1920, 7½in (19cm) wide, **J**

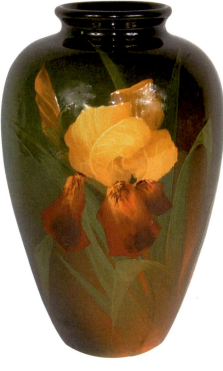

Above

A "Louwelsa" vase, with heavy slip decoration, signed "McLaughlin". c1915, 11in (28cm) high, **M**

Above

A "Knifewood" vase. c1921, 7in (18cm) high, **L**

An etched matte jardinière incised by Frank Ferrell (1871–1961). 1920s, 10½in (26cm) wide, **L**

Wheatley

Thomas J. Wheatley had been involved in various firms, including the Cincinnati Art Pottery and Weller, before opening the Wheatley Pottery Company in association with Isaac Kahn in 1903. The art pottery was typified by wares with a coloured matte glaze over relief work mainly in shades of green, ochre yellow, and blue. Some pieces show splashes of green on dark blue or black. Much of the production was imitations of the more popular Grueby pottery. The firm also produced garden pottery and architectural items. The last known exhibition of the art pottery was in 1907 but some production continued until Wheatley's death in 1917. After that the company was taken over by Kahn. The production of garden pottery and architectural faience was expanded. In 1927 the company was acquired by the Cambridge Tile Manufacturing Company of Covington.

Left

A Wheatley lamp base, in the "Kendrick" style, covered in a matte brown glaze. 1900s, 12½in (31cm) high, **K**

Above

A Sicard gourd-shaped vase. c1905, 8in (20cm) diam, **K**

Right

A Wheatley vase with leaves and buds, with curdled green glaze. This is a very obvious copy of Grueby but lacks the quality. 1900s, 9in (23cm) high, **J**

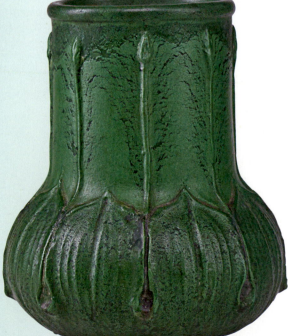

Grueby

William Henry Grueby (1867–1925) initially formed his company in 1894 to make tiles. He turned to the creation of art wares in 1897, influenced, to some extent, by the strong organic shapes found in the work of the French potter Auguste Delaherche (1857–1940).

Grueby pioneered the technique of covering ceramic vessels with thick, opaque matte glazes in rich shades of brown, ochre, and especially green, creating a surface texture that resembled the rind of a watermelon. His matte glazes, in particular the colour now referred to as "Grueby Green", drew inspiration from the flowers and plants of nature. Grueby collectors maintain that a good piece of Grueby looks more "picked than potted". The brochure published by the Grueby Faience Company compared the "peculiar texture" of the rich, monotone glazed surface with "the smooth surface of a melon or the bloom of a leaf". Although moss green remains one of the most popular shades of green for Grueby pottery glazes, the colour tones range from a pale yellowish green to the rich, dark hue found in the skin of a cucumber. Another important designer at the factory was Addison B. LeBoutillier (1872–1951). At Grueby, potters crafted the pots and modellers, usually women trained in the Boston art schools, finished them.

Many designers employed the Spanish cuenca technique, whereby patterns were impressed to form ridges that prevented coloured glazes from intermingling. Grueby declared in his company's brochure that "a fine piece of pottery is essentially an object of utility as well as of decoration".

Grueby cleverly collaborated with the Tiffany Studios to produce a successful collection of lamps – the lamp base consisting of a Grueby ceramic jar complemented by a leaded or blown glass Tiffany shade, for both oil and electricity.

Produced at his studio in Boston, Grueby's highly-prized ceramic wares received a gold medal along with international acclaim at the *Paris Exposition Universelle* of 1900, which encouraged a host of imitators. Grueby managed to unite mass-production methods with hand craftsmanship by decorating simple hand-modelled vessels with standardized patterns.

In 1902, Grueby's wares were described in an article in *Brush and Pencil* as being of a type "not…designed to catch the fancy of those who delight in excessive ornamentation, high or varied colors, or elaborate patterns. It is a pottery rather that appeals to those who are fond of simplicity of design and rich but subdued monotones."

Below

A Grueby vase, with ivory buds alternating with leaves under a rich matte mustard glaze. 1900, 11in (28cm) high, **I**

Below

A rare Grueby spherical vase, by Ruth Erickson (b.1885, active 1899–1910), with closed-in rim surrounded with tooled and applied green leaves on a blue-grey ground. c1905, 4½in (12cm) wide, **G**

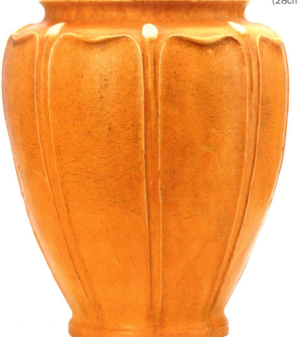

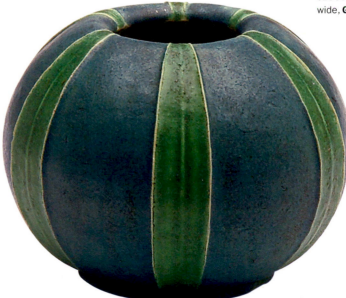

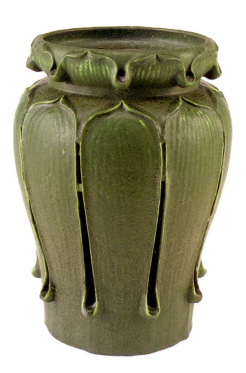

A Closer Look

Skilfully integrating a vessel's shape with its decoration, Grueby embellished his hand-thrown earthenware with stylized hand-carved or relief patterns featuring flowers, grasses, leaves, and lotus blossoms. The basic form was thrown and the raised leaves applied in thin rolls of clay, arranged and worked by hand. But the true genius was the brilliant George Prentiss Kendrick (1850–1919), who designed this rare Grueby vase. c1900, 10¾in (27cm) high, **F**

Below

An exceptional Grueby "Kendrick" vase, by Wilhelmina Post, with full-height tooled and applied leaves below a row of shorter leaves and covered in a superior feathered matte green glaze. c1897, 12in (30cm) high, **F**

Above

A rare Grueby vase, with a row of bright yellow blossoms on a corseted neck, under a superior feathered matte green glaze. c1904-1908, 10in (25cm) high, **I**

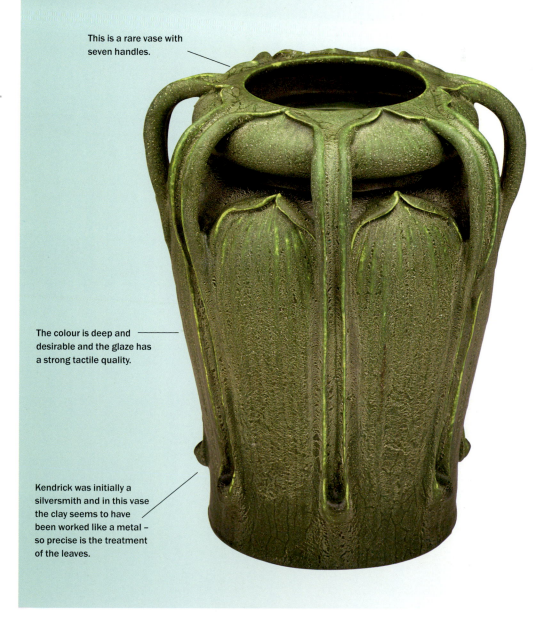

This is a rare vase with seven handles.

The colour is deep and desirable and the glaze has a strong tactile quality.

Kendrick was initially a silversmith and in this vase the clay seems to have been worked like a metal – so precise is the treatment of the leaves.

Grueby Tiles

William Henry Grueby had begun work at the Low Art Tile Works in 1880 at the age of 13. He first made tiles commercially, with his friend Eugene Atwood from Low's, under the name Atwood & Grueby from around 1890 to 1894. In 1894 he formed the Grueby Faience Company with the designer George Kendrick and business manager William Graves, producing tiles and architectural terracotta. Grueby's strengths were the glazes and enamels.

The tiles soon decorated buildings all over North America. Such was the quality and good design of the tiles that they were regularly used on important commercial and residential buildings as well as hotels, railroad stations, and the New York City subway system. One of the most important Grueby tile schemes was the Dreamworld mansion in Scituate, Massachusetts, the home of Thomas W. Lawson (1857–1925). Grueby tiles adorn the many bathrooms, fireplaces, and a conservatory. The tiles were a collaboration

A tile decorated in cuenca with a golden tulip. c1900–19, 6in (15cm) wide, **J**

between the architects Coolidge and Carlson, Boston potter Russell Crook and graphic designer Addison B. LeBoutillier, who had joined Grueby as director of design in 1903. These are some of the most desirable tiles when they come on the market today.

Just as he had with Tiffany lamps, Grueby forged a relationship with Gustav Stickley (1858–1942), resulting in Stickley using only Grueby tiles on his tables and plant stands.

The finest faience tiles were made of wet clay and moulded or decorated in cuenca. In this method outlines were drawn on the surface mixed with a greasy substance that prevented the coloured glazes from mixing. Tiles had deeply impressed patterns with the compartments filled with coloured glazes. Tiles made in conjunction with the Pardee Tile Works are often thinner than earlier tiles and decorated in the so-called cuerda seca ("dry cord") technique with animals, ships, flowers.

Left

A tile decorated in cuenca and cuerda seca with Saint George slaying the dragon, in curdled matte glazes in greens, ambers, blues, and ivory. c1900–19, 8in (20cm) square, **G**

Right

A two-tile frieze decorated in cuenca in matte blue, green, and amber glazes. c1900–19, 8¼in (21cm) wide, **I**

Left

A Pardee Cheshire Cat tile, from the "Alice in Wonderland" series. 1920s, 4¼in (11cm) square, **K**

Right

A rare advertising tile. c1900–19, 6¼in (16cm) square, **J**

Below left

A tile decorated in cuenca in curdled glazes in light blue, green, brown, yellow, grey, and white. c1900–19, 8in (20cm) square, **J**

Bottom

A rare complete frieze of eight tiles, "The Pines", decorated in cuenca with stylized trees in a landscape. c1902, 48in (122cm) long, **E**

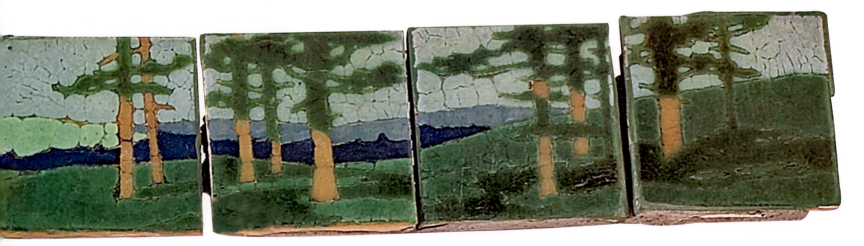

Saturday Evening Girls Club

The Saturday Evening Girls Club (SEG) was one of many library reading groups developed in Boston's North End by reform-minded local philanthropists to educate and assimilate immigrant girls. Many of the girls had dropped out of school in order to contribute to their family's income. The brainchild of Edith Brown and Mrs James Storrow, the club started meeting in the North branch of Boston Library in 1899. The idea was to have immigrant girls gather each week to decorate pottery that could be sold in support of their settlement house activities. The girls studied the basics of ceramics and learned how to glaze and fire their wares with the help of an experienced potter. They learned everything from design to chemistry.

What had begun as a relatively modest experiment in 1906 grew into a highly successful enterprise, moving to larger premises and in 1908 adopting the name of the Revolutionary War hero, Paul Revere (1735–1818). The Paul Revere Pottery was established to offer these girls a safe environment in which to earn their wages. The SEGs, as they came to call themselves, decorated the Pottery's bowls, plates, and vases with stylized

A tile marked "HULL STREET GALLOUPE HOUSE". c1912, 3¾in (9.5cm) wide, **H**

imagery of animals, flowers, and landscapes, in pretty tones of blue, green, yellow, and brown. The playful ceramics could be personalized with names, initials, or moralistic mottoes, and they were admired for their simplicity and charm.

The Saturday Evening Girls Club continued to train young women to work as ceramic decorators, although the Pottery was rarely profitable. Further expansion to a specially designed building modelled on Cincinnati's Rookwood Pottery saw the company broaden its range to include candlesticks, lamps, vases, bookends, and paperweights as well as tiles, tea wares, and dinner sets. It also produced a popular line of children's breakfast sets decorated with motifs such as rabbits, chicks, and ducks.

Wares are typically signed with an impressed or painted mark featuring Paul Revere on horseback over the words "THE PAUL REVERE POTTERY/BOSTON", and the letters "SEG" or "PRP", the artist's initials, and often the year. Director Edith Brown died in 1932 and the pottery struggled through the Great Depression; it was forced to close in 1942.

Better

A flaring bowl decorated by Sara Galner (1894–1982) in cuerda seca. Galner is a highly collected artist and this is a large bowl with good all-over decoration. 1915, 11½in (29cm) diam, **H**

Good

This bowl is well decorated by Ida Goldstein in cuerda seca. Although a pleasant and popular subject, the geese lack animation. 1912, 10¼in (25.5cm) diam, **J**

Best

A Saturday Evening Girls/ Paul Revere flaring bowl decorated by Fannie Levine in cuerda seca. This piece is unusually colourful, very crisp, a good large size and perfectly fired. 1911, 11½in (29cm) diam, **G**

Masterpiece

This early centre bowl is decorated by Frances Rocchi in cuerda seca and unusually incised "Early to bed & early to rise makes a child healthy, wealthy & wise". 1909, 12¼in (30.5cm) diam, **D**

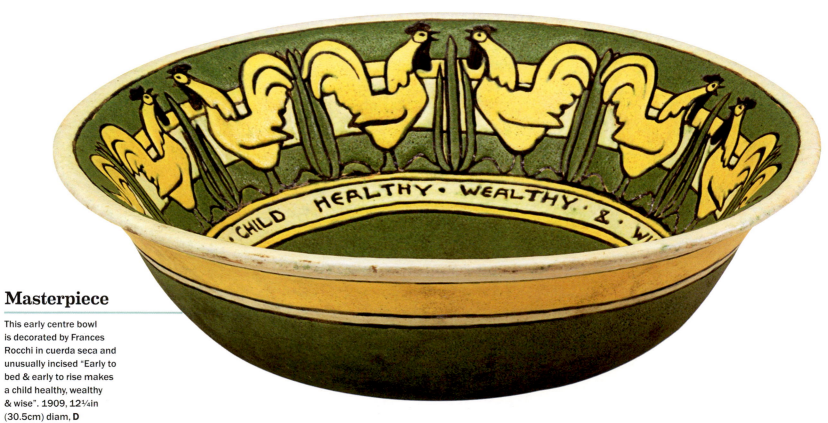

Marblehead

Founded in 1904 in the village of Marblehead, Massachusetts, by Dr Herbert James Hall (1870–1923), the Marblehead Pottery was initially conceived as a craft therapy programme, similar to the one later introduced at the Arequipa Pottery, California, to provide "quiet manual work" for convalescing "nervously worn out patients". The demands of the pottery were such that it had to be detached from the medical facility after the first year. By 1908 the pottery had a weekly output of 200 pieces, including vases, jardinières, and tiles.

By 1915 Dr Hall's Handcraft Shops, which also included metalwork, woodcarving, and weaving, had been transformed into an independent commercial enterprise. The pottery was purchased by Arthur Eugene Baggs (1886–1947) who remained as director until the company closed. Marblehead received the J. Ogden Armour prize in 1915 at the annual exhibition of the applied arts at the Art Institute of Chicago. Guided by Arts and Crafts philosophy, the Marblehead Pottery specialized in hand-thrown matte-glazed ware in simple, well-designed, and elegant shapes. Led by chief decorator Hannah Tutt (1860–1952), tiles, vases, jars, garden ornaments, and bowls were individually decorated by a team of talented artists with incised and painted geometric patterns, stylized flowers, animals, birds, insects, fish, and occasionally Native American motifs. A soft and muted colour palette boasted a range of harmonious tones, including blue, warm grey, wisteria, rose, yellow, green, and tobacco brown, and occasionally several colours were combined on a single piece. The best decorated Marblehead pieces are usually in excess of 6in (15cm) tall with more than one colour and with modelled designs that cover the majority of the subject. Most Marblehead is relatively small, averaging about 5in (13cm) tall. Marblehead pottery is usually marked with the impressed outline of a ship accompanied by the initials "MP", all enclosed within a circle, and sometimes including the initials "AEB" and/or "HT" (for Arthur E. Baggs and Hannah Tutt).

After the pottery closed, Baggs served as professor of ceramic arts at Ohio State University from 1928 until his death. The factory closed in 1936.

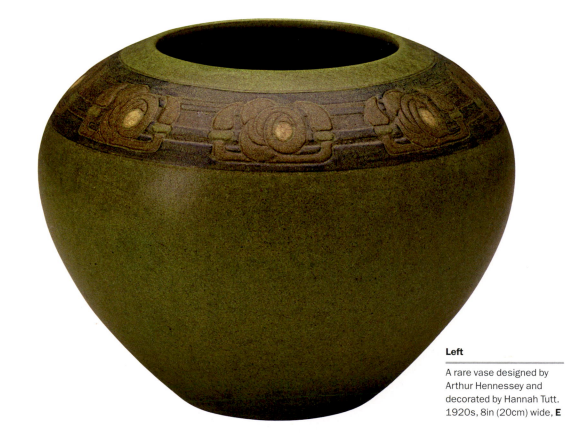

Left

A rare vase designed by Arthur Hennessey and decorated by Hannah Tutt. 1920s, 8in (20cm) wide, **E**

Above

A small early vase decorated by Hannah Tutt. 1920s, 3½in (9cm) high, **J**

An unusual vase carved by
Hannah Tutt. 1920s, 6¾in
(17cm) high, **H**

Above

A fine and early vase.
The stylized carved
poppy, combined with
the elongated geometric
design, is highly prized by
collectors. 1920s, 9¼in
(23.5cm) high, **H**

Arthur Eugene Baggs

Arthur Baggs studied under the English
potter Charles Fergus Binns (1857–1935)
at the New York School of Clayworking and
Ceramics at Alfred University. In the summer
of 1905 Binns sent Baggs, as a vacation
job, to help Dr Herbert James Hall establish
a pottery for occupational therapy at his
sanatorium in Marblehead, Massachusetts.
Baggs was charged initially with teaching
patients the craft. He ran the Marblehead
Pottery programme for Dr Hall for many
years. In 1908 the Marblehead Pottery
was reorganized on a commercial basis.
Baggs designed the wares, which were
mostly simply shaped vases covered with
muted matte glazes and contrasting stylized
decorations. He worked as a glaze chemist at
Cowan Pottery from 1925 to 1928. His work
is characterized by simple forms and muted,
earthen colours. He is known for his salt-
glazed stoneware.

Left

An unusual teapot by
Arthur Baggs. c1915, 6in
(15cm) high, **I**

Left

An early vase by Arthur
Baggs, which is more
Grueby than Marblehead
in design. c1910, 4¾in
(12.5cm) high, **E**

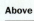

Above

A vase incised and painted
by Arthur Baggs. 1915,
8½in (22cm) high, **G**

Chelsea Keramic

One of the earliest American ceramic art potteries was the Chelsea Keramic Art Works in Chelsea, Massachusetts. Alexander Robertson, descended from a family of Scottish potters, established the pottery to produce brown ware in 1865. Having been joined by his brother Hugh in 1868, they started making flowerpots. Their father and brother joined in 1872, and in 1876 they developed a white clay body that was perfectly suited to their rich, clear glazes. They created ranges in light and moss greens, pale and dark browns, and blues of many hues. In 1888, after years of experimentation to find a Chinese oxblood glaze, Hugh succeeded in producing what he called "Robertson's Blood" or "Sang de Chelsea". It is the brilliant colour of fresh blood with a background golden lustre. Among Chelsea's most enduring work are its hand-carved designs. The pottery also produced floral designs that were achieved by pressing flower and plant forms into the still-wet clay. The most valuable pieces are signed by Hugh Robertson.

Other factories thrived in New England due to the demand for art pottery. Hugh Robertson, of Chelsea, founded the Dedham Pottery in Dedham, Massachusetts, in 1895 and continued his experimentation with glazes. He perfected his crackle glazes and volcanic ware. His crackle-glaze bunny wares kept the pottery afloat. Merrimac Pottery was established in Newburyport, Massachusetts, by T.S. Nickerson in 1902 and ran until about 1908. It was known for its excellent glazes, particularly matte green. William J. Walley was a studio potter. Walley pottery was always hand-thrown and hand-decorated. The Shawsheen Pottery was built in Billerica, Massachusetts, in 1906 by Edward and Elizabeth Burnap Dahlquist and Gertrude Singleton Mathews. The following year they moved to Mason City, Iowa. Most of their work was thrown or hand-coiled. The feathered matte green glaze that covers many of their pots is particularly desirable. Ornamentation was incised or excised in wet clay with wooden tools.

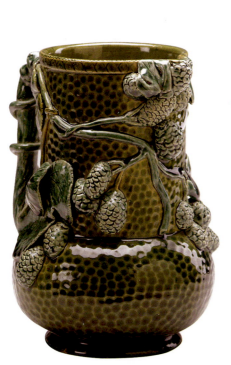

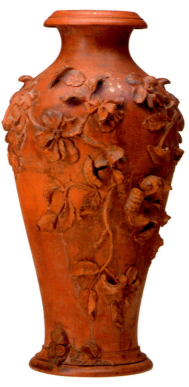

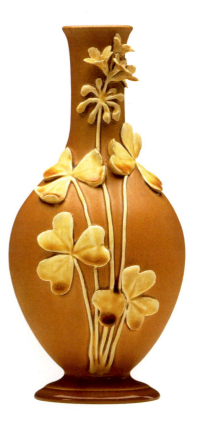

Above

A pitcher, with applied berries and leaves on vines, against a hammered ground, covered in glossy green glaze. Late 19thC, 7½in (19cm) high, **J**

Above

A tall rare early vase, with applied blooming vines and Italian Renaissance masks, in a burnished clay finish. Late 19thC, 10in (25.5cm) high, **J**

Above

A bottle-shaped vase covered in a fine oxblood glaze. c1888, 7½in (19cm) high, **J**

Above

A bottle-shaped vase, typically applied with clover leaves and blossoms, under glossy and fine vellum glaze. Late 19thC, 8¼in (21cm) high, **K**

New England Ceramics

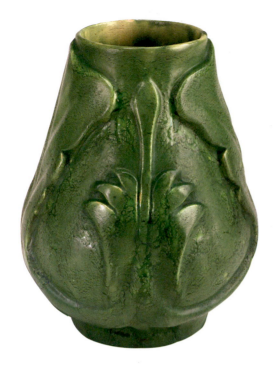

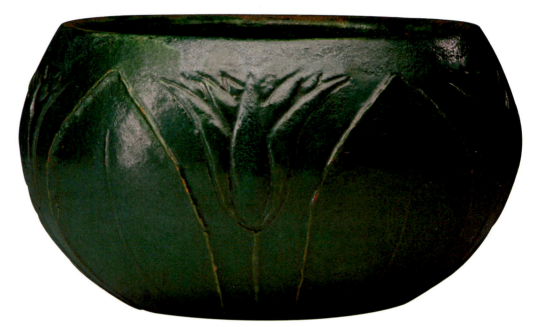

Above left

A Shawsheen vase. 1911, 9in (23cm) high, **J**

Above right

A Merrimac jardinière. c1905, 8½in (22cm) wide, **J**

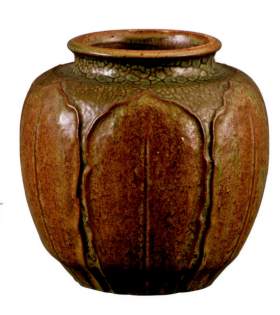

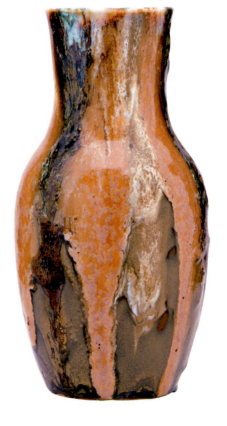

Right

A vase by William J. Walley. 1905, 6¾n (16cm) high, **I**

Left

A Dedham experimental vase by Hugh Robertson. c1895–1908, 11in (28cm) high, **J**

Newcomb

Newcomb College Pottery was the brainchild of artist Ellsworth Woodward (1861–1939) and Mary G. Sheerer (1865–1954), a ceramics designer. It was founded in 1895 as a teaching enterprise at Sophie Newcomb College, the women's division of Tulane University in New Orleans, Louisiana. Vases thrown by master potters, such as Joseph Meyer (1848–1931), were turned over to the young students for decoration. Teachers included Leona Nicholson (1875–1966), Paul Cox (1879–1968), and Frederick Walrath (1871–1921).

Newcomb Pottery specialized in the production of vases decorated with the flora and fauna of the American South. Ceramic shapes looked to the Orient for inspiration and popular decorative motifs included moonlit bayou scenes; native plants such as tobacco, cotton, and jonquils; lizards and waterfowl; and abstract Japanese-

inspired Arts and Crafts designs. Early wares feature shiny, luminous glazes in a distinctive palette of yellow, blue, green, and black, but from around 1910 a wider range of softly-coloured matte glazes was adopted.

The pottery began to market its wares in 1895, ultimately receiving international acclaim at the *Paris Exposition Universelle* of 1900. The student artists were encouraged to sign their work and funded their tuition by selling the best examples in the gallery shop.

Each piece of Newcomb was individually crafted. Following Woodward's retirement in 1931, the quality of Newcomb College art pottery declined and production finally ceased in 1940. Newcomb pottery is marked with the firm's symbol, the cipher of the artist, the potter's mark, and a designated date.

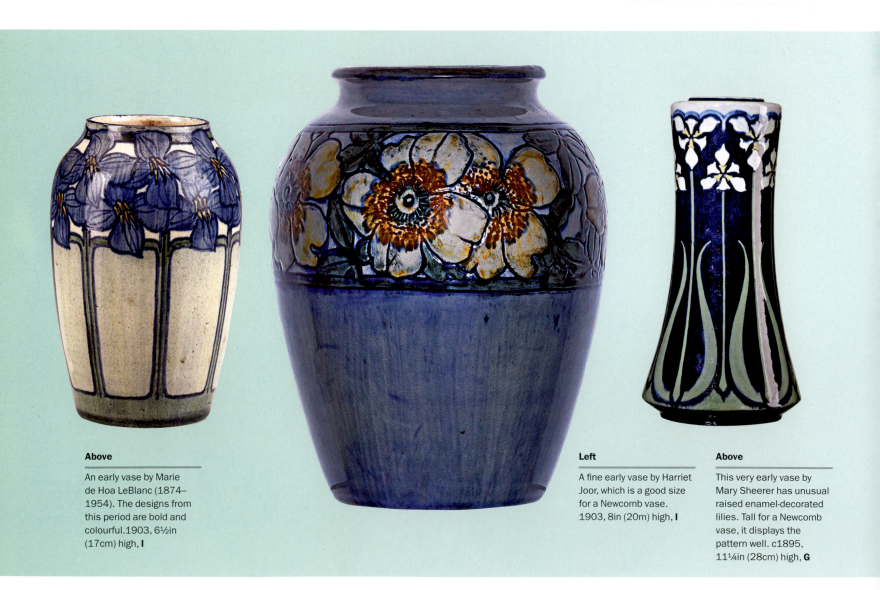

Above

An early vase by Marie de Hoa LeBlanc (1874–1954). The designs from this period are bold and colourful.1903, 6½in (17cm) high, **I**

Left

A fine early vase by Harriet Joor, which is a good size for a Newcomb vase. 1903, 8in (20m) high, **I**

Above

This very early vase by Mary Sheerer has unusual raised enamel-decorated lilies. Tall for a Newcomb vase, it displays the pattern well. c1895, 11¼in (28cm) high, **G**

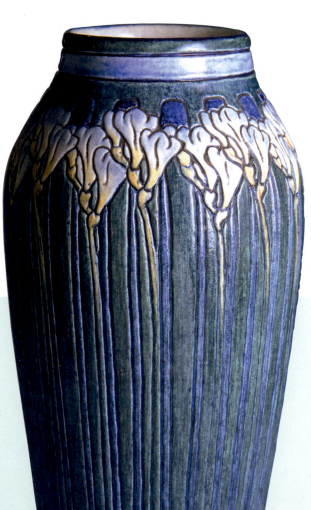

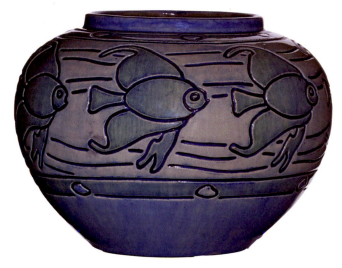

Left

Although by an unrecognized artist, the deeply incised stylized fish make this an unusual vessel. While it is a reasonably small example, its rarity explains the price. 1905, 6in (15cm) high, **G**

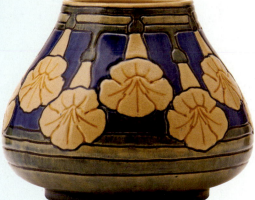

Above

An exceptionally large and early Newcomb College vase carved by Leona Nicholson. c1908, 2¾in (32cm) high, **G**

Above

An early vase by Marie de Hoa LeBlanc. 1909, 7½in (19cm) wide, **I**

Above

A large vase, carved by Sadie Irvine, with a good example of the bayou scenery. c1911, 10in (25cm) high, **H**

George Edgar Ohr

Ohr was a potter from Biloxi, Mississippi, working from about 1883 until around 1907. He was arguably the best potter America has ever produced. The self-proclaimed "Mad Potter of Biloxi", he called his workshop "Pot-Ohr-E". His eccentricity extended to his pots: he threw paper-thin vessels, which he manipulated with turns, ripples, and twists, and usually covered with one of his colourful glazes. He is best remembered for the prescient modernity of his works, which was out of place in the turn of the century American South, or just about anywhere else for that matter. He has been prolaimed the quintessential Arts and Crafts potter, which he would have hated.

Ohr dug his own clays from the Tchoutacabouffa River in Harrison County, Mississippi (Tchoutacabouffa is the Biloxi tribe's word for broken pot), mixed his own glazes, and even built his own kiln and pottery. He made every piece himself, by hand, from start to finish. The main body of his work consists of vases, ewers, teapots, and mugs. A typical piece by Ohr features manipulations such as a folded rim, an in-body twist, a pucker, or a pinch. The more manipulated the pot and the more elegant the result, the more valuable the piece. His glazing is remarkable: with little training he would cover a vessel with a bright red glaze sponged with traces of gun metal, deep blue, and soft white. Sometimes, he would use two entirely different glazes on opposite sides of the pot. After 1900, Ohr increasingly left his work in its bisque-fired state, showing crisply the hand of the artist.

He stopped potting around 1907, frail and in debt. He died in 1918.

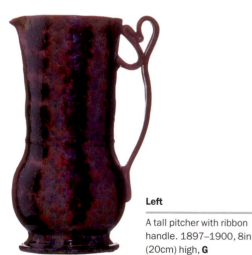

Left

A tall pitcher with ribbon handle. 1897–1900, 8in (20cm) high, **G**

Right

A large vessel with an in-body twist and folded rim. 1897–1900, 9¼in (23.5cm) high, **E**

Below

A vase with an in-body twist, used as a glaze test. When applied, all glazes look grey, so trial and experiment was a constant occupation. 1897–1900, 4½in (12cm), **H**

Burnt Baby

In the wake of the devastating fire that swept through his Biloxi pottery in October 1893, damaging his building and kiln, and destroying much of his inventory, Ohr, as usual, responded in an unexpected way. Rather than discarding the blackened pots covered with charcoal shards, Ohr called them his "burnt babies" and promoted them as yet another range of his unorthodox, highly imaginative art pottery. As he sold very little during his lifetime, because of his dislike of most people who tried to buy his pots, his work would have a limited impact until after his death.

Left

A "Burnt Baby" with pinched rim over dimpled body, and remnants of original olive green glaze. c1893, 3in (7.5cm) high, **K**

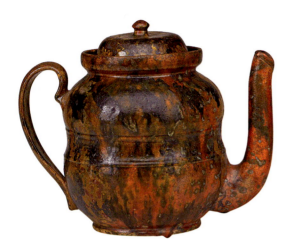

A rare corseted teapot with two different glazes. 1890s, 6¾in (17.5cm) high, **E**

Above

A bisque-fired vessel of manipulated scroddled clay. 1898–1910, 6in (15cm) high, **H**

A Closer Look

George Ohr made about 10,000 pots, or "mud babies", during his career, most of which remained in family hands because they were difficult to sell and he was extremely tough to buy from. This hoard survived mostly intact until 1970, when a barber/antique dealer purchased the collection from the Ohr family. Since then prices have soared. A large permanent collection of Ohr's work is in the Ohr-O'Keefe Museum of Art in Biloxi, designed by Frank Gehry (b.1929).

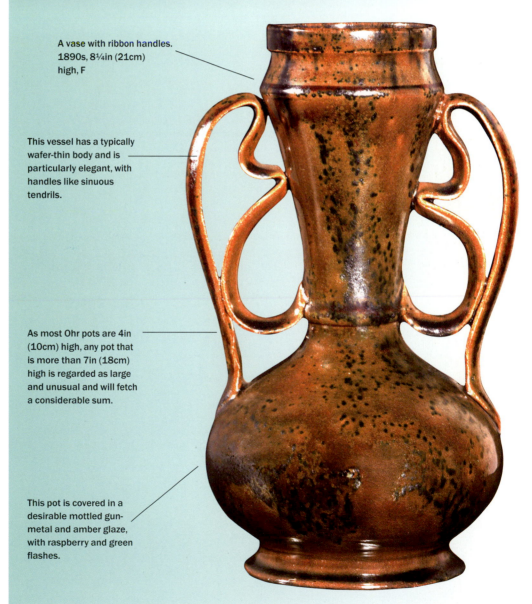

A vase with ribbon handles. 1890s, 8¼in (21cm) high, **F**

This vessel has a typically wafer-thin body and is particularly elegant, with handles like sinuous tendrils.

As most Ohr pots are 4in (10cm) high, any pot that is more than 7in (18cm) high is regarded as large and unusual and will fetch a considerable sum.

This pot is covered in a desirable mottled gun-metal and amber glaze, with raspberry and green flashes.

Van Briggle

Artus Van Briggle began his ceramic career at the Avon Pottery in 1886 and joined Rookwood in 1887. By 1891 he was a senior decorator. In 1893, he was sent to study in Paris by Rookwood and first encountered the Chinese Ming Dynasty "dry" matte glazes that would launch his quest for their formulae. Back in Cincinnati in 1896, he was involved mainly with the popular "Standard" glazes, but in his spare time he experimented on dead matte glazes. He first exhibited his matte glaze vases at the *Paris Exposition Universelle* in 1900, as part of the Rookwood display.

Tuberculosis forced him to relocate to Colorado and he founded the Van Briggle art pottery in Colorado Springs, Colorado in 1899. Following all his experimentation at Rookwood, Artus, together with his wife Anne, also an accomplished artist, began to make slip-cast ceramic vessels in organic shapes and matte glazes. One of the decorative techniques used an atomizer to spray coloured glazes onto the clean-lined pots. In order to survive financially, the company's output varied widely, ranging from high-quality original studio wares to ordinary commercial merchandise. Vases were typically moulded and decorated with embossed patterns featuring stylized flowers and leaves or Native American designs. Occasionally the factory produced vessels that were embellished with moulded animals or human figures – the best known being "Despondency", "Toast Cup", and the

Good

This early vase has a good colour, but it lacks originality. 1902, 8in (20cm) high, **I**

Better

Embossed with geese and covered in matte mustard glaze against a textured moss and mustard ground, this vase is more unusual. 1902, 6½in (17cm) high, **H**

celebrated "Lorelai" vases. The quality and originality of Van Briggle art pottery suffered after the death of Artus in 1904 although, until Anne sold the factory in 1912, the company continued to create quality art wares decorated with rich matte finishes in a variety of distinctive hues, including golds, cucumber and lime greens, purples and mauves, turquoise blues, and deep, burgundy reds. The pottery, which remains in operation today, produces mainly copies of the wares originally created by Artus Van Briggle.

Best

This is early and exceptional vase on a bronze stand was probably made for the *St Louis World's Fair*. 1904, 13in (33cm) high, **E**

Masterpiece

An early tall Van Briggle two-handled tapering vase made very desirable by the hand-applied bronze overlay of stylized mistletoe. It is a large, rare, and exquisite piece. 1904, 11in (28cm) high, **D**

Fulper

Fulper was established in Flemington, New Jersey, nearly a hundred years before it produced art pottery. The Fulper Pottery Company, incorporated in 1899, initially produced simply shaped, utilitarian ceramic wares. Under the direction of the founder's grandson, William H. Fulper II, and his partner Johann Martin Stangl, the company introduced a line of artistic wares. The relatively inexpensive range of table lamps, desk, and smoking accessories, known as "Vase Kraft", was eagerly received by a discerning American middle class eager to acquire fashionable well-made art pottery. In 25 years of production Fulper produced over 1,000 different shapes. Once the pottery vessels, many in Japanese shapes, had been cast in moulds, they were glazed individually by hand in a range of rich colours. A leader in the use of glazes, the Fulper manufactory experimented with crystalline, matte, gloss, flambé, and metallic glazes. The glazes include "Mission Matte" (brown-black), "Verte Antique" (rich green), and blues from "Alice Blue" to "Elephant's Breath". The most prestigious glaze line was "Famille Rose" introduced by W.H. Fulper Jnr, which was applied to Chinese shapes. This range was expensive at the time and the wares are rare now. Of particular note was Vase Kraft's unusual line of large table lamps – distinctive because ceramic was used for both the lamp base and the shade – which were advertised as "art pottery put to practical uses". Most wares were marked with a vertical impressed or printed "FULPER". The pottery closed in 1935.

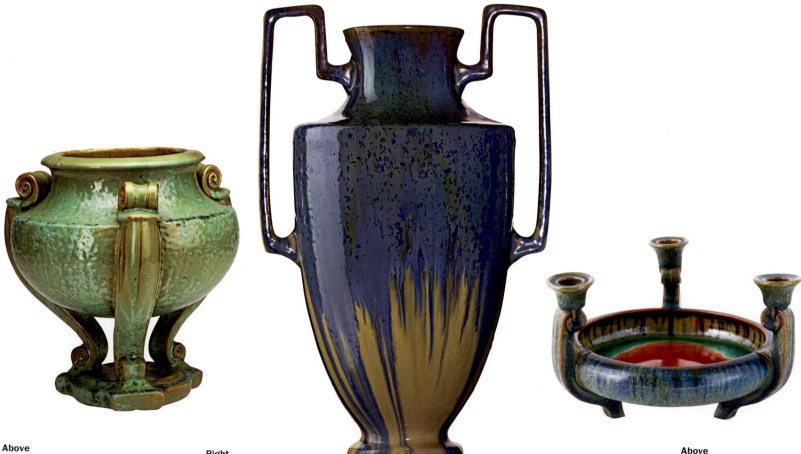

Above

Applied with great skill, the "Cucumber Green" crystalline glaze on this jar shows how these ceramics could become dazzling works of art. 1916–22, 11¼in (28.5cm) high, **J**

Right

A tall urn, with blue and ivory flambé running glaze. 1916–22, 14½in (37cm) high, **J**

Above

A Fulper candlestick bowl, with a dynamic green crystalline overglaze on a mottled blue and green ground. 1916–22, 11¼in (28.5cm) diam, **L**

Clifton

The Clifton Art Pottery was established in 1905 in Newark, New Jersey, by William A. Long, a veteran of several ceramic ventures including the Lonhuda Pottery in Steubenville, Ohio, in collaboration with chemist Fred Tschirner. The Clifton Art Pottery, although short lived, produced a wide range of designs and experimented with decorative techniques. Moulded from white Jersey clay, the company's most celebrated line was the distinctive "Crystal Patina" ware, with its microcrystalline glazes. Although most vessels were moulded smooth, a number were embossed with decorative motifs such as fish, birds, or flower blossoms. Clifton's best hand-painted line was called "Tirrube", a brick red ceramic with decoration painted in matte slip relief onto the surface.

These are quite rare and most are painted with floral designs. More desirable are examples with birds, which are occasionally signed by Albert Haubrich.

The Clifton Art Pottery's final product, the "Indian" line, were earthenware vessels that replicated artefacts excavated from famous Native American digs. These were usually covered in a brick red matte finish with black geometric decoration. After 1909, the small Clifton enterprise produced decorative wares for another two years before turning to the manufacture of floor and wall tiles. Pieces tend to be marked with an incised or impressed "CLIFTON" or "CLIFTON POTTERY/NEWARK", usually with the "CAP" cipher and often bearing a die-stamped shape number.

Above

A Clifton cabinet vase. 1906, 3½in (9cm) wide, **L**

Left

A "Tirrube" vase painted by A. Haubrich. The inclusion of a heron makes this an unusual vase. 1905–09, 12in (30cm) high, **L**

Above

An "Indian" vase, after the Mississippi tribe. 1905–09, 12¼in (30.5cm) high, **L**

Frederick Hurten Rhead

Born in the heart of the potteries in Hanley, Staffordshire, England, Frederick Hurten Rhead (1880–1942) followed in the footsteps of his father Frederick Alfred Rhead becoming art director of the Wardle Art Pottery while still in his teens. Having decided to seek his fortune in the United States in 1902, he joined William P. Jervis (1849–1925) at the Vance/Avon Faience works. After leaving Vance he went to Weller and in 1904 became art director of the Roseville Pottery. In 1908 he rejoined Jervis at the Jervis Pottery on Long Island. In 1909 he went to the University City Pottery in St Louis. In 1911 he was at the Arequipa Pottery until 1913 when he moved to Southern California and set up the Rhead Pottery in Santa Barbara in 1914.

Rhead created the designs himself and was responsible for all the glazes. He had assistants to throw the pots, particularly the large ones. He did most of the decorating although on some occasions he was assisted by his wife

Agnes Rhead (b.1877) or Lois Whitcomb (1892–1994). He utilized many of the techniques he had learned at the other potteries including incising, excising, inlaying, and enamelling. His style became more understated over time. Unlike his earlier florid designs, his Santa Barbara period saw him use simple stylized organic designs, covered in one or more of his glazes. The shapes show an Oriental influence. In 1915 he won a gold medal at the *Panama California Exposition* in San Diego. Although a creative genius, Rhead was no businessman and the pottery closed in 1917 through lack of funds. Rhead moved back to Zanesville. He became director of research at the American Encaustic Tiling Company. In 1927 he became art director of the Homer Laughlin China Company, Newell, West Virginia, a position he held until his death in 1942. There he was credited with designing the hugely successful "Fiesta" ware line.

Right

A Santa Barbara tile decorated in cuerda seca. 1914–17, 5in (13cm) square, **I**

Below

A Santa Barbara tile panel incised and enamel-decorated with fish and waves. 1914–17, 35in (89cm) long, **C**

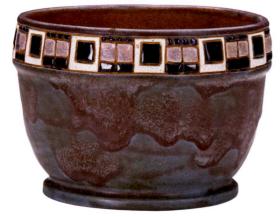

Left

A fine and rare Frederick H. Rhead jardinière *sgraffito*-decorated and enamel-glazed with a body of Santa Barbara clay. 1914–17, 5½in (14cm) high, **J**

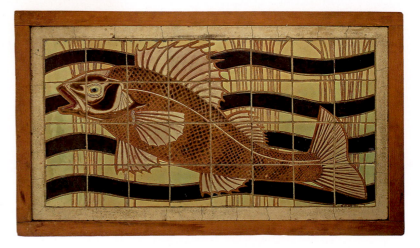

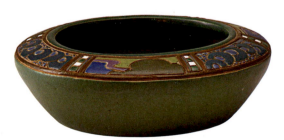

Above

A University City vessel enamel-decorated with mushrooms, by Frederick and Agnes Rhead. c1910, 6½in (17cm) high, **B**

Above

A University City squat bowl enamel-decorated with a stylized landscape, by Frederick and Agnes Rhead. 1911, 7¾in (19cm) diam, **E**

A Closer Look

This vase was designed and decorated by Frederick Hurten Rhead at his most creative in Santa Barbara, California, and was potted around 1915. It was assessed by David Rago, the world-renowned expert on Arts and Crafts pottery, as technically perfect in execution – the skilled painting on ceramic by a master technician. Rhead learned his craft in England, then emigrated to the United States and fused the native decorative trends with his European tastes, creating a style that was individual, understated, and universally beautiful. This simple hand-thrown vase combines matte and glossy glazes. The Santa Barbara pieces are the rarest of Rhead's work.

It sold for a world record price of $516,000 (£310,370).

At 11½in (29cm) high it is a large, desirable size.

It was created by an artist at the pinnacle of his career and emanated from a small studio that did not produce many Rhead pieces.

This vase is exquisitely etched with a stylized Californian landscape.

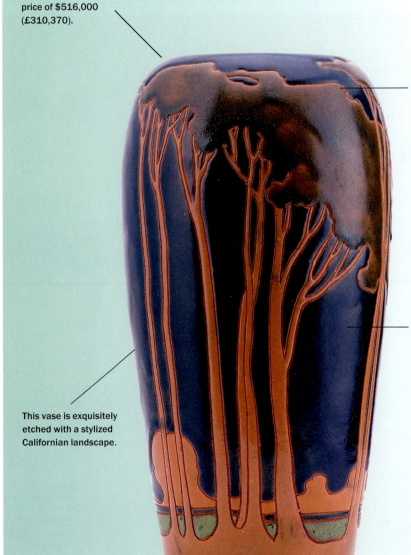

Arequipa

The idea of ceramics as a form of occupational therapy had been pioneered by Dr Herbert James Hall at a sanatorium at Marblehead, Massachusetts, in 1904. Inspired by this, Dr Philip King Brown set up a pottery at the Arequipa Sanatorium near Fairfax, Marin County, California. It was active from 1911 to about 1918.

Following the 1906 San Francisco earthquake, dust- and ash-filled air contributed to a tuberculosis epidemic in San Francisco. The incidence of the disease was much higher among women than men. The pottery was created "for the treatment of early cases of tuberculosis in wage-earning women". At the time, the only known treatment was rest and good nutrition, in the hope that the lungs could recover and heal. The name Arequipa, which is shared with a city in Peru, was said to signify "place of rest". With the help of local artists and members of the area's philanthropic community, Dr Brown introduced therapeutic handcrafts to the women. The Arts and Crafts Movement believed that participating in crafts could provide fulfilment. In addition, it would combat sloth and possibly produce revenue.

Most of the clay used by the pottery was dug locally by boys who did the heavy work. The patients spent a limited number of hours per day finishing and decorating the pots. Production was directed by a succession of well-known ceramists – Frederick Hurten Rhead, Albert Solon (1887–1949), and Fred Wilde – who were responsible for the shapes of the ware, thus resulting in dramatic variations in style. The patients added surface decorations, either in the form of designs painted on the surface or patterns carved into the damp clay. Rhead, who headed the pottery from 1911 until 1913, introduced slip-trailing, a technique that became the signature form of decoration of Arequipa pottery. Albert Solon became director in 1913. Under Solon's directorship the pottery became more recognized, successful, and output greatly expanded. He brought with him new glaze techniques, including some Persian faience ones. He was followed in 1916 by Fred Wilde. He introduced hand-pressed Hispano-Moresque tiles to the decorators. However, all the directors had problems with lack of skilled continuity. The patients stayed at the sanatorium for five months and then new untrained women would arrive. Therefore, the quality of Arequipa is very mixed. The pottery closed in 1918.

Left

A vase carved with tall jonquil leaves under green glaze, the brown clay showing through. 1911–18, 6½in (17cm) high, **J**

Above

An unusual vase embossed with branches of fruits and leaves in pale matte blue on mottled indigo ground. 1911–18, 6in (15cm) high, **J**

Above

An Arequipa cabinet vase, designed by Frederick Rhead, with squeeze bag decoration. The leaf decoration is typical of his work. 1911–18, 3½in (9cm) high, **H**

Above

An Arequipa flaring bowl, by Frederick Rhead, the interior decorated in squeeze bag. 1911–18, 6¼in (16cm) diam, **G**

Below

A vase decorated in squeeze bag and enamel by Frederick Rhead. 1911–18, 8½in (22cm) high, **H**

Redlands Art Pottery

Redlands was active in California from 1902 to 1909. Wesley H. Trippett had discovered clay suitable for pottery in the Redlands area, about 70 miles (112km) east of Los Angeles, in the early years of the 20th century. Redlands was the earliest of art potteries in this area.

Trippett had no training in the making of pots and his work was experimental. However, he was talented and the vases, bowls, and covered jars that he produced are well executed and show skilled craftsmanship.

Many of them were left in the bisque state, displaying the rich deep colour of the clay. Some, as the example here, have relief ornamentation including frogs, toads, sharks, and crabs. The pots have a circular mark "Redlands Pottery" in relief. As the quality of the output has been recognized, prices have risen for good examples.

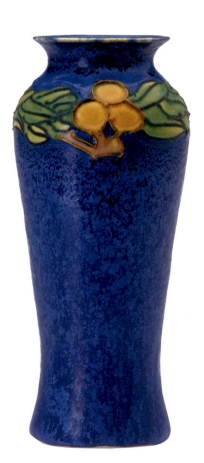

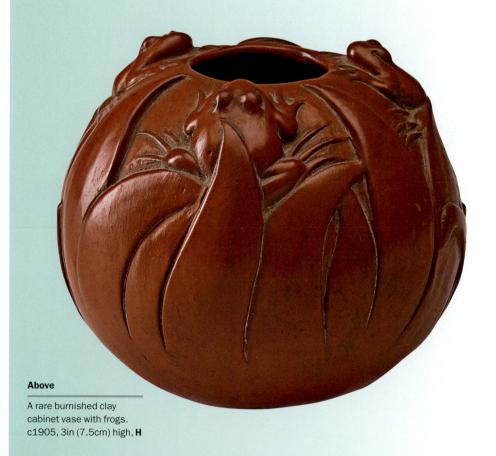

Above

A rare burnished clay cabinet vase with frogs. c1905, 3in (7.5cm) high, **H**

Teco

In 1886 William Day Gates founded the the American Terracotta and Ceramic Company in Terra Cotta, Illinois. The original intention was to produce ceramic tiles, but Gates had loftier ambitions. He wanted to develop a line of art pottery with "originality and true artistic merit", which would be affordable to the public-at-large. The only economically viable way for Gates to do this was to mould the pottery on what were effectively assembly line principles. This was at odds with the hand-crafted tenets of the Arts and Crafts Movement. However, Gates surmounted this ideological problem by applying very high standards of quality control and by commissioning some eminent designers. These included the Chicago School architect William James Dodd (1862–1930); the German sculptor Fritz Wilhelm Albert (1865–1940) (who became the company's chief designer); and the American architect Frank Lloyd Wright (1867–1959).

Production at the Teco Art Pottery began in 1902 and continued until 1922. Inspiration for the pieces produced – mostly vases, but also bowls and water pitchers – was essentially two-fold: the plant-form shapes evident in gourd-like bodies "wrapped" in sinuous leaves; and the clean geometric lines favoured by the Mid-Western "Prairie" and "Chicago" Schools of architecture.

The glazes play a huge role in the pottery's appeal. By far the most desirable and the most characteristic are the various shades of a green micro-crystalline glaze. Highly distinctive, it has an almost silvery tone and a matte finish.

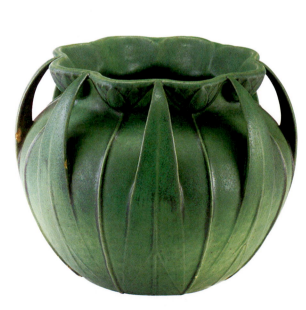

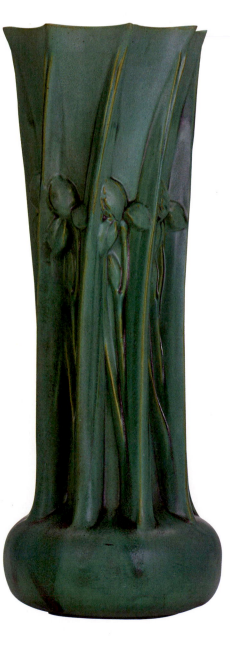

Above

A fine, large, and rare bulbous vase with eight leaf-shaped handles, covered in matte green glaze with charcoaling along the edges. c1905, 11½in (29cm) wide, **G**

Left

A rare, exceptional, and massive vase designed by Fritz W. Albert. c1905, 22½in (57cm) high, **B**

Above

A rare "Calla Lily" vase, model no.141. This is one of the most desirable Teco vases. c1905, 17in (43cm) high, **A**

North Dakota School of Mines

The North Dakota School of Mines began operation in 1898 with Earle J. Babcock (1865–1925) as director. While surveying minerals Babcock found that North Dakota had a seemingly limitless supply of clay that was an unusually pure variety of high-grade plastic potters clay. He commissioned several pottery firms around the country to produce vases, umbrella stands, and pots made from the clay. Some of these pieces, marked with a "Made with North Dakota Clay" stamp, were displayed in the state's booth at the *Louisiana Purchase Exposition* at the 1904 *St Louis World's Fair*. From this beginning, a Ceramics Department was founded at the University of North Dakota and a talented potter, Margaret Kelly Cable (1884–1960), was hired as its director in 1910. She became assistant professor in 1921. Her students referred to her as "the lady of the wheel". Cable's career as a potter was as traditional and conservative as it was groundbreaking and pioneering. Classically trained, she apprenticed at the Pottery Shop of the Handicraft Guild of Minneapolis and later studied under Charles F. Binns and Frederick H. Rhead. Under her leadership the craft tradition was maintained in Grand Forks.

Left

A North Dakota School of Mines vase painted by M.E.E. Collins with stylized trees on an amber ground. c1930, 8in (20cm) high, **J**

Below

 An exceptional double-gourd vase with four buttressed handles. This is the largest and rarest version of this form. c1910, 12½in (31cm) high, **H**

Above

A vase of classical shape with four delicate handles, covered in a dark green microcrystalline glaze with charcoaling on the handles. c1910, 11½in (29cm) high, **J**

Below

A cabinet vase by Julia Mattson. c1935, 3½in (9cm) high, **J**

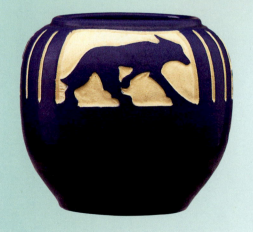

Above

A bulbous vase carved by Marie B. Thormodsgard. c1930, 7¾in (19.5cm) high, **I**

Tiffany

Tiffany Pottery was made in Corona, New York, from about 1904 to around 1917. Initially the ceramic work was utilized as lamp bases for the leaded glass shades. This developed into other ceramics with designs based on nature. Pottery wares at Tiffany Furnaces were frequently made from living models, such as wild flowers and vegetables, which were sprayed with shellac until rigid and then electroplated with copper. These, in turn, were made into the plaster of Paris moulds in which the clay was pressed into its final form. Louis Comfort Tiffany (1848–1933) probably designed most of the pots, and may have thrown many of the masters from which plaster moulds were made for production pieces. Tiffany applied his self-invented term "favrile", meaning hand-made, to his pottery as well as his glass. Although formed in a mould, each pot would have been incised with unique sculptural detail and had its own glaze. Other themes included specimens of tooled leather, American Indian pottery, and forms of marine life, such as octopi, algae, and coral growths. Tiffany's favourite glazes included a mossy green semi-gloss, often subtly variegated, that lends these pots their own life. Many of the pots have unglazed exteriors, leaving a chalky white bisque-fired surface. The interiors, however, are almost always glazed glossy green. To the public, pottery was the least readily identifiable of Tiffany's mediums, and for that reason, in part, the least financially successful. Jimmy Stewart, a glassblower at Corona, later stated that much of it was put out of sight whenever Mr Tiffany was expected to visit the factory as the staff did not want him to know how little demand there was for it. The firm's pottery was offered for sale from 1905 until around 1917, and therefore presumably remained in production for most of these years. Although all signed pieces have the "LCT" cipher, there are sometimes other marks, such as "Favrile Pottery" – a hand-made designation – or "Bronze Pottery" – denoting a piece covered with a metal jacket.

Above

A Tiffany Studios toadstool cabinet vase. 1905–17, 2¾in (7cm) high, **J**

Left

An L.C. Tiffany large ceramic vase. 1905–17, 16in (40cm) high, **J**

Above

An L.C. Tiffany copper-clad earthenware vase, with rolled-in rim embossed with a band of dogwood blossoms under a dark brown patina. 1905–17, 7in (18cm) wide, **J**

A Tiffany bottle-shaped
vase, in verdigris
microcrystalline glaze, with
a bronze lip around rim.
1905–17, 12¼in (30.5cm)
high, **K**

A Closer Look

A rare glazed earthenware vase, depicting
the bursting pods of the milkweed plant,
with emerging blossoms. This mossy green
semi-gloss glaze mimics the forest floor. When
these pots appeared in the Tiffany catalogue
of 1905 the ceramic line was relatively
expensive. This vase was rescued from a
home in New York State that was about to
be demolished. 1900s, 10in (25cm) high, **E**

Tiffany pottery vases are
rarer than glass as they
were not as popular at
the time.

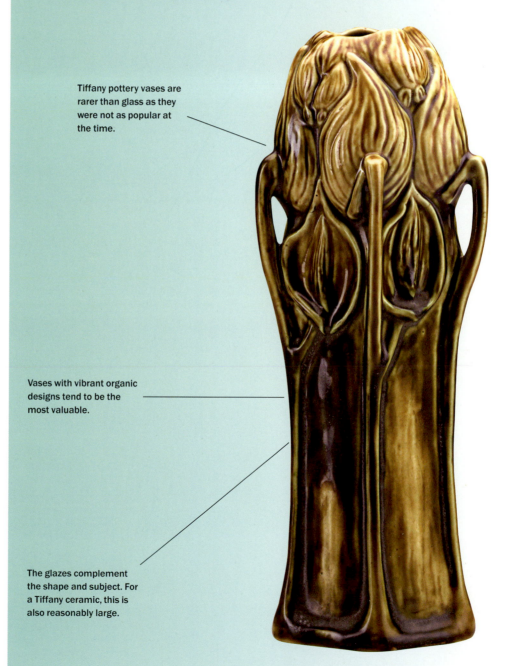

Vases with vibrant organic
designs tend to be the
most valuable.

The glazes complement
the shape and subject. For
a Tiffany ceramic, this is
also reasonably large.

Above

A rare L.C. Tiffany glazed
ceramic vessel. 1905–17,
6½in (17cm) high, **H**

Other American Ceramics

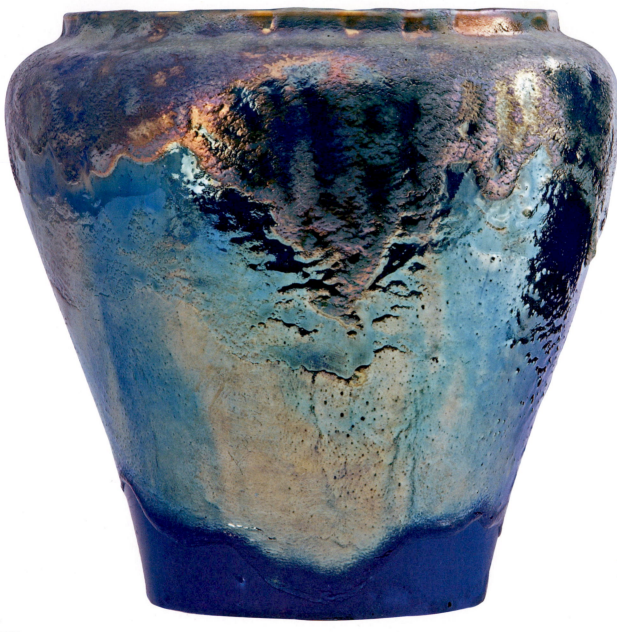

A fine, early vase by
Pewabic, Detroit, Michigan,
smothered in thick lustred
glazes dripping over the
ultramarine base. c1910,
8in (20cm) high, **J**

A rare modelled glazed stoneware footed centre bowl from Poillon Pottery, Woodbridge, New Jersey. 1905, 13in (33cm) diam, **J**

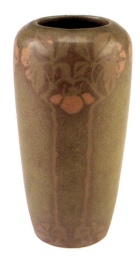

A tall vase, matte-painted with full-height stylized pink blossoms and green foliage on a green mottled matte ground made by Walrath, Rochester, New York. 1910–20, 8¾in (22.5cm) high, **I**

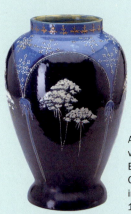

A squeeze bag decorated vase by Jervis, Oyster Bay, New York, with white Queen Anne's lace on an indigo ground. 1908–12, 16in (40.5cm) high, **K**

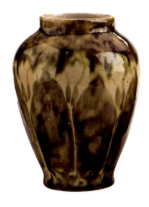

A crocus-pattern vase with a brown and green glaze, made by Byrdcliffe for White Pines, Woodstock, New York. c1915, 6½in (17cm) high, **J**

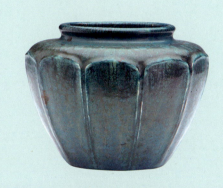

A vase made by Hampshire, Keene, New Hampshire, with moulded full-height leaves under a fine curdled blue-green glaze. c1910, 6½in (16cm) wide, **L**

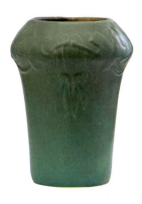

A matte green glazed vase embossed with maple leaves made for Valentien, San Diego, California. c1911, 6¾in (17cm) high, **J**

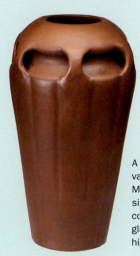

A tall "Scarabronze" floor vase from Wannopee, New Milford, Connecticut, with six buttressed handles, covered in matte bronze glaze. c1900, 20in (51cm) high, **J**

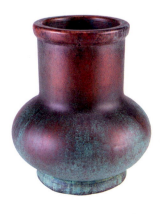

A large copper-clad vessel from Clewell, Canton, Ohio, covered in a verdigris patina. c1910, 11¼in (28.5cm) high, **K**

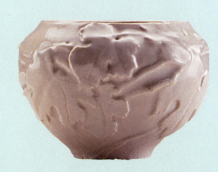

A bowl carved by Mary Louise McLaughlin (1847–1939) for Losanti, Cincinnati, Ohio, c1900, 6½in (17cm) diam, **G**

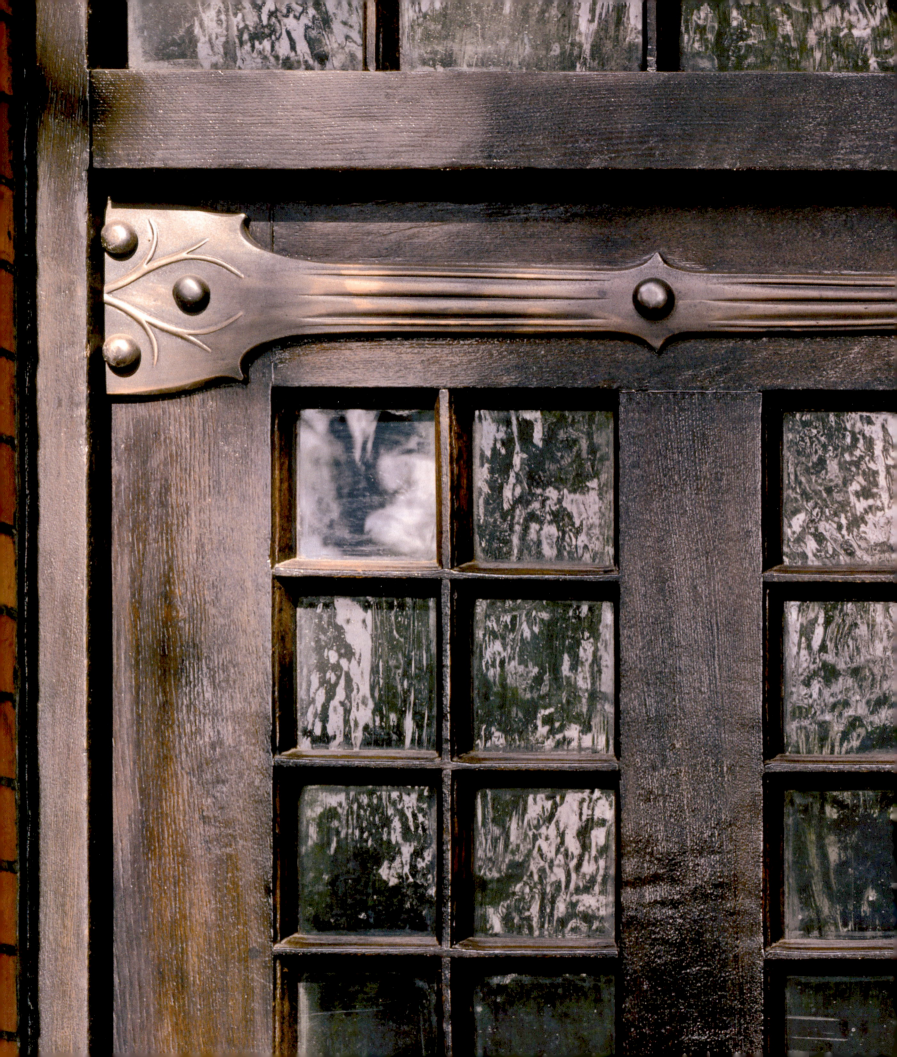

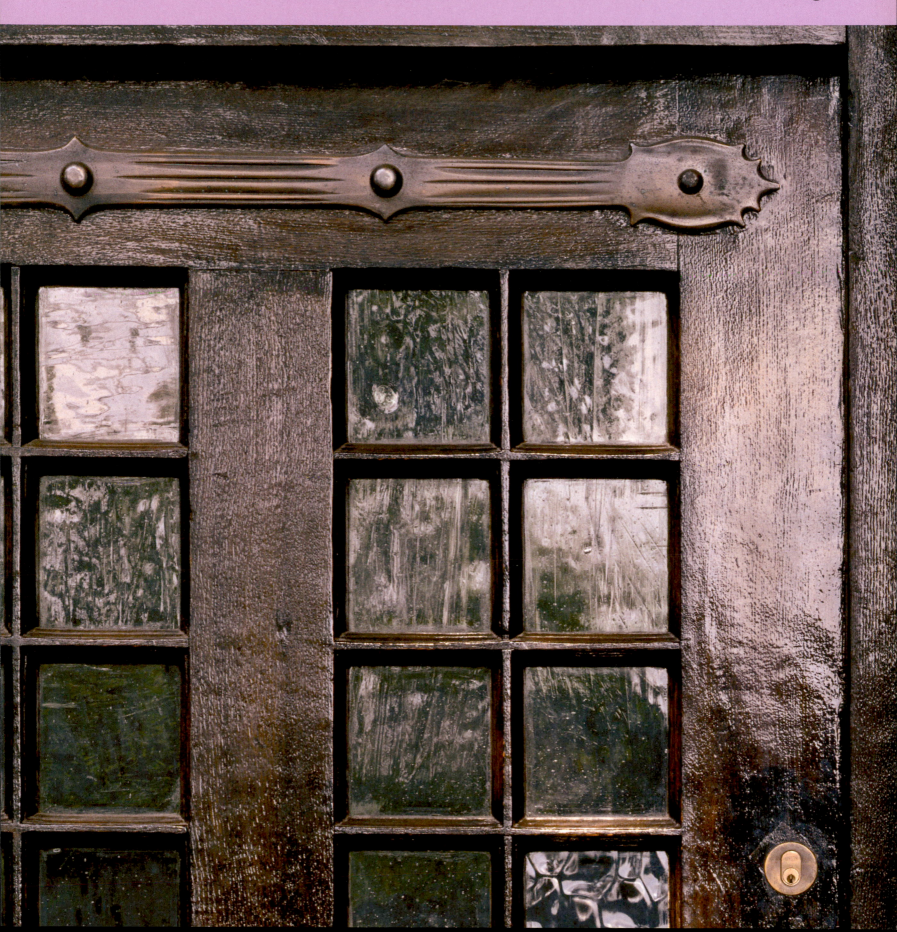

Silver, Metalware and Jewellery

British Silver and Metalware

At the close of the 19th century, across the British Isles, a new approach to metalware was taking place. From a fish-curing yard in the Cornish coastal town of Newlyn, to the elegant department store of Liberty & Co. in central London, Arts and Crafts metalwares brought joy to the maker and buyer alike.

A sense of social purpose underlay the foundation of many of the new metal workshops. Fishermen and shepherds were inspired to take up their tools at the Newlyn Industrial Class and the Keswick School of Industrial Arts. Despite the names of these workshops, the techniques they used were far from "industrial". They worked by hand often in base metals such as copper, which was satisfyingly malleable and responsive to the efforts of the newly trained craftsman. The importance of the hand, rather than the machine, was affirmed in the workshop mottoes: "the loving eye and skilful hand" at Keswick; "by hammer and hand" at the Birmingham Guild of Handicraft. Like its rural counterparts, the Birmingham Guild was initially established to help the local working population following the example of Charles Robert Ashbee's (1863–1942) Guild of Handicraft in London's East End.

Arts and Crafts metalware often has a distinctive hand-made quality. No attempt was made to smooth and polish away the marks made by the individual craftsman, the rippling pattern of hammer marks, for example, which bring texture to the surface of the silverwork. However, all is not always as it seems. Liberty & Co.'s pewter range was available with or without this "hammered" finish, which was not the result of an individual craftsman's efforts, but a texture applied to the surface of the moulds from which the pieces were cast.

Without the philanthropic purpose of the guilds and regional workshops, the commercially shrewd Liberty mass-produced metalwork in the Arts and Crafts style much to the delight of its customers and the annoyance of craftsmen such as Ashbee. Although the manufacturing techniques were different, the similarity of its strikingly simple designs for silverware, with enamel work and semi-precious stones providing touches of colour, was all too apparent to Ashbee. Frustrated by his many imitators, he was to dedicate his publication *Modern English Silverwork* (1909) "to the Trade Thief, desiring him only – if indeed he have any aesthetic honour, thieves sometimes have! – to thieve accurately". The designer William Arthur Smith Benson (1854–1924) wrote of the importance of surface texture and expressed disappointment that ordinary metalwares "have all life and feeling taken out of them by mechanical finish". But in practice he too embraced mechanical processes in his factory in Hammersmith and made the most of reflective metal surfaces in his highly influential and "palpitatingly modern" designs for lighting.

Above

A Liberty & Co. silver tree design picture frame designed by Archibald Knox, with an enamelled flower design on copper at its centre. c1903–5, 6¼in (16cm) high, **G**

Above

The "Magnus", a rare silver and enamel Cymric mantle clock designed by Archibald Knox. It comes with a fitted leather Liberty & Co. travelling case. 1902, 5in (13cm) high, **E**

Above

A John Pearson Arts & Crafts copper charger, decorated with a galleon and sea monster, 1895 24in (60cm) diam, **J**

Opposite

Arts and Crafts metalware is displayed in the master bedroom at the Hill House, Helensburgh, Scotland, designed by Charles Rennie Mackintosh and completed in 1904.

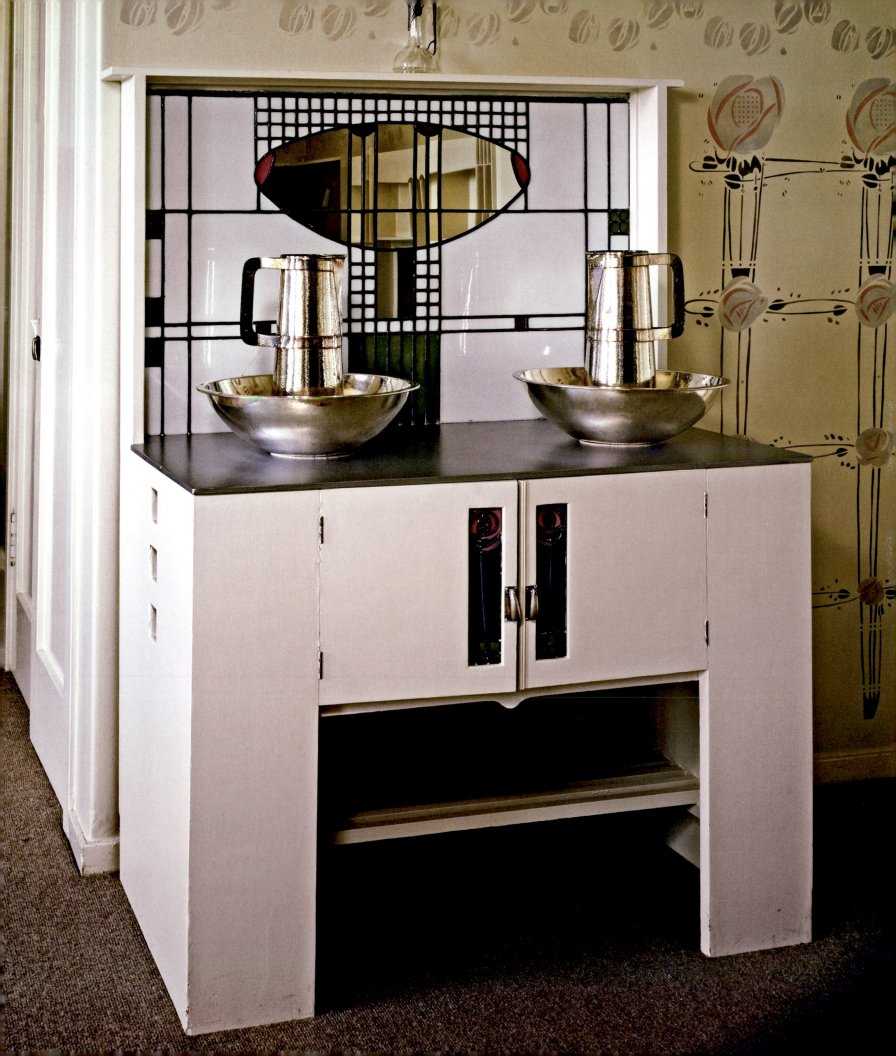

Liberty & Co.

In 1899 the successful London retailer Liberty & Co. wanted to expand the range of "artistic" furnishings that had been on offer at its Regent Street store since it was established in 1875. With characteristic bravado, an exhibition and an extensive illustrated catalogue, it launched what it described as "a new fin-de-siècle school of art silver-work". This new art metalwork was named "Cymric" silver, echoing the Welsh name for Wales, Cymru, a fact that would have appealed to Liberty's director John Llewellyn who had Welsh roots. By 1902 a second, cheaper, and more widely produced, range of metalwork, "Tudric" pewter, had also been introduced and both ranges were still being produced in the 1920s.

Although the originality and craftsmanship of Liberty & Co.'s metalwares were called into question by those with more purist Arts and Crafts values – C.R. Ashbee referred to them as "Messrs Nobody, Novelty & Co." – Liberty's approach was innovative. It developed and marketed "artistic" metalwares that had a distinctive Liberty style, which was influential on the Continent, especially in Italy, and remains easily recognizable today.

As Liberty & Co. was primarily a retailer, rather than a designer or producer, the success of its metalwares was due to a series of important collaborations.

For metalwork designs Liberty relied upon its established relationship with the commercial design studio, the Silver Studio, which had already supplied it with pattern designs for textiles. The Silver Studio was set up by Arthur Silver (1853–96) in 1880 and after his death in 1896 it was taken over by his son Rex (1879–1965), to whom, as head of the studio, the metalwork designs were often credited. They were in fact largely by the Archibald Knox (1864–1933), who had begun working for the Silver Studio in 1898 and who was responsible for introducing the Celtic decoration that typifies Liberty & Co. metalwork.

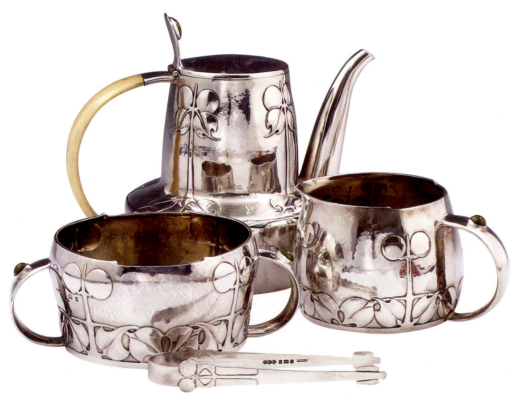

Above

A fine Liberty & Co. "Cymric" silver tea set, designed by Archibald Knox, cast with stylized honesty. 1903, teapot 7in (18cm) high, **H**

Below

A Liberty & Co. "Tudric" pewter pedestal vase, designed by Archibald Knox. The green glass liner is from a later date. c1905, 6¼in (16cm) high, **M**

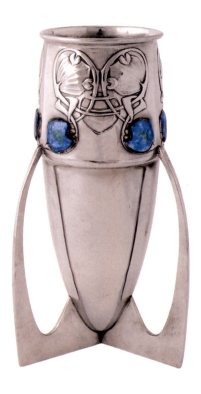

Archibald Knox

Although the identity of individual designers was subsumed within the Liberty & Co. brand, Knox's personal style shines though. Working for the Silver Studio from 1898, he produced designs for Liberty & Co. metalwork until 1911. Knox was born on the Isle of Man, where he studied at the Douglas School of Art, and throughout his career he drew upon his Manx heritage as a constant source of inspiration. His metalwork designs – often given Isle of Man place names as titles – imaginatively rework the patterns he admired on Celtic stone crosses. Interlaced Celtic scrollwork and stylized plant motifs are carefully balanced by areas of unadorned silver and pewter. The striking simplicity of his designs makes the touches of coloured enamel, semi-precious stones, and shell, or coloured glass, liners all the more intense and effective.

Above

A Liberty & Co. "Tudric" pewter and enamelled vase designed by Archibald Knox. c1905, 11½in (29cm) high, **K**

Below

A rare Liberty & Co."Tudric" pewter vase, designed by David Veazey, with twin handles and honesty roundels. c1905, 13¼in (33.5cm) high, **K**

Below

A Liberty & Co. polished pewter two-arm girandole designed by Archibald Knox and made by W.H. Haseler & Co. c1905, 11in (28cm) high, **J**

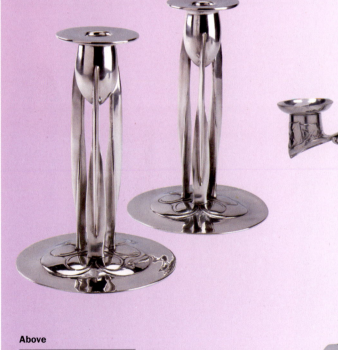

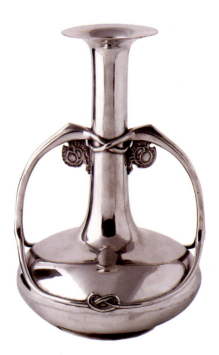

Above

A pair of Liberty & Co. "Tudric" pewter candlesticks designed by Archibald Knox. c1905, 9in (23cm) high, **J**

Liberty & Co. (continued)

Another crucial alliance for Liberty & Co. was with the Birmingham firm of jewellers W.H. Haseler. Under the directorship of William Rabone Haseler and with the help of the painter Oliver Baker (1856–1939) it too had seen the potential of an "artistic" range of silverware. A collaboration with Liberty provided the ideal opportunity and Haseler was responsible for producing all of the "Cymric" silver. The company was able to turn its hand to the new challenge of pewter for the launch of the "Tudric" range.

Only the most elaborate pieces of Liberty metalwork were hand-crafted; the majority of the silverware was machine stamped and the pewter was cast from iron moulds. This meant that manufacturing could be carried out on a larger scale than was possible in the Arts and Crafts workshops where, out of principal, every piece was worked by hand. This just added to Ashbee's frustration – Liberty could not only copy his designs but also make them in volume, although never reaching the quantities that we associate with mass-production today. Depending on the chosen finish, the metal was often polished smooth and inset with panels of enamel, abalone shell, or stones such as agates. Vases and butter dishes were fitted with coloured glass liners produced by James Powell & Sons of Whitefriars in London.

Working collaboratively with designers and manufacturers, Liberty felt that it was important to retain control over the appearance of the metalwares that it sold. Ever conscious of the needs of the customers, it would adapt the designs it received to make them more appealing and therefore more saleable. They became part of the Liberty & Co. style and, in direct contradiction to the Arts and Crafts emphasis on the importance of the individual craftsmen, specific designers were rarely given credit.

Whether visiting the Regent Street store or thumbing through an illustrated catalogue, the public were presented with a wealth of metalware from which to choose: a small pewter cigarette case, a silver tea set, a pewter or enamel mantel clock. As the "Cymric" silver catalogue declared, with items for "household and personal use and for ornament pure and simple" the choice was "practically illimitable".

Good

This pewter clock is from Liberty's "Tudric" range and was designed by David Veazey. Decorative interest is provided by the honesty seedheads framing the clock face, which are cast in low relief, but it lacks both the striking simplicity and intense areas of colour found on other Liberty & Co. clocks. c1905, 14in (35cm) high, **J**

Better

Designed by Liberty's leading metalware designer, Archibold Knox, the severity of the clock's architectural tapering form is relieved by the decorative panel of red and green enamel as well as the green and blue enamelled copper dial. c1905, 7½in (19cm) high, **I**

Best

The beauty of this "Tudric" clock lies in the contrast of the pewter case and the copper dial. The decorative motifs are highly stylized and subtle. c1905, 11½in (29cm) high, **H**

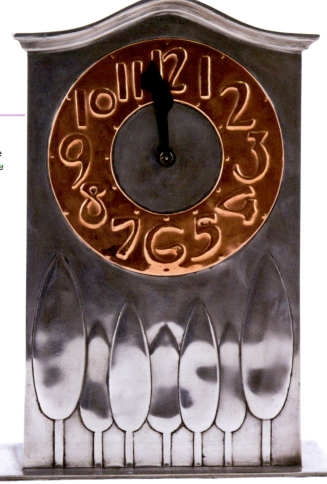

Masterpiece

This rare "Tudric" pewter clock designed by Archibald Knox is strikingly simple. The face and hands are set with small rectangular panels of abalone shell giving an iridescent shimmer to the plain expanse of the pewter surface. c1905, 12½in (31cm) high, **F**

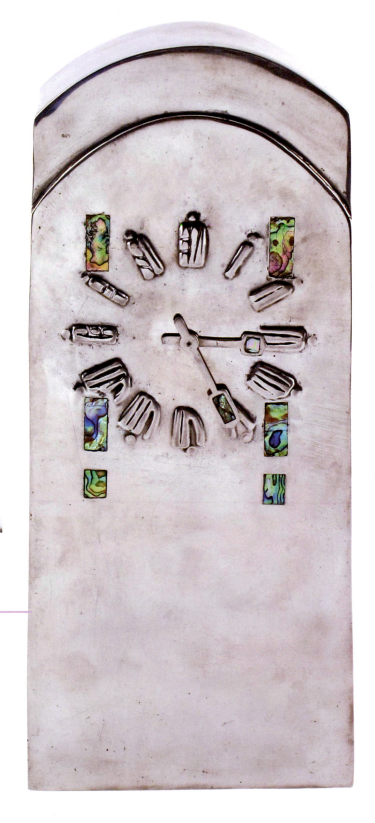

Guild of Handicraft

In 1888 the socially motivated Charles Robert Ashbee founded the Guild and School of Handicraft in Whitechapel, in the East End of London. His aim was to introduce the local, unskilled population to the simple pleasures of making in a workshop environment emulating that of a medieval guild. From the beginning, metalwork was taught in the school's evening classes and by the turn of the century the Guild's metal workshops were flourishing.

What we would see today as a typical piece of Guild metalware – a simple silver butter dish with a sinuous loop-handle and a green chrysoprase gemstone – had a very different prehistory. At first the creations of the Guild's metal workshops were robust and beautifully naïve copper and brass chargers decorated in relief with galleons, flowers, and animals. They had more in common with the work of the Newlyn Industrial Class than the restrained elegance of the Guild's later work and this is no coincidence. The first instructor of metalwork at the Guild, John Pearson (1859–1930), was later to provide instruction at the Newlyn classes. Pearson's time at the Guild was not always easy, as is evident from Ashbee's description of him as "our quaint genius, our strongest and weakest point", and he resigned in 1892. He did, however, shape the Guild's early metalwares by favouring the repoussé technique (hammering the reverse side of the metal sheet) and introducing a range of motifs that he may have absorbed while working for the ceramicist William De Morgan (1839–1917).

During the 1890s the type of metalwares produced by the Guild slowly began to change as it turned its attention to the "most degraded of all English crafts," silverware. With its extensive range of silver tableware, the Guild proved that it was possible to make pieces that celebrated the method of production without appearing rustic or crude. The hammer marks are left clearly visible on the planished surface of the silverwares, while there is no attempt to hide seams and soldering. Simple techniques created sophisticated effects such as the wirework handles and finials.

Ashbee was passionate about reviving traditional techniques, such as the lost-wax process of casting, which was used to produce the small silver balls typically acting as feet, as can be seen on the silver tazza opposite. Enamelling was also embraced to create simple bosses – such as the vivid blue enamel boss gracing the lid of a silver inkwell – as well as painted enamel plaques, which decorate the lids of silver boxes, such as the plaque featuring a ship motif and the words the "Craft of the Guild".

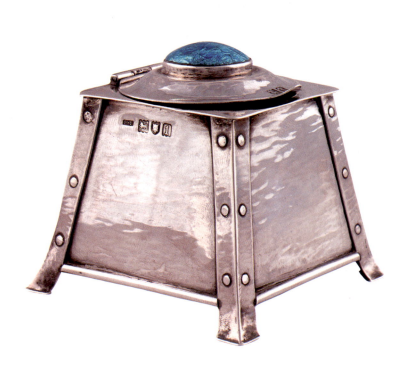

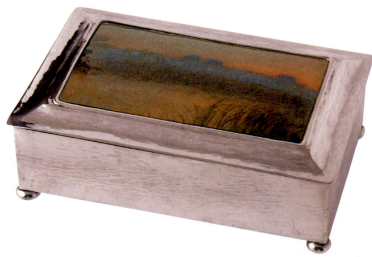

Left

A Guild of Handicraft Ltd inkwell, with "rivetted" corner supports, the hinged cover set with a blue, foiled enamel boss, 1906, 2½in (6cm) high, **K**

Above

A Guild of Handicraft Ltd box with enamel by Fleetwood Varley, London. Similar plaques are seen on Liberty pewter boxes. 1904, 6½in (17cm) high, **J**

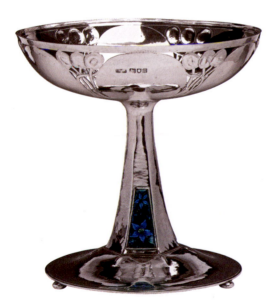

Above

A Guild of Handicraft Ltd round silver box, the lid of which features an enamel ship. 1901, 2½in (6cm) high, **J**

Charles Robert Ashbee

Charles Robert Ashbee was the multitalented visionary behind the School and Guild of Handicraft. Educated at Cambridge University, he trained as an architect with G.F. Bodley in London, and became a key figure in the development of the Arts and Crafts Movement. Highly principled, he believed that a craftsman should understand all elements of the production process and learnt to make metalwork himself. It was as a designer of silver tableware that he excelled, producing sometimes startlingly restrained pieces. However, his principles, the belief that objects should be made by hand in contrast to the mechanized techniques favoured by Liberty, and the relocation of the Guild in 1902 to the peace and quiet of Chipping Camden in the Cotswolds, contributed to its closure in 1907.

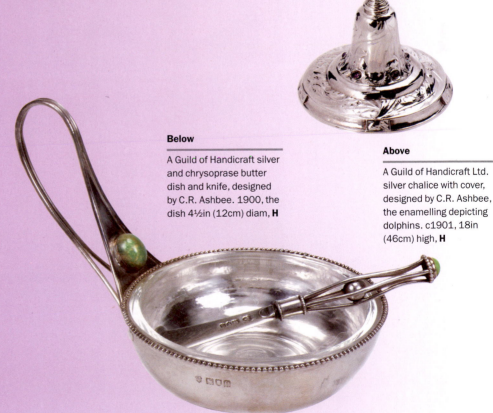

Above

A Guild of Handicraft Ltd. silver and enamel tazza. c1905, 8¾in (22.5cm) high, **I**

Below

A Guild of Handicraft silver and chrysoprase butter dish and knife, designed by C.R. Ashbee. 1900, the dish 4½in (12cm) diam, **H**

Above

A Guild of Handicraft Ltd. silver chalice with cover, designed by C.R. Ashbee, the enamelling depicting dolphins. c1901, 18in (46cm) high, **H**

Ramsden & Carr

Omar Ramsden (1873–1939) and Alwyn Charles Ellison Carr (1872–1940) were born in Sheffield, a city with a long tradition of silversmithing. Ramsden's father's firm, Benjamin W. Ramsden & Company, produced silver-plated table cutlery and in 1887 he began to follow in his father's footsteps when he was apprenticed to a silversmith. It was while taking evening classes at the Sheffield School of Art that he met Alwyn Carr and, in 1897, they left their home city together and moved to London. There they established a successful partnership that lasted until 1919, when they set up separate studios.

Their firm was less radical than other Arts and Crafts workshops and some of the silverware they produced was historicist rather than Arts and Crafts in style. Although their work was often inscribed in Latin "Omar Ramsden and Alwyn Carr made me", they were predominantly designers and employed a large team of skilled craftsmen. However, from 1904 they were members of the Art Workers' Guild and shared a belief in hand craftsmanship. Ramsden could be as critical as C.R. Ashbee of the West End shops that "sometimes pock-mark their otherwise machine-made silver, in order to draw in the chance customer who has been told if a thing is hammer-marked it is hand-made, and artistic".

Those pieces that lie more fully within the Arts and Crafts tradition use sinuous wirework handles, enamel plaques, semi-precious stones, and Celtic interlaced decoration. All are exquisitely hand-crafted.

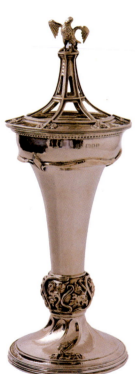

Left

An Omar Ramsden silver cup and cover. 1929, 10½in (26cm) high, **J**

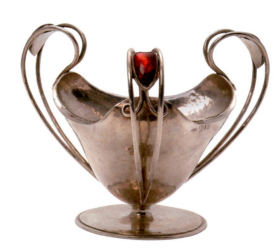

Below

A Ramsden & Carr silver and enamelled bowl, of trefoil shape with three twin-branch wirework handles, each with a red enamelled plaque. 1902, 4¾in (12.5cm) high, **J**

Left

A Ramsden & Carr silver tea urn with an ivory handle and bands of foliate motifs, raised on six lion's paw feet. c1908, 12½in (31cm) high, **J**

Caddy spoons

This is the earliest of the Ramsden & Carr caddy spoons – traditionally used to measure out tea leaves from a tea caddy – illustrated here. It was made in 1906 and features a central red enamelled panel positioned between the heart-shaped scrolls of the handle.

Produced a year later, in 1907, this caddy spoon features an oval blue enamel boss positioned on the openwork stem.

The knotted tendril stem of this silver caddy spoon is set with a single drop-shaped crimson enamelled boss, which mirrors the shape of the silver bowl. It was designed by Ramsden in 1919.

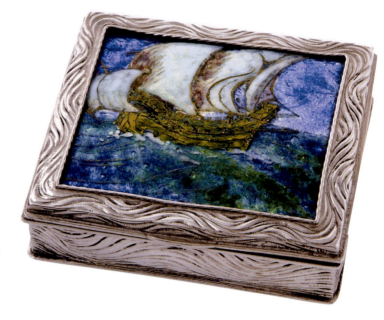

Above

A Ramsden & Carr silver and enamel box. 1907, 3¾in (9.5cm) long, **I**

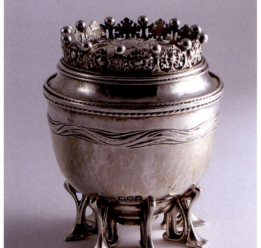

Left

A Ramsden & Carr silver tea caddy, chased with a stylized octopus. 1913 4½in (12cm) high, **I**

Left

A Ramsden & Carr silver tea caddy. This is a fine and rare example, with each panel showing a different plant. 1902, 3¾in (9.5cm) high, **J**

Produced by Ramsden in 1935, after his partnership with Carr had ended, the knotted silver handle is set with three pale green bosses made out of chalcedony – a relatively inexpensive stone.

Birmingham Guild of Handicraft

In 19th-century Birmingham the metal trades, which coalesced in the Jewellery Quarter, were a vital part of the city's growing economy. It is therefore not surprising that the metal workshops of the Birmingham Guild of Handicraft (established in 1890) also thrived.

The metalwares that the Guild produced were very different from the overly elaborate and cheap products that some of the commercial firms offered. As clearly stated in its monthly magazine *The Quest*, the Guild aimed to "supply handmade articles superior in beauty and soundness of workmanship to those made by machinery and to make only such as shall give just pleasure both to the craftsman and to the buyer of them". Following the example of C.R. Ashbee's Guild in London, emphasis was placed on creating simple, hand-

made pieces. first in copper and brass and then, after a specialist silversmith was appointed to the Guild in about 1898, also in precious metals.

The longest serving director of the Guild was Arthur Stansfield Dixon (1856–1929), who produced many designs for bowls, platters, and jugs in base metals, often combining copper and brass in a single piece to great effect.

A scrolling brass handle, for instance, stands out against the simple, hammered copper body of a jardinière.

In 1906 the Guild merged with Gittins, Craftsmen, Ltd, whose chief designer, C.A. Llewellyn Roberts, produced designs for more architectural pieces, such as railings, lamp standards, and radiator grilles.

Right

A circular Birmingham Guild of Handicraft spot hammered silver pot and cover, with a girdle of foliate decoration, on four bracket feet. 1904, 4½in (12cm) diam, **L**

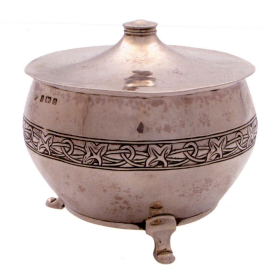

Left

A Birmingham Guild of Handicraft hammered copper jardinière, with brass scroll handles. Mid 1890s, 11in (28cm) high, **M**

Above

A Birmingham Guild of Handicraft copper double inkwell, the twin wells with hinged covers. c1900, 10in (25cm) wide, **M**

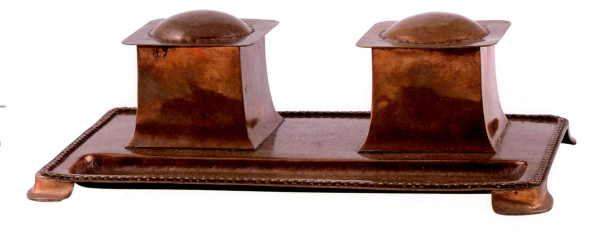

Artificers' Guild

The ripples of influence spread outwards from the Birmingham Guild of Handicraft. In 1903 a one-time director of the Birmingham Guild, Montague Fordham (1864–1948), bought out the Artificers' Guild in London, providing it with a showroom in his successful Fordham Gallery in Maddox Street, London.

The Artificers' Guild had been founded in 1901 in Chiswick by the metalworker Nelson Dawson (1859–1942). Nelson and his wife Edith (1862–1928) were experts in enamelling, Nelson having been taught by the leading enameller of the period Alexander Fisher (1864–1936). However, it was Edward Napier Hitchcock Spencer (1873–1938), rather than Dawson or Fordham, who would have the longest involvement with the Guild. Like many Arts and Crafts metalworkers, Spencer had initially trained as an architect, before going to work for Dawson as an assistant designer. When Fordham took on the Guild, Spencer became its chief designer and then, after Fordham's departure in 1906, the Guild's director.

The Guild was one of the few Arts and Crafts metal workshops that was commercially successful, surviving the First World War and continuing to produce metalwork in the 1930s up until Spencer's death. The workshops in Hammersmith produced a wide variety of pieces in a range of materials. Spencer mixed precious and base metals with more unusual materials such as ivory, and wood. He showed his allegiances when he became a member of the Art Workers' Guild in 1914 and showed his philanthropic aims by apparently employing orphans alongside the skilled craftsmen in his workshop.

Left

An Artificers' Guild Ltd circular silver box and cover, designed by Edward Spencer, with a finial of a lion. 1928, 4in (10cm) diam, **L**

Left

An Artificers' Guild Ltd burnished steel wall sconce, the pierced back plate with hexagonal panels of ball flowers and foliage. c1920s, 12½in (31cm) high, **K**

Right

An Artificers' Guild Ltd silver and copper caddy with bat finial. The base is marked for Edward Spencer. c1931, 5in (13cm) high, **K**

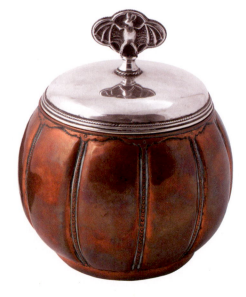

Below

An Artificers' Guild Ltd small tripod silver bowl with punched rim, probably designed by Edward Spencer. 1934, 3in (7.5cm) diam, **L**

Newlyn and Keswick Schools

The Keswick School of Industrial Arts, founded in 1884 by Canon Hardwicke (1851– 1920) and Edith Rawnsley (c1846–1916), and the Newlyn Industrial Class (later renamed the Newlyn Art Metal Industry), established in 1890 by John D. Mackenzie (1861–1918), were separated by miles but shared a common philanthropic purpose. Inspired by the teachings of John Ruskin (1819–1900), they aimed to provide a source of employment in small communities where work came and went with the seasons. At the Newlyn classes, held in a net loft above a fish-curing yard, the pupils were mainly fisherman, while at Keswick (initially in a parish hall at Crosthwaite) pencil makers rubbed shoulders with labourers, gardeners, shepherds, and tailors.

Both metal workshops specialized in the production of repoussé copper work. The fact that this technique and material were popular with amateur craftsmen and women across the country shows it was not overly difficult to learn. A flat piece of soft, malleable copper was placed face downwards on a bed of pitch or, as in the Newlyn workshops, lead. These materials were chosen because they would yield sufficiently to the force of the blows of the punch but would still support the metal nearby. Once the design had been punched out from the reverse the metal was turned over and finer details were chased on the front. Flat copper sheets were turned into simple three-dimensional objects either via folding or using wooden forms and moulds. In the words of Herbert Maryon, the first director of the Keswick School, "upon the visible traces of its method of production a considerable portion of the charm of repoussé work depends".

The motifs used to decorate the metalwares gave them a distinctive local identity. Having left Ashbee's Guild of Handicraft, John Pearson taught repoussé work at the Newlyn School bringing many of his favourite decorative motifs with him, such as fantasy creatures, galleons, and suns. But the wildlife of the local coastline was also to provide an abundant source of imagery.

Right

A Newlyn copper bowl by John Pearson, repoussé hammered with one of his favourite motifs – a sailing ship with a sun-emblazoned sail. 1896, 15in (38cm) diam, **K**

Right

A Newlyn copper tapering square section jug, hammered in relief with a cormorant flanking a central sun motif. 1890s, 7½in (19cm) high, **M**

Keswick School of Industrial Arts

At Keswick it was the landscape and history of the Lake District that provided inspiration. Interlaced patterns were borrowed from the local 17th-century carved oak furniture in the belief that they were Norse motifs.
The exhibitions organized by the Home Arts and Industries Association provided a vital outlet for the sale of metalwares produced in both of these workshops. In addition, the Keswick School had the luxury of a purpose-built showroom from 1894.

Below

A Newlyn copper double wall sconce, hammered in relief with a ship at full sail. 1890s, 15in (38cm) high, **M**

Left

A rare Keswick School of Industrial Arts charger. The rim is hammered in relief with a stag hunt frieze, the well with a Tudor rose. 1890s, 18¾in (47.5cm) diam, **J**

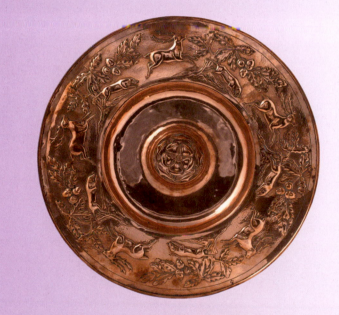

Below

A Keswick School brass wall mirror. The frame is repoussé decorated with stylized flora and wave pattern with knotwork. 1890s, 39½in (101cm) wide, **J**

A.E. Jones

With Albert Edward Jones (1879–1954) we encounter the complex networks of friendship and influences that characterize the Arts and Crafts Movement. Coming from a Worcestershire family of blacksmiths, Jones learnt his trade with the Birmingham firm of John Hardman & Co. (renamed Hardman Powell), ecclesiastical metalworkers that had made pieces for the influential Gothic Revival designer Augustus Welby Northmore Pugin (1812–52). By 1901 he was a member of the Birmingham Guild of Handicraft and although he would set up his independent company a year later he continued to produce work to designs by other Birmingham Guildsmen. In his own workshop he maintained the Guild's emphasis on working by hand, even making his own tools. Once again Ashbee's designs were influential and Jones took pleasure in combining the hammered silver surface with enamel bosses, as shown in the vase illustrated below. However, he would also incorporate ceramic roundels and liners into his metalwares, which were made by the Ruskin Pottery, established in 1898 by Edward Taylor (1838–1911), head of the Birmingham School of Art. In 1902 Jones acquired a process for colouring copper that had been developed by another metalworker, Richard Llewellyn Benson Rathbone (c1864–1939), before being sold to the Faulkner Bronze Company in Birmingham.

Right

An A.E. Jones cylindrical copper and silver tobacco jar. c1911, 5¾in (14.5cm) high, **K**

Left

An A.E. Jones silver and enamelled vase with hammered decoration, the shoulder with four inset cabochons. 1903. 4¾in (12.5cm), **M**

Below

An A.E. Jones sterling silver compote, the hammered and beaded boat-form body with loop handles and leaf medallions. 1917, 5½in (14cm) high, **L**

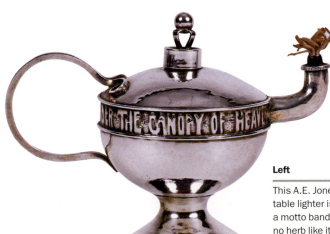

Left

This A.E. Jones silver silver table lighter is chased with a motto band: "There is no herb like it under the canopy of heaven". 1907, 3¾in (9.5cm) high, **M**

W.A.S. Benson

William Arthur Smith Benson, or "Mr Brass Benson" as William Morris (1834–96) called him, was at the centre of the London Arts and Crafts Movement. Having initially trained as an architect, it was Morris and their mutual friend the painter Edward Burne-Jones (1833–98) that persuaded him to open a metal workshop in 1880. Benson was a founding member of the Arts and Crafts Exhibition Society, established in 1888, from which the Movement gained its name and went on to become chairman of Morris & Co. in 1903.

It may, therefore, seem surprising that not far from Morris's own home in Hammersmith, Benson's factory was using machinery, stamping presses, and spinning lathes, to create his metalware designs, often utilizing a series of standard parts. Although the process of manufacture was different to many Arts and Crafts workshops, Benson's core principles were not. He believed in honesty to materials, letting the character of the metal dictate the form, and honesty to the construction method, leaving joints, screws, and rivets visible. The result was simple, graceful, often organic forms, frequently made out of a combination of brass and copper, which was polished to a high shine and given a protective lacquer finish. Benson was, as one contemporary critic declared, "the first to solve the problem of design in metal in the modern spirit".

Left

A pair of W.A.S. Benson copper and brass candlesticks, on tripod foot with floriform motif. 1890–1900, 7¼in (18.5cm) high, **M**

Left

A W.A.S. Benson copper and brass bowl, the vessel formed by curved petals, supported on a brass stem with curved foliate handle and resting on four leaf-shape feet. 1890–1900, 6in (15cm) high, **M**

Below

A pair of copper and brass W.A.S. Benson candlesticks. c1890–1900, 11¾in (29.5cm) long, **J**

Right

A rare W.A.S. Benson cast iron and copper table with circular copper and brass tray top on cast iron tripod base with foliate panels. 1890–1900, 27in (69cm) high, **I**

Scottish School

The Glasgow School of Art played a fundamental role in the development of art metalwork in Scotland. Under the directorship of Francis (Fra) Newberry (1855–1946), teachers such as William Kellock Brown (1856–1934), and Glasgow School graduates Peter Wylie Davidson (1870–1963) and De Courcy Lewthwaite Dewar (1878–1959) taught repoussé metalwork and enamel work. The school equipped students with the skills necessary to establish independent craft studios, many of them based in Hope Street, Glasgow. Davidson, a silversmith who had worked for James Reid and Co., established a studio with his brother at 93 Hope Street sharing a building with Dewar, an expert in enamels. Not far away, at 128 Hope Street, was the studio of the sisters Margaret (1864–1933) and Frances (1873–1921) MacDonald, who had studied at the Glasgow School from about 1890 to 1894. It was there that they met their future husbands, Charles Rennie Mackintosh (1868–1928) and James Herbert MacNair (1868–1955) respectively, and became known as "the Four".

A copper mantel timepiece by Marion Henderson Wilson. 1900–10, 16.5in (42cm) high, **J**

In Glasgow, metalwork was dominated by women. The MacDonalds were not the only sisters to establish studios – Margaret (1860–1942) and Mary (1872–1938) Gilmour taught and produced beaten brass and copperwork at their studio in West George Street. Similarly, Marion Henderson Wilson (1869–1956) produced excellent repoussé metalwork. These Glasgow women were, on the whole, both designers and makers who used base metals, including tin and lead as well as brass and copper, to produce striking effects. The dullness of the beaten tin and lead contrasted with vivid enamels or, in the case of picture frames, delicate works in gouache and pastels.

Their style was brought to a wider audience by Jessie Marion King (1875–1949), who produced designs for Liberty's "Cymric" silver range, and the designer Talwin Morris (1865–1911), who is linked to this group via his friendship with the architect C.R. Mackintosh. Morris moved to Glasgow in 1893 where he became art director for the publishers Blackie & Son. He also designed repoussé metalwork mirror frames, plaques, and inset panels for furniture.

Good

The repoussé peacock motifs decorating this brass wall mirror are similar to those used in the designs of Talwin Morris. However, a mirror frame made by Morris in about 1902 features bolder, more stylized peacocks. 1900–10, 34¾in (88cm) wide, **J**

Better

The sinuous lines of the stylized flower heads are typical of the "Glasgow Style" although the overall effect is less refined than the best Glasgow metalwares. Hammer marks can be clearly seen on the surface of the patinated copper. 1900–10, 22in (56cm) high, **J**

Best

This mirror has a simple elegance to its organic design and the vivid turquoise blue enamel contrasts beautifully with the brass. 1900–10, 23¼in (58.5cm) high, **I**

Masterpiece

This mirror is a masterpiece of Glasgow metalwork. The pink geometric roses were the key motif of the "Glasgow Style" and featured repeatedly in the interiors designed by C.R. Mackintosh and his wife Margaret MacDonald. Here they form part of a striking linear design. 1900–10, 30¼in (77cm) wide, **H**

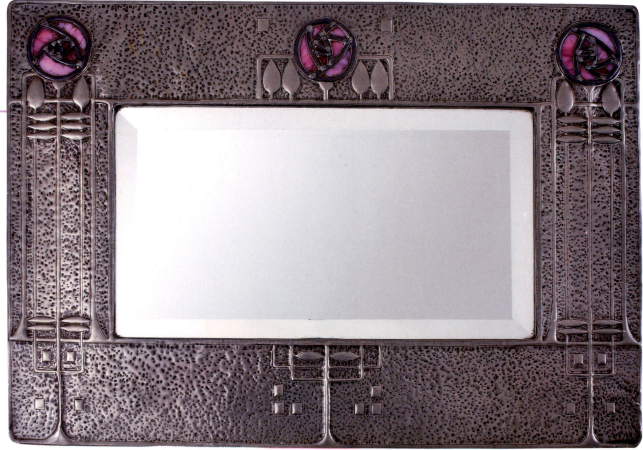

Other British Metalware

Margaret Gilmour (1860–1942)

This silvered brass and enamel wall sconce was designed and made by the Glasgow metalworker Margaret Gilmour. With a night-time theme appropriate for a candle sconce, the repoussé decoration features two owls on a branch. c1910, 29in (74cm) high, **J**

A copper mantle clock made by the Duchess of Sutherland Cripples' Guild, an organization that taught crafts, including art metalwork from 1902, to the children of the Staffordshire Potteries. c1898–1922, 7in (18cm) wide, **L**

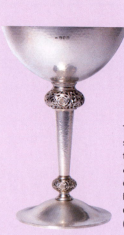

This pewter jug was made by the Sheffield family firm of William Hutton & Sons, a major supplier to Liberty & Co., not long after it had opened a London factory in 1898. The jug is set with turquoise glazed roundels and a turquoise knop. c1900, 8in (20cm) high, **L**

This Irish Arts and Crafts silver goblet was made by the Dublin firm of Wakely & Wheeler. The two knops on the tapered silver stem have scrolling pierced decoration. 1912, 11½in (29cm) high, **J**

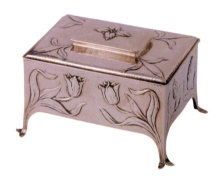

The silverwares produced by the London silversmith Gilbert Leigh Marks (1861–1905) were embossed and chased with flowers, fruit, and leaves, such as the pairs of stylized tulips that decorate the sides of this silver casket. 1898, 5in (13cm) long, **I**

Architecture-trained, John Paul Cooper (1869–1933) was head of metalwork at the Central School of Arts and Crafts in Birmingham from 1904 to 1907. He made this silver waiter, chased with stylized foliate decoration. 1912, 4½in (12cm) diam, **M**

This detail is from one of a pair of embossed copper and oak panels produced by Margaret Thomson Wilson (1864–1912), a member of the Glasgow Society of Lady Artists from about 1893. 13in (33cm) wide, **J**

A silver wine cup designed by Bernard Cuzner (1877–1956) who, in 1910, became head of the metalwork department at the Birmingham School of Art. The cup is inscribed with the phrase "And Still The Vine Her Ancient Ruby Yields". 1903, 4in (10cm) high, **L**

This is a rare cast iron stick stand designed by Talwin Morris. It features stylized heart and leaf motifs and is inset with a tile depicting a "Glasgow Rose", which was probably produced by the Pilkington Tile Co. c1900, 29in (74cm), **J**

The use of nine hand-painted enamel panels on the foot of this silver bowl is typical of the Newcastle Guild of Handicraft (c1890–1910). The Guild was founded in about 1890 with Richard G. Hatton (1865–1926) as head designer. 1907, 7in (18cm) high, **I**

American Silver and Metalware

The influences that shaped American Arts and Crafts metalwares were as diverse as the people and country that produced them. Initially Britain provided one of the "guiding lights", in the form of Charles Robert Ashbee (1863–1942) and the innovative silverwares that were produced by his Guild of Handicraft, first in the East End of London and then in the rural surroundings of the Cotswolds. From 1896, Ashbee crossed the Atlantic for eight lecture tours, while the Guild's metalwares could be seen in exhibitions such as that held by the newly formed Chicago Society of Arts and Crafts in 1898. They inspired the predominantly hand-wrought silverware produced by the Kalo Shop in Chicago and the Handicraft Shop in Boston. Both workshops followed Ashbee's example of moving out of the city – the Handicraft Shop relocated to Wellesley Hills, Massachusetts, while an outpost of the Kalo Shop called the Kalo Art-Craft Community was founded in Park Ridge, Illinois. Unlike the Guild of Handicraft, which closed after five years in the Cotswolds, these workshops returned to Chicago and Boston and continued to flourish.

Arts and Crafts metalworkers also found inspiration closer to home. For émigré silversmiths this could mean the traditions of their home countries, while for others it was the metalwork of America's colonial past or Native American crafts that provided a starting point. Growing private and public art collections, such as those at the Metropolitan Museum of Art in New York, meant that, for example, the arts of ancient China and Egypt were available for radical new interpretation by metalworkers such as Marie Zimmermann (1878–1972). It was not only this melting pot of influences and ideas that made American Arts and Crafts metalwork different from its British counterpart. While in England, Ashbee complained when stores such as Liberty & Co. in London copied his designs and used mechanical mass-production methods, but in America this was an accepted norm. In addition to the smaller independent workshops, the production of Arts and Crafts metalwork became a large-scale commercial enterprise at Gustav Stickley's (1858–1942) Craftsman Workshops in Syracuse and Elbert Hubbard's (1856–1915) Roycroft community in East Aurora, New York. The machine was widely regarded as a useful and efficient tool by American craftsmen and emphasis was often placed on the metalwork looking, rather than actually being, entirely hand-made. Hammer marks, valued by the likes of Ashbee as evidence of hand-work, were often added as a final finish to machine-made wares, and chemicals, lacquers, and waxes were used to create distinctive patinas and a sense of age.

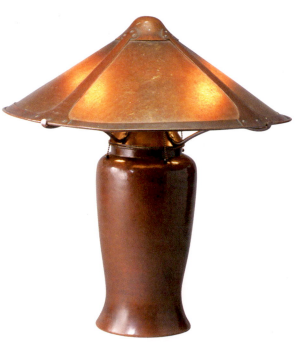

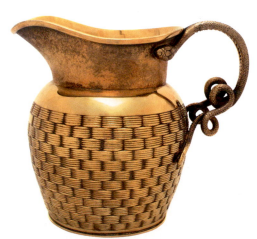

Above

A Roycroft hammered copper humidor, designed by Karl Kipp, with applied nickel details. 1910–15, 6in (15cm) high, **G**

Above

An exceptional early Dirk van Erp (1860–1933) table lamp with a hammered copper milk-can base. c1912, 24½in (62cm) high, **C**

Above

A Tiffany & Co. silver gilt water jug, with all over woven pattern and dual serpent applied handle. c1905, 7¾in (19.5cm) high, **J**

Opposite

The living room of the Log House at Craftsman Farms, the country estate of designer Gustav Stickley, features a copper-hooded fireplace.

Tiffany Studios

In the 1870s the leading silver and jewellery emporium Tiffany & Co. in New York (established 1837) developed an innovative range of hollowware inspired by Japanese objects. The Japanese influence can be seen not only in the choice of motifs, such as carp and irises, but also the technique of applying coloured mixed metals to the hammered silver surfaces – inspired by Japanese sword guards. While in these Japanesque pieces this hammering was a finish, rather than a sign of the construction methods, in the early 20th century Tiffany & Co. developed a range of hand-wrought silver marked "special hand work", which aimed to compete with that offered by smaller Arts and Crafts workshops.

Louis Comfort Tiffany (1848–1933), son of Tiffany & Co.'s founder Charles Lewis Tiffany (1812–1902), was also inspired by the arts of Japan, but in contrast to his father's firm he rarely worked in silver, preferring brass and copper. Metalwares were part of the wide range of decorative art objects produced by the Tiffany Studios (previously called the Tiffany Glass and Decorating Company), which included stained-glass lampshades requiring metal bases and "Favrile" glass, which was incorporated into many of the metalwork pieces, such as the patinated bronze desk sets. The iridescent colours of his glass were matched by his experimental enamel work, which was launched in 1899 at an exhibition at the Grafton Galleries in London. Copperwares were decorated with repoussé work, depicting natural forms, then covered with gold foil and layers of translucent enamel in order to achieve the iridescent sheen. Tiffany Studios produced vases, inkwells, pin trays, boxes, and bowls using this enamel work technique.

Among the rare examples of silver designed by L.C. Tiffany is a silver tea service patterned with stylized lotus leaves in repoussé, which was made specifically for his country estate, Laurelton Hall, Long Island.

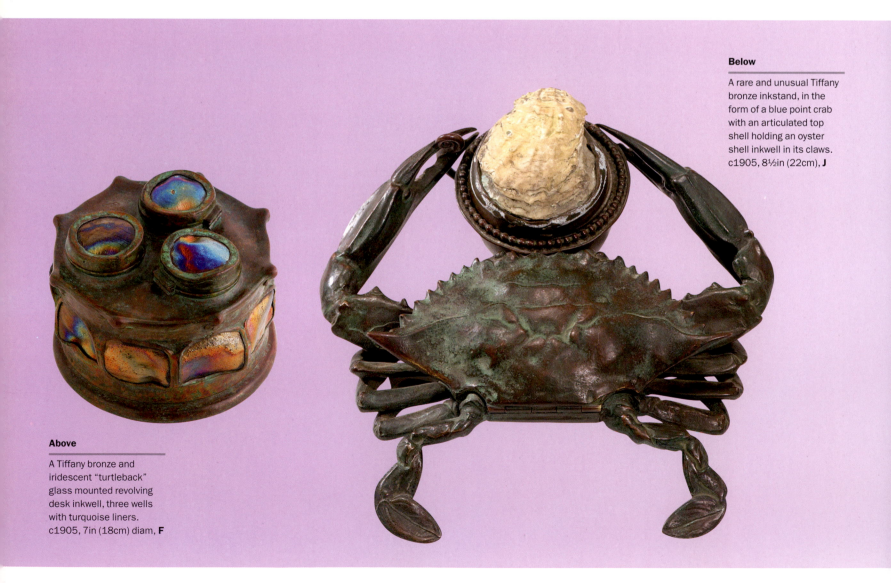

Below

A rare and unusual Tiffany bronze inkstand, in the form of a blue point crab with an articulated top shell holding an oyster shell inkwell in its claws. c1905, 8½in (22cm), **J**

Above

A Tiffany bronze and iridescent "turtleback" glass mounted revolving desk inkwell, three wells with turquoise liners. c1905, 7in (18cm) diam, **F**

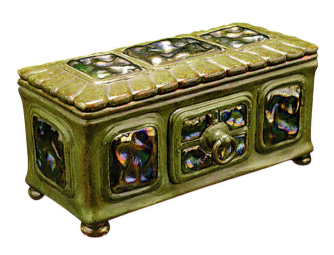

Left

A bronze Tiffany Studios casket inkwell, inset with "Favrile" glass turtleback tiles. The lid houses three pens above a pair of inkwells; the front drawer holds stamps.1906, 8½in (22cm) long, **F**

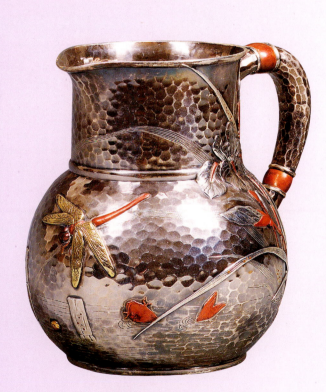

Above

A Tiffany & Co. sterling and mixed metal pitcher, with all-over hammered surface, decorated as a pool with three copper carp and two dragonflies. c1880, 7¼in (18.5cm) high, **E**

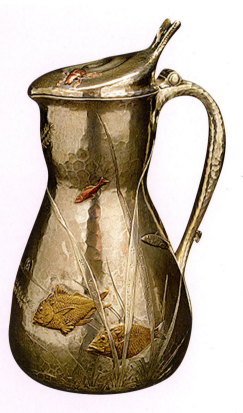

Above

A Tiffany & Co. mixed metal pitcher decorated with fish, with a snake-form handle cast with a faux scale finish, and a cobra hood lid. c1878, 9½in (24cm) high, **D**

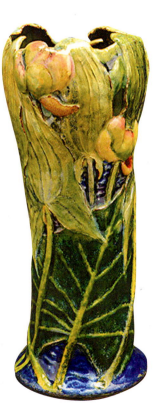

Above

A Tiffany Studios enamel-on-copper "Sagittaria" vase. The upper edges of the plant's leaves delineate the contour of the vessel's lip. c.1901, 9¾in (24.5cm) high, **C**

The Stickley Family

In 1902 Gustav Stickley, an entrepreneur and owner of the Craftsman Workshops (originally called the United Crafts) in Eastwood, Syracuse, New York, began making metalwares to complement his line of simple, sturdy, and affordable furniture. Travelling to Britain the following year, he was inspired by the *Arts and Crafts Exhibition* in London and purchases from the Faulkner Bronze Company of Birmingham. The Craftsman metal shops incorporated such British designs into their repertoire, transforming them into pieces that suited the furniture of the Craftsman house. These pieces were available in showrooms throughout the country and via mail order and were eagerly bought by middle-class Americans, whose tastes were informed by Stickley's monthly periodical *The Craftsman* (published 1901–16). In May 1902 *The Craftsman* promoted Arts and Crafts metalwares, coinciding with the establishment of Stickley's metal shop, and would go on to feature metalworkers such as Robert Riddle Jarvie (1865–1941).

The Craftsman metal shop and Elbert Hubbard's enterprise, the Roycroft Copper Shop in East Aurora, New York, were closely linked by their employees. In 1902 the Roycrofter Jerome Connor (1874–1943) became head of the Craftsman metal shop, while in 1911 Craftsman designer and metalworker Victor Toothaker (1882–1932) became manager of the Roycroft Copper Shop.

The metalwares produced by Stickley's firm are distinctive. Made out of heavy-gauge copper, the surfaces of the vessels are patterned with hammer marks and rivets and have a two-tone patina suited to the tones of his furniture. But Gustav Stickley also had imitators, not least his brothers Leopold (1869–1957) and John George (1871–1921) who established L. & J.G. Stickley in Fayetteville, New York, and would eventually absorb Gustav's company when he went bankrupt in 1915. In Syracuse the small studio known as the Onondaga Metal Shops (OMS) was also producing hand-wrought copper and iron with very similar forms to those produced in the Craftsman metal shop.

Above

An oversized Gustav Stickley copper coal bin. It is stamped with Stickley's guarantee: the Flemish phrase "Als Ik Kan", meaning "As I can". c1910, 19½in (49cm) high, **I**

Above

An unusual Gustav Stickley hammered copper inkwell with riveted base. While old, the applied owl figurine is possibly not original to the piece. c1910, 5½in (14cm) high, **M**

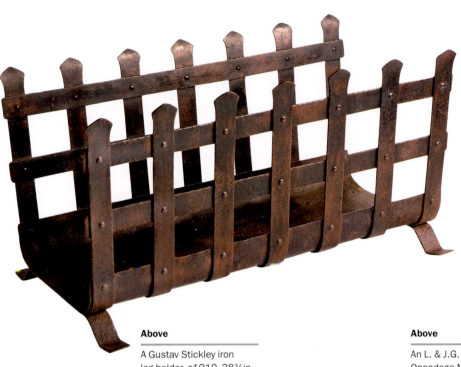

Above

A Gustav Stickley iron log-holder. c1910, 28¾in (73cm) wide, **I**

Above

An L. & J.G. Stickley Onondaga Metal Shops hammered copper coal bucket with embossed floral design. c1910, 16½in (42cm) high, **K**

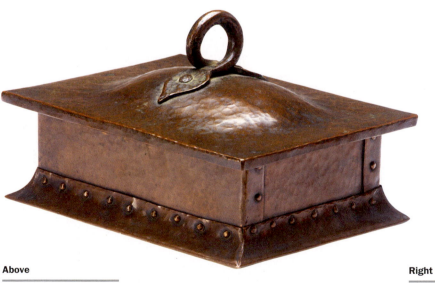

Above

An L. & J.G. Stickley Onondaga Metal Shops hammered copper cigarette box. c1910, 7½in (19cm) wide, **K**

Right

A rare hammered copper vase by the Stickley Brothers, with an unusual design crudely hammered by Russian metalworkers. 1905–15, 14¼in (36cm) high, **L**

Roycrofters

Elbert Hubbard's Roycroft community of craftsmen, based in East Aurora near Buffalo, New York, brought Arts and Crafts metalwares to a mass audience. The marketing techniques he once employed to sell soap for the Larkin Company were used to make the Roycrofters a thriving commercial enterprise. Initially established as the Roycroft Press in 1895, which Hubbard claimed had been inspired by a visit to William Morris's (1834–96) Kelmscott Press in Hammersmith, London, the workshops rapidly expanded. The Copper Shop was opened in 1903 and began producing a wide range of items, including trays, candlesticks, vases, and light fittings that were suitable for every purse. For those that made the pilgrimage to the Roycroft community, a popular tourist attraction, a small item of copperware could be purchased as a memento. But for those that were unable to make the trip there were the mail order catalogues, which made the handicrafts available across the country.

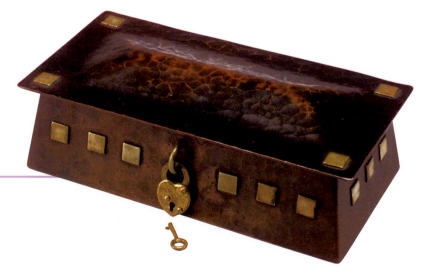

The Roycroft mark, featuring an orb and a cross, was stamped on the company's copper pieces.

Roycroft copperwares were influenced by the geometric designs popularized by the Wiener Werkstätte in Austria and the Glasgow School in Scotland. Roycroft designer Dard Hunter (1883–1966) even travelled to Europe to study these styles in person but these typically European design elements are also found in the work of former banker Karl E. Kipp (1882–1954). Kipp was in charge of the Copper Shop from 1908 to 1911 when he left to establish the Tookay Shop (returning to the Roycrofters in 1915); he was succeeded by Victor Toothaker, who moved to Roycroft from Gustav Stickley's metal shop in 1911. The Viennese and Glasgow Style influences can be seen in the nickel silver bands pierced with squares, which bring simple geometric decoration to the copperwares. The Roycroft pieces are also characterized by their hammer-marked surface, which was enhanced by the reddish-brown patina and the obvious use of rivets.

Good

This is an example of the "American Beauty" vase, which was designed by Victor Toothaker and made by the Roycroft Copper Shop for the Grove Park Inn, Asheville, North Carolina, as part of a substantial order that also included hundreds of light fittings. The original patina enhances the hammered copper surface. c1912, 21in (54cm) high, **J**

Better

This rare Roycroft hammered copper box was designed by Dard Hunter and shows the influence of Viennese Secessionist design in the use of the applied nickel silver squares. The box has its original suede liner, heart-shaped lock, and key. c1915, 6½in (17cm) wide, **I**

Best

Karl Kipp designed this rare hammered copper fernery, or jardinière, made by the Roycroft Copper Shop. A pierced band of nickel silver, hoops, and small ball finials, provide the simple decoration. 1908–11, 6in (15cm) high, 7¼in (18.5cm) diam, **G**

Masterpiece

This superb presentation piece was designed by Karl Kipp and made by the Roycrofters for Henry Clay Meacham (1869–1929), owner of a department store H.C. Meacham Company and mayor of Fort Worth, Texas, from 1925 to 1927. The handle is inscribed "H.C. Meacham" and four jade cabochons decorate the pierced nickel silver bands. 1908–11, 6½in (17cm) high, **E**

Marie Zimmermann

Marie Zimmermann was one of the most experimental metalworkers in America in the first decades of the 20th century. She had trained at New York's Art Students' League and at the Pratt Institute, Brooklyn, before moving into her studio and residence at the National Arts Club, Gramercy Park, in Manhattan in about 1910. She lived there for over 25 years producing an eclectic range of designs for metalwork in a variety of materials – bronze, copper, silver, gold, and iron. She used these metals in striking combinations with enamels, semi-precious stones, and found objects such as carved jade and coral. However, unlike some Arts and Crafts metalworkers, Zimmermann did not create the entire object with her own hands. She relied upon contractors such as the Roman Bronze Works in Greenpoint, Brooklyn, which were specialists in the lost-wax casting process.

The simple and often organic shapes of her vases, vessels, and covered boxes were inspired by a wide range of historic examples, many of which she could have observed in the growing collections of the Metropolitan Museum of Art and the Brooklyn Museum. Although she occasionally borrowed from America's colonial past, it was the arts of the Chinese T'ang period and ancient Egypt that had the greatest appeal. While she looked to China for the forms of her popular petal bowls, Egypt provided the source for patterns and motifs such as the winged scarab.

Zimmermann, more than any of her contemporaries, experimented with colour and finish. Rather than leaving copper, for instance, in its natural state, it could be gold-plated then coated with a protective lacquer or treated with chemicals, paint, and pigmented wax to create different patinas. Many of her vessels were made to look as antique as their prototypes through the application of her "Etruscan" finish or, through the combination of simple forms and dramatic colours, could appear strikingly modern.

Left

A Marie Zimmermann cornucopia-shaped vase in hammered, gold-plated copper, with applied chased leaf forms. 1920s, 10¾in (27cm) wide, **I**

Above

A Marie Zimmermann garden table, the top of petal form in copper with a natural finish, the iron base with curling shaped legs. 1920s, 19¼in (48.5cm) high, **K**

A Closer Look

This box demonstrates the freedom with which Marie Zimmermann mixed materials – carved and painted wood, amethyst, semi-precious quartz, and silver are combined into an elaborate yet cohesive design. 1920s, 12½in (31cm) wide, **C**

The domed lid is studded with cabochon jewels of amethyst and semi-precious quartz.

The silver clasp is in the form of an Egyptian winged scarab beetle, a motif that appears elsewhere in Zimmermann's metalwork, such as on the jewelled finial of her gold-plated copper box.

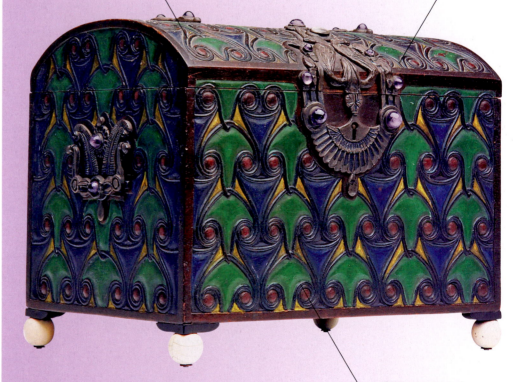

Pattern books such as Owen Jones's *The Grammar of Ornament* (1856) and Franz Sales Meyer's *A Handbook of Ornament* (1898) featured the ancient Egyptian pattern that is the basis for the carving.

Above

A Marie Zimmermann candlestick in gold-plated hammered copper, with fluted flower-form base, twisted stem and fluted candleholder at top. 1920s, 14in (35cm) high, **K**

Below

A Marie Zimmermann rectangular covered box in gold-plated copper. The elaborate jewelled Egyptian-inspired finial is formed as a winged scarab. 1920s, 13in (33cm) wide, **J**

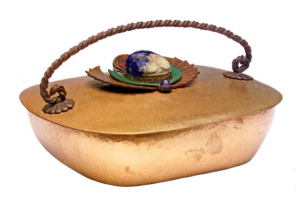

Kalo Shop

The Kalo Shop was central to the development of Arts and Crafts silverwares in Chicago. The name "Kalo" simply means "beautiful" in Greek and the shop's motto was "Beautiful, Useful, and Enduring". The Kalo Shop, as well as its products, was certainly enduring. It was established by Clara Pauline Barck Welles (1868–1965) in 1900 and continued to operate until 1970. In addition to the Chicago shop, from 1905 to 1914 Barck Welles also ran the Kalo Art-Craft Community at Park Ridge, Illinois, before opening a retail outlet in New York (open from 1914 to 1918).

Initially the Kalo Shop produced leatherwares and jewellery, before turning to metalwares in copper and brass and finally specializing in silver hollowware. Clara Pauline Barck Welles had trained at the Art Institute of Chicago and

was responsible for providing the designs that were carried out by skilled silversmiths. The simple water pitcher, below, made out of hammer-textured silver panels with an applied wire rim, is typical of her designs. The only touch of decoration is provided by the multi-lettered monogram. Another popular design was the floriform silver bowls with their scalloped petals, which were produced in at least three different sizes. Although these items were made out of machine-rolled silver, the Kalo Shop was keen to emphasize its handicraft credentials and, by 1910, incorporated the word "handbeaten" into its stamped mark. By 1914 this had been replaced by the word "handwrought".

STERLING
HAND WROUGHT
AT
THE KALO SHOP
G 152 H

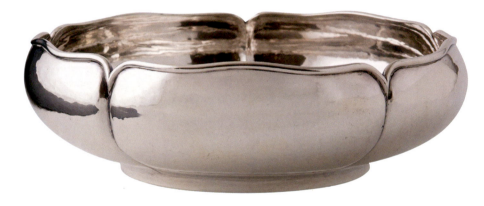

Left

An unusually large version of Kalo's "5811" silver bowl form. This design was made between 1915 and 1970, and produced in at least three differnet sizes. 1940s, 10½in (26cm) wide, **K**

Below

A pair of Kalo silver-gilt candlesticks, monogrammed "M". 1920s, 12in (30cm) high, **J**

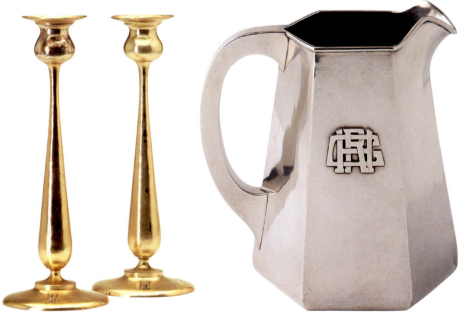

Left

A silver Kalo water pitcher, of panelled form, with hammered surfaces, applied wire to rim, and applied "GRH" monogram. 1914–15, 7¼in (18.5cm) high, **J**

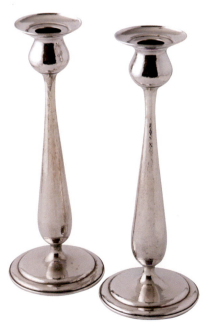

Right

A pair of monumental Kalo silver candlesticks, with stepped circular feet, in tulip form with broad flange at top. c1925, 14in (35cm) high, **I**

Dirk van Erp

Dirk van Erp (1860–1933) honed his skills, first in his family's hardware business in the Netherlands, then as a coppersmith in the San Francisco shipyards. It was not until 1908, 23 years after he moved to America, that he was able to fully explore the artistic side of his craft when he opened the Copper Shop in Oakland, California. He moved the shop to San Francisco two years later and briefly collaborated with the designer Elizabeth Eleanor D'Arcy Gaw (1868–1944), who had trained at the Art Institute of Chicago and at C.R. Ashbee's Guild of Handicraft in England.

Van Erp worked mainly in copper producing hand-wrought, often bulbous, forms with prominent hammer marks, accentuated by the reddish brown and golden patinas. In addition to vases, pitchers, and candlesticks, the shop specialized in table lamps that combined copper bases with mica shades and cast a soft, warm glow. Decoration was used sparingly, but when present it was carried out by his daughter Agatha (1895–1978) and Thomas Arnold McGlynn (1878–1966). In recognition of his Netherlandish roots, the Copper Shop's mark was a windmill.

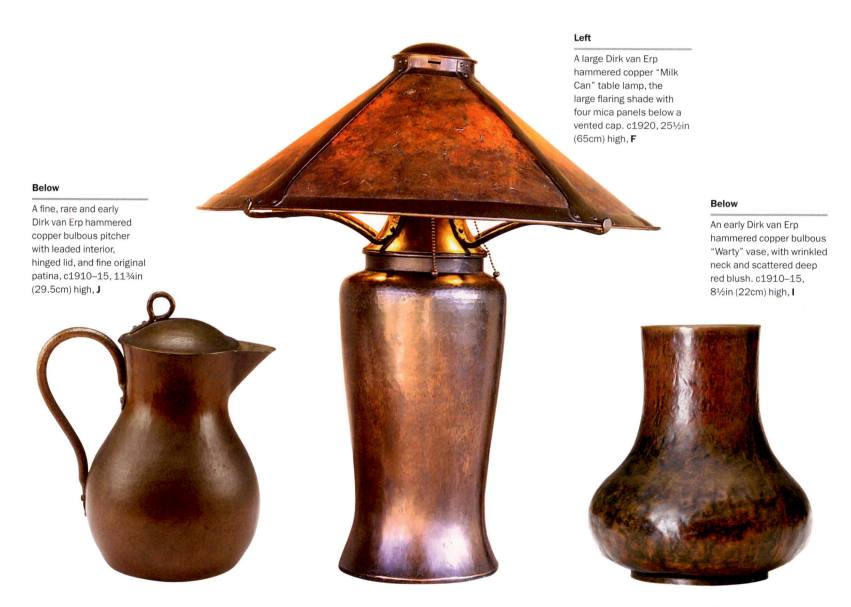

Left

A large Dirk van Erp hammered copper "Milk Can" table lamp, the large flaring shade with four mica panels below a vented cap. c1920, 25½in (65cm) high, **F**

Below

A fine, rare and early Dirk van Erp hammered copper bulbous pitcher with leaded interior, hinged lid, and fine original patina, c1910–15, 11¾in (29.5cm) high, **J**

Below

An early Dirk van Erp hammered copper bulbous "Warty" vase, with wrinkled neck and scattered deep red blush. c1910–15, 8½in (22cm) high, **I**

Jarvie

In the first years of the 20th century Robert Riddle Jarvie (1865–1941), a Chicago city clerk, transformed himself into "The Candlestick Maker". What started as a hobby and an enthusiasm for early American lighting became a successful business with the founding of the Jarvie Shop in 1905. His trademark candlesticks received a great deal of attention. They were featured in the Chicago Arts and Craft Society's exhibition in 1900 and periodicals such as *The Craftsman* and *The International Studio* described the processes by which they were produced.

The candlesticks were cast in brass, copper, and bronze and were given a range of finishes. Brass and copper were brush-polished, which, as *The Craftsman* (1903) explains, "leaves the metal with a dull glow", while the unpolished surfaces of the bronze candlesticks were treated with acids to create a patina described as "permanent green" or "verdegrene". The sinuous, organic

A hammered copper tray.
c1905, 6in (15cm) diam, K

forms of the candlesticks were widely admired and imitated. The International Studio (1904) praised "the exquisite line of design which has given Mr Jarvie an enviable reputation". Each of the designs was identified by a letter of the Greek alphabet, such as the "Iota" candlestick with its tapered stem and bulbous top, and signed "Jarvie" in script.

After 1910 the style of Jarvie's metalware began to change. He started to work in silver and the presentation pieces he created show a wide range of influences, from the Viennese Secessionists to Native American crafts.

Jarvie, born to Scottish parents, also seems to have been particularly receptive to both the geometry and Celtic interlacing that were the distinctive features of the "Glasgow Style". The softer, flowing lines of the candlesticks gave way to geometric forms, as can be seen in the faceted silver pitcher (below left), the style of which recalls the simple silverware produced by the Kalo Shop.

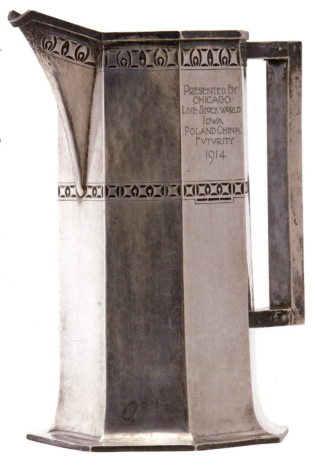

Right

A Jarvie Prairie School faceted silver pitcher, attributed to George Elsmlie. The engraving reads "Presented by Chicago Live Stock World/ Iowa Poland China/Futurity 1914". c.1914, 9½in (24cm) high, **H**

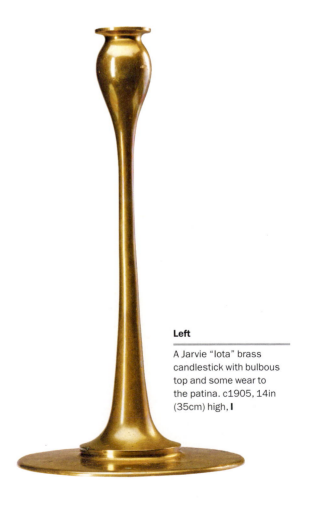

Left

A Jarvie "Iota" brass candlestick with bulbous top and some wear to the patina. c1905, 14in (35cm) high, **I**

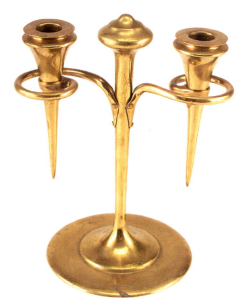

Above

A fine and rare Jarvie "Omicron" two-branch candlestick with conical holders set in spirals, bright finish, and original bobeches. c1905, 10¾in (27cm) high, **J**

Below

A Jarvie brass sconce, with tooled Arts and Crafts design. c1905, 13½in (34cm) high, **J**

Otto Heintz

Otto Heintz (d.1918) and the Heintz Art Metalshop in Buffalo, New York, used experimental and innovative techniques to produce a distinctive range of metalwares. Previously known as the Art Crafts Shop and specializing in copperwares with coloured enamel decoration, by 1906 the shop had been renamed and began to develop the techniques for which it is best known today. Heintz metalwares are made of lathe-spun bronze and decorated with delicate natural motifs in sterling silver, which were applied using a patented technique that did not require solder. These silver overlays are combined with a unique array of patinas in colours from "verde" green to the iridescent red "royal".

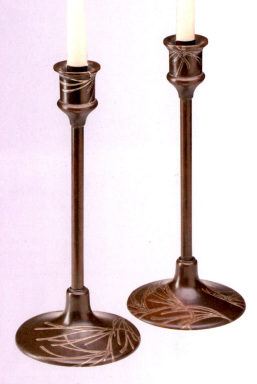

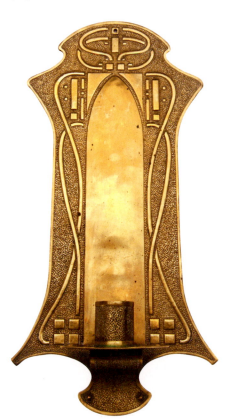

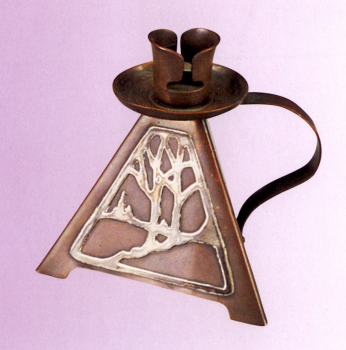

Above

A pair of Heintz silver-on-bronze tall candlesticks in a pine needle pattern on a dark brown ground, with good original patina. c1910, 14¼in (37cm) high, **L**

Left

A rare and early Heintz silver-on-bronze pyramidal chamberstick with landscape overlay. This item marks the transition from Buffalo's Art Crafts Shop to Heintz. c1910, 4in (10cm) high, **M**

Other American Metalware

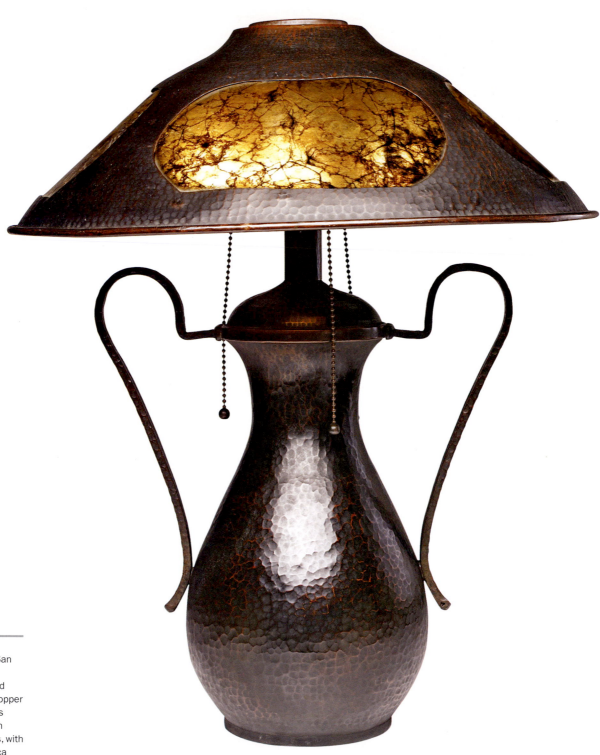

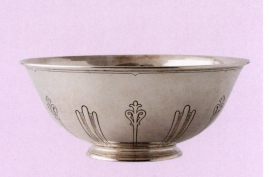

Arthur Stone (1847–1938) trained as a silversmith in his native Sheffield, England, before emigrating to America in 1884 and settling in New Hampshire. He was inspired by early American silver to create simple forms such as this silver bowl, chased with his typical stylized decoration. c1900, 9½in (24cm) wide, **K**

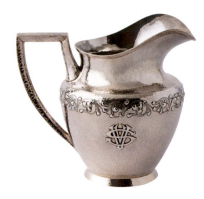

The Chicago department store Marshall Field & Company opened its Craft Shop in about 1904 and produced metalwares in the Arts and Crafts style such as this silver water pitcher, which, as was typical of Chicago hand-wrought silver, features a multi-lettered monogram. The Craft shop closed in about 1950. c1925, 7¾in (19.5cm) high, **K**

This elegantly simple silver fruit bowl, with three cast scroll feet, was hand-wrought by C.G. Forrsen and sold at the Handicraft Shop in Boston, an outgrowth of Boston's Society of Arts and Crafts. 1907, 9¼in (23.5cm) high, **L**

This hammered copper tankard, which incorporates a stag horn handle and arrowheads as decoration, was designed by Joseph Heinrichs (active c1897–1925) in New York and sold by Philadelphia firm J.E. Caldwell & Co. Early 1900s, 8¾in (22.5cm) high, **J**

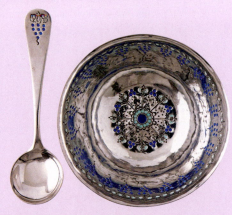

Mary Catherine Knight (1876–1956) was employed as a supervisor at the Handicraft Shop in Boston, which was established in 1901. Leather-working tools were used to produce the design on this bowl and spoon. 1906, bowl 4½in (12cm) wide, **J**

The painted enamel panels on this hammered copper box depict a female figure and deer in a wooded landscape. It was made by Gertrude Twichell (1899–1937), who had trained at the Rhode Island School of Design and was a master craftsman in the Boston Society of Arts and Crafts. c1920, 3¾in (9.5cm) wide, **I**

This repoussé copper sign is for the Pond Applied Art Studio in Baltimore, a short-lived venture run by Theodore H. Pond from 1911 until 1914. Pond was an influential teacher at the Rhode Island School of Design. 1911–14, 16½in (42cm) high, **J**

This large copper candle sconce with its organic design recalls the work of the Carence Crafters in Chicago (operational before 1908, closed 1911), although they were known for their acid-etched geometric and organic designs while here the motif is embossed. c1908–11, 20½in (52cm) high, **L**

Enamelled panels bring decorative interest to these simple hammered copper bookends. They are typical of the art metalwares that were produced in small workshops across Boston, linked together by the Boston Society of Arts and Crafts. c1910, 6¼in (16cm) high, **L**

Jewellery

Arts and Crafts jewellers believed craftsmanship and design were more important that the value of the materials they used. In common with other Arts and Crafts disciplines, they turned their back on the excess of the Victorian era in favour of restrained designs made in simple materials and those which exhibited artistic integrity.

As with other areas of the decorative arts, craftsmen revived ancient hand-working techniques, such as enamelling and hammered finishes, and created pieces based on natural themes, including birds and flowers, with clean, pure lines. Rather than diamonds and other precious stones, they used a variety of colourful semi-precious stones – turquoise, moonstone, pearls, opals, malachite, and coral – in unexpected combinations or together with unconventional materials such as horn, shagreen, ivory, and mother-of-pearl.

Charles Robert Ashbee (1863–1942) was the first to apply William Morris's (1834–96) ideals to jewellery as part of his Guild of Handicraft, but he was soon followed by Archibald Knox (1864–1933), John Paul Cooper (1869–1933), Alexander Fisher (1864–1936), Edith (1862–1928) and Nelson (1859–1941) Dawson, and Arthur (1862–1928) and Georgina Gaskin (1866–1934) among others in Britain.

Women were often at the forefront of this revolution, with talented designers, including Jessie Marion King (1875–1949), Dorrie Nossiter (1893–1977), Phoebe Traquair (1852–1936), Phoebe Stabler (d.1955), and Kate Harris (active c1899–1905) in the United Kingdom, and Clara Pauline Barck Welles (1868–1965) at the Kalo Shop in Chicago, making sophisticated pieces for women like themselves.

Birmingham remained a centre for British silversmithing and craftsmen there produced high-quality jewellery in the Arts and Crafts style. Among them were Arthur Gaskin (1862–1928), the head of the Vittoria Street School for Jewellers and Silversmiths, and his wife Georgina (1866–1934), who created simple yet original hand-crafted gold and silver jewellery in delicate floral patterns set with enamels or semi-precious stones.

Commercial firms such as Liberty & Co. and Murrle, Bennett & Co. mass-produced well-designed pendants, necklaces, bracelets, and brooches decorated with an imitation hammered finish by designers such as Archibald Knox and Kate Harris. In the United States, the "new" jewellery was made at the workshops of craftsmen such as Edward E. Oakes (1891–1960) and Frank Gardner Hale (1876–1945).

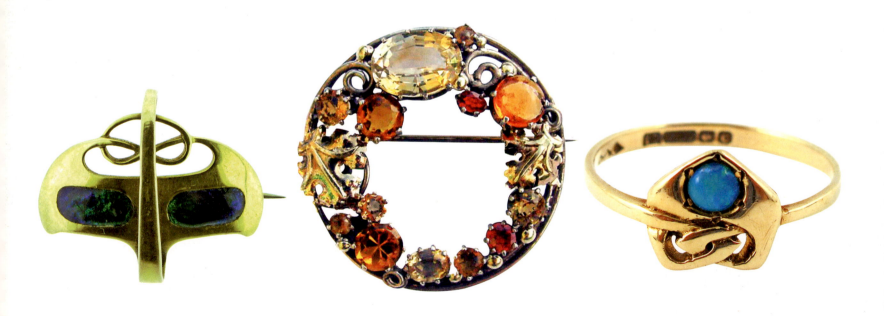

Above

Murrle, Bennett & Co. decorated this simple, symmetrical gold scroll-shape brooch with two enamel panels. c1900, 1in (2.5cm) wide, **M**

Above

This gem-set brooch by Dorrie Nossiter features citrines and other stones of autumnal colours, flanked by golden vine leaves. c1900–10, 2in (5cm), **L**

Above

A Celtic entrelac knot is set with an opal in this Liberty & Co. gold ring designed by Archibald Knox. 1902, **J**

Opposite

This photograph from 1908 shows designer May Morris (1862–1938), the daughter of designer William Morris, wearing Arts and Crafts jewellery.

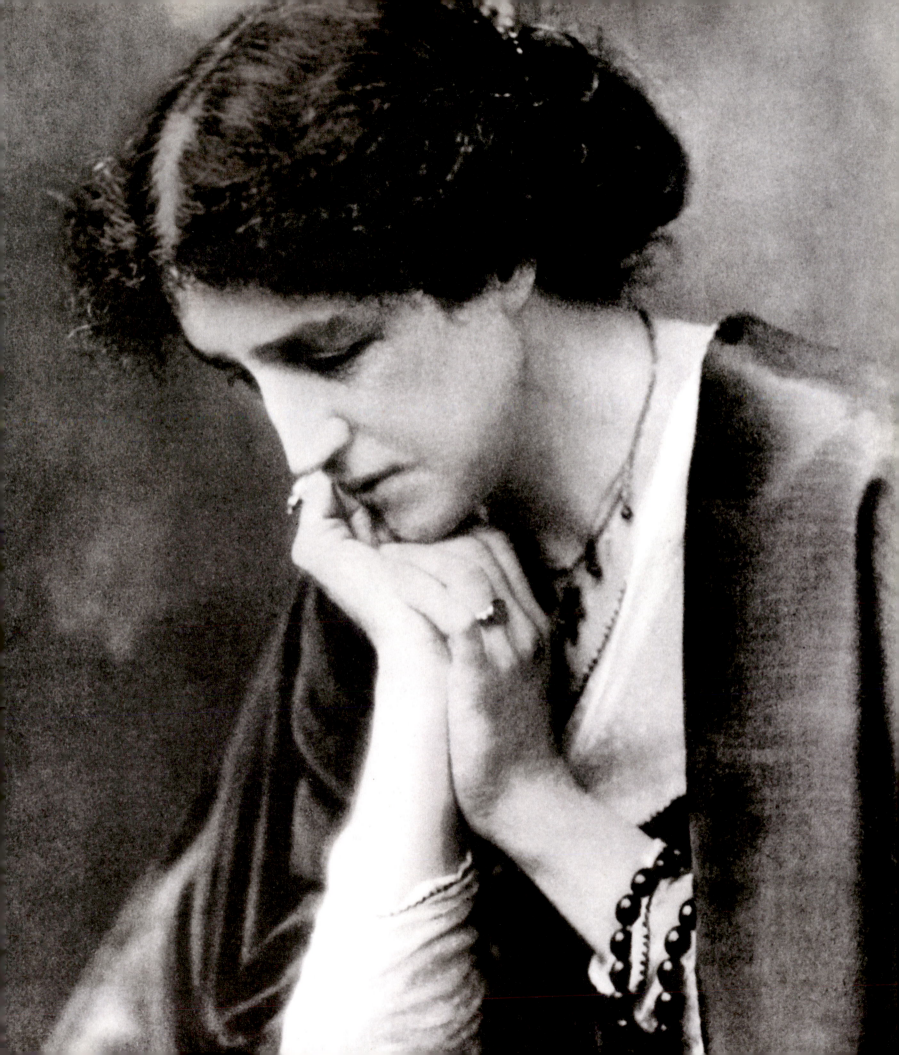

Liberty & Co.

Alongside furniture, metalware, and textiles, Liberty & Co. produced a range of well-designed, mass-produced Arts and Crafts jewellery. Many pieces are in the Celtic Revival style and feature interlaced, whiplash, and natural forms. Liberty commissioned many of the leading jewellery designers to create pieces, although these are rarely signed by the designer. Liberty & Co.'s founder, Arthur Lasenby Liberty (1843–1917), ran design competitions in conjunction with art magazines such as *The Studio* as a means of finding and working with the best designers on a freelance basis.

In 1894 Liberty produced its first Arts and Crafts pieces, persuading the designers to ignore the principle of items being hand-made and instead creating jewellery that could be mass-produced by machine. The pieces were made in silver and gold in the Celtic Revival style and under the name "Cymric". They were advertised as "artistic productions in which the individuality of idea and execution is the essence of the work."

Names linked to the company include Archibald Knox (the inspiration behind the "Cymric" range), Jessie M. King, Murrle, Bennett & Co., and Theodor Fahrner (1868–1928). Pieces can be attributed to a particular designer by comparing them with designs in original Liberty catalogues.

From 1899, Knox was a driving force behind Liberty & Co.'s interpretation of the Celtic Revival style. Born and trained on the Isle of Man, he grew up in

Above

A Celtic knot design silver brooch with blue and green enamel decoration by Archibald Knox. c1900, 1¼in (3cm) wide, **M**

Left

An enamelled gold, garnet, and pearl brooch, designed by Harold Stabler (1872–1945) for the Morton family, which had close trading links with Liberty & Co. c1910, 2in (5cm) long, **K**

Belt buckles

SCROLLWORK
Silver, set with a turquoise cabichon, designed by Oliver Baker (1856–1939) and made in Birmingham. 1900, 2¾in (7cm) wide, **K**

CABOCHONS
Foil-backed cabochon stones and enamel decorate this silver buckle designed by Oliver Baker. 1901, 2½in (6cm) long, **L**

CELTIC KNOT
Celtic knots and large enamel ovals decorate this silver buckle by William H. Haseler, Birmingham. 1907, 2½in (6cm) long, **M**

PIERCED
A silver and enamel buckle designed by Jessie M. King and produced in Birmingham. 1909, 2½in (6cm) wide, **L**

ENAMEL
A silver, enamel, and mother-of-pearl buckle designed by Jessie M. King. Made in Birmingham. 1910, 3¾in (9.5cm) wide, **J**

ENTRELACS
A Liberty & Co. enamelled silver buckle, designed by Archibald Knox, with interwoven entrelacs. c1901, 3in (7.5cm) wide, **L**

Cronkbourne, a model village built on egalitarian, philanthropic principles. This may well have encouraged him to make his designs available to the mass market, in contrast to the rarefied, artisan-crafted products of William Morris. His wares feature restrained designs, often with interlacing, hanging blister pearls, enamel combined with turquoise or mother-of-pearl, and a distinctive "floating" blue and green enamel that was imitated by other manufacturers.

As well as jewellery, Jessie M. King designed ceramics and silver for Liberty's and worked as an illustrator and designer of fabrics, wallpaper, costumes, and interiors. She designed enamelled silver belt buckles reminiscent of designs by Charles Rennie Mackintosh (1868–1928). Her jewellery was set with enamel or

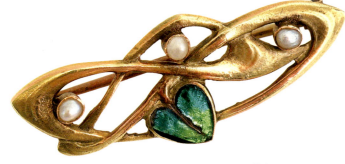

Below

A 9ct gold brooch, with an interlaced design set with enamel and pearls, designed by Archibald Knox and made by William H. Haseler. 1905, 1½in (4cm) long, **L**

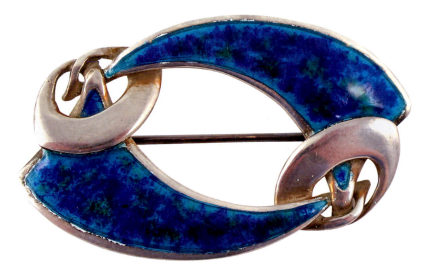

Above

A Celtic knot motif silver and enamel brooch designed by Archibald Knox. c1905, 1¾in (4.5cm) wide, **K**

Right

A silver and gold brooch decorated with enamel. c1900, 1in (2.5cm) long, **M**

WHIP LASH
A sterling silver belt buckle designed by Archibald Knox. 1905, 3¾in (9.5cm) wide, **K**

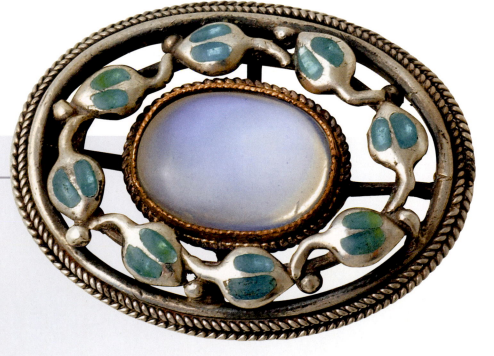

Liberty & Co. (continued)

semi-precious stones and she made some pieces in support of the suffragette movement featuring the colours purple (symbolizing dignity), white (for purity), and green (for hope).

Theodor Fahrner ran a factory in Pforzheim, Germany, from c1883. He produced limited editions of artistically designed, mass-produced gold and silver jewellery highlighted with marcasites and embellished with a variety of semi-precious stones such as blue chalcedony, topaz, and orange cornelian. The designs were in a style known as Jugendstil, which shared some of the ideals of the Arts and Crafts Movement. Fahrner's bold, abstract, modernistic jewellery in geometric shapes won a silver medal at the 1900 *Paris World Fair*

To mass-produce the jewellery, the shapes were stamped from sheets of metal and the hand-hammered surface was created by the die stamp itself, or by the hammer used to clean up the item after stamping. Made in large numbers, pieces were relatively inexpensive at the time.

After 1899 the entire "Cymric" range was made by W.H. Haseler in Birmingham, an established jewellery manufacturer. The companies merged in 1901 to create Liberty & Co. Cymric Ltd and registered the mark in 1903. The partnership lasted until 1927. Despite the success of the Liberty designs they remained a small part of Haseler's output – the Celtic style being too avant-garde for the majority of its consumers. Haseler did, however, produce a few pieces in the Liberty style featuring its own mark (W.H.H.). These were the work of its chief silversmith, Harry C. Craythorn (1881–1949).

Liberty jewellery was also copied by Connell & Co. in London, William Hutton & Sons in Sheffield, and Charles Horner in Sheffield. The latter was the only company to mass-produce jewellery without any hand finishing – the result was a watered-down version of the Liberty style decorated with touches of enamel. Liberty used a number of marks, including "L & C Cymric" and "L C & C Ltd" (from 1893–94), and "Ly & Co" from 1898–1901).

Below

Stylized flowers set with enamel and mother-of-pearl decorate this silver necklace. c1900, 9in (23cm) long, **J**

Below

Blister pearls and stylized swirling motifs form the pendant of this silver repoussé necklace. c1900, 9½in (24cm) long, **M**

Below

Blister and Mississippi pearls and enamel decorate this stylized wing-form silver pendant necklace with a replacement chain. c1900, 12in (30cm) long, **M**

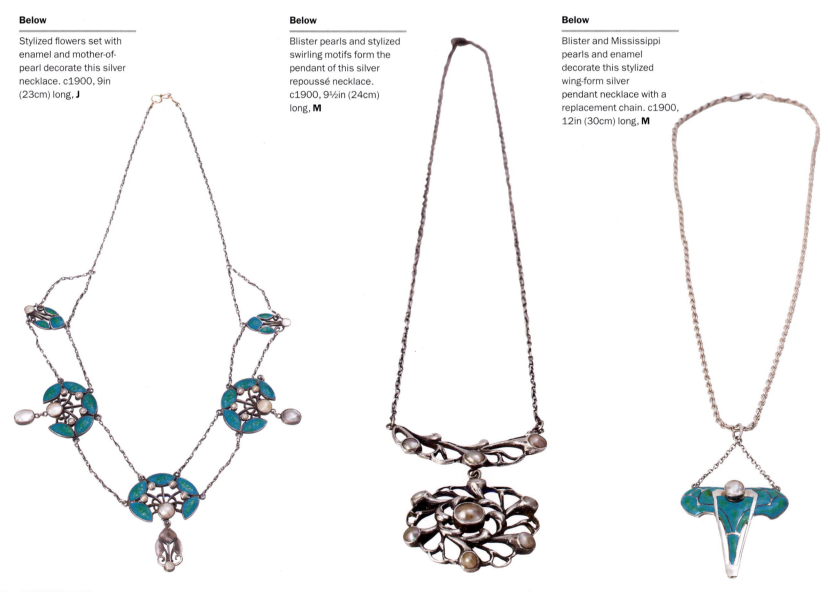

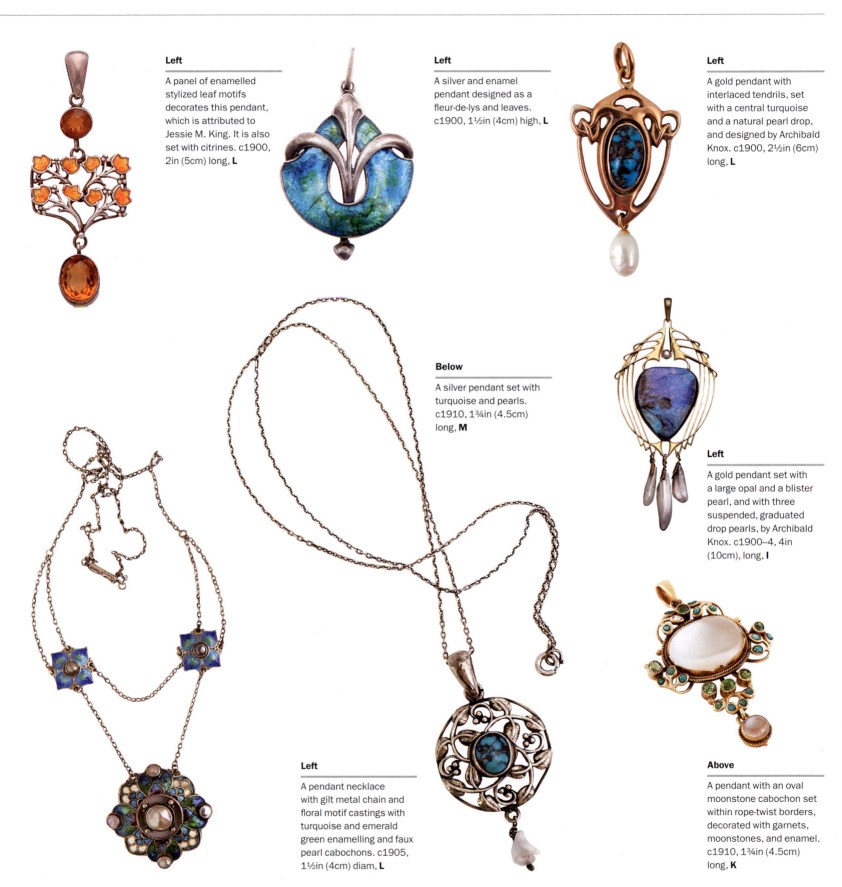

Left

A panel of enamelled stylized leaf motifs decorates this pendant, which is attributed to Jessie M. King. It is also set with citrines. c1900, 2in (5cm) long, **L**

Left

A silver and enamel pendant designed as a fleur-de-lys and leaves. c1900, 1½in (4cm) high, **L**

Left

A gold pendant with interlaced tendrils, set with a central turquoise and a natural pearl drop, and designed by Archibald Knox. c1900, 2½in (6cm) long, **L**

Below

A silver pendant set with turquoise and pearls. c1910, 1¾in (4.5cm) long, **M**

Left

A gold pendant set with a large opal and a blister pearl, and with three suspended, graduated drop pearls, by Archibald Knox. c1900–4, 4in (10cm), long, **I**

Left

A pendant necklace with gilt metal chain and floral motif castings with turquoise and emerald green enamelling and faux pearl cabochons. c1905, 1½in (4cm) diam, **L**

Above

A pendant with an oval moonstone cabochon set within rope-twist borders, decorated with garnets, moonstones, and enamel. c1910, 1¾in (4.5cm) long, **K**

Murrle, Bennett & Co.

At the turn of the 20th century, the London-based wholesale company Murrle, Bennett & Co. was Liberty's main rival as the supplier of Arts and Crafts jewellery. The company used a combination of commercial expertise and innovative designs, from flowing Art Nouveau tendrils to rectilinear German motifs, to produce jewellery styles that would appeal to a wide range of customers.

The firm was founded in 1884 as Siegele & Bennett when the German-born Ernst Mürrle formed a partnership with an Englishman, John Baker Bennett. The company changed its name to Murrle, Bennett and Co. in 1896. It sold affordable, mass-produced gold and silver jewellery inspired by a number of styles, including Liberty's "Cymric" range. It is estimated that 80 per cent of its goods were imported from Mürrle's home town of Pforzheim in Germany – many of these created by Theodor Fahrner and Wilhelm Fühner – where the company had an office. Many of its silver pieces were designed to have a "hand-worked", hammered finish, and often featured translucent enamelling cabochon stones and mother of pearl, used interlaced Celtic motifs, or imitated Austrian Wiener Werkstätte designs, encasing a pearl or turquoise with gold or silver wires.

Although the quality of the jewellery was not always high, its design make it desirable. Some of the most popular ranges included necklaces decorated with enamel, while other pieces had delicately hammer-textured surfaces and simulated rivets. Pieces are usually marked "MB" or "MB & CO"; some also carry the Theodor Fahrner mark (a "TF" in a circle). The company's distinctive designs mean that unmarked pieces can be attributed to the firm as well.

Ernst Mürrle was interned on the Isle of Man in 1914 and was repatriated to Germany in 1916. That year the firm was purchased by some of its British staff and the business continued as White, Redgrove & Whyte.

Left

A cast-silver Jugendstil-inspired pendant with a raised central lozenge of mottled blue and green enamelling, with indented slivers of turquoise enamelling. c1900–10, 1¾in (4.5cm) long, **K**

Right

A German-made silver Celtic-inspired brooch with blue enamel and a fresh water pearl drop. Made in Germany. c1900, 1½in (4cm) long, **K**

Above

A 15ct gold brooch featuring a cabochon amethyst surrounded by entwined Celtic tendrils and set with a seed pearl, made in Germany. c1900, 1½in (4cm) long, **K**

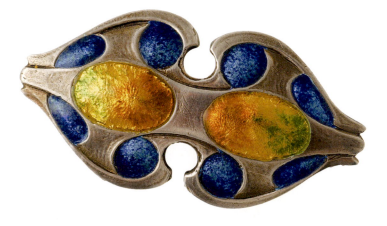

Above

A silver organic-form brooch set with enamel and made in Germany for Liberty & Co. c1900, 1¾in (4.5cm) long, **L**

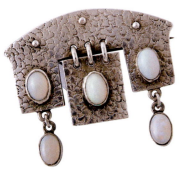

Above

A German-made 15ct gold brooch, with a central turquoise surrounded by coiled tendrils and hung with a pearl drop. c1900, 1¼in (3cm) long, **L**

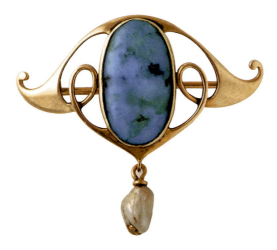

Above

A silver brooch in a German Jugendstil design. The hammered surface is set with three opals and it has two opal drops. Made in Germany. c1900, 1½in (4cm) long, **M**

Right

An enamelled pendant with interwoven loops picked with a similarly enamelled drop. c1900–10, pendant 1¾in (4.5cm) long, **M**

A Closer Look

This silver brooch has been set with a matrix stone and features a fresh water pearl drop. The surface has fine hammer marks that were probably created by machine rather than by hand. Small silver beads were attached to the hammered surface to simulate rivets. The brooch was made in Germany. c1900, 1¼in (3cm) diam, **L**

The looped tendrils suggest earlier Art Nouveau styles and fashionable Celtic motifs.

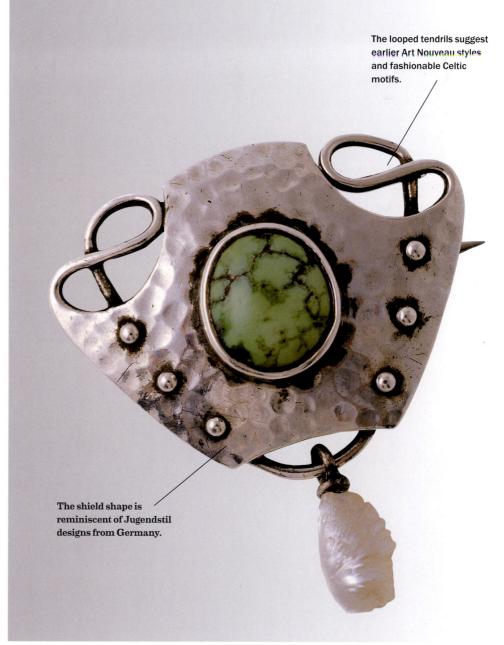

The shield shape is reminiscent of Jugendstil designs from Germany.

Guild of Handicraft

The Guild of Handicraft was founded in 1888 by Charles Robert Ashbee, a disciple of John Ruskin and William Morris who had studied history at Cambridge and architecture under the London architect George Frederick Bodley (1827–1907).

The Guild, which functioned as a cooperative, and its associated School of Handicraft, was based in the East End of London and its aim was to: "seek not only to set a higher standard of craftsmanship, but at the same time, and in so doing, to protect the status of the craftsman. To this end it endeavours to steer a mean between the independence of the artist – which is individualistic and often parasitical – and the trade-shop, where the workman is bound to purely commercial and antiquated traditions, and has, as a rule, neither stake in the business nor any interest beyond his weekly wage."

By 1901, it was able to boast a shop in Brook Street in the West End of London as well as workshops in the East End of the city.

A year later Ashbee decided to realize his dream of getting "back to the land" and relocated the Guild to the medieval town of Chipping Campden in Gloucestershire. There he hoped to escape from the distractions of city life and get closer to the ideal of creating a medieval-style guild of craftsmen.

A simple silver brooch embellished with an enamel pansy. c1902, 1¾in (4.5cm) wide, J

He set up workshops in a former silk mill where workers used traditional hand-working techniques to produce furniture, metalware, stone carving, stained glass, and jewellery.

The simple forms Ashbee chose for his jewellery were radical for their time, used silver wire and relatively inexpensive coloured stones, and – unlike much Victorian jewellery – had no obvious historical precedents. This made Ashbee's work the first distinctly Arts and Crafts jewellery. It earned an international reputation for its hand-hammered finishes and elegant forms incorporating flowing wire-work, with semi-precious stones and enamel.

Many pieces were based on natural forms, some inspired by Renaissance pieces by jewellers such as Benvenuto Cellini (1500–71). Common motifs include peacocks, the sun, ships, the tree of life, stylized foliage, and swirling, interlaced tendrils known as entrelacs.

However, soon after moving to Chipping Camden the fashion for the Arts and Crafts style began to wane and, in 1905 the Guild recorded a loss before going into liquidation in 1908. Some craftsmen stayed in Chipping Camden, while others moved on. Ashbee stayed until 1919, when he went to work in Egypt and Jerusalem; he returned to Britain in 1922, finally settling in Kent.

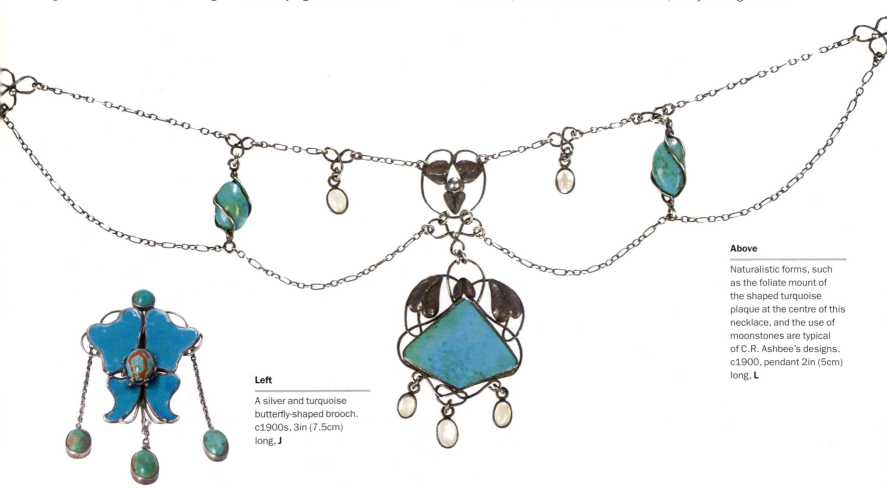

Left

A silver and turquoise butterfly-shaped brooch. c1900s, 3in (7.5cm) long, **J**

Above

Naturalistic forms, such as the foliate mount of the shaped turquoise plaque at the centre of this necklace, and the use of moonstones are typical of C.R. Ashbee's designs. c1900, pendant 2in (5cm) long, **L**

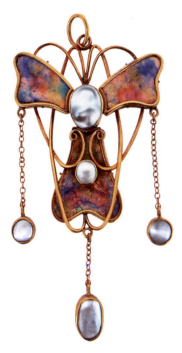

Above

A gold pendant designed in a naturalistic form, with multicoloured enamels and blister pearls. c1900, 2½in (6cm) long, **J**

Below

A silver brooch set with turquoise cabochons. c1900, 2in (5cm) long, **J**

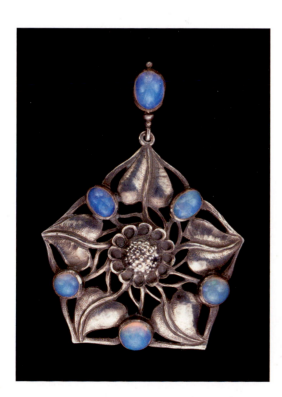

Bernard Instone

Bernard Instone (1891–1987) was born in Birmingham and won a scholarship to the city's Central School of Art at the age of 12. As a young man he worked for a number of jewellers and fought in the First World War before returning to the West Midlands; he founded the Langstone Silver Works in 1920.

The works produced tablewares, but it is celebrated for its jewellery, which was designed for individual clients with great attention to detail and craftsmanship. Every piece is unique and motifs are often taken from the English countryside, or use European designs such as vines or Continental stone inclusions.

Instone wanted his jewellery to be affordabe and so he used semi-precious stones. Many pieces are made in silver rather than gold.

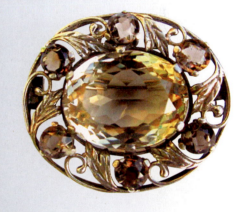

Left

Flowers and leaves surround a cornelian in this silver brooch. c1900, 1½in (3cm) wide, **M**

Above

Slender leaves and pale smoky quartz stones surround the central faceted citrine in this brooch. c1900–10, 1½in (3cm) wide, **M**

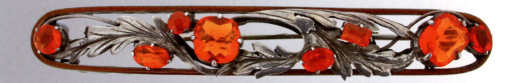

Above

A silver openwork brooch with foliate decoration, set with fire opals and with an orange enamel border. c1925, 3in (7.5cm) long, **K**

Artificers' Guild

The Artificers' Guild was founded in 1901 by the metalworker and enameller Nelson Dawson. His aim was to create uncomplicated jewellery following the principles of William Morris. After just two years, Dawson sold the Guild to Montague Fordham (1864–1948), a former director of the Birmingham Guild of Handicraft, who turned the Guild into a commercial enterprise and displayed its work to great popular acclaim in his gallery in Maddox Street, London.

The simple, high-quality jewellery was decorated with flower and foliage motifs and its designers remained anonymous. As a result pieces are usually stamped with a London maker's mark.

Fordham promoted Dawson's principal designer Edward Spencer (1872–1938) to be the director of the Guild's workshop in Hammersmith, west London. Spencer appears to have been responsible for most of its designs, although the Guild did employ other designers, including the architect and designer John Houghton, Maurice Bonnor (1875–1917) and the architect and metal craftsman John Paul Cooper. At its peak it employed over 40 people, many of them skilled craftsmen who were trained in the workshop.

It was one of the few organizations that was a commercial success, partly due to its ability to respond to fashion. It remained in production until 1938.

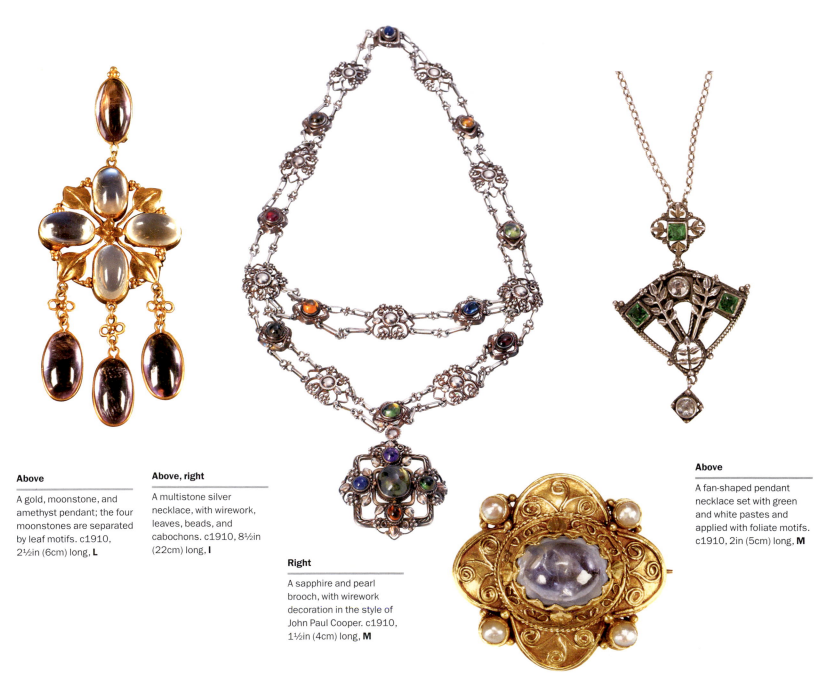

Above

A gold, moonstone, and amethyst pendant; the four moonstones are separated by leaf motifs. c1910, 2½in (6cm) long, **L**

Above, right

A multistone silver necklace, with wirework, leaves, beads, and cabochons. c1910, 8½in (22cm) long, **I**

Right

A sapphire and pearl brooch, with wirework decoration in the style of John Paul Cooper. c1910, 1½in (4cm) long, **M**

Above

A fan-shaped pendant necklace set with green and white pastes and applied with foliate motifs. c1910, 2in (5cm) long, **M**

Ramsden & Carr

Sheffield-born Omar Ramsden (1873–1939) and Alwyn Charles Ellison Carr (1872–1940) were one of the most successful metalworking partnerships of the early 20th century. They moved to London in 1898 where they and their skilled team created distinctive silver and enamel jewellery in Chelsea.

In addition to jewellery, they made individually designed presentation silverware, vases, bowls, boxes, and tea urns in the Arts and Crafts tradition, occasionally incorporating Art Nouveau decorative motifs. Their work was well received and their partnership continued until 1919.

Carr went on to design silver and wrought iron independently and Ramsden stayed at the London workshop and continued to work with the team of craftsmen creating high-quality historically inspired designs. Like most Arts and Crafts designers, Ramsden used hand-hammered finishes and hand techniques such as chasing, repoussé, and pierced embellishment in its place. He also embellished pieces with coloured enamels or hardstones.

Ramsden's designs are usually marked with the engraved or stamped Latin inscription "OMAR RAMSDEN ME FECIT" – Omar Ramsden made me.

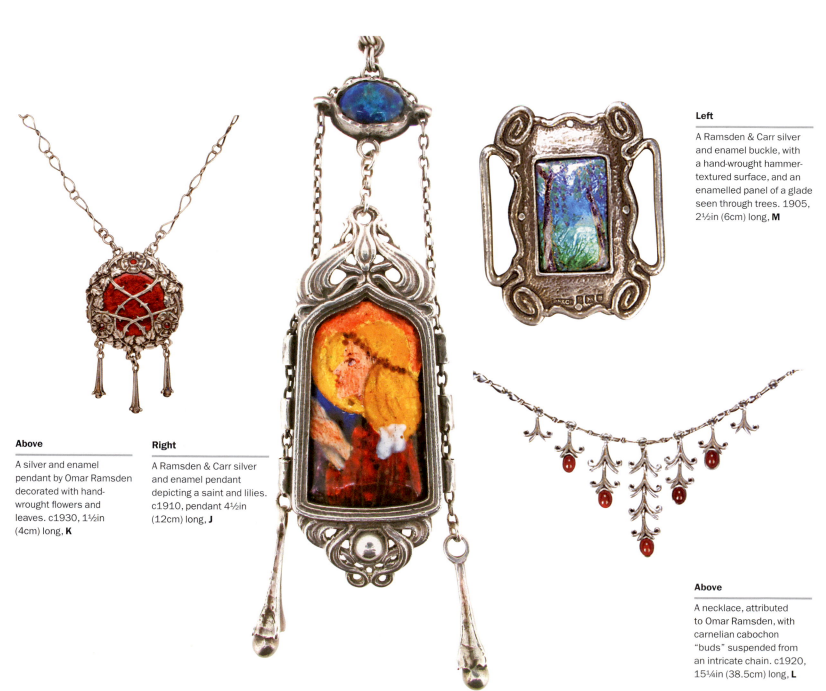

Left

A Ramsden & Carr silver and enamel buckle, with a hand-wrought hammer-textured surface, and an enamelled panel of a glade seen through trees. 1905, 2½in (6cm) long, **M**

Above

A silver and enamel pendant by Omar Ramsden decorated with hand-wrought flowers and leaves. c1930, 1½in (4cm) long, **K**

Right

A Ramsden & Carr silver and enamel pendant depicting a saint and lilies. c1910, pendant 4½in (12cm) long, **J**

Above

A necklace, attributed to Omar Ramsden, with carnelian cabochon "buds" suspended from an intricate chain. c1920, 15¼in (38.5cm) long, **L**

Other British Jewellery

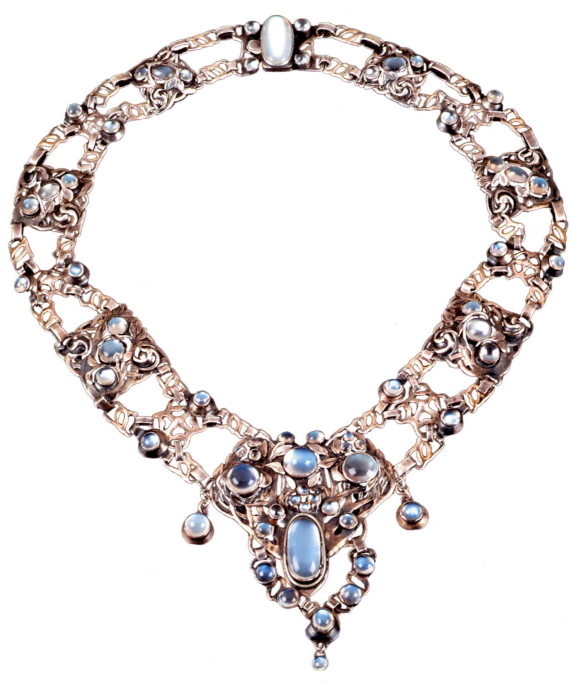

A silver necklace attributed to Frances Thalia How (1880–1940) and Jean Milne (exhibited 1904–17). The shield-shaped pendant has a festoon of moonstone cabochons. c1900, 17in (43cm) long, **I**

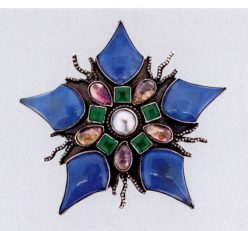

A floral brooch in the style of Sybil Dunlop (1889–1968), set with chalcedony, a blister pearl, chrysoprase, and amethyst-coloured cabochons. 2½in (6cm) wide, **J**

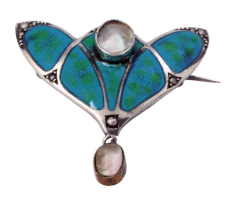

A silver brooch in the shape of an insect's wings with hand-wrought repoussé work, enamel, a blister pearl, and a drop pearl, in the style of James Fenton. c1900, 1½in (4cm) wide, **M**

A silver annular brooch by Gwendoline Whicker (1900–66), set with navette and square cabochon cornelians, against a spiral wire and beaded ground. 1949, 2¼in (5cm) diam, **M**

A silver necklace with sealed butterfly wing pendant necklace with a floral frame, by Henry William King. c1905, 12in (30cm) long, **M**

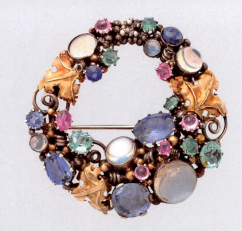

A brooch by Dorrie Nossiter (1893–1977). The hoop frame is decorated with gold leaves, silver scrolls, and beading, and set with cabochon moonstones, sapphires, and pink and green tourmalines. 1¾in (4.5cm) diam, **K**

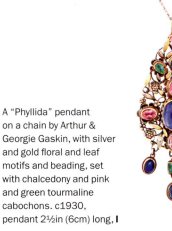

A "Phyllida" pendant on a chain by Arthur & Georgie Gaskin, with silver and gold floral and leaf motifs and beading, set with chalcedony and pink and green tourmaline cabochons. c1930, pendant 2½in (6cm) long, **I**

A gold ring attributed to William Thomas Pavitt, set with a turquoise cabochon between rose, leaf, and tendril shoulders. The shank is decorated with beads and wire. 1909, **L**

A silver pendant necklace by Nelson Dawson (1859–1941), decorated with an enamelled central roundel with a flower. c1900, pendant 2in (5cm), **K**

An enamel brooch by Phoebe Anna Traquair (1852–1936) inscribed "The Kiss", set within a later silver mount by Linda Margaret Hodge. Enamel c1903, mount 1979, the whole 2¼in (5.5cm) across, **I**

Kalo Shop

The Kalo Shop is often regarded as the most important American Arts and Crafts maker of hand-made silverware and jewellery thanks to the wide range of pieces it made, its longevity, and its influence on other designers and makers. It was founded in Chicago in 1900 by Clara Barck Welles, a graduate of the Art Institute of Chicago. From the outset she was determined to create a large, commercial operation, rather than a smaller crafts workshop, and one which would train young women. All her staff were female and at one point she employed more than 25 silversmiths. They created a simple and elegant range of award-winning jewellery in the Arts and Crafts style.

At first, the Kalo Shop created leather goods and weaving, but after her marriage to amateur metalworker George Welles in 1905, she and her students, known as "Kalo girls", added a line of simple and elegant hand-crafted jewellery and tableware to their repertoire.

The name Kalo Shop is derived from the Greek word *kalos*, meaning beautiful, and the company's motto was "Beautiful, Useful, and Enduring". Most pieces were made from silver – although they did sometimes use gold – and like many other Arts and Crafts enterprises usually feature naturalistic decorative motifs such as flowers and leaves, nuts and berries, sinuous Art Nouveau curves, and occasionally stylized geometric shapes. Some designs were set with semi-precious stones, such as moonstones, carnelians, and pearls, and feature a hammered surface texture inspired by the work of C.R. Ashbee.

During the First World War, when silver was scarce, the company concentrated on making jewellery and smaller items – many of these are among its most highly regarded designs. Unlike other silversmiths, the Kalo Shop did not sell co-branded products through department stores. In the late 1920s a line of Danish-influenced items branded "Norse Line", which was intended to be sold through other outlets, was brought to an end by the start of the Depression. These pieces, usually marked with an "NS" in addition to the "Kalo Sterling" stamp, are rare. A loyal clientele helped the Kalo Shop to survive the 1930s – when many similar ventures failed – and it closed in 1970.

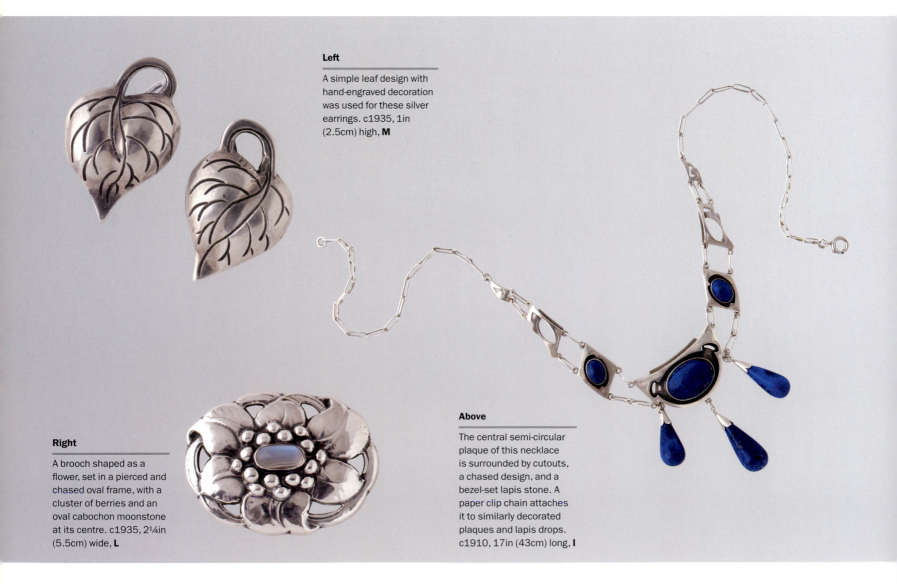

Left

A simple leaf design with hand-engraved decoration was used for these silver earrings. c1935, 1in (2.5cm) high, **M**

Right

A brooch shaped as a flower, set in a pierced and chased oval frame, with a cluster of berries and an oval cabochon moonstone at its centre. c1935, 2¼in (5.5cm) wide, **L**

Above

The central semi-circular plaque of this necklace is surrounded by cutouts, a chased design, and a bezel-set lapis stone. A paper clip chain attaches it to similarly decorated plaques and lapis drops. c1910, 17in (43cm) long, **I**

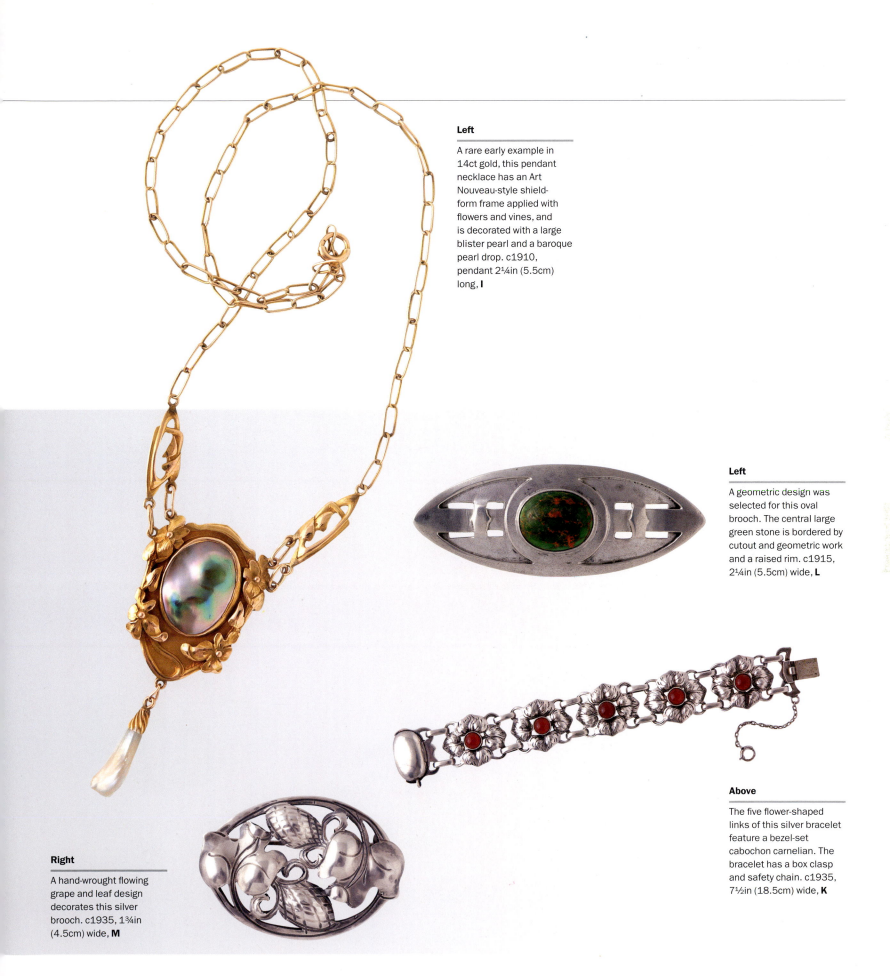

Left

A rare early example in 14ct gold, this pendant necklace has an Art Nouveau-style shield-form frame applied with flowers and vines, and is decorated with a large blister pearl and a baroque pearl drop. c1910, pendant 2¼in (5.5cm) long, **I**

Left

A geometric design was selected for this oval brooch. The central large green stone is bordered by cutout and geometric work and a raised rim. c1915, 2¼in (5.5cm) wide, **L**

Above

The five flower-shaped links of this silver bracelet feature a bezel-set cabochon carnelian. The bracelet has a box clasp and safety chain. c1935, 7½in (18.5cm) wide, **K**

Right

A hand-wrought flowing grape and leaf design decorates this silver brooch. c1935, 1¾in (4.5cm) wide, **M**

Edward E. Oakes

Edward Everett Oakes created imaginative, award-winning jewellery inspired by nature. Although he did not work independently until 1917, he tends to be linked to early 20th-century American Arts and Crafts jewellers thanks to the quality and style of his work. His gold and platinum designs are decorated with naturalistic forms including small leaves and flowers, tendrils, coils, and beads. He used hand-crafted techniques such as wirework sawing, carving, and chasing, and embellished these settings with colourful semi-precious stones in a wide range of hues to create decorative effects.

As a young man he hoped to study at Massachusetts Institute of Technology, but in 1909 he accepted work as the assistant to the jeweller Frank Gardner Hale, who had set up a studio in Boston. He trained with Hale for five years, before going on to work for Josephine Hartwell Shaw (1865–1941). In 1917 Oakes was named a Master Craftsman by the Boston Society of Arts and Crafts, and set up his own studio in the city. His work received two accolades in 1923: a medal of excellence from the Boston Society of Arts and Crafts (the most distinguished award for craftsmen in America at the time); and news that one of his pendants had been purchased by the Metropolitan Museum of Art in New York City for inclusion in its permanent collection (believed to be the first time the museum had acquired a piece from a living American craftsman).

Oakes visited museums to study historic jewellery and used techniques he saw there in his own work. The result was a characteristic style that combined delicate motifs with rich colours and sophisticated finishes often more spectacular than those achieved by jewellers working with precious stones.

Oakes's son, Gilbert, worked for his father and continued the shop after his death. He reportedly said that in his father's vocabulary "casting was used only when fishing with a rod", not in making jewellery. All elements of a design were built by hand with wire, sawed parts, and carved and chased. Almost all of Gilbert's pieces were unique. He wrote: "It is much better to have the design all different when several motifs are used in a bracelet, but have them of the same value so one motif does not stand out more than the other. This is not a new idea but Chinese, as they believe that the first is an exciting experience, the second is labor. They also believe that the more you think, the better you can think."

"The whole duty of a jeweler is to satisfy himself. A true jeweler always plays to an audience of one. Let him start sniffing the air or glancing at the trend machine and he is as good as dead, although he may make a good living. Choose a suitable design and hold to it."

A few pieces are marked with "OAKES" inside an oak leaf.

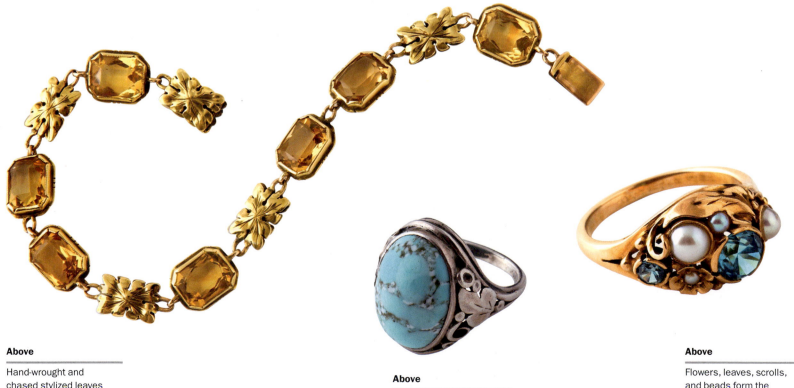

Above

Hand-wrought and chased stylized leaves join together faceted rectangular golden topaz stones in this 14ct gold bracelet. 1920s, 6¾in (17.5cm) long, **I**

Above

Leaves and tendrils support a cabochon turquoise matrix stone set in this sterling silver ring. c1945, ¾in (2cm) diam, **L**

Above

Flowers, leaves, scrolls, and beads form the background for pearls and blue-faceted zircons in this 18ct yellow gold ring. 1925–30, ½in (1cm) high, **I**

Frank Gardner Hale

Frank Gardner Hale was one of the earliest, and most important, American Arts and Crafts jewellers. He became immersed in the theories of the British Arts and Crafts Movement while working with C.R. Ashbee's Guild of Handicraft in Chipping Camden, and in London with Frederick Partridge (1876–1946), in 1906. A year later he set up a studio in Boston where his apprentices included Edward Oakes. All his jewellery was made by hand and was celebrated for the practicality of its settings and links – an issue other designers often failed to address. Pieces were often set with enamels and semi-precious stones.

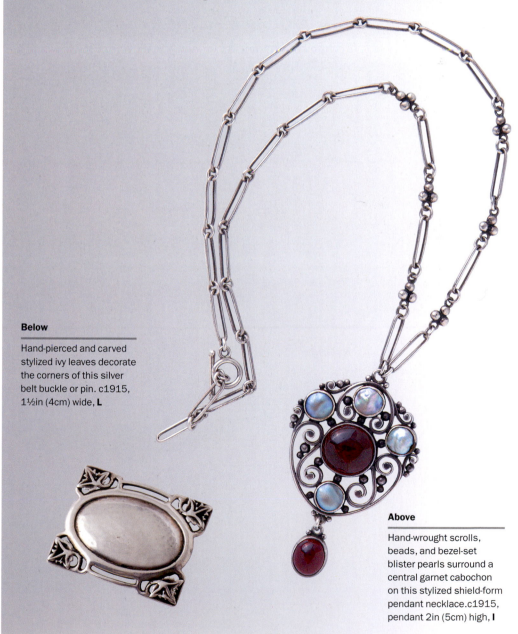

Below

A pair of sterling silver leaf, berry, and tendril earrings by Oakes's son Gilbert. c1950, ½in (1cm) wide, **L**

Above

A heart-shaped purple stone is surmounted by a curving leaf, coiled tendrils, and beads in this brooch by Oakes's student Viven Lyke. c1945, 2in (5cm) wide, **M**

Below

Hand-pierced and carved stylized ivy leaves decorate the corners of this silver belt buckle or pin. c1915, 1½in (4cm) wide, **L**

Above

Hand-wrought scrolls, beads, and bezel-set blister pearls surround a central garnet cabochon on this stylized shield-form pendant necklace. c1915, pendant 2in (5cm) high, **I**

Other American Jewellery

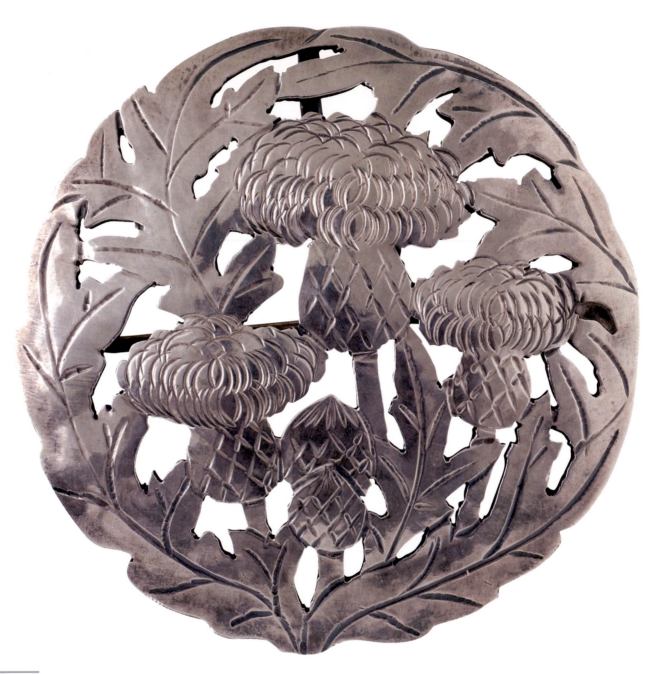

Brooch

A pierced and hand-wrought circular sterling silver brooch decorated with a thistle by the Panis Gallery, Falmouth, Massachusetts. c1940s, 1½in (4cm) wide, **M**

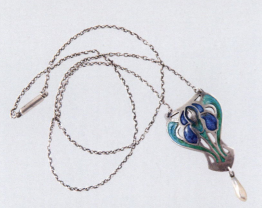

A saw-pierced orchid or iris is embellished with green and purple enamel on this shield-form pendant by the Rokesley Shop. It is further decorated by a pearl drop. c1910, pendant 1¾in (4.5cm) high, **J**

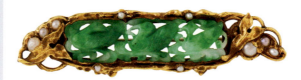

Seed pearls embellish the hand-wrought gold frame of this jade brooch by Potter Mellen Inc., Cleveland, Ohio. c1940, 2½in (6cm) wide, **K**

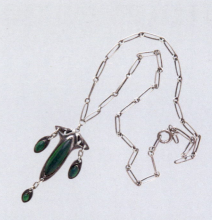

A geometric pierced and tooled silver setting is embellished with oval bezel-set chyroprase stones in this rare Robert Riddle Jarvie (1865–1941) pendant on a paper clip chain. c1915, pendant 2in (5cm) high, **I**

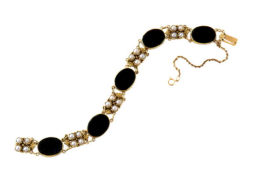

Alternating links of bezel-set oval black onyx stones and smaller links comprised of gold fleur-de-lys with bezel-set pearls connected by tiny gold chain links decorate this hand-wrought 18ct gold bracelet by Margaret Rogers. 1920s, 7¼in (18.5cm) long, **I**

Renaissance jewellery techniques and designs inspired this bi-colour 14ct gold brooch by Marie Zimmerman (1878–1972). An enamelled amethyst glass disc is framed by a row of seed pearls within a row of alternating green-gold leaves and bezel-set blue sapphires. c1910, 1½in (4cm) diam, **J**

The rounded centre of this bar-pin brooch by the Art Silver Shop is set with a bezel-set oval light blue-grey cabochon stone and the flared sides are decorated with chased and applied leaves. c1920, 2¼in (5.5cm) long, **L**

A lifelike three-dimensional silver lily brooch with detailed beaded stamen and chased leaves by Peer Smed (1878–1943). c1930, 2½in (6cm) long, **L**

A symmetrical, naturalistic leaf design was acid-etched onto this brass brooch by George C. Frost. c1915, 2½in (6cm) wide, **M**

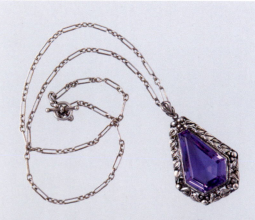

Stylized leaves decorate the silver setting for an amethyst pendant by James Scott of the Elverhöj Craft Colony, Milton-on-Hudson, New York. c1925, pendant 1¾in (4.5cm), **K**

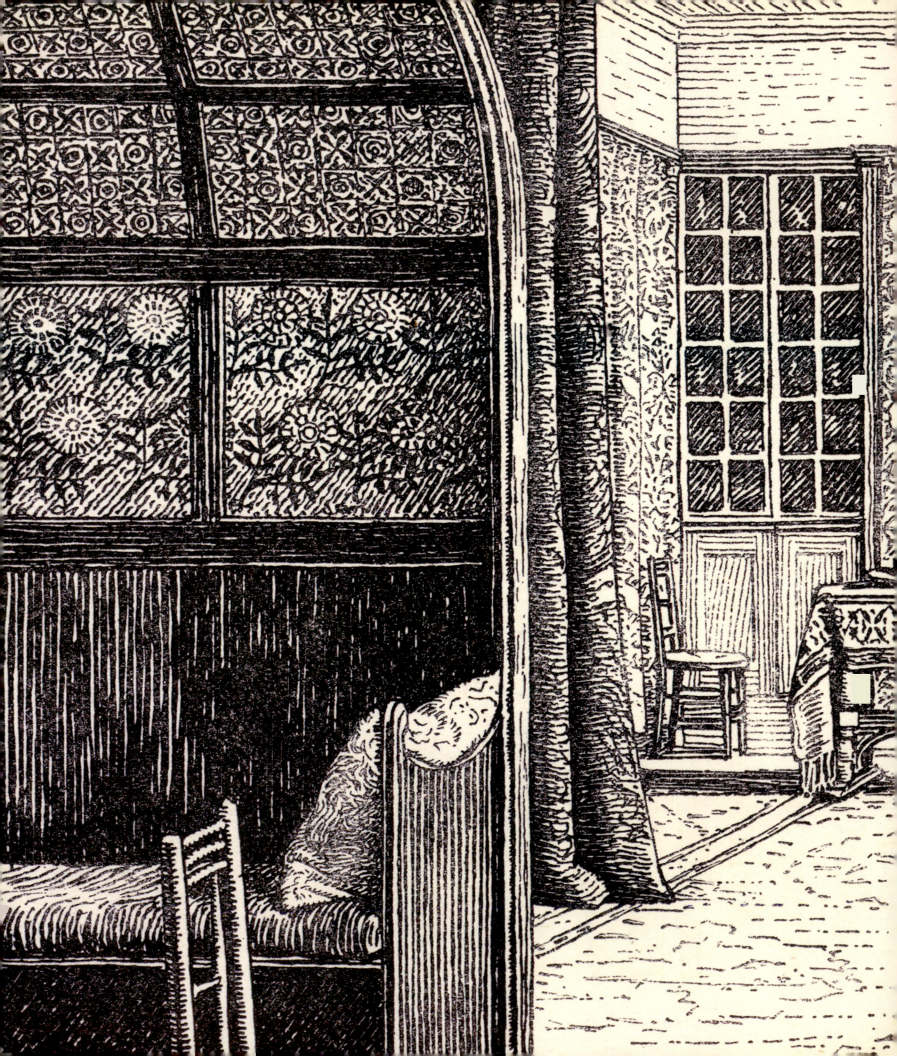

Miscellaneous

Lighting and Glass

Glassmakers had spent centuries trying to refine the quality of their glass by removing impurities. By the 19th century, British firms had perfected a clear colourless lead crystal, decorated with mechanical precision through cutting, engraving, and etching. Arts and Crafts glassmakers such as James Powell & Sons and James Couper & Sons, although highly accomplished technically, rejected the sterile perfection of the Victorian era. Drawing inspiration from the earthy colours and fluid vessel forms of earlier times, they used glass as a more directly expressive and creative medium, deliberately highlighting the fact that their vessels were hand-made. The extreme organic shapes developed by Christopher Dresser (1834–1904) in his "Clutha" range for James Couper, for example, exploited the naturally organic qualities of blown glass.

As well as reviving traditional colours such as green and brown, Arts and Crafts glassmakers developed cloudy, streaky, and bubbled effects. Other textures were created by adding metallic inclusions such as slivers of mica, gold foil, or aventurine. In addition, blobs and trails of molten glass were often applied to the surface in the form of straps, tears or prunts. The American glassmaker Louis Comfort Tiffany (1848–1933) embraced Arts and Crafts concepts, creating boldly experimental eye-catching vessels in exotic hues with a lustrous gold sheen. Some of his pieces were inlaid with millefiori canes, while others were decorated on the surface with bubbled lava-like trails.

Metal mounts were a distinctive feature of Arts and Crafts glass, particularly on bottles and decanters, but also on lighting, which was often made by the same firms, as in the case of James Powell. Forged by hand from materials such as silver, copper, or wrought iron, these mounts were tour de force Arts and Crafts creations in themselves, further enhancing the beautifully crafted lampshades or vessels with which they were combined.

Above

A "Cymric" decanter designed by Archibald Knox (1864–1933) for Liberty & Co. 1903, 10in (25cm) high, **H**

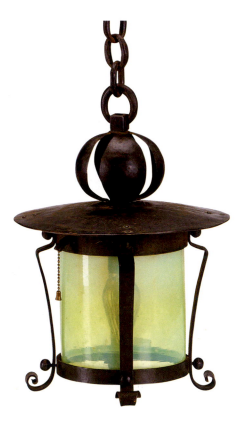

Above

A Gustav Stickley copper, iron and vaseline-glass lantern, designed by Harvey Ellis. c1903, 13½in (34cm) high, **I**

Below

A rock crystal and silver mounted vase designed by Charles Robert Ashbee for the Guild of Handicrafts. 1902, 10in (25cm) high, **J**

Opposite

In 1865, William Morris was commissioned to design the interior of a dining room at London's Victoria and Albert Museum. The windows are by Edward Burne-Jones.

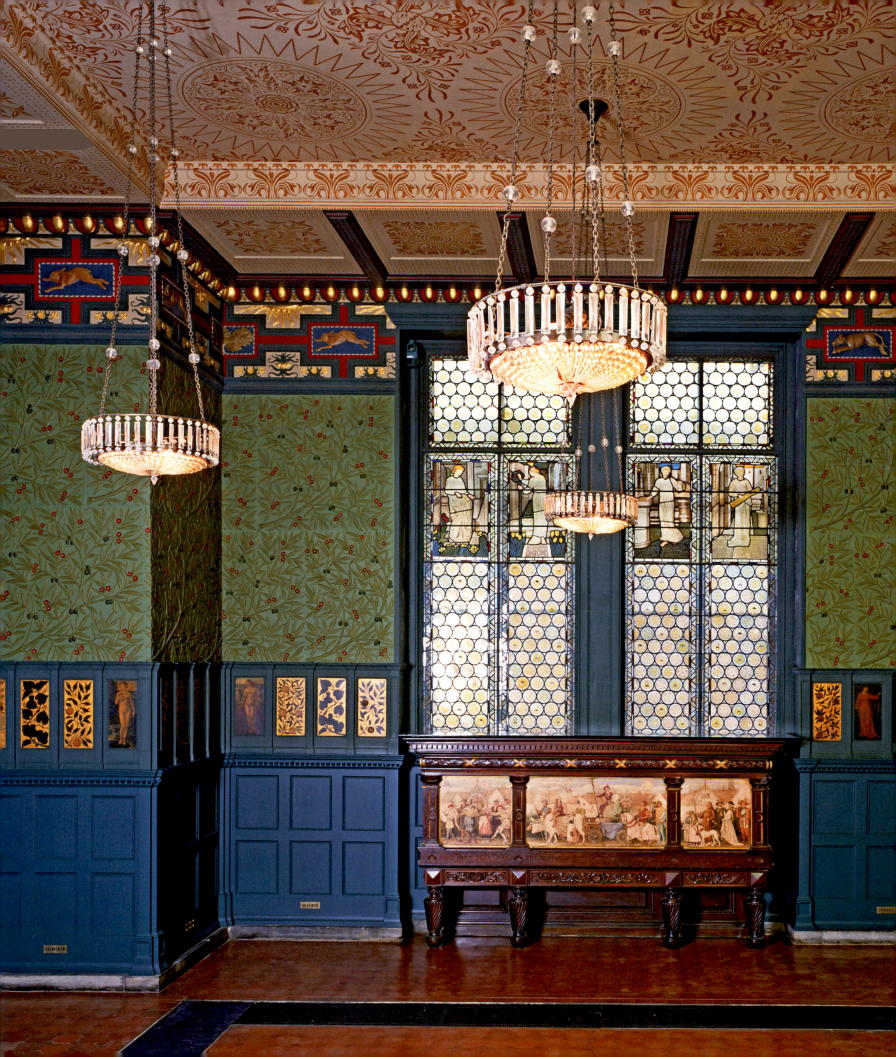

James Powell & Sons (Whitefriars)

James Powell & Sons, also known as Whitefriars Glass, was founded in 1834 by a wine merchant called James Powell (1744–1840), who acquired a small glassworks in the Whitefriars district of London. The company produced scientific and industrial glass, such as thermometers and glass tubing, as well as stained glass and domestic glass. James's three sons – Arthur Powell (1812–94), Nathanael Powell (1813–1906) and John Cotton Powell (1817–1907) – took over after their father's death in 1840. From 1873 to 1919 the factory was run by Nathanael's gifted son Harry James Powell (1853–1922).

The firm's involvement with the Arts and Crafts Movement arose initially through its stained glass. The company was one of the first to revive the vivid stained-glass colours of the medieval period, producing windows by artists such as Edward Burne-Jones (1833–98). In 1860 William Morris (1834–96) commissioned the factory to make a set of table glass for his new home, the Red House, designed by the architect Philip Webb (1831–1915). Radical in its simplicity, the service included drinking glasses with bulged profiles and twisted rod stems, and jugs and tumblers decorated with fine threads. Variants of these designs were later sold through Morris, Marshall, Faulkner & Co. and its successor Morris & Co. A subsequent range designed by the architect T.G. Jackson (1835–1934) for Powell's in 1870 proved lastingly successful.

Harry Powell cemented the company's alliance with the Arts and Crafts Movement after joining the firm in 1873 at the age of 20. An inspired glass designer as well as a pioneering glass technologist, he established Whitefriars as the leading art glassmaker of its day. A chemist by training, Powell developed two heat-reactive opalescent colours, straw opal and blue opal, with graduated cloudy effects. Other pieces were made in dark green, sea green (which was lighter in tone) and a brownish-orange called dark amber. To showcase these colours, he devised new shapes inspired by Venetian glass, including delicate, finely-blown optic-ribbed and wavy-rimmed vases, tazzas and lighting, often with scrolling wrought iron mounts, which were also fabricated at the factory.

His pièce de résistance was his "Glasses with Histories" series, developed

Above

A decanter designed by C.R. Ashbee for the Guild of Handicraft, probably produced by James Powell & Sons. 1903, 8¼in (21cm) high, **I**

Above

A James Powell & Sons Whitefriars straw opal glass basket on a wrought iron mount, probably designed by Harry Powell. 8in (20cm) high, **M**

Above

A decanter engraved with a laurel wreath, designed by Harry Powell for James Powell & Sons. It was based on a Schwarzwald bottle dated 1782. 1904, 11in (28cm) high, **K**

from 1894 onwards, inspired by historical artefacts in museums. Being a polymath, Powell's sources were wide-ranging, encompassing Roman glass, Egyptian gold and faience, and Bronze Age and Minoan pots. These objects provided the starting point for new shapes and decorative motifs reinterpreted in an Arts and Crafts idiom. He also studied vessels depicted in historical paintings, such as the Portinari Altarpiece by the 15th-century Flemish painter Hugo van der Goes (c1440–82), which inspired a set of wine glasses decorated with applied tears.

Glass by James Powell & Sons was exhibited regularly in the Arts and Crafts Society's exhibitions from 1888 to 1916. The firm's turn-of-the-century designs took on the attenuated organic forms and rich streaky colouring associated with Art Nouveau.

The company sometimes collaborated with other leading Arts and Crafts practitioners, such as the metalwork and lighting designer William Arthur Smith Benson (1854–1924) and the silversmith Charles Robert Ashbee (1863–1942), to create exquisite pieces combining metalwork and glass.

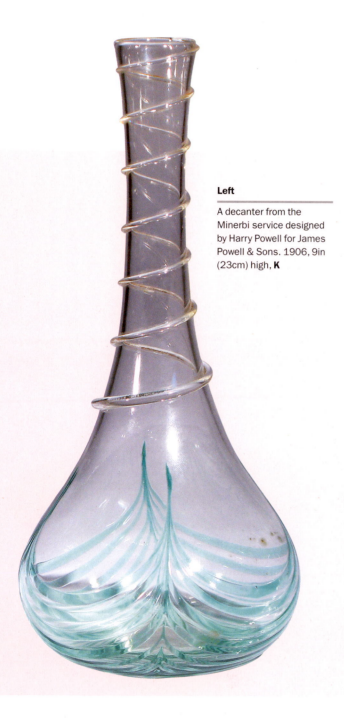

Left

A decanter from the Minerbi service designed by Harry Powell for James Powell & Sons. 1906, 9in (23cm) high, **K**

Above

A rare James Powell & Sons Whitefriars glass inkwell with silver cover, probably designed by Harry Powell. The green glass body has mica inclusions. 1907, 4in (10cm) high, **L**

Above

A vase probably designed by Harry Powell, produced by James Powell & Sons. It contains streaks of white glass and fragments of gold leaf. c1901–10, 10in (25cm) high, **J**

Clutha

"Clutha" was the title of a range of art glass designed by Christopher Dresser for the firm of James Couper & Sons in Glasgow. Registered as a trademark in 1888, "Clutha" was the old name for the River Clyde, which runs through the city. "Clutha" vessels were exaggeratedly fluid and organic with swirled colouring in the glass. The blown forms were often asymmetrical, with indented bodies, attenuated necks, and extra-wide or undulating rims. Drawing loosely on Roman, Persian, and Pre-Columbian vessel forms, Dresser's shapes were prescient of Art Nouveau. Amber, green, brown, and pink were the most common "Clutha" colours, often with white streaks or swags in the glass. Metallic inclusions and bubbles further emphasized the conscious irregularity of the unconventional vessel shapes.

Dresser was not an Arts and Crafts practitioner as such, but he was a highly accomplished and versatile industrial designer, adept at working in a wide variety of media, including ceramics, metalwork, textiles, and wallpapers as well as glass. In the "Clutha" range he encapsulated the essence of the Arts and Crafts ethos – the idea that objects should be individual in character and visibly hand-made – while accommodating the constraints of industrial production. Startlingly original and visual compelling, his "Clutha" vessels were displayed at the third exhibition of the Arts and Crafts Society in London in 1890, and were sold by Liberty & Co. throughout the following decade.

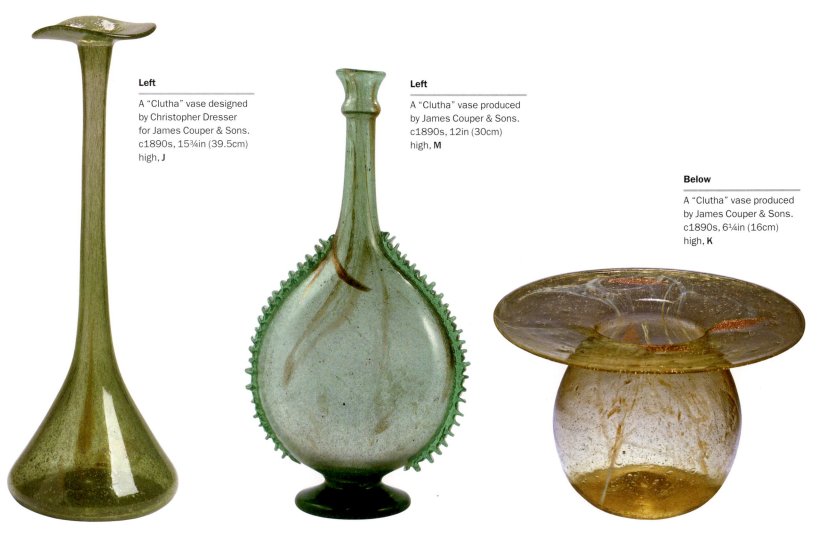

Left

A "Clutha" vase designed by Christopher Dresser for James Couper & Sons. c1890s, 15¾in (39.5cm) high, **J**

Left

A "Clutha" vase produced by James Couper & Sons. c1890s, 12in (30cm) high, **M**

Below

A "Clutha" vase produced by James Couper & Sons. c1890s, 6¼in (16cm) high, **K**

A tall "Clutha" green glass
solifleur vase, designed
by Christopher Dresser
for James Couper & Sons.
c1890s, 19¼in (48.5cm)
high, **J**

A Closer Look

A "Clutha" vase designed by Christopher
Dresser for James Couper & Sons. The extra-
long neck and broad disc-shaped rim are
typical of Dresser's extravagant vessel forms,
which challenge the conventions of standard
proportions. c1890s, 19in (48cm) high, **I**

The "Clutha" trademark
etched on the base is in
pseudo-Celtic lettering.
The "CD" initials refer to
the designer Christopher
Dresser.

The lotus flower motif is
the symbol of Liberty & Co.,
the London department
store that successfully
marketed these avant-
garde designs to their
style-conscious clientele.

The tall neck and broad
disc-shaped rim are typical
of Dresser's style.

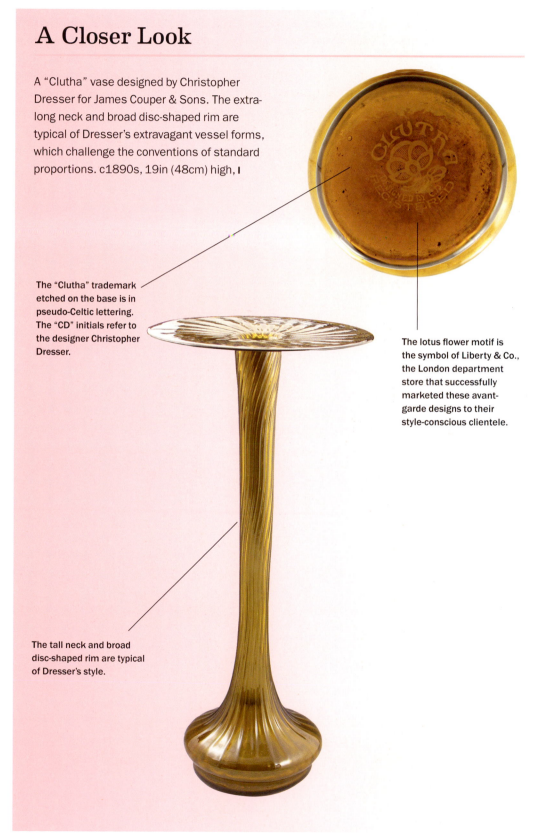

Other British Glass

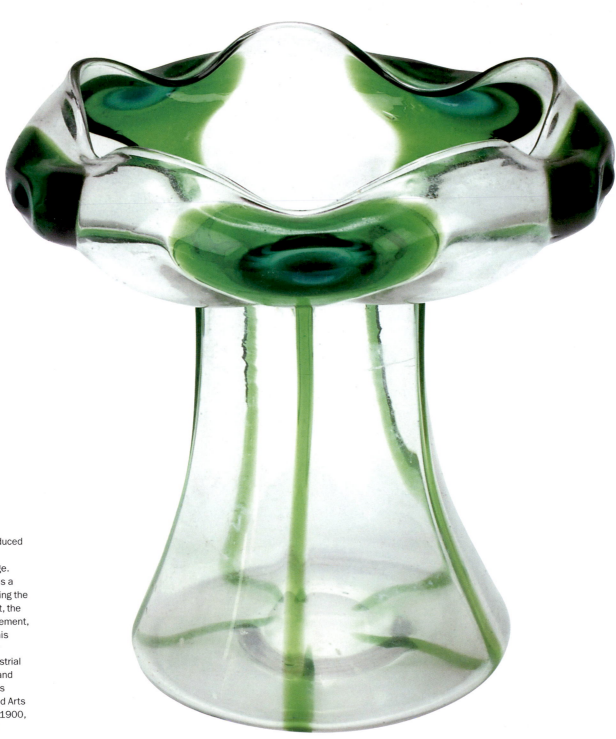

A Peacock vase produced by Stuart & Sons of Wordsley, Stourbridge. Peacock imagery was a common thread linking the Aesthetic Movement, the Arts and Crafts Movement, and Art Nouveau. This vase illustrates how factories in the industrial glassmaking heartland of the West Midlands successfully adopted Arts and Crafts styling. c1900, 9in (23cm) high, **M**

An Archibald Knox for Liberty & Co. pewter and glass claret jug and cover, cast with entrelac motifs. 1904, 8in (20cm) high, **K**

A striated glass vase produced by H.G. Richardson & Sons, Stourbridge, after a design by Christopher Dresser. Late 19thC, 8¼in (21cm) high, **M**

A Liberty & Co Tudric pewter and glass decanter designed by Archibald Knox, model no.0308, cast in low relief with berried, whiplash stems. c1905, 12½in (31cm) high, **K**

A Christopher Dresser tall glass and silver mounted decanter, by Heath and Middleton, with ebonized handle. 1880, 14½in (37cm) high, **I**

A claret jug produced by Norton & White of Birmingham, with applied handle possibly made by Stevens & Williams of Stourbridge, silver collar and lid. 1895, 7½in (19cm) high, **M**

An English glass water jug, the silver mounts by John Grinsell & Sons. 1901, 7in (18cm) high, **H**

A Stevens & Williams decanter, the body cased in green over clear glass and flash cut with classical inspired foliate scrolls and swags. c1900, 10½in (26cm) high, **G**

A silver mounted clear glass claret jug by Norton & White, Birmingham. 1898, 7½in (19cm) high, **H**

A glass claret jug made by John Grinsell & Sons, Birmingham. 1890, 9in (23cm) high, **G**

Tiffany Glass Company

The Tiffany Glass Company was established by Louis Comfort Tiffany (1848–1933) in New York in 1885. It changed its name to the Tiffany Glass & Decorating Company in 1892 and eventually became Tiffany Studios in 1902. L.C. Tiffany, who had originally trained as a painter before pursuing a career as an interior decorator, was the son of Charles Lewis Tiffany (1816–1902), founder of the celebrated New York silver and jewellery store.

Unconventional from the outset, the Tiffany Glass Company specialized in richly-coloured, painterly stained glass for domestic interiors, manufactured initially at the Brooklyn glassworks run by Louis Heidt. It was after encountering the work of Emile Gallé (1846–1904) at the *Paris Exposition Universelle* in 1889 that L.C. Tiffany decided to venture into the field of art glass vessels.

His new range, "Favrile", was launched in 1894. Its unusual name – derived from the archaic English term "febrile", meaning "belonging to a craftsman or his craft" – allied the firm to the Arts and Crafts Movement, which was rapidly taking hold internationally at this date. Tiffany recruited an Englishman called Arthur J. Nash (1894–1934), who had previously managed Thomas Webb & Co.'s glassworks in Stourbridge, to assist him in developing "Favrile". The range was an artistic tour de force, with Nash providing the technical expertise and Tiffany the aesthetic vision. The glass was manufactured at the Stourbridge Glass Company at Corona, Long Island, New York, run by Nash and his two sons, Leslie and Arthur Douglas Nash, which was renamed Tiffany Furnaces in 1902.

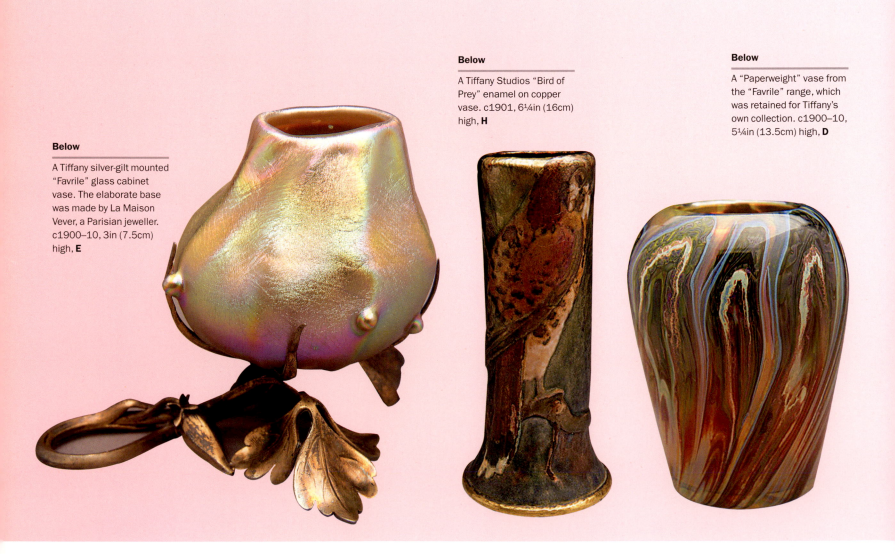

Below

A Tiffany silver-gilt mounted "Favrile" glass cabinet vase. The elaborate base was made by La Maison Vever, a Parisian jeweller. c1900–10, 3in (7.5cm) high, **E**

Below

A Tiffany Studios "Bird of Prey" enamel on copper vase. c1901, 6¼in (16cm) high, **H**

Below

A "Paperweight" vase from the "Favrile" range, which was retained for Tiffany's own collection. c1900–10, 5¼in (13.5cm) high, **D**

Tiffany's "Favrile" vessels were extraordinary for two reasons: their expressive organic shapes, which exploited the viscosity and malleability of molten glass; and their rich colouring and striking iridescent lustres, created by spraying the hot glass with metallic salts. Tirelessly inventive, Tiffany developed a range of Lustre Decorated Ware with threaded and swagged patterns, including peacock feather designs. His "Agate" glass, made by mixing various opaque colours in the pot, sometimes incorporated heat-reactive glass, which changes colour when cooled and reheated. Tiffany's "Lava" glass, with its fractured lustre surface overlaid with large trailing drips, is thought to have been inspired by a visit to Mount Etna. His most complex "Favrile" pieces were the Textured Lustre Wares, decorated with inlaid cross-sections of millefiori canes evoking flowers.

Below

A Tiffany "Cypriote" glass vase, inspired by glass vessels excavated from archaeological sites in Cyprus. c1900–10, 7in (18cm), **F**

Left

This Tiffany Studios "Lava" vase is one of the largest and heaviest examples of its kind. c1900–10, 12½in (31cm) high, **B**

Below

A Tiffany "Lava" glass ewer from the "Favrile" range. Metallic oxides mixed within the glass create an iridescent "lava flow" and black voids. c1900–10, 4½in (12cm) high, **B**

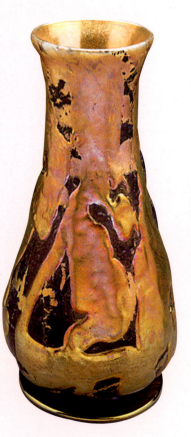

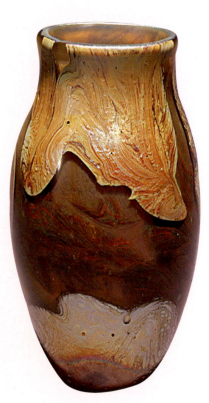

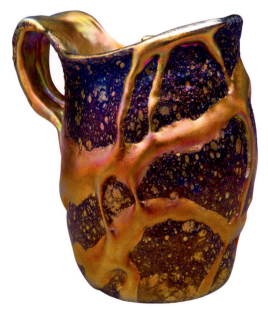

Tiffany Lamps

Lighting was the most successful branch of Tiffany's glassmaking activities from a purely commercial point of view. The lamps for which the company became world famous incorporated the richly coloured stained glass made by the firm since its early days when it specialized in decorative windows. Most of the stands and fittings for these lamps were produced in-house at the company's foundry and metalwork shop.

Tiffany's earliest lighting designs had blown glass shades with similar colouring to his "Favrile" vessels, but it was his mosaic glass shades – resembling stained-glass windows – that made Tiffany a household name. Initially the firm used lead to hold the pieces of glass in place, but this made the lampshades very heavy so a new technique was developed using copper foil. As well as being lighter, this made the frame more malleable. Tiffany's patent on this process lasted until 1903, hence the firm's dominance around the turn of the century.

Constructed like a three-dimensional jigsaw puzzle, the designs were depicted in a remarkably free and painterly way, with the rim of the lampshade sometimes following the outline of the pattern. Flowers such as iris, poppies, laburnum, and wisteria were the most common motifs, along with dragonflies. Apart from the striking designs, it was the vivid colours and varied textural effects in the glass that made these lampshades so arresting. Each lamp had its own distinctive character because the colouring within individual pieces of glass was unique.

In addition to lighting, stained glass, and "Favrile" art glass, Tiffany Studios also made glass mosaics and pressed glass tiles. The company, latterly known as Louis C. Tiffany Furnaces Inc., was dissolved in 1924, but Arthur Douglas Nash (son of Arthur J. Nash), who bought the factory, continued to make Tiffany-style pieces under his own name until it closed in 1931.

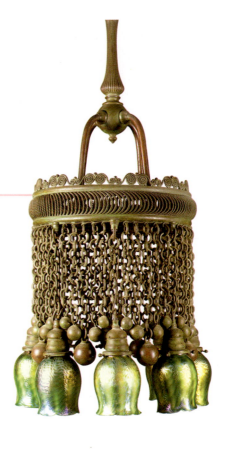

Good

A "Moorish" chandelier designed by L.C. Tiffany. 1900–10, 36½in (93cm) high, **E**

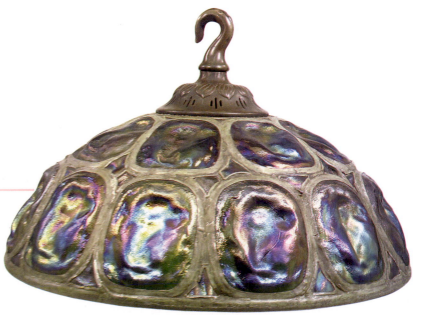

Better

"Turtleback" chandelier produced by Tiffany Studios. 1900–10, 14½in (37cm) high, 22in (56cm) diam, **D**

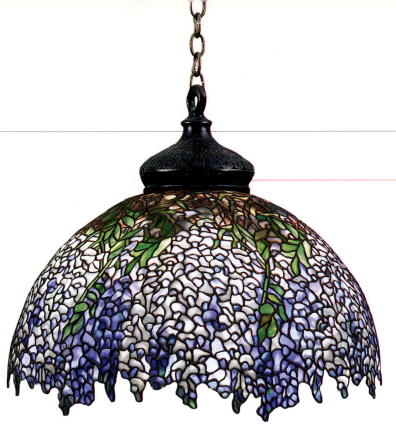

Best

A "Wisteria Laburnum" chandelier produced by Tiffany Studios. This piece is very rare because it combines the "Wisteria" pattern on a "Laburnum" mould. c1910, 24in (60cm) diam, **A**

Masterpiece

An early Tiffany Studios chandelier, commissioned by the First Presbyterian Church of Buffalo, New York. A rare large-scale early piece with complex decoration, the amber glass lampshade is suspended by jewelled chains hung from a six-armed mount. 1895, 68in (173cm) high, **A**

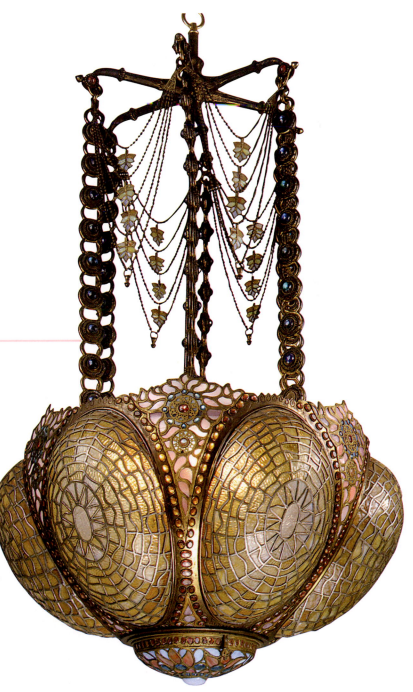

Handel

The Handel Lamp Company was founded in Connecticut in 1876 by Philip J. Handel and Adolph Eydam, although Handel subsequently bought his partner out in 1893. The firm's speciality was domed glass lampshades, reverse-painted on the inside in coloured enamels. Over 500 designs were developed, mainly landscape scenes, sometimes featuring animals or exotic birds. Painted in detail with graduated shading, the images took on a three-dimensional quality when the lampshades were illuminated.

In 1890 the Handel Lamp Company opened a retail showroom in New York and, in 1902, it established its own foundry to produce the metal bases for its lamps. Table lamps with rounded conical shades were the most common pieces. Smaller boudoir lamps and piano lamps were also produced, as well as floor lamps with bell-shaped shades. From 1904 onwards Handel began to produce leaded-glass lampshades, inspired by those produced by Tiffany, but simpler and more affordable. The firm's "Teroca" lamps, made from slag glass (opaque pressed glass with streaky colouring, also known as marble glass) with metal overlay patterns, were launched in 1906.

After Philip's death in 1914, his wife Fannie and subsequently, in 1919, her husband's cousin William H. Handel, took over the running of the firm. Following a fall from fashion, in 1925 Handel's New York showroom closed and the company ceased trading in 1936.

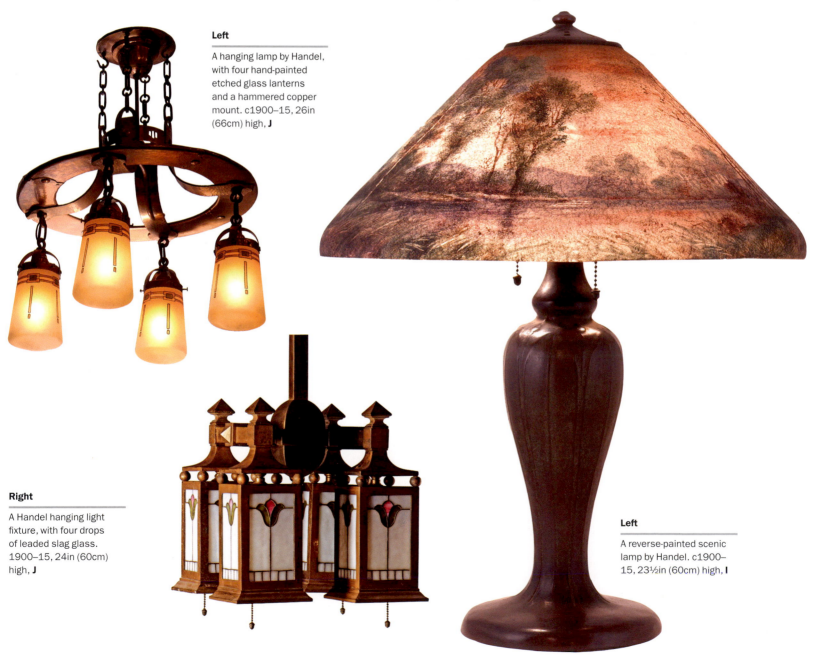

Left

A hanging lamp by Handel, with four hand-painted etched glass lanterns and a hammered copper mount. c1900–15, 26in (66cm) high, **J**

Right

A Handel hanging light fixture, with four drops of leaded slag glass. 1900–15, 24in (60cm) high, **J**

Left

A reverse-painted scenic lamp by Handel. c1900–15, 23½in (60cm) high, **I**

Roycroft

The Arts and Crafts community of Roycroft was founded in 1895 by the idealistic Elbert Hubbard (1856–1915) at East Aurora in New York State. Active until 1938, Roycroft was the largest alliance of its kind in North America, with over 400 members at its peak. Like fellow Arts and Crafts advocate Gustav Stickley, Hubbard was a disciple of John Ruskin and William Morris. His ideas were also shaped by the American writer Henry David Thoreau (1817–62).

The Roycroft workshops encompassed a wide range of disciplines, from furniture-making, printing, and book-binding, to metalwork, china-painting, and leaded glass, the last a significant feature of its lighting. As well as being sold directly, Roycroft's products could be purchased by mail order, a typically American form of retailing prompted by the vastness of the country.

Renowned for its high standards of craftsmanship, Roycroft nurtured innovative modern design. Dard Hunter (1883–1966), who was one of its most notable designers, was part of the community from 1904 to 1910. He introduced avant-garde ideas from Europe, notably the Viennese Secessionist style. Although Hunter's main field was graphics, he also created designs for lighting, including leaded-glass lampshades with geometric patterns influenced by the Austrian architect Josef Hoffmann (1870–1956).

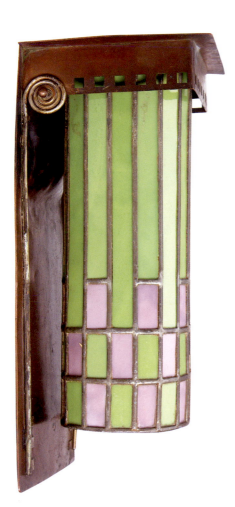

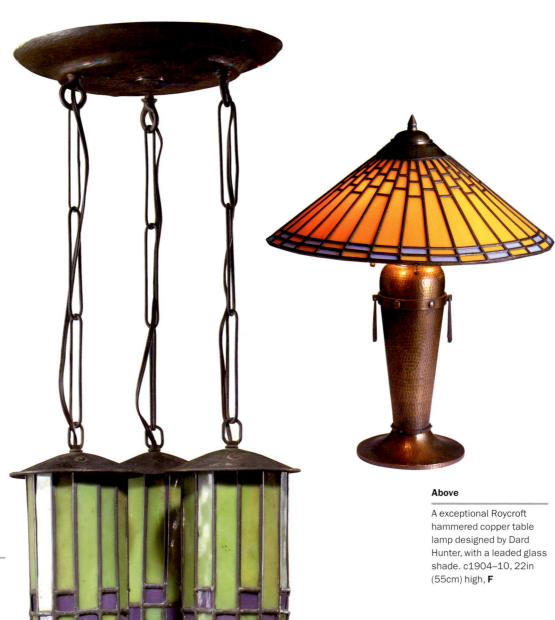

Above

A Roycroft Secessionist-inspired wall sconce designed by Dard Hunter, with a copper and silver frame. c1904–10, 14½in (37cm) high, **F**

Right

A Roycroft ceiling fixture designed by Dard Hunter, with three leaded glass drops. c1904–10, 22in (56cm) high, **G**

Above

A exceptional Roycroft hammered copper table lamp designed by Dard Hunter, with a leaded glass shade. c1904–10, 22in (55cm) high, **F**

Other American Lamps

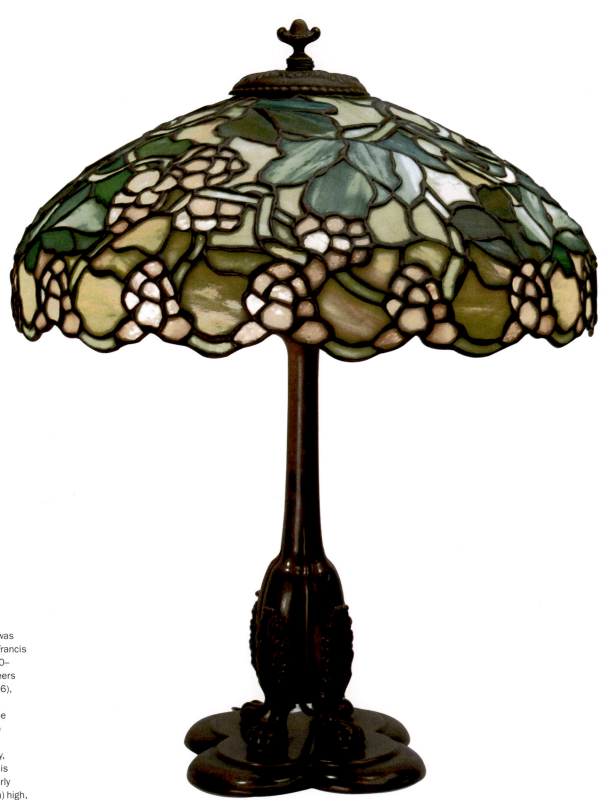

A Roman table lamp produced by Duffner and Kimberly, which was founded in 1905 by Francis Joseph Duffner (1860–1929) and Oliver Speers Kimberly (1871–1956), who had previously worked for Tiffany. The scalloped lower edge of this lampshade is reminiscent of Tiffany, although the pattern is less complicated. Early 20thC, 21in (53.5cm) high, 16in (40.5cm) diam, I

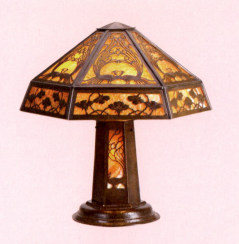

A table lamp by the Limbert Furniture Company. Founded in Michigan in 1902, the company produced mainly furniture. Early 20thC, 25in (64cm) high, **I**

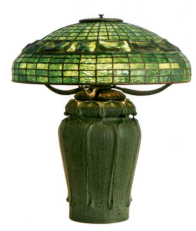

A table lamp with a base attributed to designer George Prentiss Kendrick (1850–1919), produced by Grueby Faience Company, Boston. Lampshade produced by Tiffany Studios, New York. c1905, 21¾in (55.5cm) high, **C**

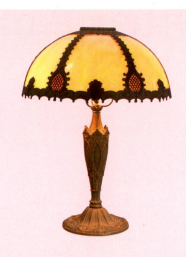

A table lamp produced by Salem Brothers of Massachusetts. Early 20th century, 13in (33cm) high, **M**

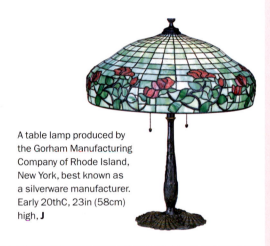

A table lamp produced by the Gorham Manufacturing Company of Rhode Island, New York, best known as a silverware manufacturer. Early 20thC, 23in (58cm) high, **J**

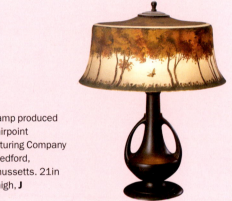

A table lamp produced by the Pairpoint Manufacturing Company of New Bedford, Massachussetts. 21in (54cm) high, **J**

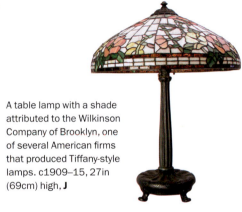

A table lamp with a shade attributed to the Wilkinson Company of Brooklyn, one of several American firms that produced Tiffany-style lamps. c1909–15, 27in (69cm) high, **J**

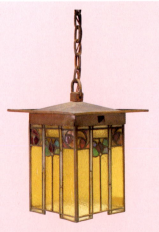

A pendant lamp produced by Gustav Stickley's Craftsman Workshops at Syracuse, New York. c1910, 13in (33cm) high, **G**

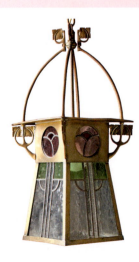

An American Arts and Crafts hanging lamp. c1910, 25in (64cm) high, **L**

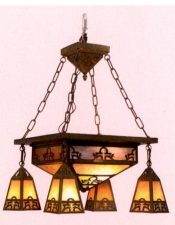

An American Arts and Crafts five-light hanging lamp. Early 20th century, 16in (40cm) wide, **L**

Stained-glass Panels

Stained glass was an important medium for Arts and Crafts designers. In Britain it was William Morris who fuelled a creative revival in this field by encouraging a return to medieval techniques of stained-glass making. Morris lamented the fact that, from the 16th century onwards, church windows had lost their potency by attempting to simulate oil paintings, with much of the colour, as well as the fine details, painted on the surface in the form of enamels. Morris believed that this was both false (in the sense of misleading) and superficial, because in "true" stained glass the colouring is within the glass itself.

James Powell & Sons of Whitefriars, who had carried out lengthy experiments to improve the colours of their stained glass, supplied some of the glass used by Morris & Co. The windows exploited a limited range of pure colours – green, blue, purple, and red – which were extremely vivid in intensity. Morris enlisted his Pre-Raphaelite artist friends to create designs, including Dante Gabriel Rossetti (1828–82) and Edward Burne-Jones. Burne-Jones, who had previously collaborated with Powell's from 1857 to 1861, began to design stained glass for Morris in the 1860s and by 1874 was responsible for most of the firm's figurative designs.

Below

A stained-glass lunette, with glass painted in black enamel using the Schwarzlot technique. c1905, 85¼in (216.5cm) wide, **J**

Bottom of the page

A stained-glass panel with its streaky colours blended in a painterly way rather like watercolour. c1900, 81in (205.5cm) wide, **L**

Left

A stained-glass window depicting Saint Peter, designed by Edward Burne-Jones for Morris & Co., made for the Cheadle Royal Hospital Chapel, Cheshire. The background consists of a trellis of stylized flowers. 1909, 48in (122cm) high.

Below, centre

An American stained-glass panel entitled "The Birth of Our Nation's Flag June 14 1777", made for Princeton University, New Jersey. The roundels include a portrait of George Washington (1732–99), the first President of the United States. c1900, 78½in (199cm) high, **L**

Below, right

An American Arts and Crafts stained-glass panel depicting a bacchanalian female figure. The influence of Louis Comfort Tiffany is apparent in the rich jewel-like colours and painterly effects. c1900, 36½in (93cm) high, **K**

Scottish Stained-glass Panels

The design of stained-glass panels enjoyed a revival in Scotland from the mid- to late-19th century, particularly in Glasgow. As well as exploiting the improved quality and strength of glass, artists and designers began to recognize the potential for expressing artistic flair in a medium that would integrally decorate ecclesiastical and domestic environments. Eschewing the poor quality reproductions of Gothic Revival stained-glass, designers such as James Ballantine sought to reinterpret the looser style of 15th-century glass painting. He established his Edinburgh studio, Ballantine & Allen in 1837, and his new approach was widely admired and won him significant commissions.

Encouraged by Ballantine's success, Stephen Adam founded his company in 1870, while John and William Guthrie expanded their father's business in 1884. Based in Glasgow, these companies experimented with new techniques and aesthetics, including acid etching and polychromatic colour combinations, and trained apprentices such as Alfred Webster and David Gauld.

By the Glasgow International Exhibition of 1888, Scottish stained-glass panels had developed distinctive qualities– it can often identified by the loose drawing style, with a minimal of detailing on drapery and ornamental aspects.

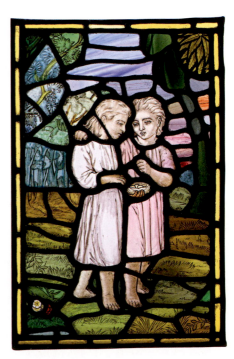

Above

A stained-glass panel depicting Robert the Bruce. The Nationalist connotations of this design indicate that the window is of Scottish origin. c1890, 38½in (98cm) high, **J**

Above

A stained-glass panel depicting the Holy Grail with two female attendants, produced by Guthrie & Wells of Glasgow, 1930, 31½in (80cm) high, **I**

Above

A stained-glass panel. The unaffected simplicity of the design and the subtlety of the colours mark it out as an Arts and Crafts piece. Late 19th century, 21in (54cm) high, **M**

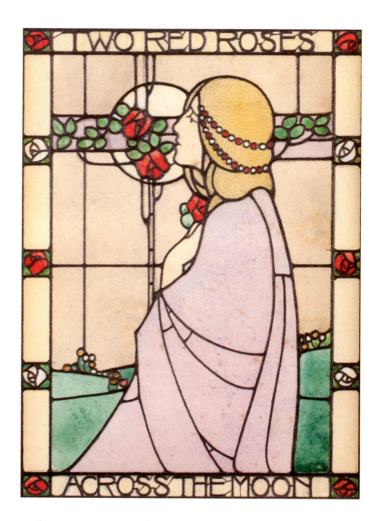

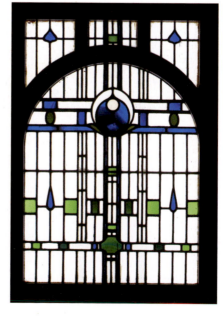

Above

A stained-glass panel produced by Stephen Adam & Son of Glasgow. As well as ecclesiastical glass, the company undertook secular commissions for the homes of wealthy industrialists. Although the figures in this window are drawn in a fairly conventional style, the stylized landscape and the vivid reds of the boy's garments are pure Arts and Crafts. c1900, 52in (132cm) high, **J**

Right

A Scottish leaded-glass panel. The heart-shaped leaves reflect the influence of architect and designer C.F.A. Voysey (1857–1941). c1910, 30¼in (77cm) high, **K**

Above

"Two Red Roses Across the Moon", a pencil and watercolour design for a stained-glass panel by Ernest Archibald Taylor (1874–1951). Taylor studied at Glasgow School of Art in the 1890s, before joining the cabinetmaking firm of Wylie & Lochhead. This symbolist design reflects the influence of the architect Charles Rennie Mackintosh and his wife, the artist Margaret MacDonald Mackintosh. Early 20thC, 6½in (17cm) high, 5in (13cm) wide, **L**

Textiles

Textiles were one of the most significant areas of the Arts and Crafts Movement and it was largely through this medium that British design influence spread to Europe and the United States. It was to textiles, along with the related area of wallpapers, that William Morris (1834–96) devoted much of his creative energy at the peak of his design career. Although few other manufacturers adopted the archaic working practices and socialist ideals upheld by Morris, who opposed the Victorian factory system with its reliance on mechanized looms, his aesthetic had a huge impact on the British textile industry as a whole.

Instead of relying so heavily on stock patterns bought in from commercial studios (often in Paris), many of which were revivals of earlier historical styles, enlightened British companies began to commission original patterns from freelance designers such as Lewis F. Day (1845–1910) and Walter Crane (1845–1915). The Ayrshire-based firm of Alexander Morton & Company, which produced machine-woven lace, carpets, and furnishing fabrics, was at the forefront of this transformation. Teaming up with the leading Arts and Crafts architect Charles Frances Annesley Voysey (1857–1941) and the designer Lindsay Butterfield (1869–1948), the company developed an exquisite range of reversible furnishing fabrics or double cloths, decorated with stylized plants, flowers, and birds. These "art furnishings" were sold by the fashionable London department store Liberty & Co., which also developed an innovative range of printed fabrics in the Arts and Crafts style.

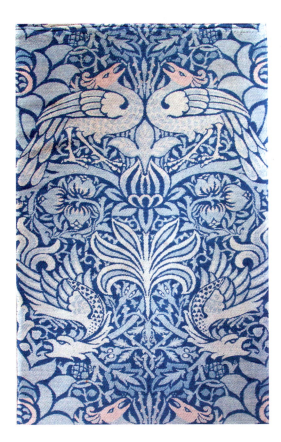

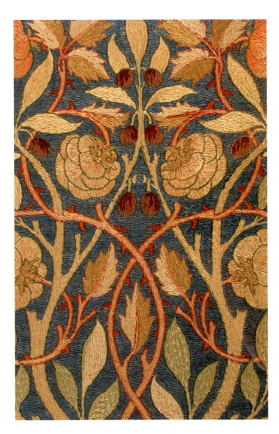

Above

A woven wool fabric panel by William Morris & Co., decorated with stylized birds amid scrolling foliate background. Late 19th C, 86½in (220cm) long, **L**

Above

A Morris & Co. "Bird" jaquard loom wool fabric. Made in three colourways – red, blue and green – this was one of Morris's most popular weaves. c1880s, 29in (74cm) long, **M**

Above

A piece of silk embroidery, attributed to Morris & Co., c1900, 17in (43cm) wide, **M**

Opposite

This illustration of the chintz-printing room used by Morris and Co. at Merton Abbey in Surrey is taken from *The Life of William Morris*, originally published in 1899.

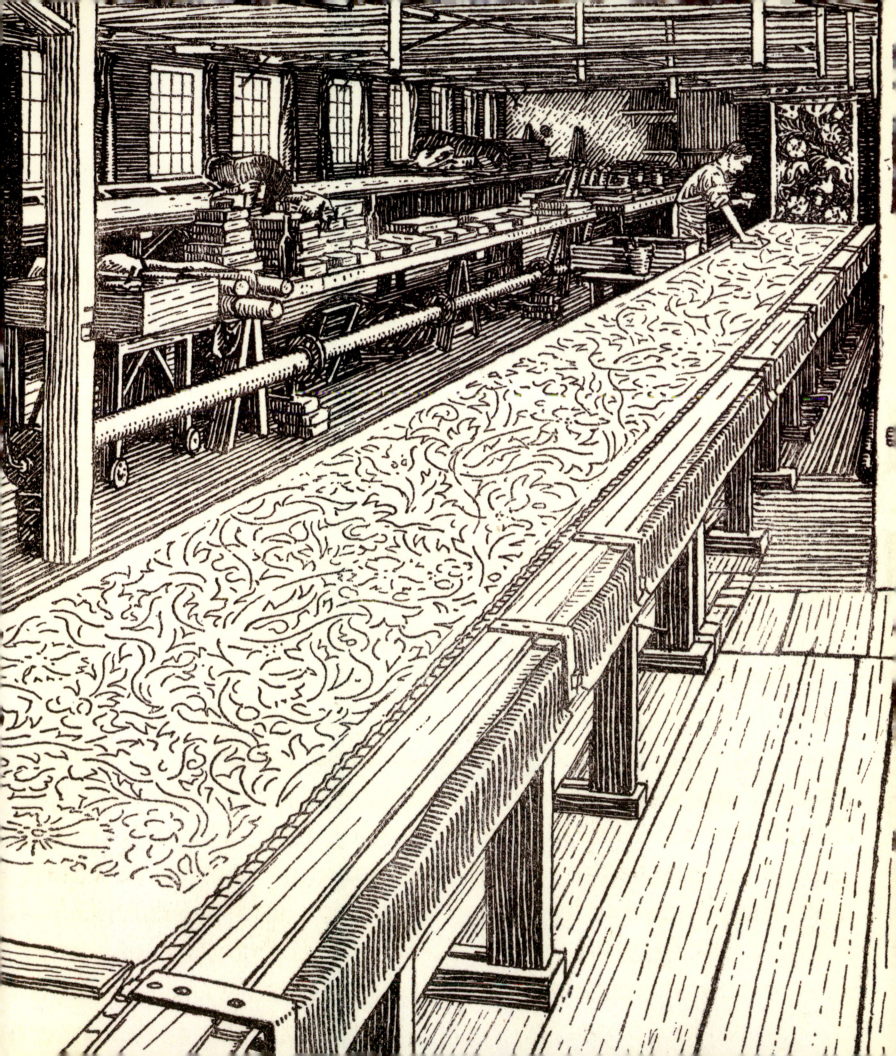

William Morris

William Morris may seem like an establishment figure today, yet back in the mid-19th century he was the angry young man of British textile design. It was his frustration with the formulaic furnishings on offer that prompted Morris to become a textile and wallpaper designer and establish his own firm. "Have nothing in your house that you do not know to be useful, or believe to be beautiful", he decreed.

Initially called Morris, Marshall, Faulkner & Company when it was established in 1861, the firm's name was changed to Morris & Co. in 1874. Through this avenue Morris explored many different branches of textiles, from jacquard-woven and block-printed furnishing fabrics to tapestry weaving and embroidery. The company significantly expanded its operations during the 1880s after taking over a disused silk dyeworks at Merton Abbey on the River Wandle south of London. Central to Morris's ethos was the idealized notion that textiles should be crafted by hand, hence his rejection of power looms in favour of hand looms. Morris believed that this method of production not only provided greater satisfaction for the artisans, but also resulted in better quality products in terms of materials and design.

His approach to pattern design was equally revolutionary. Rejecting the conventionality of the Victorian era, Morris pioneered a dynamic new vocabulary, drawing inspiration from familiar English garden flowers such as daisies, roses, and honeysuckle. Vigorous twining stems and dense scrolling leaves, such as acanthus and willow, formed the backbone and backdrop of his multilayered designs, with birds often perched among the foliage.

Rejecting the harsh tones of recently developed aniline dyes, Morris and his ally Thomas Wardle (1831–1909), a sympathetic textile manufacturer based at Leek in Staffordshire, experimented with traditional natural dyes. These were not only adopted for dyeing yarns and cloth but also for block printing fabrics. Indigo blue – one of the most intense natural dye colours – was Morris's particular favourite. Using a technique called discharge printing, the cloth was immersed in a vat of indigo, then printed with a bleaching agent to create a white silhouette onto which the remaining pattern was block printed. The richness of these effects, combined with the energy of Morris's patterns, resulted in textiles of great immediacy and depth.

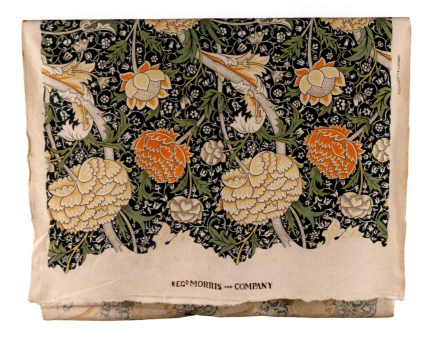

Above

"Cray", a cotton furnishing fabric designed by William Morris for Morris & Co. The design was expensive to print because it required so many different printing blocks. 1884, 49ft 2in (15m) long, **J**

Right

"Peacock and Vine", a linen hanging embroidered in wool, designed by William Morris and architect Philip Webb (1831–1915) for Morris & Co. Late 17th-century English crewelwork was the inspiration for the fruiting vines in this embroidery. The peacock was designed by Webb. c1876, 40in (102cm) wide, **J**

Patterns

HONEYSUCKLE
A textile hanging designed by William Morris, embroidered in wool on a block-printed fabric produced for Morris & Co. by Thomas Wardle of Leek, Staffordshire. 1876, 59in (150cm) long, 36in (91.5cm) wide, **M**

VINE AND POMEGRANATE
A pair of Morris & Co. "Vine and Pomegranate" wool curtains, each lined and lengthened with red woollen cloth addition, braided edges and tie backs. 92in (230cm) long, **L**

STRAWBERRY THIEF
A linen furnishing fabric designed by William Morris for Morris & Co. Working from dark to light, the pattern was block-printed onto indigo-dyed cloth with a bleaching agent. The other colours were then printed on top. 1883, 8ft 4in (2.5m) long, **M**

COMPTON
One of five pairs of Morris & Co. "Compton" printed cotton curtains, each pair lined. Late 19thC, **J**

TULIP AND ROSE
A Morris & Co. woven woollen triple cloth designed by William Morris. First produced in 1878, this design was also woven in silk and linen, and silk and cotton mixed fabrics. **L**

PEACOCK AND DRAGON
A Morris & Co. woven wool panel with original trim. "Peacock and Dragon" was one of Morris's four fabric designs in which he tried to use Islamic colours and Eastern-inspired designs. 1878, 102 x 93in (260 x 236cm), **L**

Other Textiles

During the second half of the 19th century there was a flowering of creativity in British textiles. *The Grammar of Ornament* (1856), compiled by the architect Owen Jones (1809–74), was a key reference, highlighting the rich diversity of patterns and decorative motifs from around the world. Japan, in particular, became a great source of inspiration for designers from the 1860s onwards after the country opened up its previously closed borders and began participating in international trade. The architect Edward William Godwin (1833–86) and the industrial designer Christopher Dresser (1834–1904) both embraced Japanese applied arts with great enthusiasm and incorporated Japanese-inspired patterns in their textiles and wallpapers.

Working within the industrial system, Dresser supplied designs to a host of manufacturers in almost every field of the applied arts. Originally trained as a botanist, Dresser was fascinated by the geometrical characteristics of plants, which he explored in his book *Unity in Variety, as Deduced from the Vegetable Kingdom* (1859). His appreciation of the "oneness" of plant forms led him to develop complex organic patterns that contrast with, but complement, those of Morris.

Morris himself had an enormous impact on textile design from the 1860s onwards. Native English flora and fauna, depicted in a refreshingly honest way, were central to his design language. Such unaffected naturalism was completely revolutionary at a time when imitation and illusion held sway. The founding of the Art Workers' Guild in 1884 and the Arts and Crafts Exhibition Society in 1888 consolidated the aesthetic reforms that Morris had initiated over the previous two decades. The Arts and Crafts Movement represented a broad spectrum of artists, architects, designers, and craftspeople, encompassing a wide range of studio, workshop, and factory production. While Morris was at his most prolific as a textile designer during the 1870s and 1880s, the liberating effect of his work was at its height during the 1890s and 1900s

One of the most influential textile designers at the end of the 19th century was the architect Charles Francis Annesley Voysey (1857–1941). Having begun designing wallpapers in 1883, he turned to textiles in 1890, initially designing printed fabrics for the Lancashire company Turnbull & Stockdale. From 1895 he worked closely with the Ayrshire firm of Alexander Morton & Company, for whom he created carpets and jacquard-woven furnishing fabrics. Voysey's patterns were simpler and more pared down than those of Morris. Drawing on a pool of recurrent motifs, mostly stylized plants and birds, he reduced individual elements to their essence, emphasizing outline, minimizing detail and flattening the surface to create stencil-like effects. "To be simple is the end, not the beginning, of design", Voysey declared.

Above

One of a pair of wool hangings attributed to George Faulkner Armitage, produced by Arthur H. Lee & Sons of Birkenhead. c1900, 97in (246cm) long, **K**

Above

An embroidered panel, worked in coloured silks with flowering and fruiting leafy stems and buff coloured lozenge ground. 25¼in (64.5cm) high, **M**

Above

One of three rectangular crewelwork panels, each worked in coloured wools by Lady Phipson Beale on an unbleached linen ground. c1880, largest 62½in (159cm) wide, **L**

Above

A jacquard-woven velveteen furnishing fabric designed by Christopher Dresser. c1898, 54in (137cm) long, 27in (69cm) wide, **J**

Glasgow School

The Glasgow School refers to a group of artists and designers associated with the husband-and-wife duo of architect Charles Rennie Mackintosh (1868–1928) and artist Margaret MacDonald Mackintosh (1864–1933). Although C.R. Mackintosh did not design any printed fabrics until around 1917, decorative motifs from his furniture and the couple's highly original interiors had a strong impact on textiles at the end of the 19th century and at the start of the 20th.

Their ideas were also propagated at Glasgow School of Art, a progressive educational establishment housed in a building designed by C.R. Mackintosh in 1896 and run by artist Herbert McNair (1868–1955), who was the husband of Margaret's sister Frances (1873–1921). Embroidery was one of the fields championed at the School, where the embroidery department was headed from 1894 by the talented Jessie Newbery (1864–1948).

Below

A Glasgow School panel embroidered in silk on linen. The design bears a close resemblance to the decorative gesso panels created by Margaret MacDonald Mackintosh, which were prominently featured in the interiors she designed with her husband C.R. Mackintosh. 1900, 23in (58cm), **L**

Above

A pair of cotton and rayon panels, possibly designed by the Silver Studio, founded by Arthur Silver (1853–96). 1920s, 91in (231cm) long, 46½in (118cm) wide, **K**

Top

A jacquard-woven silk and cotton furnishing fabric designed by E.W. Godwin for J.W. & C. Ward of Halifax. c1876, **K**

Above

A silk and linen portière made by Ann Macbeth (1875–1948), appliquéd and embroidered with stylized flowers. Macbeth studied at Glasgow School of Art and later succeeded Jessie Newbery as head of the embroidery department. c1900–6, 8ft 6in (2.59m) long, **H**

Other Textiles (continued)

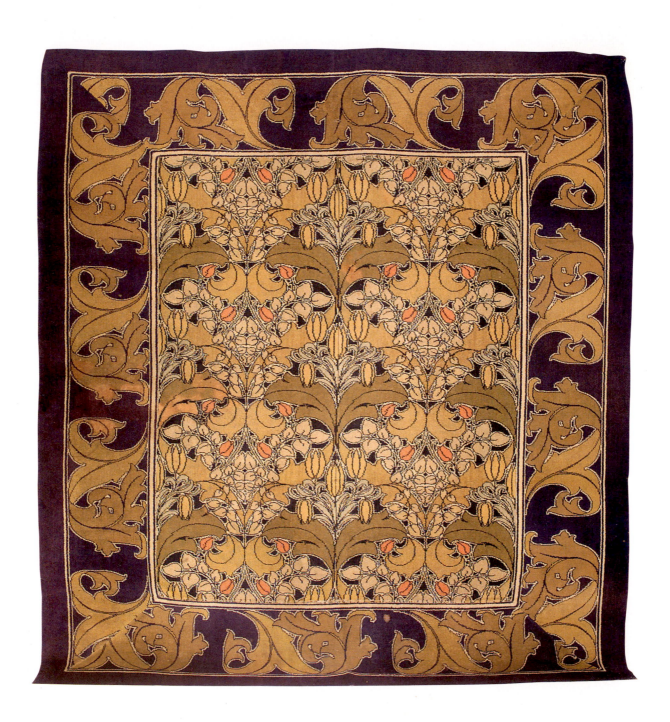

A Wilton carpet designed by C.F.A. Voysey, woven by Tomkinson and Adam for Liberty & Co. This scrolling pattern is typical of Voysey. c1900, 9ft ½in (2.71m) long, **J**

A hand-knotted wool carpet attributed to Gavin Morton, produced by Donegal Carpets. Donegal Carpets was renowned for its subtle dye colour and the superb quality of its carpet-making, which was carried out entirely by hand using the hand-knotting technique. Early 20thC, **K**

A machine-woven carpet in the Arts and Crafts style, with foliate design on a blue ground. The stylistic influence of William Morris is clearly discernible in this factory-produced carpet. c1900, **L**

A machined wool carpet, with interlaced fan design in blue, green and pink within multiple borders. Early 20thC, 109½in (274cm) long, **M**

A drugget rug produced by Gustav Stickley's Craftsman Workshops at Syracuse, New York, decorated with overlapping faceted circles and a Greek key pattern border. c1900–10, 9in (23cm) long, 6in (15cm) wide, **L**

A Donegal carpet, attributed to Gavin Morton. The design features plant forms on a madder ground. Early 20thC, 179¼in (448cm) long, **L**

An rug with pomegranate and fern motifs, loosely reflecting the influence of William Morris. Early 20thC, 19ft 9in (6.02m) long, 10ft (3.05m) wide, **L**

A hand-knotted wool carpet runner attributed to Gavin Morton, possibly produced by Donegal Carpets. Gavin Morton (1867–1954) was the nephew of Alexander Morton (1844–1923), founder of the Ayrshire textile firm of Alexander Morton & Company. As well as running the company's design studio, he created patterns for its Irish subsidiary Donegal Carpets, established by Alexander Morton at Killybegs in County Donegal in 1898. Early 20thC, 10ft 6in (3.2m) long, **L**

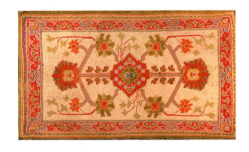

Scottish area rug with a floral vine pattern in rose and green, on a oatmeal ground. Early 20thC, 84in (213cm) long, **L**

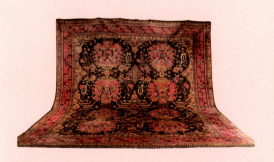

A Turkish carpet in the Arts and Crafts style, the green field with overall pattern of large rose palmettes and cruciform motifs, within rose rosette and scrolling vine border between yellow bands. Early 20thC, 14ft 9in (4.42m) wide, **J**

Books and Graphics

Private printing presses, established as part of the Arts and Crafts Movement, changed the look and feel of books. They grew out of a dissatisfaction with the contemporary printing world and its use of weak typefaces, poorly spaced, and discordant text and illustrations. For William Morris (1834–96), founder of the influential Kelmscott Press, a book could be a beautiful and tactile work of art, as pleasurable to handle as to read. He described how "a big folio lies quiet and majestic on the table, waiting kindly till you please to come to it, with its leaves flat and peaceful, giving you no trouble of body, so that your mind is free to enjoy the literature which its beauty enshrines". Only the best materials were used – strong black ink and hand-made paper – and printing was carried out using hand presses. The resulting books, produced in small editions, were beautiful but expensive. Therefore, cheaper, more ephemeral printed items, such as exhibition catalogues, posters, and monthly magazines, were responsible for widening the appreciation of the Arts and Crafts graphic style. Like Arts and Crafts books, wallpapers were also hand-printed. Rather than this taking place at small private presses, the printing was carried out by larger manufacturers, which were eager to employ the leading artists and architects of the day in order to produce "art wallpaper".

Above

Detail of a woodcut by Edward Burne-Jones (1833–98), for the frontispiece of *Dream of John Ball* by William Morris, printed by the Kelmscott Press. c1888, **K**

Above

Detail of a first edition of William Morris's *The Roots of the Mountains*, one of 250 copies bound in Morris patterned chintz, Chiswick Press for Reeves & Turner. 1890, **K**

Above

Three rectangular sheets of Morris & Co. wallpaper in different floral patterns. Late 19thC, each panel 22½ in (57cm) wide, **L**

Opposite

This engraving is taken from the Kelmscott Press edition of *The Works of Geoffrey Chaucer*, published in 1896, which features illustrations by Edward Burne-Jones.

Kelmscott Press

The Kelmscott Press, founded in Hammersmith in 1891, was William Morris's last great endeavour. Inspired by the printers of the 15th and 16th centuries, his aim was simply to produce beautiful and readable books. In order to achieve this he looked afresh at all elements of book design and production. He designed new typefaces – the roman type Golden, and the gothic types Troy and Chaucer (a smaller version of Troy) – and made sure that the letters were properly laid out upon the page without the excessive amount of white space favoured by contemporary printers. He considered each opening, rather than each individual page, the unit of the book and by making the inner, bound, margins the narrowest the two pages were visually linked together.

Books with well-designed type and well-proportioned margins could, in Morris's opinion, look "positively beautiful" without any further ornamentation. Many of the pages of the Kelmscott Press books are in fact left unornamented. But Morris was a decorator by profession and therefore it was only natural that he also wanted to decorate the page. Morris was responsible for designing the decorative borders and initials that appear in the Kelmscott Press books, often marking the beginning of a new chapter, while artists such as Edward Burne-Jones (1833–98) and Walter Crane (1845–1915) provided the illustrations.

It was essential that illustrations, ornamental borders, and type should form a unified whole. The strong black lines of the wood engravings complemented the typography and were, in contrast to the copperplate or steel engravings favoured by many 19th-century printers, printed at the same time as the type.

The Kelmscott Press books were printed on hand-made paper of pure linen with watermarks – a flower, a perch, and an apple – designed by Morris. The books were also printed on thin vellum, while limp vellum was used for bindings, with coloured silk ties as an alternative to the "temporary" binding of blue-grey laid paper. The black ink was stiff making the task for Morris's pressmen, printing by hand with Albion presses, all the more laborious. Despite this, the Kelmscott Press published 53 titles before its closure in 1898. Many of these were either written or translated by Morris, such as *The Story of Sigurd the Volsung*, an epic poem based on an Icelandic saga. Others were by contemporaries such as Alfred Tennyson (1809–92). But the most elaborate book produced was a medieval text. The Kelmscott Press edition of *The Works of Geoffrey Chaucer* was printed just before Morris's death in 1896. Burne-Jones, who provided more than 80 illustrations, described it as "a pocket cathedral" adding "I think Morris the greatest master of ornament in the world".

Left

One of two wood-engraved illustrations by Edward Burne-Jones in *The Story of Sigurd the Volsung* by William Morris, Kelmscott Press, London. 1898, **J**

Right

William Morris designed the wood-engraved border and initials for the Kelmscott Press edition of *The Life of Thomas Wolsey* by George Cavendish (c1500–1562). 1893, **M**

Below

Artwork from William Morris's *A Dream of John Ball and a King's Lesson*, published by Kelmscott Press in an edition of 300. 1892, **K**

Right

Maud: a Monodrama by Alfred, Lord Tennyson (1809–92), designed by William Morris and published by Kelmscott Press in an edition of 500. 1893, **K**

Left

Pages from a mid 1970s facsimile reprint of *The Works of Geoffrey Chaucer*, originally published by Kelmscott Press in 1896, with illustrations by Edward Burne-Jones. This edition also include *A Companion Volume to the Kelmscott Chaucer* by Duncan Robinson. One of 515 copies. 1974–75, **K**

Above

First edition of William Morris's *Letters on Socialism*, one of 30 copies on paper. 1894, **L**

Edward Burne-Jones

By the mid 1860s the artist Edward Burne-Jones had produced only a handful of illustrations for publications such as Archibald Maclaren's (1891–84) book *The Fairy Family* (1857) and the magazine *Good Words*. But later in the decade this was all about to change as he embarked on the momentous task of illustrating a long narrative poem written by his friend and collaborator William Morris. Even while Morris was writing *The Earthly Paradise* he saw the episodes as pictures, and noted down which illustrations he wanted Burne-Jones to carry out. Beginning in 1866, Morris and Burne-Jones set about creating a fully illustrated edition of the poem and Burne-Jones produced over a hundred illustrations before the project was eventually abandoned.

Seventy of the illustrations sketched by Burne-Jones for *The Earthly Paradise* were for "The Story of Cupid and Psyche", 44 of which made it to the printing-block stage with Morris engraving many of the woodblocks himself. However, when printing trials were carried out the relationship between text and image was deemed unsuccessful. In the end the edition published in 1868 included only one of Burne-Jones's illustrations, depicting three female minstrels, on the title page. Further sets of prints from the original woodblocks were made in 1898, after Morris's death, but it was not until 1974 that the "Cupid and Psyche" illustrations were printed together with the text.

Morris and Burne-Jones admired the woodcuts of Gothic books with their crisp, clean lines and Burne-Jones was critical of the "scribbly work" appearing in 19th-century books and periodicals. He was enraged by what he deemed "stupid, senseless rot that takes an artist half a minute to sketch and an engraver half a week to engrave". But the process of transferring Burne-Jones's light pencil sketches into wood engravings for the Kelmscott *Chaucer* was far from simple, as they had to be redrawn in ink by Robert Catterson-Smith (1853–1938) before being transferred to the woodblock using photography. Burne-Jones's best illustrations were produced for the Kelmscott Press and he loved "to be snugly cased in the borders and buttressed up by the vast initials" that Morris designed. Towards the end of his life he did, however, produce some independent and intensely personal illustrations inspired by traditional flower names and published posthumously in 1905 as *The Flower Book*.

Above

Engravings by Edward Burne-Jones for "The Story of Cupid and Psyche", printed from the original blocks at the Rampant Lions Press. 1974, **M**

Right

Two pages from *The Flower Book* by Edward Burne-Jones. 1882–98, roundel 2½in (6cm) diam, **K** each

A Closer Look

This wood engraving from "The Story of Cupid and Psyche" depicts Psyche being led to to meet the monster she is meant to marry. The scene was divided into two prints: the front of the procession is shown here, while the second print included Psyche and her father.

Burne-Jones's original pencil sketch was traced and transferred onto the woodblock by the draughtsman George Wardle (1836–1910).

The processional figures have strongly defined outlines.

The action is concentrated in the foreground strip and the silhouettes of the figures stand out against the flat background.

Shading is kept to a minimum and is achieved by parallel diagonal lines.

Left

A page from *The Story of Sigurd the Volsung* by William Morris published by Kelmscott Press, showing one of two full-page wood-engraved illustrations by Edward Burne-Jones. 1898, **J**

Far left

Detail of a woodcut by Edward Burne-Jones, for the frontispiece of *Dream of John Ball* by William Morris. The book was printed by hand by Kelmscott Press. c1888, **K**

Essex House Press

The Essex House Press founded by Charles Robert Ashbee (1863–1942) was the direct heir of Morris's Kelmscott Press. An announcement printed in November 1898 stated that Ashbee's Guild of Handicraft had purchased from the trustees of the late William Morris its plant and presses and, although they did not inherit the engraved woodblocks, which were deposited at the British Museum, or the types, which were not for sale, they did arrange to employ a number of the Kelmscott Press staff and hoped "to continue in some measure the tradition of good printing & fine workmanship which William Morris revived". The Essex House Press was formed, taking its name from the 18th-century mansion on Mile End Road in east London to which the Guild had moved in 1891.

Without Morris's type, the press initially relied upon William Caslon's (1693–1766) 18th-century typefaces. However, in 1901, with the publication of *An Endeavour towards the Teaching of John Ruskin and William Morris*, Ashbee launched his own typeface, which became known as Endeavour. The book is a brief account of the aims, work and principals of the Guild and is typical of the promotional material printed by the press. While its title page includes an illustration by George Thomson (1860–1939) depicting Essex House, books and pamphlets published after the Guild's move to Chipping Campden in 1902 captured the new rural setting.

A second typeface, the Prayer Book type, was designed for the Essex House Press's most ambitious project, the *Prayer Book of King Edward VII*. Begun in 1901 and published in 1903, the book included one hundred new designs for wood engravings. A prospectus explained that the book was intended for wealthy men to purchase and give to their parish churches. In an American edition, aimed at the American bishops, the prayer for King Edward VII was replaced with the Prayer for the President of the United States and all in Civil Authority. Despite the commercial success of this *Prayer Book*, the Press was closed temporarily in 1906 and permanently in 1910.

Above

A page from "The Psalter or Psalms of David" from the *Bible of Archbishop Cranmer*, with woodcut illustrations and initials by C.R. Ashbee, Essex House Press. 1902, **M**

Above

A page from *The Prayer Book of King Edward VII*, with woodblocks and typeface by C.R. Ashbee, published by Essex House Press in an edition of 400. 1903, **L**

Above

Woodcut frontispiece by C.R. Ashbee from *An Endeavour towards the Teaching of John Ruskin and William Morris*, printed at the Essex House Press. 1901, **M**

Below

Cover of the catalogue of the third exhibition of the Arts and Crafts Exhibition Society, designed by Walter Crane. 1890, 6in (15cm) high, **M**

Above

A page from Edmund Spenser's *The Faerie Queene*, illustrated by Walter Crane. 1894–7, **L**

Right

A rare copy of *Craftsman Homes* by Gustav Stickley. 1910–12, 11in (28cm) high, **M**

Left

The Book of Glasgow Cathedral, a Talwin Morris bookbinding designed for Morrison Brothers, Glasgow. c1889, **M**

Artwork, Posters, and Wallpaper

Original artwork and posters provide an insight into how Arts and Crafts objects were made and sold. Carefully rendered designs reveal how the boundaries between the fine and decorative arts were broken, making a roll of wallpaper, a stencil, a bookplate, all worthy of an artist's time and attention. The drawing skills of Edward Burne-Jones, for instance, were as evident in a figure study for a tapestry as the preparatory sketches he produced for his paintings.

Designs can help us to understand how repeating patterns were constructed and provide evidence of the designer's original colour choices. As John Henry Dearle's (1860–1932) design for the 1892 wallpaper "Blackthorn", produced for Morris & Co., demonstrates, it was normal practice for only a single repeat to be fully finished and coloured, providing just the necessary information for the block cutter and printer. While Arts and Crafts theory stated that the designer and maker should be the same person, this was often impractical and a scribbled note on the paper can give us a glimpse into the working relationship between the designer and manufacturer. The intermediary stages, from design to finished wallpaper, are shown in printing trials and proofs.

Printed posters became visual manifestos for the Movement's ideals. They advertised the schools, societies, and exhibitions that trained craftsmen and gave them a sense of shared purpose as well as selling opportunities. For the influential American printmaker Blanche Lazzell (1878–1956) the cover of an exhibition catalogue provided the perfect medium for her woodblock prints.

Printed collections of nursery rhymes, fairytales, and folk stories gave Arts and Crafts illustrators the opportunity to use their imaginations, generating books that appeal to children and adults alike. Walter Crane and Kate Greenaway (1846–1901) created nostalgic images of English childhood, while Glasgow artists Jessie M. King (1875–1949) and Annie French (1872–1965) produced ethereal illustrations. The English-born illustrator Louis Rhead (1857–1926) brought fairytales to life for an American audience in watercolours, such as the illustration depicting the Yellow Dwarf, for the *The Fairy Book* published in 1922.

Above

An Arts and Crafts bookmark design, made for John Turnbull Knox. c.1900–10, 6¾in (17.5cm) high, **K**

Left

An Edward Burne-Jones study for the Holy Grail tapestries, with a typically elongated stylized form. c1890s, **J**

Below

A Christopher Dresser wallpaper design. Late 19thC, **J**

WOOD BLOCK PRINTS
BY
BLANCHE LAZZELL

CITY OF
LIVERPOOL
SCHOOL OF
ARCHITECT-
URE AND AP-
PLIED ART

CLASSES IN
ARCHITECTURE
MODELLING
PAINTING AND
DRAWING CAR-
VING IN WOOD
AND STONE OR-
NAMENTAL
WROUGHT IRON
WORK ETC ETC
FOR PARTICULARS
APPLY TO THE DIRECTOR

UNIVER
SITY

FIAT LUX

COL
LEGE

ROBERT

ANNING BELL DEL.

Top

A Blanche Lazzell woodblock print depicting a Providence, Rhode Island, dock scene, featured as cover art for an exhibition of her work. 1928, 8in (20cm) high, **M**

Above

An original watercolour drawing by Louis Rhead. The image was published in *The Fairy Book* by Harper & Brothers, New York. 1922, 10in (25cm) high, **J**

Left

A rare and historically important poster for the City of Liverpool School of Architecture, designed by Robert Anning Bell. Early 20thC, 94½in (240cm) high, **I**

Below

"Blackthorn", a watercolour design for wallpaper. This naturalistic and complex pattern was one of the last designs for Morris & Co. 1892, 40in (102cm) wide, **E**

PATER NOSTER QUI ES IN COELIS

Above

A John Potter design for a stencil, oil on canvas. This panel was awarded a Gold medal in the National Art Competition. 1904, 47½in (120.5cm) high, **K**

Left

A Christopher Dresser wallpaper design. Late 19thC, **K**

Wallpaper

Arts and Crafts wallpaper designers respected the flatness of the wall surface by creating flat patterns that adapted rather than imitated the natural forms of flowers and foliage. As William Morris stated, "You can't bring a whole countryside, or a whole field, into your room" but you could produce patterns that were reminders of the natural world and which sparked the imagination. In Morris's hands nature was tamed into sophisticated pattern repeats that do not readily reveal their method of construction but encourage the viewer to follow the twists and turns of every tendril.

To make these wallpapers artists and architects formed alliances with larger manufacturers such as the London-based firm Jeffrey & Co. Even Morris, originally intending to print his wallpapers himself from etched zinc plates, used this outside contractor. The papers were hand-printed from woodblocks, a method that, as Morris and Co. was keen to point out, was superior to the high-speed machine printing, which left only a thin film of colour on the surface of the paper. The company explained to its customers that "hand-printed papers are produced very slowly, each block used being dipped into pigment and then firmly pressed on to the paper, giving a great body of colour. This process takes place with each separate colour, which is slowly dried before another is applied. The consequence is that in the finished paper there is a considerable mass of solid colour".

The director of Jeffrey & Co., Metford Warner (1843–1930), saw the advantage of employing leading designers, such as Walter Crane, Bruce Talbert (1838–81), and William Burges (1827–81), in order to improve standards. In contrast to Morris, Crane used human figures as part of his patterns and designed a series of coordinating papers that were intended for use within the same room. While Morris advised people not to overdo the amount of pattern-work in their rooms through the use of several papers, designers such as Crane and Talbert provided different patterns for the dado, the main portion of the wall or "filling", the frieze, and the ceiling. Crane also produced a charming range of nursery wallpapers that drew upon his skills as an illustrator of children's books.

Right

A Walter Crane wallpaper with peacocks and lilies, from the residence of British Prime Minister Balfour. 1902–11, 41in (104cm) wide, **J**

Patterns

ACORN
This wallpaper, made by Morris & Co., was first issued in 1879 and was available both in distemper and with a gold ground. 1879, 22in (56cm) wide, **M** per repeat

CELANDINE
This was designed by John Henry Dearle, who joined Morris & Co. in 1878 and by the 1890s had become their main pattern designer. The delicately coloured flowers are arranged within a floriated diaper pattern. Late 19thC, 22in (56cm) wide, **M** per repeat

DOVE AND ROSE
Designed by Morris, this was the first silk and wool double cloth woven for Morris & Co. by Alexander Morton & Co., Darvel, Scotland. Woven fabrics were often used for wall hangings, as was the case in Morris's own home. 1879, 48in (122cm) high, **J**

Left

A Morris & Co. wallpaper catalogue. Late 19thC, **M**

Above

Detail of Morris & Co. "Acorn" wallpaper. First issued c1879, 22in (56cm) wide, **M** per repeat

GOLDEN LILY
This Morris & Co. wallpaper was designed by Morris's apprentice and successor, John Henry Dearle. This design was produced after Morris's death, and the lilies and tulips form undulating and meandering lines. 1897, 22in (56cm) wide, **M** per repeat

FLOWERING SCROLL
This wallpaper is typical of the light colours increasingly favoured by John Henry Dearle in the first years of the 20th century. 1908, 22in (56cm) wide, **M** per repeat

SUNFLOWER
This relatively flat and formal pattern, made up of sunflowers and grape vines, was designed by Morris and was available in distemper and on a gold ground. 1877–8, 22in (56cm), **M** per repeat

Glossary

abalone shell
ear-shaped shell lined with mother-of-pearl.

acid etching
technique involving treatment of glass with hydrofluoric acid, giving a matt or frosted finish.

Aesthetic Movement
decorative arts movement with a strong Japanese influence, which flourished in Europe and the USA from c1860 to the late 1880s

agate ware
Type of pottery resembling agate due to the partial blending of different coloured clays.

aniline dye
synthetic, industrial dye used in textile and carpet manufacture from the 1850s. It produces strong, brighter colours that are cruder than those of traditional vegetable dyes.

annealing
process by which silver is heated and then rapidly cooled in order to soften it sufficiently to be workable. Also refers to slow cooling of hot glass, which reduces internal stresses that may cause cracking once the glass is cold.

armoire
French term for a linen-press, wardrobe or large cupboard.

armorial
crest or coat of arms.

armorial wares
ceramic, glass, or silverwares decorated with coats of arms or crests.

Art Nouveau
Movement and style of decoration characterized by sinuous curves and flowing lines, asymmetry, and flower and leaf motifs, prevalent from the 1890s to c1910.

astragal
small, semi-circular moulding; term applied to the glazing bars on cabinets and bookcases.

aventurine
a form of quartz characterized by bright inclusions of mica or other minerals that give the stone a shimmering or glistening effect.

banding
veneer cut into narrow strips and applied to create a decorative effect; usually found around the edges of tables and drawer fronts.

base metal
non-precious metal such as iron, brass, bronze or steel.

bezel setting
in jewellery, a setting with a metal rim that encircles the sides of a gemstone and extends slightly above it, holding the stone securely in place.

bleu-celeste
a rare tincture used in heraldry, which is sometimes also called *ciel* or *celeste* and is a lighter shade than that of the traditional heraldic azure tincture.

cabochon
gemstone (often heavily flawed) with an uncut but highly polished surface.

caddy
container for tea.

caddy spoon
spoon for measuring tea out of the caddy. Made in vast quantities from the late 18th century.

carat
measurement of gold; one carat equals 200mg.

carver
19th-century term for an elbow dining-chair.

casting
method of making objects by pouring molten metal or glass into a mould or cast made from sand, plaster or metal, conforming to the shape of the finished object.

chrysoprase
a rare and valuable gemstone of the chalcedony family that has a bright apple-green colour due to trace amounts of nickel.

cloisonné
enamel fired in compartments (cloisons) formed by metal wires.

closed-back setting
type of jewellery setting in which the gemstone is secured by projecting prongs.

collet setting
type of jewellery setting in which the gemstones are set in a metal ring or band.

cornice
horizontal top part or cresting on a piece of furniture

crackled glaze (craquelure)
deliberate crackled effect achieved by firing ceramics to a precise temperature.

crazing
tiny, undesirable surface cracks caused by shrinking or other technical defects in a glaze.

credenza
long side cabinet, with shelves at either end.

***cuerda seca* ("dry cord") technique**
thin bands of waxy resist maintain colour separation between glazes during firing, but leave behind "dry cords" of unglazed tile.

drugget rug
a heavy felted fabric of wool, or wool and cotton, used as a floor covering

earthenware
term for a type of pottery that is porous and requires a glaze.

ebonized
wood stained and polished black to simulate ebony.

embossing
method of creating relief ornament on metal by hammering or punching from the reverse.

enamel
form of decoration involving the application of metallic oxides to metal, ceramics, or glass in paste form or in an oil-based mixture, which is then usually fired for decorative effect.

engraving
decorative patterns cut into a metal surface using a sharp tool.

entrelac
interlaced tendril decoration of Celtic origin used on jewellery and revived by Arts and Crafts designers.

everted
outward-turned or flaring, usually describing a rim.

ewer
large jug with a lip that is often part of a set with a basin. Ewers originally held the water used by diners to wash their hands during meals, prior to the introduction of the fork.

faceted
decorative surface cut into sharp-edged planes in a criss-cross pattern to reflect the light.

faience
French term for tin-glazed earthenware.

field
large area of a rug or carpet usually enclosed by borders.

finial
decorative turned knob.

flambé
glaze made from copper, usually deep crimson, flecked with blue or purple, and often faintly crackled.

frieze
long, ornamental band.

gilding
method of applying a gold finish to a silver or electroplated item, ceramics, wood or glass.

glaze
glassy coating that gives a smooth, shiny surface to ceramics and seals porous ceramic bodies.

griffin
mythical animal with the head, wings, and claws of an eagle but a lion's body. It was a popular motif in the Regency and Empire periods.

hallmark
mark on silver that indicated it has been passed at assay. The term derives from the Goldsmiths' Hall, London, where marks were struck.

hardstone
generic term given to non-precious stones.

hollow-ware
any hollow items such as bowls, teapots, jugs; distinct from flatware.

inclusions
natural flaws in gemstones.

inlay
setting of one material (e.g. marble, wood, metal, tortoiseshell, or mother-of-pearl) in another (usually wood).

intaglio
incised design, as opposed to a design in relief.

ivorine
an artificial product made to resemble ivory in colour or texture.

jacquard
fabric with an elaborately woven pattern produced on a Jacquard loom.

jardinière
an ornamental receptacle, usually a ceramic pot or urn, for holding plants or flowers.

Jugendstil
German and Austrian term for the Art Nouveau style.

knop
decorative knobs on lids and covers or the projection or bulge in the stem of a glass or candlestick.

ladder-back
vernacular chair with a series of horizontal back-rails.

lustreware
pottery with an iridescent surface produced using metallic pigments, usually silver or copper.

majolica
corruption of the term maiolica, which refers to a type of 19th-century earthenware in elaborate forms with thick, brightly coloured glazes.

marquetry
use of veneer and often other inlays to make decorative patterns in wood.

matrix
hardstone, such as opal or turquoise, embedded in its parent rock. Much used in Arts and Crafts jewellery.

millefiori ("thousand flowers")
glassmaking technique whereby canes of coloured glass are arranged in bundles so that the cross-section creates a pattern. Commonly used in glass paperweights.

mould blowing
method of producing glass objects by blowing molten glass into a wooden or metal shaper or mould.

openwork
pierced decoration.

palette
range of colours used in the decoration of ceramics.

parcel gilding
Gilding that only partially covers a metal or ceramic surface.

parure
matching set of jewellery, comprising necklace, earrings, and brooch. A "demi-parure" comprises matching earrings and brooch.

pâte-de-verre ("glass paste")
translucent glass created by meting and applying powdered glass in layers or by casting it in a mould.

patina
fine surface sheen on metal or wood that results from ageing, use, or chemical corrosion.

pavé setting
in jewellery, gemstones set so closely together that no backing material is visible.

pewter
alloy of tin or lead (and usually a variety of other metals), used for utilitarian domestic ware.

piercng
intricate cut decoration, originally done with a sharp chisel, later with a fretsaw, and finally with mechanical punches.

plate
term originally applied to domestic wares made of silver and gold but now also used for articles made of base metal covered in silver, e.g. Sheffield plate and electroplate.

portière
a hanging curtain placed over a door or doorless entrance to a room, from *porte*, the French word for door.

provenance
documented history of any antique item, passed on to each new owner. An unusual or notable provenance may enhance the value of a piece.

prunt
blob of glass applied to a glass body for decoration. Prunts are sometimes impressed with a decorative stamp to form "raspberries".

puce
purple red colour formed from manganese oxide, which was used on ceramics.

punch-bowl
large bowl on a stepped or moulded foot.

quatrefoil
shape or design incorporating four foils or lobes.

rail
horizontal splats of a chair back.

reeding
decoration created by narrow, convex mouldings in parallel strips and divided by grooves.

repoussé ("pushed out")
term for embossing. More precisely, the secondary process of chasing metal that has been embossed to refine the design.

roundel
round, flat ornament.

runner
name given to long, narrow rugs, generally c2.6m (8ft 6in) long by c1m (3ft 3in) wide.

salt glaze
thin, glassy glaze applied to some stoneware and produced by throwing salt into the kiln at the height of firing. The glaze may show a pitted surface, known as "orange peel".

sang-de-boeuf
brilliant red ceramic glaze developed in early 18th-century China.

scroddled
mottled pottery fabricated from pieces of differently coloured clays.

seams
visible joins in metalwork that has been cast in several places.

settle
early form of seating designed for two or more people.

sgraffito
form of ceramic decoration incised through a coloured slip, revealing the ground beneath.

shoe
projecting piece rising from the rail back of a chair seat into which the base of the splat is fixed.

shoulder
outward projection of a vase under the neck or mouth.

sleeve vase
tall vase of long thin tubular shape.

slip
smooth dilution of clay and water used in the making and decoration of pottery.

slip-casting
manufacture of thin-bodied ceramic wares and figures by pouring slip into a mould.

slip-trailing
application of slip onto a ceramic form as a way of decorating the surface.

splat
central upright in a chair back, loosely applied to mean all members in a chair back.

solder
lead applied to repair cracks and holes in silver.

solifleur
a vase shaped with a long slender neck, suitable for displaying a single cut flower or bud.

spade foot
tapering foot of square section.

standard
required amount of pure silver in an alloy.

sterling silver
British term for silver that is at least 92.5 per cent pure.

stiles
back uprights on a chair and other pieces of furniture.

stoneware
type of pottery fired at a higher temperature than earthenware, making it durable and non-porous. May be covered in a salt glaze.

strapwork
decorative ornament resembling a series of thongs, rings, and buckles, used mainly in the 16th and 17th centuries and revived in the 19th century.

stretcher
rail joining and stabilizing the legs of a chair or table.

studio pottery/glass
pottery or glass that has been individually designed and crafted.

tapestry
western European flatwoven textile.

Tazza
large, shallow bowl on a stemmed foot made in glass, silver, and ceramics from the 16th century.

throwing
the technique of shaping ceramic vessels by hand on a rotating wheel.

tin glaze
glassy glaze made opaque by the addition of tin oxide and commonly used on earthenware.

trefoil
decorative motif shaped like clover, with three pronounced lobes.

tube lining
type of ceramic decoration in which thin trails of slip are applied as outlines to areas of coloured glaze.

turning
type of process by which a solid piece of wood is modelled by turning on a lathe.

underglaze
colour or design painted before the application of the glaze on a ceramic object. Blue is the most common underglaze colour.

veneer
thin slice of expensive and often exotic timber applied to an inexpensive secondary timber (carcass) using glue.

verre églomisé
glass that has been decorated on the reverse with silver or gold leaf, which is covered with a varnish to protect it.

warp
foundation material running the length of a carpet. Before weaving can begin, warps need to be correctly positioned on the loom. The warp is generally made from silk, cotton, or wool.

weft
horizontal threads in the foundation of a rug that are interwoven with the warps. In most flatweaves, the visible surface of the rug is composed of weft threads.

wreathing
spiralling indented rings inside thrown pottery, left by the potter's fingers, or caused by distortions during the firing process.

Resources

UK AUCTION HOUSES

Bonhams
101 New Bond Street
London W1S 1SR
Tel: +44 20 7447 7447
www.bonhams.com

Cheffins
Clifton House
1 & 2 Clifton Road
Cambridge CB1 7EA
Tel: +44 122 321 3343
www.cheffins.com

Christie's South Kensington
85 Old Brompton Road
London SW7 3LD
Tel: +44 20 7930 6074
www.christies.com

Clevedon Salerooms
The Auction Centre, Kenn Road,
Clevedon
Bristol BS21 6TT
Tel: +44 193 483 0111
www.clevedon-salerooms.com

Dreweatts & Bloomsbury
Auctions
Donnington Priory
Newbury RG14 2JE
Tel: +44 163 555 3553
www.dreweatts.com

Duke's
The Dorchester Fine Art
Saleroom
Weymouth Avenue
Dorchester DT1 1QS
Tel: +44 130 526 5080
www.dukes-auctions.com

Fielding's
Mill Race Lane
Stourbridge DY8 1JN
Tel: +44 138 444 4140
www.fieldingsauctioneers.
co.uk

Gorringes
15 North Street
Lewes BN7 2PE
Tel: +44 127 347 2503
www.gorringes.co.uk

Lyon & Turnbull
33 Broughton Place
Edinburgh EH1 3RR
Tel: +44 131 557 8844
www.lyonandturnbull.com

John Nicholson Auctioneers
Longfield
Midhurst Road
Fernhurst
Haslemere GU27 3HA
Tel: +44 142 865 3727
www.johnnicholsons.com

Sothebys
34–35 New Bond Street
London W1A 2AA
Tel: +44 20 7293 5000
www.sothebys.com

Tennants
The Auction Centre
Leyburn DL8 5SG
Tel: +44 196 962 3780
www.tennants.co.uk

Woolley & Wallis
51-61 Castle Street
Salisbury SP1 3SU
Tel: +44 172 242 4500
www.woolleyandwallis.co.uk

UK DEALERS

Art Furniture
www.artfurniture.co.uk

Circa 1900
London
Tel: +44 771 370 9211
www.circa1900.org

The Design Gallery
5 The Green
Westerham TN16 1AS
Tel: +44 195 956 1234
www.designgallery.co.uk

The Fine Art Society
148 New Bond Street
London W1S 2JT
Tel: +44 20 7629 5116
www.faslondon.com

Hall-Bakker Decorative Arts
Antiques at Heritage
Woodstock OX20 1TA
Tel: +44 199 381 1332
www.hall-bakker.com

Hill House Antiques &
Decorative Arts
The Electric Cinema
17 Market Place
Brentford TW8 8EG
Tel: +44 20 8560 1463
www.hillhouse-antiques.co.uk

The Millinery Works
Gallery
87 Southgate Road
London N1 3JS
Tel: +44 20 7359 2019
www.milleryworks.co.uk

David Pickup
115 High Street
Burford OX18 4RG
Tel: +44 199 382 2555

Puritan Values Ltd
The Dome
St Edmunds Road
Southwold IP18 6BZ
Tel: +44 796 637 1676
www.puritanvalues.com

Morgan Strickland Decorative
Arts
Tel: +44 797 456 7507
or +44 795 690 9707
www.
morganstricklandantiques.
com

Paul Reeves
Cirencester
Gloucestershire
By appointment
Tel: +44 128 564 3917
www.paulreeveslondon.com

Sandy Stanley Jewellery
58–60 Kensington
Church Street
London W8 4DB
Tel: +44 797 314 7072
www.sandystanleyjewellery.
co.uk

Strachan Antiques
40 Darnley Street
Pollokshield
Glasgow G41 2SE
Tel: +44 141 429 4411
www.strachanantiques.co.uk

Style Gallery
10 Camden Passage
London N1 8ED
Tel: +44 20 7359 7867
www.styleantiques.co.uk

Tadema Gallery
10 Charlton Place
London N1 8AJ
Tel: +44 20 7359 1055
www.tademagallery.co.uk

Titus Omega
London
www.titusomega.com

Sylvia Powell Decorative Arts
Suite 400 Ceramic House
571 Finchley Road
London NW3 7BN
Tel: +44 20 8201 5880
www.sylviapowell.com

Van Den Bosch
123 Grays Antiques Market
58 Davies Street
London W1K 5LP
Tel: +44 20 7629 1900
www.vandenbosch.co.uk

Mike Weedon
7 Camden Passage
London N1 8EA
Tel: +44 20 7226 5319
www.mikeweedonantiques.com

US AUCTION HOUSES

Bonhams
220 San Bruno Avenue
San Francisco
CA 94103
Tel: +1 415 861 7500
www.bonhams.com/auctions

Freeman's
1808 Chestnut Street
Philadelphia
PA 19103
Tel: +1 215 563 9275
www.freemansauction.com

James D. Julia, Inc.
203 Skowhegan Rd.
Fairfield
ME 04937
Tel: +1 207 453 7125
www.jamesdjulia.com

Michaan's
2751 Todd Street
Alameda
CA 94501
Tel: +1 510 740 0220
www.michaans.com

Northeast Auctions
93 Pleasant St
Portsmouth
NH 03801
Tel: +1 603 433 8400
www.northeastauctions.com

Pook & Pook, Inc.
463 East Lancaster Avenue
Downingtown
PA 19335
Tel: +1 610 269 4040
www.pookandpook.com

Rago Arts and Auction Center
333 North Main Street
Lambertville
NJ 08530
Tel: +1 609 397 9374
www.ragoarts.com

Skinner Auctions Inc.
63 Park Plaza
Boston
MA 02116
Tel: +1 617 350 5400
www.skinnerinc.com

Swann Auction Galleries
104 East 25th Street
New York
NY 10010
Tel: +1 212 254 4710
www.swanngalleries.com

William Doyle Galleries
175 East 87th Street
New York
NY 10128
Tel: +1 212 427 2730
www.doylenewyork.com

US DEALERS

John Alexander Ltd
Philadelphia
Pennsylvania
Tel: +1 215 242 0741
www.johnalexanderltd.com

Berman Gallery
9 Long Point Lane
Rose Valley
PA 19063
Tel: +1 215 733 0707
www.bermangallery.com

Chicago Silver
Chicago, IL
www.chicagosilver.com

Circa 1910 Antiques
Galisteo, NM
Tel: +1 505 466 6304
www.circa1910antiques.com

Craftsman Antiques
The Lafayette Mill Antiques
Center
12 Morris Farm Road
Lafayette
NJ 07848
Tel: +1 862 812 0574
www.craftsmanantique.com

Dalton's Antiques
1931 James Street
Syracuse
NY 13206
Tel: +1 315 463 1568
www.daltons.com

Geoffrey Diner Gallery
1730 21st Street NW
Washington
DC 20009
Tel: +1 202 483 5005
www.dinergallery.com

David H. Surgan
315 Flatbush Avenue
PMB311, Brooklyn
NY 11217
Tel: +1 718 638 3768
www.heintzcollector.com

Treadway Gallery
2029 Madison Road
Cincinnati
OH 45208
Tel: +1 513 321 6742
www.treadwaygallery.com

John Toomey Gallery
818 North Boulevard
Oak Park
IL 60301
Tel: +1 708 383 5234
www.johntoomeygallery.com

J. Austin Antiques
31 South Pleasant St.
Amherst
MA 01002
Tel: +1 413 253 3986
www.jaustinantiques.com

JMW Gallery
144 Lincoln Street
Boston
MA 02111
Tel: +1 617 338 9097
www.jmwgallery.com

Just Glass Auctions
www.justglass.com

JW Art Glass
8466 N Lockwood Ridge, #252
Sarasota
FL 34243
Tel: +1 941 266 8206
www.jwartglass.com

Macklowe Gallery
667 Madison Avenue
New York
NY 10065
Tel: +1 212 644 6400
www.macklowegallery.com

Lillian Nassau Ltd
220 East 57th Street
New York
NY 10022
Tel: +1 212 759 6062
www.lilliannassau.com

Jerry Cohen
109 Main Street
Putnam
CT 06260
Tel: +1 860 933 2961
www.artsncrafts.com

Pearce Fox Decorative Arts
159 Lancaster Avenue
Wayne
PA 19087
Tel: +1 610 308 9941
www.webteek.com/foxmission

Peter-Roberts Antiques Inc.
82 Roslyn Ave
Sea Cliff
NY 11579
Tel: +1 516 428 2790
www.peter-roberts.com

Pete's Pots
Tel: +1 770 846 6704
www.webteek.com/petespots

Phil Taylor Antiques
224 Fox-Sauk Road
Ottumwa
IA 52501
Tel: +1 641 799 1097
www.philtaylorantiques.com

Strictly Mission
Tel: +1 610 428 2930
www.strictlymission.com

Stuart F. Solomon Antiques
9¾ Market Street
Northampton
MA 01060
Tel: +1 413 586 7776
www.ssolomon.com

Voorhees Craftsman
1415 North Lake Avenue
Pasadena
CA 91104
Tel: +1 626 298 0142
www.voorheescraftsman.com

Austria

Auktionshaus im Kinsky GmbH
Palais Kinsky Freyung 4
A-1010 Wien
Tel: +43 1 532 42 00
www.imkinsky.com

Dorotheum
Dorotheergasse 17
1010 Wien
Tel: +43 1 515600
www.dorotheum.com

France

Antiquités de la Vieille Ville
Nancy
81 Grande Rue
54000 Nancy
Tel: +33 83 32 82 73

Antiquités Denis Ruga
13 Rue Stanislas
54000 Nancy
Tel: 00 33 83 35 20 79

Antiquités Eury
53 Rue du Maréchal Oudinot
54000 Nancy
Tel: 00 33 83 55 06 32

Le Louvre des Antiquaries
2 Place Du Palais Royal
75001 Paris
www.louvre-antiquaires.com

Germany

Auktionshaus Bergmann
Möhrendorfer Str. 4
DE-91056 Erlangen
Tel: +49 9131 45 0666
www.auction-bergmann.de

Dr. Fischer Kunstauktionen
Trappensee-Schlösschen
74074 Heilbronn
Tel: +49 7131 15557
www.auctions-fischer.de

Kunst- & Auktionshaus
W. G. Herr
Friesenwall 35
50672 Cologne
Tel: +49 221 25 45 48
www.herr-auktionen.de

Quittenbaum
Theresienstraße 60
D-80333 München
Tel: +49 89 273702125
www.quittenbaum.de

MUSEUMS

UK

7 Hammersmith Terrace
(Emery Walker Trust)
London W6 9TS
Tel: +44 20 8741 4104
www.emerywalker.org.uk

Birmingham Museum & Art
Gallery
Chamberlain Square
Birmingham B3 3DH
Tel: +44 121 348 8007
www.bmag.org.uk

Blackwell
The Arts & Crafts House
Bowness-on-Windermere
LA23 3JT
Tel: +44 153 944 6139
www.blackwell.org.uk

Cheltenham Art Gallery &
Museum
Clarence Street
Cheltenham GL50 3JT
Tel: +44 124 223 7431
www.cheltenhammuseum.
org.uk

Court Barn Museum
Church Street
Chipping Campden
GL55 6JE
Tel: +44 138 864 1951
www.courtbarn.org.uk

Crafts Study Centre
UCA
Falkner Road
Farnham GU9 7DS
Tel: +44 125 289 1450
www.csc.ucreative.ac.uk

Dorman Museum
Linthorpe Road
Middlesbrough
TS5 6LA
Tel: +44 164 281 3781
www.dormanmuseum.co.uk

The Glasgow School of Art
167 Renfrew Street
Glasgow G3 6RQ
Tel: +44 141 353 4500
www.gsa.ac.uk

Goddards
27 Tadcaster Road
York YO24 1GG
Tel: +44 190 477 1930
www.nationaltrust.org.uk/
goddards

The Gordon Russell Museum
15 Russell Square
Broadway WR12 7AP
Tel: +44 138 685 4695
www.gordonrussellmuseum.org

Hidcote
Hidcote Bartrim
near Chipping Campden
GL55 6LR
Tel: +44 138 643 8333
www.nationaltrust.org.uk/
hidcote

Hunterian Museum and Art
Gallery and Mackintosh House
Gallery
University of Glasgow
University Avenue
Glasgow G12 8QQ
Tel: +44 141 330 4221
www.gla.ac.uk/hunterian/

Kelmscott Manor
Kelmscott
Lechlade GL7 3HJ
Tel: +44 136 725 2486
www.kelmscottmanor.co.uk

Manchester Art Gallery
Mosley Street
Manchester M2 3JL
Tel: +44 161 235 8888
www.manchestergalleries.org

Museum of Domestic Design
and Architecture
9 Boulevard Drive
London NW9 5HF
Tel: +44 20 8411 5244
www.moda.mdx.ac.uk

The Red House
Red House Lane
Bexleyheath
London DA6 8JF
Tel: +44 208 304 9878
www.nationaltrust.org.uk/
red-house

Rodmarton Manor
Cirencester GL7 6PF
Tel: +44 128 584 1442
www.rodmarton-manor.co.uk

Standen
West Hoathly Road
East Grinstead RH19 4NE
Tel: +44 134 232 3029
www.nationaltrust.org.uk/
standen

Victoria and Albert Museum
Cromwell Road
London SW7 2RL
Tel: +44 20 7942 2000
www.vam.ac.uk

Wightwick Manor
Wightwick Bank
Wolverhampton
WV6 8EE
Tel: +44 190 276 1400
www.nationaltrust.org.uk/
wightwick-manor

William Morris Gallery
Lloyd Park, Forest Road
Walthamstow
London E17 4PP
Tel: +44 20 8496 4390
www.wmgallery.org.uk

USA

The Gamble House
4 Westmoreland Place
Pasadena
CA 91103
Tel: +1 626 793 3334
www.gamblehouse.org

The Art Institute of Chicago
111 S Michigan Avenue
Chicago
IL 60603
Tel: +1 312 443 3600
www.artic.edu

Charles Hosmer Morse
Museum of American Art
445 North Park Avenue
Winter Park
FL 32789
Tel: +1 407 645 5311
www.morsemuseum.org

The Elbert Hubbard Roycroft
Museum
363 Oakwood Avenue
East Aurora
NY 14052
Tel: +1 716 652 4735
www.roycrofter.com/museum.
htm

Los Angeles County Museum of
Art (LACMA)
5905 Wilshire Blvd
Los Angeles
CA 90036
Tel: +1 323 857 6000
www.lacma.org

Marston House Museum
& Gardens
3525 Seventh Avenue
San Diego
CA 92103
Tel: +1 619 297 9327
www.sohosandiego.org

The Metropolitan Museum
of Art
1000 5th Avenue
New York
NY 10028
Tel: +1 212 535 7710
www.metmuseum.org

Michener Art Museum
138 S Pine Street
Doylestown
PA 18901
Tel: +1 215 340 9800
www.michenermuseum.org

Museum of Fine Arts, Boston
Avenue of the Arts
465 Huntington Avenue
Boston
MA 02115-5523
Tel: 001 617 267 9300
www.mfa.org

The Museum of Arts & Design
2 Columbus Circle
New York
NY 10019
Tel: +1 212 299 7777
www.madmuseum.org

Neue Galerie
1048 5th Avenue
New York
NY 10028
Tel: +1 212 628 6200
www.neuegalerie.org

Frank Lloyd Wright Trust
951 Chicago Ave,
Oak Park
IL 60302
Tel: +1 312 994 4000
www.flwright.org

Philadelphia Museum of Art
2600 Benjamin Franklin
Parkway
Philadelphia
PA 19130
Tel: +1 215 763 8100
www.philamuseum.org

The Stickley Museum at
Craftsman Farms
2352 Route 10 West
Morris Plains
NJ 07950
Tel: +1 973 540 0311
www.stickleymuseum.org

The Stickley Museum
300 Orchard Street
Fayetteville
NY 13066
www.stickleymuseum.com

The Thorsen House
2307 Piedmont Avenue
Berkeley
CA 94704
Tel: +1 510 845 4187
www.thorsenhouse.org

Virginia Museum of Fine Arts
200 North Boulevard
Richmond
VA 23220
Tel: +1 804 340 1400
vmfa.museum

The Wolfsonian Museum of
Modern Art and Design
1001 Washington Ave
Miami Beach
FL 33139
Tel: +1 305 531 1001
www.wolfsonian.org

Canada

Gardiner Museum of Ceramic
Art
111 Queen's Park
Toronto, Ontario
M5S 2C7
Tel: +1 416 586 8080

Textile Museum of Canada
55 Centre Avenue
Toronto, Ontario
M5G 2H5
Tel: +1 416 599 5321
www.textilemuseum.ca

Austria

Wien Museum
Karlsplatz 8
1040 Vienna
Tel: +43 1 505 87 47 0
www.wienmuseum.at

France

Petit Palais, City of Paris Fine
Art Museum
Avenue Winston Churchill
75008 Paris
Tel: +33 1 53 43 40 00
www.petitpalais.paris.fr

Musée de l'Ecole de Nancy
36-38 Rue Sergent Blandan
54000 Nancy
Tel: +33 3 83 40 14 86
www.ecole-de-nancy.com

Germany

Bröhan-Museum
Schloßstraße 1a
14059 Berlin
Tel: +49 30 326906
www.broehan-museum.de

Museum fur Kunst und
Gewerbe
Steintorplatz
20099 Hamburg
Tel: +49 40 428134880
www.mkg-hamburg.de

Picture acknowledgements

The publishers would like to thank the following organizations for supplying pictures for use in this book.

Calderwood Gallery
1622 Spruce Street
Philadelphia
PA 19123
USA
Tel: +1 215 546 5357
www.calderwoodgallery.com
p.53tc, p.53bl, p.53br, p.61r

Cheffins
Clifton House
1&2 Clifton Road
Cambridge CB1 7EA
UK
Tel: +44 1223 213343
www.cheffins.co.uk
p.82tl, p.83br, p.83tr

Clars Auction Gallery
5644 Telegraph Avenue
Oakland
CA 94609
USA
Tel: +1 510 428 0100
www.clars.com
p.73tr, p.73br

Clevedon Salerooms
The Auction Centre
Kenn Road, Clevedon
Bristol BS21 6TT
UK
Tel: +44 1934 830 111
www.clevedon-salerooms.com
p.24tr

Dorotheum
Palais Dorotheum
Dorotheergasse 17
A-1010 Vienna
Austria
Tel: +43 1 515 600
www.dorotheum.com
p.135r, p.206t

Dreweatts and Blooms
Donnington Priory
Newbury RG142JE
UK
Tel: +44 1635 553 553
www.dreweatts.com
p.18br, p.21l, p.28tl, p.31bl, p.35bl, p.36br, p.38bl, p.39bl, p.40, p.41tl, p.41c, p.41bc, p.41br, p.42tc, p.43tl, p.43tr, p.43bl, p.43br, p.68bl, p.76tc, p.87tc, p.139bc, p.140tc, p.142tr, p.143tl, p.146br, p.147tr, p.151tc, p.151bc, p.151cr, p.170tr, p.170br, p.175bl, p.176bc, p.178l, p.178r, p.178br, p.179tr, p.179br, p.180, p.181bl,
p.181tr, p.196, p.197c, p.197bc, p.218c, p.220r, p.221bc, p.221tr, p.222tr, p.224bl, p.224br, p.227bl

Duke's
The Dorchester Fine Art Saleroom
Weymouth Avenue
Dorchester DT1 1QS
UK
Tel: +44 1305 265 080
www.dukes-auctions.com
p.21tr, p.29br, p.37tr, p.38br, p.39tl, p.151c

Dunbar Sloane
7 Maginnity Street
Wellington 6011
New Zealand
Tel: +64 472 1367
www.dunbarsloane.co.nz
p.74tr

Fielding's
Mill Race Lane
Stourbridge DY8 1JN
UK
Tel: +44 1384 444 140
www.fieldingsauctioneers.co.uk
p.72l, p.75c, p.80bl, p.80br, p.81br, p.170bcll, p.170bcl, p.197bl

The Fine Art Society
148 New Bond Street
London W1S 2JT
UK
Tel: +44 20 7629 5116
p.82bc, p.207l, p.213tc, p.213br, p.213bc, p.214r, p.215tl, p.226r, p.227br

Freeman's
1808 Chestnut Street
Philadelphia, PA 19103
USA
Tel: +1 215 563 9275
www.freemansauction.com
p.11br, p.12bl, p.60tc, p.61tl, p.61bl, p.62, p.146bl, p.154r, p.220l, p.223br, p.225tl

Gardiner Houlgate
Leafield Way
Corsham SN13 9SW
UK
Tel: +44 1225 812912
www.gardinerhoulgate.co.uk
p.69, p.144l

Gorringes
15 North Street
Lewes, East Sussex
BN7 2PD
UK
Tel: +44 1273 472503
www.gorringes.co.uk
p.132r, p.146tr, p.181bc,

Grays
58 Davies Street
London W1K5AB
UK
Tel: +44 20 7629 7034
www.graysantiques.com
p.174tc

Hampton and Littlewood
The Auction Rooms
Alphin Brook Road
Alphington
Exeter EX2 8TH
Tel: +44 1392 413100
www.hamptonandlittlewood.co.uk
p.87cl

Hartleys
Victoria Hall Salerooms
Little Lane
Ilkley LS29 8EA
UK
Tel: +44 1252 843 222
www.andrewhartleyfinearts.co.uk
p.34br, p.42bl, p.73tl, p.197br

James D Julia Inc.
PO Box 830
Fairfield
ME 04937
USA
Tel: +1 207 453 7125
www.juliaauctions.com
p.201r, p.204, p.205cr

Jeanette Hayhurst Fine Glass
PO Box 83
Tetbury, Gloucestershire
GL8 0AL
UK
Tel: +44 20 7938 1539

John Nicholson's Fine Art
Auctioneers & Valuers
Longfield, Midhurst Road
Fernhurst, Haslemere
Surrey GU27 3HA
UK
Tel: +44 1428 653 727
www.johnnicholsons.com
p.74bl, p.74br

Gorringes

Law Fine Art Ltd
Ash Cottage
Ashmore Green
Newbury, Berkshire
RG18 9ER
UK
Tel: +44 1635 860033
www.lawfineart.co.uk
p.37tl

Lawrence's Auctioneers
The Linen Yard
South Street, Crewkerne
Somerset TA18 8AB
UK
Tel: +44 1460 73041
www.lawrences.co.uk
p.141tl

Leslie Hindman
1338 West Lake Street
Chicago
IL 60607
USA
Tel: +1 312 280 1212
www.lesliehindman.com
p.90cl, p.152r, p.210l

Lyon and Turnbull Ltd
33 Broughton Place
Edinburgh EH1 3RR
UK
Tel: +44 131 557 8844
www.lyonandturnbull.com
p.2-3, p.18c, p.20, p.23bl, p.24br, p.26bl, p.27r, p.28tr, p.28br, p.29tl, p.29tr, p.29bl, p.29bc, p.30bl, p.32bl, p.32br, p.33tl, p.33c, p.33br, p.36c, p.80cl, p.81c, p.85c, p.85br, p.86, p.87tl, p.135c, p.140bl, p.142br, p.145bc, p.148tc, p.148bl, p.150, p.170bcr, p.170bcrr, p.173cr, 173br, p.181br, p.190l, p.190r, p.194l, p.194r, p.197tl, p.197cl, p.208l, p.208c, p.208r, p.209l, p.209tr, p.209br, p.212tr, p.212bl, p.212bc, p.212br, p.213bl, p.214l, p.214lc, p.214rc, p215bc, p.216, p.217tl, p.217tc, p.217tr, p.217c, p.217br, p.224tc, p.224bc, p.225br, p.227tr, p.227cr

Macklowe Gallery
667 Madison Avenue
New York
NY 10065
USA
Tel: +1 212 644 6400
www.macklowegallery.com
p.154l

Michaan's
2751 Todd Street
Alameda
CA 94501
USA
Tel: +1 510 740 0220
www.michaans.com
p.126l, p.155tl, p.155bc, p.155br, p.198l, p.198c, p.198r, p.199l, p.199c, p.199r

Omega Auctions
Unit 3.5, Meadow Mill
Stockport, Cheshire
SK1 2BX
UK
Tel: +44 0161 865 0838
www.omegaauctions.co.uk
p.135tl

Pook & Pook
463 East Lancaster Avenue
Downington
PA 19335
USA
Tel: +1 610 269 4040/0695
www.pookandpook.com
p.207c

Puritan Values Ltd
The Dome
St Edmunds Road
Southwold, Suffolk IP18 6BZ
UK
Tel: +44 7966 371676
Email: sales@puritanvalues.com
p.23r, p.28bl, p.30br, p.31br, p.35tl, p.35r, p.41cr, p.41bl

Quittenbaum
Theresienstrasse 60
D-80333 Munich
Germany
Tel. +49 89 273702125
www.quittenbaum.dem
p.24l

Rago Arts and Auction Center
333 North Main Street
Lambertville, NJ 08530
USA
Tel: +1 609 397 9374
www.ragoarts.com
p.10, p.22bl, p.25br, p.36bl, p.41cl, p.44l, p.44c, p.44r, p.46l, p.46r, p.47l, p.47tl, p.47tr, p.47bl, p.47bc, p.47br, p.48bl, p.48br, p.49t, p.49b, p.50l, p.50r, p.51l, p.51bl, p.51bc, p.51r, p.52l, p.52r, p.53tl, p.54tl, p.54tr, p54bl, p.54bc, p.54br, p.55bl, p.55bc, p.55br, p.56tl, p.56tr, p.56br, p.57tl, p.57cl, p.57bl, p.58bl, p.58tl, p.58br, p.58tc, p.59tl, p.59bl, p.59cr, p.60bl, p.60bc, p.60br, p.61tl, 61bl, 61bc,

p.63tl, p.63cl, p.63bl, p.63tc, p.63c, p.63tr, p.63cr, p.63br, p.64tr, p.65tl, p.65bl, p.65tr, p.65br, p.70br, p.71r, p.75bl, p.79bl, p.88bl, p.88c, p.88br, p.90tl, p.90tr, p.90bl, p.91tl, p.91r, p.90cr, p.90br, p.91bl, p.91bc, p.91br, p.92l, p.92c, p.92r, p.93tl, p.93bl, p.93r, p.94l, p.94cl, p.94cr, p.94r, p.95l, p.95c, p.95r, p.96l, p.96cl, p.96cr, p.96r, p.96tc, p.97l, p.97cl, p.97cr, p.97r, p.98tc, p.98bl, p.98br, p.99l, p.99c, p.99r, p.100l, p.100r, p.101tl, p.101bl, p.101c, p.101r, p.102l, p.102br, p.103tl, p.103bl, p.103r, p.104tc, p.104l, p.104r, p.104b, p.105tl, p.105bl, p.105r, p.105b, p.106tc, p.106bl, p.106cr, p.107t, p.107b, p.108l, p.108c, p.109tl, p.109bl, p.109. tc, p.109bc, p.109r, p.110l, p.110lc, p.110rc, p.110r, p.111tr, p.111tr, p.111bl, p.112tc, p.112bl, p.112bc, p.112br, p.113l, p.113tc, p.113bc, p.113br, p.114tc, p.114cl, p.114c, p.114cr, p114br, p.115tl, p.115bl, p.115r, p.116tc, p.116bl, p.116br, p.117l, p.117r, p.118tc, p.118bl, p.118bc, p.118br, p.119l, p.119c, p.119r, p.120l, p.120c, p.120r, p.121tl, p.121bl, p.121r, p.122t, p.122bl, p.122br, p.123tl, p.123bl, p.123r, p.124l, p.124c, p.125tl, p.125bl, p.125tc, p.125bc, p.125cr, p.126c, p.126r, p.127tl, p.127bl, p.127r, p.128, p.129tl, p.129tc, p.129tr, p.129cl, p.129c, p.129cr, p.129bl, p.129bc, p.129br, p.141br, p.152l, p.152c, p.156l, p.156r, p.157tr, p.157bl, p.158tl, p.158bl, p.159tl, p.159br, p.160l, p.160r, p.161tl, p.161bl, p.161r, p.162bl, p.163bl, p.163bc, p.163br, p.164tc, p.164bl, p.164br, p.165tl, p.165bl, p.165bc, p.165tr, p.166, p.167cl, p.167bl, p.167bc, p.167cr, p.167br, p.187c, p.190c, p.200t, p.200b, p.202bc, p.203l, p.203c, p.203r, p.205tl, p.205cl, p.205bl, p.205c, p.205bc, p.206b, p.207r, p.215r, p.216cl, p.217bl, p.217bc, p.217cr, p.217cl, p.218r, 226tl, p.228tc

Skinner Inc.
The Heritage on the Garden
63 Park Plaza
Boston
MA 02116
USA
Tel: +1 617 350 5400
www.skinnerinc.com
p.53bl, p.64l, p.64br, p.74tl, p.77r, p.83bl, p.111bl, p.155bl, p.205tr, p.205br, p.221tl, p.221tc

Sothebys
34–35 New Bond Street
London W1A 2AA
UK
Tel: +44 20 7293 5000
www.sothebys.com
p.27tl, p.63bc, p.79r, p.124r

Style Gallery
10 Camden Passage
London N1 8EA
UK
Tel: +44 20 7359 7867
p.147bl

Swann Galleries
104 East 25th Street
New York
NY 10010
USA
Tel: +1 212 254 4710
www.swanngalleries.com
p.227c

Sworders
14 Cambridge Road
Stansted Mountfitchet
Essex CM24 8BZ
UK
Tel: +44 1279 817 778
www.sworder.co.uk
p.39tr, p.84cl, p.171bl

Tennants
The Auction Centre
Leyburn DL8 5SG
UK
Tel: +44 1969 623780
www.tennants.co.uk
p.18bl, p.37br, p.42br, p.43bl, p.143br, p.151tr, p.173tl, p.181cr, p.181c

Van Den Bosch
Shop 1, Georgian Village
Camden Passage
London N1 8DU
UK
Tel: +44 20 7629 1900
www.vandenbosch.co.uk
p.138r, p.139tl, p.139bl, p.139tr, p.140tl, p.140tr, p.141tr, p.143bl, p.146tl, p.151cl, p.151bl, p.171br, p.170bl, p.172l, p.172c, p.172r, p.174cr, p.174bl, p.174br, p.175tl, p.175cl, p.175r, p.176tc, p.176bl, p.177bl, p.177c, p.178c, p.179l, p.181cl, p.181tc

Von Zezschwitz Kunst und Design
Friedrichstrasse 1a
D-80801 München
Germany
Tel: +49 89 38 98 930
www.von-zezschwitz.de
p.26r

Woolley and Wallis
51-61 Castle Street
Salisbury
Wiltshire, SP13SU
UK
Tel: +44 1722 424 500
www.woolleyandwallis.co.uk
p.5, p.8, p.21br, p.22br, p.25tl, p.39br, p.41tc, p.41tr, p.68bc, p.68br, p.70tc, p.70bl, p.71l, p.72r, p.73bl, p.75tl, p.75br, p.76bl, p.76br, p.77tl, p.78tc, p.78br, p.78bl, p.79tl, p.80tc, p.80cr, p.81bl, p.82tr, p.83tl, p.84l p.84cr, p.84r, p.85tl, p.85bl, p.87tr, p.87c, p.87cr, p.87bl, p.87bc, p.132c, p.134l, p.134r, p.135bl, p.136l, p.136r, p.137l, p.137r, p.138l, p.140bc, p.140br, p.141bl, p.142tl, p.142b, p.143tr, p.144r, p.145l, p.145tc, p.147tl, p.147br, p.148br, p.151tl, p.181tl, p.151br, p.168l, p.168r, p.170tl, p.171cl, p.173tc, p.173tr, p.177tl, p.177cb, p.179c, p.192l, p.192c, p.192r, p.193l, p.193c, p.193r, p.194c, p.195l, p.195c, p.195tr, p.196, p.197tc, p.197tr, p.197cr, p.210r, p.225tr, p.229l, p.229br

Additional photographic credits

Alamy Arcaid 130; Elizabeth Whiting & Associates 45

Arcaid Charlotte Wood 11, 12; Mark Fiennes 133; Richard Powers 19

Bridgeman Art Library The De Morgan Centre, London 66; Private Collection/The Stapleton Collection 219

Getty Images British Library/ Robana 211; Cincinnati Museum Center 89; Hulton Archive 169

Photoshot Ken Hayden/Red Cover 7

Richard Powers 15

Scala The British Library, London 188

The Stickley Museum at Craftsman Farms Used by permission of The Craftsman Farms Foundation, Inc, Parsippany, New Jersey 16, 153

Victoria and Albert Museum, London 191

Endpapers: "Strawberry Thief" furnishing fabric, Morris & Co., 1883; V&A Images/Alamy

Case: "Acanthus" wallpaper, Morris & Co., 1875; The National Trust Photolibrary/ Alamy

Additional picture captions

Furniture, pp16–17:
One of the largest and most impressive pieces Gustav Stickley's firm ever produced, this oak and chestnut sideboard with copper hardware now stands in the dining room of the Log House at Craftsman Farms, Stickley's country estate in New Jersey.

Ceramics, pp66–7:
Ceramic tiles depicting galleons, designed by William De Morgan (1839–1917) and manufactured by Sands End Pottery, London, 1888–97.

Silver, Metalware and Jewellery, pp130–1:
The front door of Garden Corner, London, a Queen Anne revival house that was refurbished by C.F.A. Voysey in 1906. The door features brass hinges and gilded lettering in the Arts and Crafts style.

Miscellaneous, pp188–9:
The drawing-room at Kelmscott House, Hammersmith, an illustration from *The Life of William Morris*, originally published by Longmans & Co., London, in 1899.

Index

If you want a golden rule that will
fit everybody, this is it:
Have nothing in your houses
that you do not know to be
useful, or believe to be beautiful.

—WILLIAM MORRIS